Avant-Garde Theatre Sound

Avant-Gardes in Performance

Series Editors
Sarah Bay-Cheng, University at Buffalo, The State University of New York
Martin Harries, University of California, Irvine

Media Parasites in the Early Avant-Garde: On the Abuse of Technology and Communication
By Arndt Niebisch

Avant-Garde Theatre Sound: Staging Sonic Modernity
By Adrian Curtin

AVANT-GARDE THEATRE SOUND
STAGING SONIC MODERNITY

Adrian Curtin

 AVANT-GARDE THEATRE SOUND
Copyright © Adrian Curtin, 2014.

All rights reserved.

First published in 2014 by
PALGRAVE MACMILLAN®
in the United States—a division of St. Martin's Press LLC,
175 Fifth Avenue, New York, NY 10010.

Where this book is distributed in the UK, Europe and the rest of the
World, this is by Palgrave Macmillan, a division of Macmillan Publishers
Limited, registered in England, company number 785998, of Houndmills,
Basingstoke, Hampshire RG21 6XS.

Palgrave Macmillan is the global academic imprint of the above
companies and has companies and representatives throughout the world.

Palgrave® and Macmillan® are registered trademarks in the United
States, the United Kingdom, Europe and other countries.

ISBN: 978–1–137–32478–8

Library of Congress Cataloging-in-Publication Data

Curtin, Adrian, 1980–
 Avant-garde theatre sound : staging sonic modernity / by Adrian Curtin.
 pages cm. — (Avant-gardes in performance)
 Includes bibliographical references and index.
 ISBN 978–1–137–32478–8 (alk. paper)
 1. Theaters—Sound effects. 2. Experimental theater—History—
19th century. 3. Experimental theater—History—20th century.
4. Theater—Production and direction. I. Title.
PN2091.S6C87 2014
792.02′4–dc23 2013040831

A catalogue record of the book is available from the British Library.

Design by Integra Software Services

First edition: April 2014

10 9 8 7 6 5 4 3 2 1

To my grandfather, Michael Kelly (1921–1998), a theatrical rogue who loved to perform

Contents

List of Illustrations	ix
Foreword	xi
Acknowledgments	xiii
Introduction: The Sound of No Hands Clapping	1
1 The Acoustic Imaginary	21
2 Theatre Sound in the Age of Mechanical Reproduction	63
3 Reinventing Language: Sense and Nonsense	101
4 Hearing *Affectively*: The Noise of Avant-Garde Performance	143
Conclusion: A Resounding...	199
Notes	205
Bibliography	235
Index	251

Illustrations

I.1 Mike Turner, "the sound of no hands clapping…" www.CartoonStock.com. — 2

1.1 Lionel Barrymore as Mathias in James Young's 1926 silent film *The Bells* — 23

1.2 Illustration from Albert Robida, *Contes pour les Bibliophiles* (Paris: Librairies-imprimeries reunites, 1895), p. 142 — 27

1.3 Illustration from Albert Robida, *Contes pour les Bibliophiles* (Paris: Librairies-imprimeries reunites, 1895), p. 139 — 28

1.4 Fernand Khnopff, *En écoutant du Schumann* (1883) — 29

1.5 Fernand Khnopff, *Du Silence* (1890) — 33

1.6 *The Yellow Sound*, performed by students of the University of Glamorgan at the Tate Modern in 2011 — 59

2.1 Scenographical design for Cocteau's *The Eiffel Tower Wedding Party* — 82

2.2 Illustration from Arthur Mee, "The Pleasure Telephone," *The Strand Magazine* (September 1898), p. 340 — 89

2.3 Illustration from George Sims, *Living London* (London: Cassel and Company, 1902–03), Vol. 3, p. 115 — 90

3.1 Illustration from Albert Robida, *Le Vingtième Siècle* (Paris: Montgredien, 1882), p. 128 — 104

3.2 Illustration by Warwick Goble from "An Esperanto City," *The Strand Magazine* (December 1908), p. 520 — 113

4.1 Umberto Boccioni, *La Strada Entra Nella Casa* (1911) — 157

Foreword

Despite the many acts of denial and resistance embodied in the phrase "death of the avant-garde," interest in experimental, innovative, and politically radical performances continues to animate theatre and performance studies. For all the attacks upon tradition and critical institutions (or perhaps because of them), the historical and subsequent avant-gardes remain critical touchstones for continued research across media and disciplines. We are, it seems, perpetually invested in the new.

Avant-Gardes in Performance enables scholarship at the forefront of critical analysis: writing that not only illuminates radical performance practices but also transforms existing critical approaches to those performances. By engaging with the charged phrase "avant-garde," the series considers performance practices and events that are *formally* avant-garde, as defined by experimentation and breaks with traditional structures, practices, and content; *historically* avant-garde, defined within the global aesthetic movements of the early twentieth century, including modernism and its many global aftermaths; and *politically* radical, defined by identification with extreme political movements on the right and left alike.

Adrian Curtin's *Avant-Garde Theatre Sound: Staging Sonic Modernity* brings sound to the forefront of these considerations. His investigations of the relations among sound technologies, aural and oral traditions, and the performance dynamics of the modernist or historical avant-gardes open up significant new avenues of scholarship for not only avant-garde studies but also the role of sound in theatre and performance historiography. As Curtin argues, theatre studies has tended to privilege vision over performance aurality, despite the fact that the history of theatre is rife with evidence of sonic communication and manipulation. As he points out in his introduction and develops throughout his readings of key modernist texts (and scores), negotiations between sight and sound are integral to the development of modernist literature and drama. Moreover, as Curtin compellingly demonstrates, a cultural history of sound presents an ideal

way to negotiate the diverse and often contradictory impulses and histories of the avant-garde(s) precisely because the historical development of sound resists linear narrative.

Embracing, therefore, a circular perhaps even recursive strategy, Curtin revisits well-known icons of the theatrical avant-garde including Maurice Maeterlinck, Wassily Kandinsky, Guillaume Appolinaire, Jean Cocteau, and Gertrude Stein, alongside works less often considered, such as Albert Robida's science-fiction novel *Le Vingtième Siècle* (*The Twentieth Century*) from 1882. His attention to the use of recorded sound, particularly in turn-of-the-century Europe, and the interplay between technological advances and aesthetic experimentation effectively trace the mutual exchanges in theatre and performance of the period. Curtin disrupts the often-accepted notion that the advent of digital media was the first to introduce manipulations of sound on stage.

We are therefore pleased to include *Avant-Garde Theatre Sound* within the *Avant-Gardes in Performance* series. This book offers not only a useful corrective to historical studies and an addition to our understanding of the modernist avant-garde, but also a valuable addition to contemporary theorizing of the relations among diverse media and theatrical performance. As we continually look to the "new," Curtin reminds us of the value in listening.

<div style="text-align: right">Sarah Bay-Cheng and Martin Harries</div>

Acknowledgments

Writing a book of this sort is a solitary activity, which makes the conversation that takes place before and after words are put on the page tremendously important.

I first wish to thank Tracy Davis, who guided this project from the outset. Tracy read countless drafts, made brilliant suggestions, and posed incisive questions. I could not have asked for a better advisor or academic mentor. (I am now prepared to concede that everything important happened in the nineteenth century.) I am also grateful to Linda Austern and Susan Manning for their sage counsel. Linda inspired and then encouraged my first inquiries into sound studies, while Susan was my ever-enthusiastic guide to modernism, theatre studies, and the academy. I benefited greatly from communities of scholars at Northwestern University, and in particular my immediate colleagues in the Interdisciplinary PhD in Theatre and Drama program: Katie Zien, Jon Foley Sherman, Sam O'Connell, Rashida Shaw, Emily Sahakian, and Oona Kersey Hatton. I also wish to thank Harvey Young for his good cheer and professional guidance and Liz Luby for her administrative savvy and kind-hearted support.

I have been fortunate to find new scholarly interlocutors in recent years. Claire Warden, whose passion for scholarship and higher education is seemingly boundless, provided helpful and amusing commentary on chapter drafts. Kara Reilly also offered instructive feedback on work in progress and helped me navigate the sometimes-choppy waters of the book-writing process. I'm grateful to my colleagues in the drama department at the University of Exeter for their bonhomie and spirited engagement in all things. Jon Primrose and Chris Mearing provided expert technical assistance. I wish to thank my editors at Palgrave, Robyn Curtis and Erica Buchman, for their courteousness and professionalism, as well as my eagle-eyed copy editor at Integra.

Portions of this book have been published elsewhere in modified format. My account of Apollinaire's *The Breasts of Tiresias* appears in *Theatre*

Noise: The Sound of Performance (Lynne Kendrick and David Roesner, eds., 2011) and is republished courtesy of Cambridge Scholars Press. The section on the theatre phone appears in *Theatre, Performance and Analogue Technologies: Historical Interfaces and Intermedialities*, edited by Kara Reilly (Palgrave, 2013). My discussion of Richard Huelsenbeck's poetry performances is included in an essay I wrote for *Vibratory Modernism*, edited by Anthony Enns and Shelley Trower (Palgrave, 2013). My analysis of Artaud's *The Cenci* borrows from an article published in *Theatre Research International* 35.3 (2010) and is presented here courtesy of Cambridge University Press. Thank you to all the editors for their comments and assistance.

This project was initially funded by a graduate research grant, a research fund from the Alice Kaplan Institute for the Humanities, and a presidential fellowship, all from Northwestern University. It was subsequently supported by a British Academy/Leverhulme research grant.

Conversation that was not about research and academia was also invaluable. For this, and for their long-standing moral (and financial!) support, I wish to thank my friends and family (curtain call for Audrey, Darren, Ian, Denis, and Valerie). They usually find the right thing to say.

Introduction: The Sound of No Hands Clapping

While researching this book I came across an amusing, slightly irksome, cartoon. The image, which appears on a commercial cartoon website, shows two people standing outside a building. One has his ear to the door. Evidently, he is trying to discern what is going on inside. The other looks at him with a goofy grin. The sign on the door, written in quirky lettering, says "Avant-Garde Theatre Company." The eavesdropper has the group's initials on his clothing. The cartoon caption reads: "Listen, you can hear the sound of no hands clapping..." (Figure I.1). What is the "sound" of no hands clapping? Silence, presumably. The cartoon insinuates the "Avant-Garde Theatre Company" does not have an audience, or if it does, their applause is either withheld or so muted the sound does not travel far. The cartoon recalls the well-known Zen koan of Hakuin Ekaku (1685–1768) about the seemingly impossible sound of one hand clapping, which serves in popular discourse as a non sequitur or paradox.[1] Avant-garde theatre is so radical, the cartoon mischievously implies, it goes beyond the sound of *one* hand clapping (how jejune) and obtains the eminently more achievable, but perhaps less desirable, "sound" of *no* hands clapping. It does this, one assumes, by bamboozling, frustrating, disregarding, or eschewing a general audience and cultivating gormless devotees instead. The cartoon lampoons art deemed so esoteric, unconventional, or just plain bad it does not receive public approval—traditionally signaled at the end of a performance by the sound of clapping hands.

But perhaps the "Avant-Garde Theatre Company" did not seek this familiar, reassuring sound. Audience applause is sanctioned noise, and it is usually solicited or even craved by theatre artists. It allows those in attendance to acknowledge the efforts of the performers and the production team, including the dramatist, if there is one. The quality, volume, and duration of the applause are measures of the audience's satisfaction or

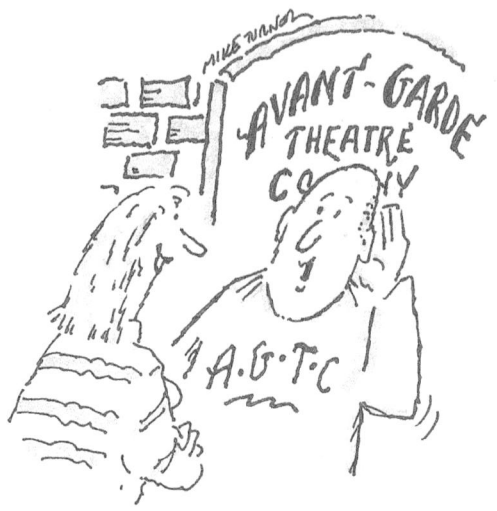

"Listen, you can hear the sound
of no hands clapping..."

Figure I.1 Mike Turner, "the sound of no hands clapping . . . " www.CartoonStock.com.

the lack thereof. Applause is also a feature of social propriety (it is impolite *not* to clap). Applause theoretically allows audience members to respond individually while functioning as part of a collective sounding body—or gestural body, as in the practice of hand-waving among deaf audiences. It is ritualized noise and gesture. Applause punctuates the proceedings and marks the near-completion of the performance as a social and theatrical event. It provides actors who have played characters an opportunity to appear before the audience as themselves, or in their public personae, or as an indeterminate actor–character hybrid.[2] Applause frames theatre *as* performance. The "Avant-Garde Theatre Company," with its supposed sound of no hands clapping, disrupts these conventions. If applause did not exist as a convention, or if, hypothetically (and amusingly), applause were purely conceptual, then the feedback loop between performers and audience would be severed; it might not be entirely clear when—or if—a performance had ended. The performance frame would be unhinged. One would be uncertain if the complete performance had made much of an impression, especially if one were an eavesdropper or onlooker. If the sound of no hands clapping occured in avant-garde theatre, would anyone hear it? And would anyone care?

This Fluxus-style thought experiment is admittedly a little facetious, but so is the cartoon. No avant-garde theatre company calls itself the

"Avant-Garde Theatre Company," even in an ironic, postmodern, knowing fashion, nor is the sound of no hands clapping a standard feature of avant-garde performance, though there are some theatre *auteurs* who claim to prefer audience silence, with its various affective shades, to the clamor of clapping at the end of a show.[3] Conversely, avant-gardists such as F. T. Marinetti sought the "pleasure of being booed" in lieu of standard applause.[4] The cartoon aims to offer a quick gag, not cultural critique, yet its humor depends on popularly held conceptions about the avant-garde, including avant-garde theatre, that merit acknowledgment and interrogation. *The avant-garde is a joke*, the cartoon suggests. *The avant-garde is passé. The avant-garde is dead. The avant-garde is a failure. The avant-garde is a members-only club. The avant-garde does not have an audience. The avant-garde is not impactful. The avant-garde does not make a sound.* Are these conceptions accurate or fair? I think not, but it is difficult to generalize about the avant-garde and misguided to suppose it is all of a type. This book examines the modernist theatrical avant-garde, whose panoply of sound-making is still worth consideration today. If this cartoon's eavesdroppers had been listening outside the Cabaret Voltaire in Zurich in 1916 when the dadaists were performing, or outside the Théâtre des Folies-Wagram in Paris in 1935 during Antonin Artaud's production of *Les Cenci* (*The Cenci*), they would have heard a lot more than the "sound of no hands clapping." They would, quite possibly, have heard the fractious noise of vibrant audiences idiosyncratically responding to dynamic, agitational, provocative, and sonically inventive theatrical performances. The fact that both the conceptual and the actual noise of modernist avant-garde theatre have mostly been forgotten and no longer activate the popular imaginary is regrettable. This book seeks to correct this cultural deaf spot by attending to the exuberant noise of late-nineteenth- and early-twentieth-century avant-garde theatre, which is manifold and fascinating.

THE SONIC TURN

The analysis of sonic phenomena, artistic and commonplace, historical and present day, is the business of scholars who work in, or intersect with, sound studies: an interdisciplinary, not-quite-cohesive-or-unified field of practice. In the introduction to *The Oxford Handbook of Sound Studies*, published in 2012, Trevor Pinch and Karin Bijsterveld offer this account:

> Sound studies has become a vibrant new interdisciplinary field with many different, yet often overlapping, strands. Among the areas involved are acoustic ecology, sound and soundscape design, anthropology of the senses, history of everyday life, environmental history, cultural geography, urban

studies, auditory culture, art studies, musicology, ethnomusicology, literary studies, and STS [science and technology studies]. New fields of study always come with competing definitions of what should be studied, and sound studies is no exception. Each strand conceptualizes its topic and thus the reality it constructs as its proper subject in different ways.[5]

Sound studies forms part of the wider field of sensory studies, which is similarly diverse; it surveys the historicity and intertwining of the senses in culture and society. Sound scholarship in the humanities examines soundmaking, sonic representations, and ideas about sound in cultural texts and everyday life, examining how the sounds we hear and the way we hear them help shape understanding and perception. Sounds, especially human-authored sounds, are often ideologically coded and are integral to social formations and identity constructions. Sound informs the social construction of categories such as gender, race, sexuality, nationality, and class, and can operate stereotypically and performatively. It is naive to think vocal/sonic characteristics associated with personal identities are necessarily or simply "natural." Actors know this best of all. Moreover, sonic environments can be replete with sociocultural and personal significance, especially for individuals and communities attuned to them. For hearing-enabled people, the sonic environment may inflect how one feels about and understands one's place in the world. The Canadian composer and acoustic ecologist R. Murray Schafer popularized the term "soundscape" in his landmark study *The Tuning of the World* (1977), using it to mean "any aural area of study."[6] The term has subsequently come to refer to "almost any experience of sound in almost any context," notes Ari Y. Kelman.[7] Literary scholars have examined how references to sound and hearing in literature ("literary soundscapes") provide hermeneutics for understanding fictional worlds as well as authors' lived experiences of their own historical periods.[8] Literary texts can provide insight into prior conceptions of sound and hearing. Authors transduce aural impressions into textual form; readers replay the "recordings," imaginatively hearing evocations of acoustic worlds, albeit with questionable fidelity. After all, the sounds one imagines when reading a novel may differ quite considerably from those the author first heard, or imagined hearing. Literary soundscapes invariably involve semantic drift; the same is true of dramatic texts.

Traditionally, theatre scholars have given the sounds of drama and performance short shrift. Theatre and performance studies are notably missing from the list of scholarly fields mentioned by Pinch and Bijsterveld, quoted earlier. This is slightly puzzling. Although sight is etymologically figured in the word *theatre* (from the Greek word *theatron*, meaning

seeing-place), theatre is also a place for hearing, obviously (hence the Latin-derived words *auditorium* and *audience*), not to mention the other senses. Theatres have been archaeoacoustically designed since the time of the Ancient Greeks, whose plays were carefully composed with hearing in mind and were orchestrated in performance for sonic (and visual) effect. However, most books on theatre sound have taken the form of instructional guides for creating sound design; historical investigation and critical analysis have been less common. This has been an oversight (pun intended), because the acoustic dimension of plays and performances provides more than just contributory effects or added value; it is a marker of the socio-historical circumstances of artistic creation. Plays "record" acoustic impressions; these may be analyzed for their cultural meanings. Wes Folkerth makes this point in his study of sound in Shakespearean drama:

> Shakespeare's playtexts record past acoustic events, vivifying the past presences of different voices, tones, and intonations in the early modern theatre. The sounds embedded in these playtexts ask us to assent to the fullness and reality of their temporal and cultural otherness. At the same time, they also express, at various registers of theatrical and linguistic representation, their author's understanding of sound. They do so at least partially because the spoken word is the communicative medium the playtexts were employed to notate in the first place.[9]

Folkerth's book is one of several scholarly works that consider the sound of English early modern theatre. The importance of aurality in everyday life in that period is undisputed. Bruce R. Smith's landmark study *The Acoustic World of Early Modern England* (1999) is an exemplar.[10] Smith shows how sonic environments helped condition subjecthood and lived experience in early modern England. He describes the Globe theater in Vitruvian terms as a vintage "instrument to be played upon," a "device for propagating sound" that was "extraordinarily efficient."[11] Shakespeare's theatre created auditory events *par excellence*, and his plays are composed with sound and hearing in mind, not just with respect to directions for music and sound cues, but on the levels of dramatic action, cultural reference, and philosophical import. The growing importance of spectacle onstage and in society since the early modern period does not mean that the acoustic dimension of performance matters less.

In recent years, the "sonic turn" has been more evident in theatre scholarship. "Is it sound's turn?," asks Patrice Pavis in the preface to *Theatre Noise: The Sound of Performance*, an essay collection published in 2011, inspired by a conference held at the Central School of Speech and Drama

in London two years earlier: "Are we currently discovering sound?... *Mise en scène, mise en son, mise en songe.* Staging, sounding, sounding out?"[12] It would seem so. *Theatre Journal* published a special issue on "hearing theatre" in 2006. *Performance Research* had an issue "On Listening" in 2010. Ross Brown authored a reader on theatre sound the same year.[13] Further conferences on theatre and performance sound took place in 2012 at the University of Montreal and the University of Bayreuth.[14] Matthias Rebstock and David Roesner advanced "composed theatre" as a means of theorizing contemporary theatrical work in an edited collection of the same name, published in 2012.[15] As I prepared the submission of this manuscript, Mladen Ovadija's monograph *Dramaturgy of Sound in the Avant-Garde and Postdramatic Theatre* was published, exploring aesthetic continuities and developments in experimental theatre, thereby offering a complementary but distinctive study to this one.[16] Scholars worldwide are beginning to buzz about the intellectual possibilities afforded by the acoustic dimensions of plays and performances, both historical and contemporary.

Attending to sound does not mean ignoring the other senses or giving biased accounts of perception and cultural history. The sense of hearing works in concert with the other senses. It must be theorized accordingly. Scenography is always potentially inter-sensorial: costumes, props, and sets are not just things to be looked at, but things to be touched or heard—actually or imaginatively. The point at which hearing and touch interconnect is not always easily determined, but this makes the effect of their crossing more powerful. Attending to sound in performance does not mean ignoring other sensory data. The goal is not to disentangle sensory effects but rather to reveal the significance of their entanglement and highlight aspects that might go unnoticed or unremarked in the experiential flux of perception.

Analyzing theatre sound is arguably more complicated than analyzing sound in literature. The sounds inscribed, or implied, in dramatic texts may or may not be made—or heard—in performance, or they may be heard discrepantly. Sounds that do not appear in dramatic texts may form part of a production's design or execution courtesy of choices made by a sound designer, director, or performer. Moreover, the total sonic environment in which a performance takes place also informs one's experience of the performance event. Ambient, potentially incongruous sound foreign to the production may intrude upon the scene and inflect it, as in the recurrent sound of passing airplanes at Shakespeare's Globe in London, or, more prosaically, noise made by individual audience members (e.g., phone-ringing, which nowadays can provoke rebuke or even violent action). In theatre, diegetic and extra-diegetic sound intermingle. Both

may be of interest to a performance scholar. Semiotic analysis can fail to account for the fugitive, idiosyncratic elements of performance sound. The interpretation of auditory "signs" is dependent on one's location, hearing ability, knowledge, experience, and disposition. This is implicit in the term "soundscape," which does not merely entail an autonomous grouping of sounds but a historically situated, culturally informed acoustic impression. A soundscape is a phenomenological construction, open to divergent points of hearing. It is not simply uniform. Emily Thompson notes:

> Like a landscape, a soundscape is simultaneously a physical environment and a way of perceiving that environment; it is both a world and a culture constructed to make sense of that world. The physical aspects of a soundscape consist not only of the sounds themselves, the waves of acoustical energy permeating the atmosphere in which people live, but also the material objects that create, and sometimes destroy, these sounds. A soundscape's cultural aspects include scientific and aesthetic ways of listening, a listener's relationship to their environment, and the social circumstances that dictate who gets to hear what. A soundscape, like a landscape, ultimately has more to do with civilization than with nature, and as such, it is constantly under construction and always undergoing change.[17]

A soundscape does not simply "exist" any more than a landscape simply "exists"; it must be apprehended (perceived, composed) in the first instance. A soundscape is "a sound plus a certain kind of relation," remarks Steven Connor. "The sounds in a soundscape must always be for-me, in something of the way that a landscape must always be for me; but, buried within that relation, they must also always be for-each-other-for-me, made consonant with each other by being included within the scope of my auditory attention."[18] A soundscape is an individual arrangement, or *gestalt*, of the sonic environment; it is a personal apprehension informed by circumstance, biology, enculturation, and training. This means that people in the same environment who can hear the same sounds may still hear them distinctively, depending on *how* they hear them. A soundscape is only notionally shared. Claims to have designed a production's soundscape are therefore somewhat misleading. A sound design can inform how a performance soundscape is perceived, but *what* is heard and *how* it is heard are unfixed elements. Sonic meaning is not universally shared or historically consistent. Plays written a hundred years ago but produced today may be heard quite differently than they were originally. The sonic environment has changed and so have cultures of listening; consequently, the meanings assigned to sounds may have shifted. This

does not invalidate attempts to "sound out" the cultural past; rather, it encourages attentiveness to historical "acoustemologies" (acoustic ways of knowing) that are context specific.[19] These may be embedded in a wide range of discourses, not just those principally about sound.

SONIC MODERNITY

Scholars who work on sound-related matters have abolished the decidedly absurd notion that modernity signaled a shift in perceptual dominance from hearing to sight, and that, in some dada-esque battle of the sense organs (like in Tristan Tzara's 1921 play *Le Cœur à Gaz*), the eye won out and reigned supreme in a scopic regime. It has become cliché to rail against "ocularcentrism" and decry the visualist bias of modernist historiography. The current critical consensus is that modernity organized the senses in complex, overlapping, and situationally contingent ways. No single sense was privileged; each was uniquely configured and utilized. Why, then, speak of "sonic modernity"? It would surely be misguided to suggest modernity was predominantly or essentially sonic; that might institute a "countermonopoly of the ear," to use Veit Erlmann's amusing phrase.[20] Nevertheless, modernity was crucially informed by sonic phenomena; investigating the role sound and hearing played in modernity reveals historical experiences and modes of being that might otherwise be obscured. Modernity is itself a conceptual abstraction, of course, one of those problem terms whose meaning is endlessly debated. To quote James Joyce's alter ego Stephen Dedalus: "I fear those big words... which make us so unhappy."[21] Adding the word "sonic" does not ostensibly help clarify the meaning of "modernity" or render it less abstruse, though this has not discouraged scholars from using the compound term (I am not the first to do so).[22] When did modernity, or sonic modernity, begin and end—or has it ended? What does this term, with or without its modifier, mean?

It is a truism that the attribution *modern* perpetually shifts, so that the modernity of yesteryear can seem quaint in comparison with that of the present day. Modernity is not a monolithic, unitary phenomenon peculiar to a single historical period, pertinent only to Western societies, and everywhere equivalent. Theorists and historians no longer advance a teleological conception of history in which modernity is figured as "*one* thing, towards which every society is inevitably moving, though at different rates of development," with the West leading the way and the non-West (i.e., "the Rest") picking up the rear, to quote Stuart Hall, but a multiprocess, multicausal, multitemporal model of mutually interacting modernities, which may begin at different times and follow different trajectories and

rates of development.[23] One must identify which "modernity" one has in mind when using this contested but still necessary term. The "modernity" examined in this book refers to social and technological developments of the late nineteenth and early twentieth centuries—formerly considered to be the *only* modernity—and focuses on Western Europe. During this time, the invention and proliferation of sound-reproduction technologies crystallized long-standing processes of modernization relating to sound and hearing, which is why "sonic modernity" is worth consideration. Jonathan Sterne explains:

> As there was an Enlightenment, so too was there an 'Ensoniment.' A series of conjunctures among ideas, institutions, and practices rendered the world audible in new ways and valorized new constructs of hearing and listening. Between about 1750 and 1925, sound itself became an object and a domain of thought and practice, where it had previously been conceptualized in terms of particular idealized instances like voice or music. Hearing was reconstructed as a physiological process, a kind of receptivity based on physics, biology, and mechanics. Through techniques of listening, people harnessed, modified, and shaped their powers of auditory perception in the service of rationality. In the modern age, sound and hearing were reconceptualised, objectified, imitated, transformed, reproduced, commodified, mass-produced, and industrialized. To be sure, the transformation of sound and hearing took well over a century. It is not that people woke up one day and found everything suddenly different. Changes in sound, listening, and hearing happened bit by bit, place by place, practice by practice, over a long period of time.[24]

Sterne's investigation of the cultural origins of sound-reproduction technology reveals that sonic modernity has a lengthy history and is not simply technologically determined. On the contrary, a vast array of contributing factors helped shape it. Science, technology, culture, environment, and biology all played a part in its variant constitution.

Sonic modernity encompasses a range of experiences and perceptions. It does not refer to any one thing and therefore cannot be neatly encapsulated. Modernity involved multiple, discrepant soundscapes, which were not experienced identically. It gave rise to a plethora of acoustemologies and sound-related developments that informed what it meant to be "modern" in the period under survey. These included:

- negotiating the increased noise levels and dense sonic environments of modern metropolises;
- experiencing sound as an invasive, affective force;

- witnessing acoustic alteration in the countryside due to modern agricultural methods and the sound of passing trains;
- engineering the sound of a building or place to make it seem acoustically "pure" (i.e., free of noise);
- striving to communicate intelligibly in multilingual environments;
- establishing zones of acoustic privacy and self-cocooning;
- developing a sense of self modeled on auditory principles, relating psyche to soundscape;
- hearing previously inaudible sounds with the aid of a microphone;
- developing techniques of listening attuned to rational analysis (e.g., telegraphy);
- being able to preserve the sound of one's own voice and the voices of others using sound-recording technology;
- conceiving of sound as a "thing"-like entity that can be purchased and owned (e.g., a gramophone recording);
- hearing the voice of a geographically distant interlocutor telephonically;
- listening to broadcasts conducted over the airwaves or on the telephone, thus partaking in a fragmented but still unified auditory collective.

This is a nonexhaustive, grab-bag list of items, not all of which are peculiar to *fin-de-siècle* modernity but nonetheless enjoyed special resonance at this time. This period entailed crossover with Victorianism, to boot, particularly in relation to sound. Lest we forget, modern technologies of sound reproduction were inventions of the Victorian period, and the Victorians (and other Westerners of this era) were the first to experience this keynote feature of sonic modernity, as well as others, such as increased urban noise.[25] Sound in the theatrical avant-garde is inscribed with traces of "Victorian modernism" as well as Romanticism.[26] This complicates claims about period distinctiveness and aesthetic uniqueness trumpeted by modernists (i.e., the radicalness and novelty of "the modern" and its supposed break with the past); these now seem retrospectively suspect.

Scholarship on sound in modernity has documented but not yet fully accounted for all its various components. It is a massive subject area; there is still a great deal to be explored. A conference on modern soundscapes held at the University of New South Wales, Sydney, in July 2013, revealed the extensive variety of topics currently animating scholarly work on sound in the humanities, ranging from the importance of rhythm, especially the rhythm of the rails, in modernist literature and early cinema; literary representations of animal sounds in urban soundscapes; "negro" voices and modernist aesthetics; and artistic explorations of the "audial

unconsciousness," to draw from just the keynote presentations.[27] There is a considerable amount of work being done across the humanities examining interconnections between sound, modernity, and modernism. There is not, however, consensus with regard to terminology, methodology, periodicity, evidence, or scope, which is to be expected given differing disciplinary perspectives and the diversity of research. At the concluding plenary, Steven Connor suggested this lack of cohesion is possibly a good thing, and that "sound studies" as a quasi-field or interdiscipline has moved beyond the idea of singular "sound thinking" (i.e., an exclusively "aural" way of apprehending things) toward embracing a broad range of epistemologies that may or may not be wholly sonically inclined. This means that there is no single or optimal way of analyzing sonic modernity or hoping to account for it in its entirety. One can only hope to identify aspects in a circumscribed field of study.

Sam Halliday bases his wide-ranging study *Sonic Modernity: Representing Sound in Literature, Culture and the Arts*, published in 2013, around a series of topics including sound and sociality, "seeing" sounds, modernizing music, and the art of listening. Halliday draws on examples of modernist literature, music, art, and, occasionally, drama to explore the ways in which sound is both directly and indirectly imbricated in modernism. He astutely observes that "sound in modernism, in whatever art form, is irreducible to sound alone. Sound, instead, is best conceived as a configuration, with 'real' sound at its centre, to be sure, but other sense phenomena, such as touch and vision, rarely at more than one or two removes on its periphery."[28] He singles out the concept of the "acousmatic" (following Pierre Schaeffer, "sound heard without accompanying visual impressions of its cause or source"); the mechanical capture and retention of sound; and Douglas Kahn's notion of "all sound" facilitated by the phonograph, which treats sound indiscriminately (i.e., it does not hear or listen; it "only stores and reproduces whatever sonic objects it encounters"), as a means of identifying quintessentially modern sonic configurations, though he recognizes that "modern and pre-modern sounds always, necessarily, exist in a dialectical relationship."[29] The phonograph may be indiscriminate in its capturing of sonic phenomena; the scholar, however, is forced to attend to some things and disregard others, isolating signals from the noise of history, only tuning into certain frequencies. *Vibratory Modernism*, an edited collection also published in 2013, uses vibration, not sound, as an organizing principle. The volume's editors, Anthony Enns and Shelley Trower, declare that modernism was "clearly inspired by a growing fascination with vibrations as the unseen force that mediated all interactions between the interior self and the exterior world"; the volume's essays "trace the interconnections between

[a] new scientific understanding of vibrations and various fields of artistic production."[30] As scholars bring new conceptual paradigms and intellectual histories to bear, the noise of modernism and modernity becomes increasingly apparent, though it will always retain semantic density, a massive mess of meanings.

The focalizing element of this book is the theatrical avant-garde of the late nineteenth and early twentieth centuries (roughly 1890–1935). I examine how avant-garde, or otherwise modern (there is slippage here), theatre artists integrated aspects of sonic modernity into their work through subject matter, characterization, scene setting, staging, technology, performance style, verbal and nonverbal communication, environmental considerations, audience interaction, and performance reception. I argue that the theatrical avant-garde dramatized and staged elements of sonic modernity in specific, identifiable ways, engaging conceptual and communicative possibilities as well as experiential realities associated with new sounds, ways of hearing, and modes of expression. The four main aspects of sonic modernity examined in this book, which I will subsequently elaborate, are (a) acoustic interiority; (b) the mechanical reproduction of sound; (c) invented, "universal" languages; and (d) affective responses to noise. These facets of sonic modernity have not yet been analyzed in depth in relation to theatre, which is uniquely equipped to demonstrate sonic ideas and experiences. Theatre can do more than represent sonic phenomena (which is literature's chief capacity in this regard); it can embody and enact them, testing ideas about sound in actual sonic environments. This suited avant-gardists, many of whom delighted in provoking their audiences, presenting them with unusual or unconventional scenes, and making them question their senses and assumptions. However, sounding out "the avant-garde" as a conceptual category and mode of practice, which this book does, can be just as perplexing, just as vexing.

THE "MESSY" AVANT-GARDE

The meaning of the term "avant-garde" is just as contentious as "modernism" and "modernity." Its periodicity, geography, and politics are all open to debate.[31] This is as it should be, because just as modernity is not *one thing*, neither is the avant-garde. It is internally discontinuous and contradictory: a conglomeration of artistic programs, manifestos, ideologies, experiments, provocations, whimsy, and efforts to subvert conventions and challenge the status quo. As such, avant-gardism is not confined to Western modernity but may emerge in variant forms whenever and wherever the conditions for its production and reception warrant

or permit. Mike Sell uses the phrase "vectors of the radical" to describe the avant-garde, breaking with the idea of a singular, unitary, forward-marching, collective movement.[32] A roundtable discussion organized by Sell at Indiana University in 2009 broached the usefulness and liberating possibilities of this approach:

> *Kimberley Jannarone [KJ]*: Whether we talk about rough edges or vectors, whether we ground that talk in technologies or performance strategies, we're able to move beyond a linear, monolithic, imperialistic avant-garde idea. We can begin thinking about the gives and takes between communities, aesthetic forms, structures of performance, and so on, so that it becomes impossible to locate the original source. As long as we're always thinking about originality and origins, we're thinking in a linear, imperialistic way...
> *Mike Sell*: And a sexist way...
> *KJ*: Right, so if we get out of that mode of thinking—as your theoretical models help us to do, James [Harding] and Mike—the question becomes not, 'Where does this come from?' but, "What are people doing with it?" Then we get to a new way of theorizing the avant-garde, one that sees it as a constant process of grabbing, reappropriating, getting grabbed, and that creates new forms for new moments. That may be Balanchine grabbing from the Futurists or right-wingers grabbing from the Sex Pistols. That is far more interesting and illustrative than only wanting to put people that we like into a line that we like.
> *Jean Graham-Jones*: I'd propose a kind of "collision analysis" that works by bringing seemingly disparate elements into conversation with one another—a kind of critical-historical collage. We take a page from some of the avant-gardist artists themselves—cut-up poems, collage—and linger in the conflict without seeking resolution or simple binaries.
> *KJ*: Right. If we recognize that influences are coming from places we're not comfortable with, either because of the nature of the influence or the way they got the influence, that makes us more mindful about what makes the avant-garde significant, which is not going to be covered by a neat, linear theory, because it's a bit of a mess.[33]

Accepting the "messiness" of the avant-garde means forgoing a strict, essentialist definition of its meaning. It also means reconsidering a standard account of its role in the cultural history of modernism: namely, that the avant-garde sought to antagonize audiences, shock them, and advance a radical politics from a position of social marginality. This is true of some avant-gardists, to be sure, but it occludes as much as it reveals and forces a lot of oddly shaped, irregular pegs into square holes, or else ignores them because they do not fit. Frantisek Deak offers a more nuanced and generous conception of the avant-garde in his study

of symbolist theatre, an avant-garde movement that did not intentionally antagonize audiences (though it was certainly hostile to the "well-made play"). "The avant-garde," Deak writes, "is characterized not by a simple antagonism to bourgeois society and art but by a systematic, conscious, and radical attempt to reclaim through art the fullness of life—to bring onto the level of discourse those aspects of life that society chooses to neglect, disregard, or openly suppress."[34] One might add to this list those aspects of life that society has not quite yet fully addressed or understood. Avant-garde artists can provoke audiences into grappling with the complex, shifting reality—or surreality—of their historical situations through defamiliarizing lived experiences. Avant-garde art can operate as a laboratory of sorts for testing out new ideas and realities in a playful, inventive manner.

This does not discount or invalidate the political charge of avant-garde art; it merely highlights its thematic multiplicity and range of ambition. Some might see this as an evacuation of the term's meaning; I believe it offers productive complication. Formerly held distinctions between "modernists" and "avant-gardists" are moot. The conjunctive phrase "the modernist avant-garde" is arguably a much better descriptor for the ways in which formally experimental and/or politically engaged artists of this time responded to their own historicity. It is reductive to cordon off the avant-garde from the "fullness of life," including other modernists, art forms, and cultural activities. Avant-gardists were often indiscriminate in sourcing ideas for their art, as Jannarone indicates in the roundtable discussion quoted above. This has implications for how artist networks are understood and for how canons are constructed and maintained (or not). In Chapter 1 of this book, I examine Chekhov alongside Maeterlinck and Kandinsky. Although Chekhov is not typically considered an avant-gardist, he is certainly a modernist, and his work relates to other examples of formally experimental drama of the period, especially in relation to sound. Jean Cocteau's play *La Voix Humaine* (*The Human Voice*, 1927), discussed in Chapter 2, was written for the commercial stage, yet it still demonstrates aspects of avant-gardism in its sonic design. Cocteau himself flitted in and out of the avant-garde. Rather than construct a strictly determined, exclusionary grand narrative of the avant-garde, one may instead accept the disunity of the avant-garde as a whole while identifying patterns of association, affiliations, and lines of influence that are not unidirectional or geographically bounded but operate in overlapping networks of transnational circulation and cross-influence (a.k.a. the helter-skelter, messy, free-for-all process of "grabbing, reappropriating, [and] getting grabbed," to quote Jannarone). This is as suitable for the avant-gardes of the late nineteenth and early twentieth centuries as it is for those in operation today.

Moreover, it is especially appropriate for writing a cultural history of sound, which resists linear narrative. Douglas Kahn remarks: "As a historical object, sound cannot furnish a good story or consistent cast of characters nor can it validate any ersatz notion of progress or generational maturity. The history is scattered, fleeting, and highly mediated—it is as poor an object in any respect as sound itself."[35] Jonathan Sterne concurs, stating: "piecing together a history of sound from the bewildering array of stories about speech, music, technology, and other sound-related practices has all the promise and appeal of piecing together a pane of shattered glass. We know that the parts line up somehow, we know that they can connect, but we are unsure of how they actually link together."[36] Given the constitutive breadth of sonic modernity, it is unsurprising that avant-garde theatre artists responded to it in an impromptu, disjointed manner, only occasionally drawing attention to this activity. This is not to say their efforts were entirely incoherent and idiosyncratic. The history of avant-garde theatre sound may be like a pane of shattered glass, but the shards fall suggestively and catch the light in an intriguing manner.

The Shape of Things to Come

This book relates a little-known history of sonic experimentation in theatrical modernism. It brings together artists of different nationalities and aesthetic stripes into new and sometimes surprising alignments, interrelating the work of theatre artists with that of composers, filmmakers, visual artists, linguists, and novelists. This type of mosaic composition ("a kind of critical-historical collage," to quote Graham-Jones in the aforementioned discussion), necessary for the piecing-together of sonic history, does not presuppose overall unity in the avant-garde but acknowledges links between artists in relation to certain topics. Furthermore, it reveals avant-gardists to have been more than just social agitators and provocateurs, shocking audiences for the sake of it, but to have provided oblique cultural refashioning and social commentary. This book does not aim to uncover who did what first or theorize cause and effect in a deterministic manner. Rather, it seeks to locate resonance between social phenomena and cultural activity, treating these as interacting and mutually constitutive enterprises. This means junking a model of the avant-garde that follows a recurrent pattern of innovation, breach, and recuperation, with one movement giving rise to another, and so on, in favor of a conception that foregrounds overlap, cross-influence, and parallelism between movements. I am less interested in the aesthetic particularities of individual avant-garde movements (e.g., differentiating between the sonic innovations of the symbolists and the futurists) than in correlating artistic engagements with particular aspects of modernist sonority. Consequently,

this history is selective: it does not pretend to offer exhaustive accounts of either avant-garde theatre sound or sonic modernity. That would be impossible. The main movements considered herein are symbolism, realism, expressionism, futurism, dadaism, and surrealism, though, due to practical limitations, I only treat exponents of these movements and largely focus on their emergence in Western Europe. I have chosen artistic examples that best illustrate the topic of each chapter, not in order to showcase diversity of avant-garde contribution. Unfortunately, this means the artists discussed in this book are nearly all white men, who tend to dominate the historical avant-garde.[37] Nevertheless, it is not my intention to perpetuate closed ranks. I am alert to gender constructions and patriarchal ideology, as well as formulations of race, class, and sexuality. Exploring identity politics forms part of the investigative "sounding out" of this project.

Each of the four main chapters of this book outlines a compelling feature of sonic modernity and correlates it with the work of the theatrical avant-garde.

CHAPTER 1: THE ACOUSTIC IMAGINARY

This chapter examines sound, possibly hallucinatory sound, heard in one's own head, which was especially pressing in modernity as urban sonic environments ostensibly became louder and more difficult to endure. Modernity promoted a form of psychological interiority that was acoustically inspired. Modern artists were attuned to this. Their artwork, plays, and performance pieces investigated the collusion, or confusion, of psyche and soundscape, exploring the potential of abstract sound as a conveyor of private feeling and indeterminate meaning. This chapter discusses Leopold Lewis's melodrama *The Bells* (1871); illustrations by Albert Robida; symbolist paintings by Fernand Khnopff; Maurice Maeterlinck's symbolist drama; Chekhov's play *Vishniovy Sad* (*The Cherry Orchard*, 1903); and Wassily Kandinsky's synaesthetic fantasy *Der Gelbe Klang* (*The Yellow Sound*, 1912). I argue that avant-garde theatre activated the acoustic imaginaries of audiences, encouraging those in attendance to ponder the meaning of what they heard, or thought they heard.

CHAPTER 2: THEATRE SOUND IN THE AGE OF MECHANICAL REPRODUCTION

This chapter bridges the fantastical and the actual in the form of newly developed technologies of sound reproduction such as the telephone and the phonograph, previously only dreamt about, and explores how

avant-gardists incorporated these inventions into their work. Avant-garde theatre provides insight into the "social construction of technology": the ways in which technologies become socially meaningful through their usage and representation. The history of sound-reproduction technology in theatre is peculiar but fascinating, as the "theatre phone"—a device that enabled listeners to connect to theatrical performance over the telephone, predating wireless broadcasting—reveals. This chapter examines attempts to integrate the phonograph and the telephone into theatrical production, and analyzes the mechanical (re)production of sound in *Les Mamelles de Tirésias* (*The Breasts of Tiresias*, 1917) by Guillaume Apollinaire, and *Les Mariés de la Tour Eiffel* (*The Eiffel Tower Wedding Party*, 1921) and *The Human Voice* by Cocteau. I discuss these plays as theatrical spectacles of technological embodiment respectively inspired by phonography, telephony, and cinema.

CHAPTER 3: REINVENTING LANGUAGE: SENSE AND NONSENSE

Chapter 3 addresses a different kind of modern sonic fantasy: namely, the dream of a universal language, which was especially powerful in the cultural imaginary of the *fin de siècle*. Modernity's "babel" problem sparked the invention of artificial languages intended to facilitate global communication. The most famous of these is Esperanto. This chapter situates linguistic experimentation by avant-garde theatre artists in this context, considering how avant-gardists staged the modern fascination with invented languages and encouraged audiences to appreciate alternative forms of sense-making. This chapter surveys modernity's mooted communication problems, focusing in particular on the emergence of Esperanto and the cultural responses it generated. I analyze the performative babble of the dadaists Tristan Tzara (in his plays and "simultaneous" poetry), Hugo Ball (in his 1916 cycle of sound poems), and Kurt Schwitters (in his elaborate sound poem "Ursonate", composed between 1922 and 1932). The chapter concludes with a consideration of the Russian futurist Velimir Khlebnikov's play *Zangezi: A Supersaga in 20 Planes* (1922), which features the invented language of "zaum."

CHAPTER 4: HEARING *AFFECTIVELY*: THE NOISE OF AVANT-GARDE PERFORMANCE

Chapter 4 turns up the volume and lends an ear to the performance noise of the modernist avant-garde. This chapter considers how sonic

phenomena perceived as noise can affect listeners on a physiological level. This was a felt experience of modernity and avant-gardists were keen to exploit it for their own purposes. This chapter investigates eclectic examples of affective, noisy soundscapes in modernist avant-garde performance, situating this activity in the context of contemporaneous attitudes toward silent spectatorship and noise reduction in theatre and society. Performances discussed include the rowdy soundscapes of Italian futurist *serate* (theatrical "evenings") and dada cabaret; the explosive poetry performances of Richard Huelsenbeck and F. T. Marinetti; Antonin Artaud's cacophonous sound design for his 1935 production of *The Cenci*; and Arseny Avraamov's mass concert *Sinfoniia Gudkov* (*The Symphony of Sirens*), which took place in Baku, Azerbaijan in 1922. The chapter, which is the longest and most geographically far-reaching in the book, builds to a mighty crescendo and goes out, appropriately, with a bang.

The arc of this study ranges from *ideas* about sound and silence in Chapter 1—things we may only imaginatively hear—to theatrical *manifestations* of sonic power and density in Chapter 4, which are too loud to ignore. The discussion veers from abstraction to concreteness and back again as avant-garde theatre artists explore the multiple, overlapping registers of sonic modernity. As the synopses suggest, the following chapters are fairly self-contained and may be read out of order if the reader prefers, though some thematic connections will be lost. Each chapter generally proceeds chronologically, but the chronology resets from chapter to chapter as each new topic is explored.

This is a work of theatre history, but it is one that incorporates dramatic interpretation into its methodology. I call attention to this because of the traditional binary in theatre history, observed by Jacky Bratton, in which there is

> a strict divide set up between [a] 'scientific' activity, susceptible of concrete proofs and never venturing beyond demonstrable facts, and the critical activities of students of the drama, who interpret and study the written texts in the light of the facts generated elsewhere. The theatre historian is expressly debarred from considering the plays that were put on by the people she or he studies, except in clearly limited and defined, factual ways.[38]

I do not hold to this binary or to the recent shunning of dramatic analysis in theatre scholarship. As Martin Puchner states in a 2007 editorial in *Theatre Survey*, "opposing literature and theatre, thinking of them as incompatible objects of which one must be chosen, seems no longer necessary, or relevant, or even helpful."[39] Dramatic analysis need not be a

wholly formalist or fanciful pursuit but may be used in conjunction with other types of analysis to investigate interconnections between text and context, script and performance, dramaturgy and historiography. Interpretive acts and speculative inquiry should be acknowledged as part of the meaning-making processes of historians, audience members, and readers alike. Obviously, dramatic analysis is insufficient by itself, but it may be used in combination with analysis of sound recordings, for instance, and other evidentiary sources (e.g., promptbooks, reviews, memoirs, paintings, illustrations, musical scores) to explore potential meaning and posit interfaces between design and execution. I frequently employ visual illustrations in this book as evidentiary bases for my argument, analyzing the ways in which sensory ideas relating to sound and hearing are visually encoded, thereby revealing the "sight" of sound, along with modernism's artistic fusions.

This book harks back to the sonic fantasies and realities of the modernist theatrical avant-garde and elaborates upon their aesthetic, cultural, and historical significance. It makes the case, quietly but insistently, that avant-garde theatre sound *matters* whether it is met with raucous laughter or perplexed silence—the paradoxical sound of no hands clapping. It invites readers to reconsider the dramatic and theatrical possibilities of sound, as avant-gardists have done.

CHAPTER 1

THE ACOUSTIC IMAGINARY

YOU ALREADY KNOW ABOUT THE ACOUSTIC IMAGINARY. If you have ever had a tune stuck in your head (an "earworm") or have recalled the sound of someone's voice or of a particular place, or have mistakenly thought you heard something in your immediate environment, then you have experienced the faculty of *imagined* hearing. Theorists and psychologists have given this phenomenon a variety of names, but there is broad consensus about its meaning: *some sounds we only think we hear*; they exist not in the phenomenal world but in the "mind's ear."[1] This does not necessarily make them any less real. Most of the same areas of the brain activate when we hear a sound imaginatively as when we hear "actual" sound.[2]

When I was a child I had a hearing test. This consisted of identifying tones of different frequencies in order to map my hearing range. An audiologist gave me a pair of headphones and told me to press a button whenever I heard a sound. What fun, I thought! I was soon identifying boops and beeps both high and low—quiet foghorns in the night. At first, the tones were evenly spaced, but they gradually began to cluster together, or so it seemed. I began to hear an assortment of sustained pitches: far more, it turned out, than was coming through my headphones. The audiologist was not amused. She thought I was being mischievous and pretending to hear sounds just so I could press the button. She was mistaken. If memory serves, I genuinely thought I could hear additional tones. How was I to know some of these were phantom? Thankfully, this was an isolated incident. I do not suffer from auditory hallucinations or the condition of tinnitus (ringing in the ears) that can drive people to distraction—though just writing about this has made me mentally hear a piercing sound (it is like the trick directive *not* to think

about a purple elephant; one invariably does so). Reader, don't imagine ringing in your ears.

The ability to hear sound imaginatively is a boon for musicians. Composers speak about hearing music fully formed in their heads before scoring or practically creating it. Some conductors are able to read an orchestral score and imagine its complete sounding. People with absolute pitch can identify and produce named pitches without external reference or support. These abilities form part of the lore surrounding figures like Mozart, Schubert, Weber, Schumann, Gluck, Tchaikovsky, Berlioz, Bruckner, Wagner, and—perhaps understandably, given his profound deafness in later life—Beethoven.[3] However, this faculty may be a curse as well as a blessing, akin to the schizophrenic condition of hearing internal voices (Tchaikovsky was reportedly tormented as a child by the music in his head; likewise, Schumann is thought to have spent his final years in an asylum mentally obsessing over a single tone in the key of A).[4] We can try to block unwelcome sound if it is coming from without by covering our ears, say, or masking it with other input; this is harder to achieve if sound is self-generated. Technically, all sound is a psychoacoustic conception. Without rehashing the old philosophical chestnut about a tree falling in an empty forest, it is worth noting that sound is anthropocentric: it is a human perception of vibration, not a discrete thing-in-itself. As Jonathan Sterne remarks, "[We] can say either that sound is a class of vibration that *might* be heard or that it is a class of vibration that *is* heard, but, in either case, the hearing of the sound is what makes it."[5] This is not just an issue of semantics; it has bearing on how we conceive of sound, what we make of it, and how we distinguish acoustic perceptions. If sound is not simply natural, not merely external to ourselves, but rather something *we* create through the mechanism of hearing, then we need to account for its subjective nature and consider how it may help to form us as listening subjects.

The acoustic imaginary is not just a quirk of human hearing; it is also an artistic formulation. An artwork can connote an acoustic imaginary: a conceptual framework prompted by "real" or imagined hearing. Music can suggest narrative, landscape, imagery, characters, and so forth, as evinced in the symphonic poem, a musical genre popular in the latter half of the nineteenth century and the early twentieth century, which aims to tell a story in music. Film composers capitalize on music's illustrative and connotative powers. Who can hear John Williams's famous two-note leitmotif from *Jaws* and not picture a shark in the water? (Answer: someone unfamiliar with this trope.) Poems and novels connote acoustic imaginaries through language. The reader may imaginatively hear a presented

scene or image, filling in the blanks, recreating or elaborating upon an artistic construction. Visual art can also have sonic signification, as contradictory as this might seem. Looking at a painting or illustration can conjure an auditory impression of it (e.g., this book's cover image, which depicts Avraamov's *Symphony of Sirens*.). Even fine art (e.g., sculpture) might be thought to elicit aurality in construction, if not design.[6] A play can have an acoustic imaginary too. This forms part of what Andrew Sofer calls theatrical "dark matter": "the invisible dimension of theatre that usually escapes detection, even though its effects are felt everywhere."[7] The acoustic imaginary of the play-as-text and the play-as-performance may or may not align depending on the staging. One of the things a theatre sound designer can do is realize the acoustic imaginary (or *an* acoustic imaginary) of a play text, transforming conceptual sound into actual sound—ideally without being terribly obvious about it.

A prime example of an acoustic imaginary in drama is the hallucinated titular sound of Leopold Lewis's melodrama *The Bells* (1871). In this play, imagined sound has psychological import and motivates the plot. The protagonist, Mathias (famously played by Henry Irving), is forced to confront his past action of murdering a passing Jewish merchant for his money and covering up the crime. His inner turmoil is prompted by sleigh bells worn by the Jew's horse ringing in his ears as a reminder of the crime he has repressed. In a 1926 silent film version directed by James Young, the imagined jingling is presented through trick photography as a visual superimposition of the Jew's hand shaking bells; Lionel Barrymore (playing Mathias) signals the abnormality by clutching the sides of his head and gaping his eyes and mouth, looking the very picture of derangement (Figure 1.1). The silent film makes the acoustic imaginary—Mathias's *idée fixe*—visually explicit. As the stage melodrama unfolds, Mathias becomes increasingly distracted, complaining about the "noises" in his ears (one remarkable stage direction says he tries to

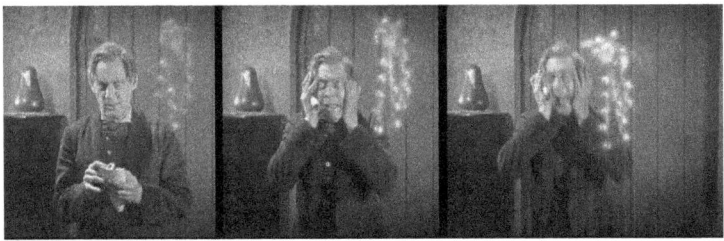

Figure 1.1 Lionel Barrymore as Mathias in James Young's 1926 silent film *The Bells*.

"*squeeze sound out of ears*").[8] His auditory hallucinations precipitate a visual hallucination of the crime scene (also presented onstage), and later a dream sequence in which he is quizzed about hearing the bells ("It is nothing! Nothing! 'Tis but a jangling in my ears") and made to confess his crime upon the summoning of a mesmerist.[9] At the end of the third act, the tolling of the death bell rung at Mathias's nightmare-court segues into the peal of marriage bells for his daughter, marking a crossover between the acoustic imaginary and sonic reality of the melodrama: a bridge between Mathias's "inner" and "outer" worlds made at the moment of his death.

Mathias's imagined jangling is one of the keynote sounds of this chapter, which probes the significance of ambiguous and indeterminate sounds in modernist drama: sounds that operate in a liminal realm between reality and fantasy, a twilight zone of aural perception that shadows the interplay of sound and hearing in modernity. I argue that modern artists used sound creatively in drama and theatre to explore new, acoustically inflected modes-of-being. The acoustic imaginary, though not peculiar to modernity or modern drama, provided a means for modern artists to explore a type of subjectivity modeled on acoustic principles; sound thereby acquired new valence in dramatic design. It helped reveal conceptual domains and realms of experience that might otherwise be obscured or ignored. There is precedent for this line of thought. Elinor Fuchs suggests every dramatic world is conditioned by a "landscape imaginary," a "deep surround suggested to the mind that extends far beyond the onstage environment reflected in the dramatic text and its scenographic representation. This spatial surround both emerges from the text and shapes its interpretation, guiding the 'visitor' to a reading in depth of the dramatic world's scale and tone."[10] Fuchs notes a shift from "preconscious" to "conscious" landscape imaginaries in European dramatic texts of the late nineteenth century. She writes: "In the symbolic avalanches of Ibsen, the threatened forests of Chekhov, the ecstatically open or pathologically closed worlds of Wedekind, the trembling atmospheres of Maeterlinck, and the *lehr*scapes of late Strindberg one can begin to see landscape itself as an independent figure: not simply as ground to human action, but entering it in a variety of roles, for instance, as mentor, obstacle, or ironist."[11] The acoustic dimension inflected modernist drama in a similar fashion, intervening on or even constituting the action, imaginatively relocating listening subjects.

This chapter investigates some of modern drama's most perplexing sounds, situating them in an intellectual and cultural history of sonic subjectivity (subject formation) in modernity, and identifying them as avant-garde provocations. I survey the dramatic sound worlds of Maurice

Maeterlinck's symbolist plays, highlighting his use of sonic ambiguity as a means of expressing the unknown and unknowable (key symbolist concerns); Anton Chekhov's putative use of psychological sound as indicated in the infamous "breaking string" effect of *Vishniovy Sad (The Cherry Orchard*, 1903); and Wassily Kandinsky's theory of "inner sound"—the essential nature of all things and the core principal or driving force of a work of art—in his 1912 stage composition *Der Gelbe Klang* (*The Yellow Sound*). I argue that these dream worlds of sound (nightmare worlds in some instances) were not simply escapist fantasies or forays into sensory disrepair but indirect engagement with the experiential possibilities of sonic modernity.

Acoustic Interiority

Modern drama's fascination with imaginary sound—sound that seems to come from "within"—is connected to particular kinds of auditory engagement. Characters who ostensibly hear sounds in their heads, or whose principal means of knowing the world is through the sense of hearing, signal the importance of the auditory in forming modern subjectivity. Certain types of hearing, both real and imagined, helped shape what it meant to be modern in this period. One of these involved attending to sound in an isolated, subject-oriented manner. I call this "acoustic interiority." We see examples on an everyday basis: people walking down the street, only half-engaging with the world around them, caught up in a bubble of sound because they're listening to something on their personal devices. When we engage in headphone listening, we experience a private sound world; we turn inward, to an extent, and buffer our engagement with the outside world. (How comforting it can be to listen to a familiar piece of music on headphones while wandering through a strange city! Enclosing oneself sonically can shore up ontological security—though this means ignoring one's actual sonic environment and possibly imperiling personal security.)

This particular form of acoustic interiority emerged in the late twentieth century; *flâneurs* in the *fin de siècle* did not have Walkmans or iPods, of course, though technology of this sort was adumbrated. It was nonetheless possible to hear sound in a mediated, immersive, and isolated fashion. Stethoscopes and telegraph machines facilitated individuated, specialized listening. In his study of sound in modernity, Jonathan Sterne outlines how "audile technique" developed throughout the "long" nineteenth century, tailoring listening to logic, analytical thought, professionalism, capitalism, and individualism.[12] He shows how listening became a technical, virtuoso skill that could be developed and used toward

instrumental ends, such as a doctor using a stethoscope to listen to a patient's body for signs of health and illness or a telegraph operator listening to a machine with headphones and decoding a message with increased efficiency. As a result, focused auditory attention—the ability to discern signal from noise—acquired cachet. This encouraged ontological separation.

> Audile technique did not occur in the collective, communal space of oral discourse and tradition (if such a space ever existed); it happened in a highly segmented, isolated, individuated acoustic space. Listening technologies that promoted the separation of hearing from the other senses and promoted these traits were especially useful. Stethoscopes and headphones allowed for the isolation of listeners in a "world of sounds" where they could focus on the various characteristics of the sounds to which they attended.[13]

Sterne argues that this listening technique, which relied on the construction of an individualized acoustic space "around" the listener, proliferated across cultural and media contexts in the second half of the nineteenth century and into the early decades of the twentieth century. Moreover, it was furthered by the growth of sound-reproduction technologies such as the telephone, the phonograph and gramophone, and later the radio (heard via headset), and functioned as a sign of social status. Audile technique was a bourgeois form of listening, Sterne writes, rooted in a practice of individuation: "listeners could own their own acoustic spaces through owning the material component of a technique of producing that auditory space.... The space of the auditory field became a form of private property, a space for the individual to inhabit alone."[14]

Albert Robida captures the individuation of acoustic space in illustrations from *Contes pour les Bibliophiles* (*Tales for Bibliophiles*, 1895), a work of fiction co-authored with Octave Uzanne that speculates on the future of phonographic technology (Figure 1.2).

This illustration, which one could title "The iPod *avant la lettre*," obtains retrospective prescience in a contemporary world where users of personal sound devices regularly inhabit what Michael Bull calls "mobile media sound bubbles," retaining acoustic privacy in public situations.[15] In this futuristic carriage, the occupants enjoy the paradoxical status of being *alone together* through sound: each is hooked up to his or her own recording, even the child sitting on her mother's lap who is lending an ear to political economy (presumably a joke on Robida's part) and the gentleman in the middle (reminiscent of George Bernard Shaw) who is connected to two phonographic selections ("philosophy" and "cheerful authors"). Three of the figures in Robida's illustration are connected in

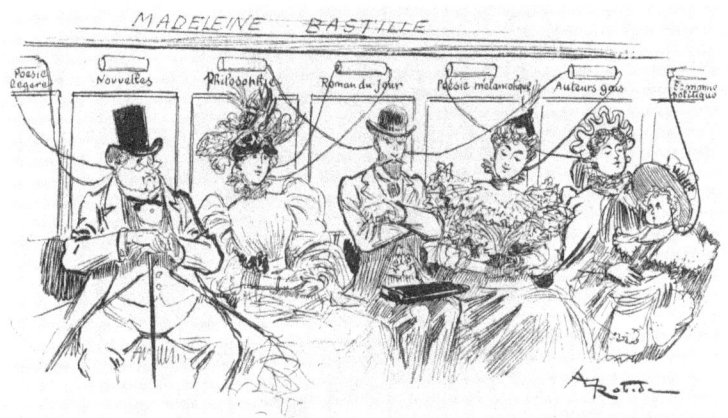

Figure 1.2 Illustration from Albert Robida, *Contes pour les Bibliophiles* (Paris: Librairies-imprimeries reunites, 1895), p. 142.
Source: Courtesy of the Charles Deering McCormick Library of Special Collections, Northwestern University Library.

both ears, enclosing them in private sound worlds that abstract them from their immediate environment and isolate them from each other (the central gentleman's stiff deportment—sitting bolt upright, knees clenched together, arms tightly crossed, staring straight ahead—accentuates this perception). The auditors are seemingly in their own publicly conducted, experientially private sound worlds. The illustration may exemplify, and possibly critique, the breakdown of public discourse. Robida imagined future phonograph users would seek acoustic isolation even without the company of others (Figure 1.3). The users of mobile phonography are described as follows: "At home, walking, sightseeing, these fortunate hearers will experience the ineffable delight of reconciling hygiene with instruction; of nourishing their minds while exercising their muscles; for there will be pocket phono-opera-graphs, for use during excursions among alpine mountains or in the [canyons] of the Colorado."[16] This imagined use of technology blends—and possibly parodies—Romantic fantasies about isolation in nature, the sublime (especially mountain peaks), ideologies of healthy living, and acoustic interiority. Here, the sounds of the natural world are substituted for the individual's preferred acoustic experience, what is known today as "the soundtrack for your life." Robida's mountaineer, sonically absorbed in the midst of visual splendor, brings to mind a phrase once used by Gertrude Stein: "I like a view but I like to sit with my back turned to it."[17]

Acoustic interiority also featured in Romantic philosophy and literature and in symbolist aesthetic theory (though it was not named

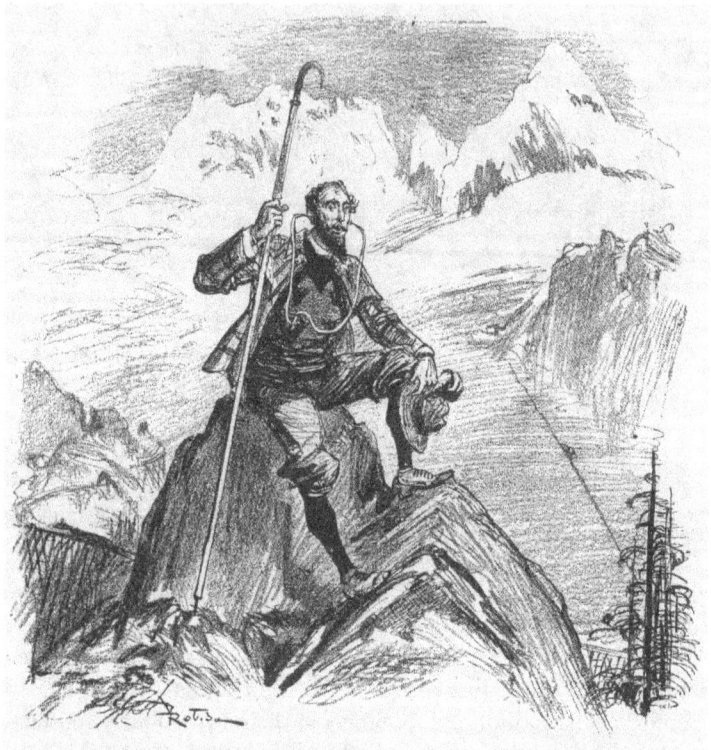

Figure 1.3 Illustration from Albert Robida, *Contes pour les Bibliophiles* (Paris: Librairies-imprimeries reunites, 1895), p. 139.
Source: Courtesy of the Charles Deering McCormick Library of Special Collections, Northwestern University Library.

as such).[18] According to Hegel, for whom hearing is an ideal sense (i.e., it is suited to apprehend aesthetic ideals), musical sound may both prompt and be a corollary of subjective inwardness. He writes:

> In this relation [between inner and outer worlds], the inner, so pushed to the extreme, is an expression without any externality at all; it is invisible and as it were a perception of itself alone, or a musical sound as such without externality and shape, or a hovering over the waters, or a ringing tone over a world which in and on its heterogeneous phenomena can only accept and re-mirror a reflection of this inwardness of soul.[19]

In this opaque passage, Hegel suggests that radical inwardness, a complete abjuring of the outside world, may find form in musical expression. He

does not consider this optimal as the fullness of the world (its "heterogeneous phenomena") is ignored in favor of narcissistic self-reflection or absorption in musical abstraction (think of the iPod *flâneur*). Hegel, perhaps unsurprisingly, did not approve of nineteenth-century "absolute music": music that is nonrepresentational, principally instrumental, and independent of nonmusical concerns. Absolute music encourages listeners to become enraptured by sound, swept up in musical fantasy.

This is ostensibly depicted in Fernand Khnopff's symbolist painting *En écoutant du Schumann* (*Listening to Music by Schumann*, 1883) (Figure 1.4).

Khnopff's portrait, which is of his mother, shows a woman in profile, dressed in black, sitting upright in a living-room armchair, her right hand held to her brow and obscuring her face, its thumb pointing toward her ear, her left hand resting on her lap. She sits with her back to the pianist (cf. Stein's proclamation), whose right hand is shown, and appears to have withdrawn into herself entirely. The painting's title tells us the subject is

Figure 1.4 Fernand Khnopff, *En écoutant du Schumann* (1883).
Source: © KIK-IRPA, Brussels.

listening to music (how else could we know the woman is actively *listening* to music and not passively hearing or even ignoring it?) and the implication is that she has become enraptured. The fact that it is Schumann's music is fitting, as Schumann was a composer for whom mental hearing (i.e., the acoustic imaginary) was paramount. "The ear should not need the eye," Schumann reportedly remarked, "the eye should not need the (outward) ear."[20] This woman appears to have blocked out the world around her entirely, such is her implicit involvement with what she is hearing (and imagining or feeling). If she is making any facial expression, we cannot see it. Daniel Albright observes that subjects' eyes in symbolist paintings are sometimes closed, whitened, or turned impossibly up "as if to suggest a mind that has lost touch with the world of visual facts."[21] This woman's torqued torso suggests liveliness and motion even in repose: a sense of pent-up emotion, deep feeling kept in check, and serious engagement, which the music has presumably inspired. Her closed-off countenance and body language implies participation in the existence of a realm that can only be imaginatively intuited by the viewer—the acoustic imaginary.

In "The Artwork of the Future" (1849), Wagner speculates about the existence of such a realm:

> [Besides] the world that presents itself to sight, in waking and in dreams, we are conscious of the existence of a second world, perceptible only through the ear, manifesting itself through sound; literally, a *sound world* beside the *light world*, a world of which we may say that it bears the same relation to the visible world as dreaming to waking: for it is quite as plain to us as is the other, though we must recognize it as being entirely different. As the world of dreams can come to vision only through a special operation of the brain, so music enters our consciousness through a kindred operation; only, the latter differs exactly as much from the operation consequent on *sight*, as that dream organ from the function of the waking brain under the stimulus of outer impressions.[22]

Wagner believes music can lull us into a uniquely auditory way of apprehending the world. This can prompt absorption on the listener's part, even in the social context of concert performance. Even with our eyes open, he writes, we can

> [fall] into a state essentially akin to that of hypnotic clairvoyance. And in truth it is in this state alone that we immediately belong to the musician's world. From out that world, which nothing else can picture, the musician casts the meshwork of his tones to net us, so to speak; or, with his

wonder-drops of sound he dews our brains as if by magic, and robs it of the power of seeing aught save our own inner world.[23]

Like Wagner's spellbound listener, Khnopff's subject disregards the material conditions of her immediate surroundings, foregoing shared participation (with the pianist) in order to have a private auditory experience.

However, the woman's surroundings may have made such reverie possible in the first place. The domestic interior theoretically served as a site in which to construct or consolidate the private individual away from the impersonal, potentially debilitating forces of the outside world. According to Walter Benjamin, the domestic interior helps sustain the private individual in his (or her) illusions. The phantasmagorias of the interior represent the universe for the private individual. "In the interior, [the private individual] beings together locales and memories of the past. His living room is a box in the theater of the world."[24] The living room in Khnopff's painting is distinguished by sound design (chamber music) and noise reduction (a byproduct of the seemingly heavy, sound-absorbing furniture and carpeting).[25] In order to experience acoustic interiority undisturbed, the soundscape matters. John Picker has outlined the importance of the soundproof study for male Victorian middle-class professionals who felt besieged and enraged by street music and noise (associated with the lower-class, foreigners, and "deficient" women and children); they thought it undermined their labor and damaged their health. Thomas Carlyle had a soundproof study built at the top of his house; Charles Babbage conducted public campaigns against street musicians in an effort to impose "the tenor of interior middle-class domesticity upon the rowdy terrain outside."[26] The domestic interior in modernity was ideally soundproof, keeping worldly noise at bay.

I will return to the subjects of noise and affectivity in Chapter 4. My purpose here has been to sketch a cultural context and prehistory for modernist engagement with acoustic interiority and fantasized hearing. I am not claiming that acoustic interiority was the essential basis of modern subjectivity, merely *an* ontology that has not been fully sounded out, especially in relation to drama. Modernist inwardness was not absolute. Modernity yielded "fantasies of monadic inwardness," Justus Nieland observes, but it was also invested in "eccentric feeling, a broad range of affects that worry the stable confines, and attendant metaphysics, of modernist inwardness."[27] Sound and hearing contributed to this process, too, destabilizing acoustic interiority by making listening subjects enter into experiential flux. Modernist artists explored a range of aural subjectivities, as will be discussed later on and in the chapters that follow.

SILENCE IN SYMBOLISM

For the symbolists, as for other modern artists, music functioned as an inspiration: a form of expression that was ostensibly autonomous and modeled a type of artistic perfection. Silence also functioned as an aesthetic ideal for symbolists because it promised reduced engagement with the distractions of the everyday world and a possible entry into a more elevated zone of personal and spiritual contemplation. Khnopff's pastel drawing *Du Silence* (*About Silence*, 1890) (Figure 1.5) shows a wan, somewhat androgynous, airy figure (Khnopff's sister, Margeurite) with a far-off look. The figure wears what seems to be a nightdress (intimating sleep) or a smock of some sort (intimating work) and holds a gloved finger to her lips.

The drawing's signification is ambiguous. The figure could be calling for silence (hushing noise), listening to silence, or, conceivably, listening or calling attention to the sounds that silence may (paradoxically) contain. In symbolist fashion, silence is the subject of the drawing but is depicted obliquely (hence the preposition in the title, perhaps). The figure has what looks like a blue aura around her head (matching the color of her eyes and costume), giving the drawing a religious cast and implying the spiritual dimension the state of silence may permit. The gesture may also be construed as an invitation to (or a command for?) silence on the part of the viewer, who is invited to share in the state of silent contemplation, just as the viewer of *Listening to Music by Schumann* may engage in the act of imaginative listening and so entertain the artwork's conceptual and spiritual propositions.

Symbolists did not only value silence for its imagined aesthetic clarity; they considered it the expressive modality of the soul. Symbolists regarded silence as the ideal "language" of inner life. Maeterlinck, whom Khnopff greatly admired, wrote an essay on the subject of silence in which he argues for the importance of cultivating silence for the purpose of personal and spiritual development. Maeterlinck describes "the essential silence of our soul, our most inviolable sanctuary" that mere words cannot express, and distinguishes between "passive" silence, which has a negative connotation ("the shadow of sleep, of death or non-existence... the silence of lethargy"), and "active" silence chosen by an individual, which provides the opportunity of "listening to another soul, and of giving existence, be it only for an instant, to our own."[28] Maeterlinck treasures this form of silence and urges his reader to appreciate it in kind.

> When our spirit is alarmed, its own agitation becomes a barrier to the second life that lives in this secret [silence]; and, would we know what it is that lies hidden there, *we must cultivate silence among ourselves*, for it

Figure 1.5 Fernand Khnopff, *Du Silence* (1890).
Source: © KIK-IRPA, Brussels.

is only then that for one instant the eternal flowers unfold their petals, the mysterious flowers whose form and colour are ever changing in harmony with the soul that is by their side. As gold and silver are weighted in pure water, so does the soul test its weight in silence, and the words that we let fall have no meaning apart from the silence that wraps them round.[29]

For Maeterlinck, silence is, like death, a conditioning element of life ("[it] surrounds us on every side; it is the source of the undercurrents of our life") even if we typically avoid it, covering it with empty words and protecting against its invitation to engage in personal reflection.[30]

What Maeterlinck does not (or chooses not to) address in this essay are the conditions under which silent engagements might be achieved, and, indeed, the type of person that might achieve them. The attainment of spiritual silence was plainly a bourgeois—if not an aristocratic—pursuit. Only people in these economic classes could afford the luxury of entering into a private acoustic space set apart from the noise of the world. Despite this, absolute silence may be an impossible ideal (as John Cage found when he visited an anechoic chamber at Harvard University in 1951 and was surprised to hear his nervous system and blood circulation). This is especially true in modern urban environments, which makes the proposition even more elusive and impractical. Consider the debilitated creature presented by the symbolist poet and novelist Georges Rodenbach in a selection from his poem *Le Règne du Silence* (*The Reign of Silence*, 1891):

> Silence: it is the voice that trails, wearily,
> Of the lady of my Silence, with very gentle step,
> Shedding the white lilies of her complexion in the mirror;
> Barely convalescent, she watches everything in the distance,
> The trees, a passerby, the bridges, a stream,
> Where wander the great clouds of daylight,
> But who, still too feeble, is suddenly struck
> With the tedium of living and a feeling of loathing,
> And more subtle, being ill and half-exhausted,
> She says: "The noise hurts me; have the windows closed..."[31]

Rodenbach's Lady of Silence recalls the waif-like delicacy of the figure gesturing for silence in Khnopff's drawing, who likewise appears to only half belong to the phenomenal world. The symbolists were fascinated by liminal figures who have one foot in this world, so to speak, and one in a world that is hidden and only dimly intuited. In Rodenbach's poem even the relative peace of a suggestively rural setting does not afford the condition of silence the convalescent Lady (and by extension the poet) craves. Silence may have been an unobtainable ideal, even in the domestic sphere.

While music and silence function as aesthetic ideals for the symbolists, environmental sounds enjoy less favorable—and an altogether more ambiguous—status in their art. Indeed, ambient sound is treated as an impediment to aesthetic contemplation and spiritual development.

The symbolists associated it with the destructive, soul-destroying conditions of material reality (late-nineteenth-century modernity) to which they were opposed. This does not mean symbolist art has nothing to do with modernity. While symbolist art favors ethereality, indirectness, and mythical locales and subject matter, and seems pointedly divorced from the everyday world, it was nonetheless informed by it. Sharon L. Hirsh suggests symbolist "escapism" was not so much a flight into fancy as a deliberate search for an alternative to the European urban life the symbolists were living. In this view, the symbolists strove to protect against what they perceived to be a loss of individuality and "inner being"; hence their exploration of states of interiority, reverie, and meditation.

> [It] was this need for an inner life, and the ability to interpret the contemporary external world as but a system of signs that could lead to the contemplation of a higher existence, that makes the symbolists so modern. Like the Romantics who exerted such a strong influence over them, the Symbolists prized the personal, the interior, and the individual. Unlike the Romantics, however, the Symbolists were living in city conditions with unprecedented physical changes accompanying an urban population explosion so that the system of signs they were reading was quite new. For the most astute critics of this late-nineteenth century situation, a crisis was clear: how to maintain individuality, a unique personality, and, most important, an inner life under such circumstances was seen as the dilemma of the day.[32]

Silence and music offered havens for the symbolist artist, as did the cocoon-like structure of acoustic interiority. The domestic interior consequently found favor in symbolist art, which was made at a time when, as Hirsh notes, "the city's public spaces—the shops, parks, and boulevards—became the most frightening and alienating of locations."[33] However, a symbolist sound world might not take the form of an idealized state of being, a self-enclosed acoustic interiority, but a psychological landscape full of potential sources of threatening disruption and unknown (and unknowable) menace. This informs the dramaturgy of Maeterlinck's symbolist plays.

Sonic Ambiguity in Maeterlinck's Symbolist Drama

Maeterlinck uses sound in his symbolist plays not simply for incidental effect or scene setting but to motivate the action. His plays work well on the radio because they require close listening and imaginative engagement with scenarios that are, to a large extent, sonically driven. Plays such as *La Princesse Maleine* (*The Princess Maleine*, 1889), *L'Intruse* (*The Intruder*,

1890), *Les Aveugles* (*The Blind*, 1890), and *La Mort de Tintagiles* (*The Death of Tintagiles*, 1894) make use of sound to estrange characters from their environments and from themselves. Maeterlinck exploits sound's potential strangeness—its seeming intangibility, inscrutability, ambiguity, and uncertain provenance, especially when made acousmatically (without visual reference)—to unsettle, thereby introducing a necessary alterity, a quotient of mystery or abstraction in keeping with symbolist ethos, into his fictional worlds and hence onto the stage. His early plays offer wonderful opportunities for theatrical sound design. They are full of references to sound and hearing and have rich, vibrant acoustic imaginaries. The first stagings at the Théâtre d'Art in Paris did not fully exploit their sonic potential. The dramatic sound worlds were largely evoked through the actors' speech as they related what their characters were hearing. They *described* the acoustic imaginary rather than mimetically presenting it. This was in keeping with Pierre Quillard's dictum about symbolist staging: "speech creates scenery like everything else."[34] Symbolist theatre was to be a theatre of evocation rather than strict realization. The symbolists' scenographical experiments—soft lighting that kept the stage in semi-darkness; the use of a scrim to provide a misty, veiled, or dream-like cast—worked to "dematerialize" and "spiritualize" the proceedings, drawing attention to the power of the spoken word, typically uttered by actors in a stylized manner suitable for poetry recitation. Acoustic description, in concert with the *mise-en-scène*, was intended to suggest a symbolic domain. In Maeterlinck's drama, this typically involves uncertainty, disequilibrium, and disrepair as opposed to contented inner reflection or meditation, as in Khnopff's portraits. This may be because idealized silence (active rather than passive in Maeterlinck's philosophy) is difficult if not impossible to achieve in theatre, where noise of one sort or another is standard. One might make the case for Maeterlinck's plays as closet drama, except this would ignore their theatrical ingenuity: they make audiences listen to what they cannot see and also perhaps cannot hear (except in their heads). This can make for curiously compelling, intriguingly frustrating, or simply frustrating theatre, depending on the execution and reception.

In *The Intruder*, a bourgeois family spends an unsettled evening as they await the arrival of one of their own, a nun, expected to visit the mother, who is recovering from a recent, difficult childbirth. The play largely consists of short, harried exchanges between the characters: terse questions and answers uttered in undertones, giving rise to an atmosphere of dread. The family appears to be stalked by Death, whose entrance is implicitly announced by a sudden silencing in the sonic environment. The grandfather, who is blind, is especially sensitive to this silent presence:

THE UNCLE: What sort of night is it?
THE DAUGHTER: Very fine. Do you hear the nightingales?
THE UNCLE: Yes, yes.
THE DAUGHTER: A little wind is rising in the avenue.
THE GRANDFATHER: A little wind in the avenue?
THE DAUGHTER: Yes; the trees are trembling a little.
THE UNCLE: I am surprised that my sister is not here yet.
THE GRANDFATHER: I cannot hear the nightingales any more.
THE DAUGHTER: I think that someone has come into the garden, grandfather.
THE GRANDFATHER: Who is it?
THE DAUGHTER: I do not know; I can see no one.
THE UNCLE: Because there is no one there.
THE DAUGHTER: There must be someone in the garden; the nightingales have stopped singing.
THE GRANDFATHER: But I do not hear anyone coming.[35]

The silent, indefinite disturbance appears to come closer and closer, stifling signs of life and causing disruptions in the natural world (according to the daughter, the swans in the pond seem frightened, the fish are diving suddenly, and the watchdog has retreated to the back of its kennel). The stage directions state a scythe-sharpening sound is made outside. The characters assume it must be the gardener. The grandfather later wonders if he hears scything *inside* the house. Seemingly innocuous sounds (footsteps, wind, sighing, a door opening, murmuring) unnerve them, especially the grandfather. They worry about the lingering, "extraordinary" silence outside ("a silence of the grave") and the lack of sound from the mother's room.[36] Then, as the clock strikes midnight, "*a sound is heard, as if someone were getting up* [from the table] *in haste.*"[37] Is someone—or something—else now in the room with them? They are terrified as none of them have risen. The grandfather is convinced an intruder has been among them and something untoward has happened in the house. Subsequently, a sister of charity appears on the threshold and indicates in "deathly silence" that the mother has died.[38] The play ends with the grandfather crying out alone in terror and confusion.

Sound is an active, destabilizing force in this play. It provides the principal means by which the symbolic dimension is made manifest (not-so-subtly signaled by scything references). Death cannot be *seen* in the play; rather it is audibly intuited by the silences it ostensibly enacts. It operates through the modality of imagined sound: sonic phenomena the characters think are malevolent and portentous. Apparently, it exists not (just?) in their heads but in the phenomenal (or supernatural) world. This is the play's conceit and provocation. As the intruder steals toward

its victim, the play's sound world shrinks to encompass their immediate vicinity. The characters listen intently—almost manically—to individual sounds and attempt to explain their significance: similar to how the first audience of this play was reportedly forced to strain their ears to make out the actors' speech. The critic Francisque Sarcey gave the following report of the production in *Le Temps*:

> [The actors] start speaking but so low that they can't be heard in the third row of the orchestra, where I'm sitting. It is impossible to hear one full sentence. The audience, which sees or hears nothing, begins to be impatient. From all the sides of the theatre one can hear: Louder! Louder! The symbolist followers who are numerous begin to rise in indignation: "Open your ears, they are big enough!" shouts one of them. It seems that the playwright is trying to achieve the effect of terror by having the actors speak in a low voice in the night. We are disrupting the impression of the terror. Still one of the actors decides to raise his voice, and the first sentence that reaches us is this one: "My daughter, do you hear something?" She replies: "My father, I hear nothing." A crazy laughter shakes the whole theater. The feeling of terror disappears instantly. The actors, discouraged by this reception, go back to the first manner of acting, and we grasp, only at intervals, bits of sentences passing beyond the extinguished footlights.[39]

Sarcey's comments do not provide a ringing endorsement of symbolist staging strategy and performance techniques, though some in attendance may have been willing and able to "tune into" the production's low-key sound-making and evocated acoustic imaginary.

Maeterlinck repeatedly uses sound as a marker of unseen, threatening forces that impinge on the lives of his characters. They often describe what is happening to them through what they hear, or what they imagine they hear (hence why Maeterlinck may be thought to have pioneered radio drama before the radio was even invented). Take, for example, Princess Maleine's melodramatic exclamations:

> Oh! Oh! Oh! Oh! What is amiss now? All these noises in my room!... Oh! how the reeds in my room do creak! And as I tread upon the floor, everything sets talking in my room.... Oh! What a storm is raging over the cemetery! And how the wind does blow among the weeping willows!... I can hear nothing more, now. I would rather hear some sound. [*Listens.*] There are footsteps in the corridor—footsteps so strange! They are whispering around my chamber; and I can hear hands being laid upon my door. [*Dog begins to howl.*]... I feel my heart fainting to death![40]

Maeterlinck's sonic descriptions seem excessive, but he is not aiming at naturalism. In *The Death of Tintagiles*, the protagonist is captured by the

Queen (who is only mentioned in the play, never seen), held offstage, and finally killed by her. We hear his voice from behind an iron door as his sister, Ygraine, attempts to locate and free him:

> TINTAGILES: Quick, open! open!... She is here!...
> YGRAINE: Oh! Oh!... Who?...
> TINTAGILES: I can see nothing... but I hear... oh, I am afraid, sister Ygraine, I am afraid... She is here!... Oh, I am so weak. Sister Ygraine, sister Ygraine... I feel her on me!...
> YGRAINE: Whom?... whom?
> TINTAGILES: I do not know... I cannot see... But it is too late now.... She... she is taking me by the throat.... Her hand is at my throat... Oh, oh, sister Ygraine, come to me!...
> *[The fall of a little body is heard behind the iron door]*[41]

In 1898, Khnopff made a pastel illustration of this scene entitled "*Ygraine à la porte*" ("Ygraine at the Door") for the Vienna periodical *Ver Sacrum*. It shows a woman stretching out her arms, pressing onto nothingness, surrounded by darkness. Khnopff was evidently drawn to the scene's symbolist suggestiveness, its audio description of unfolding horror.

Maeterlinck's most sustained exploration of acousmatic and potentially hallucinatory sound is in *The Blind*. This play is set in an ancient Norland forest where a group of blind adults (six men, six women) and an infant, residents of a local asylum, are marooned. They await the return of their guide, a priest, who, unbeknownst to them, has died and is in their midst. The play documents their fumbling attempts to understand their situation, locate themselves, become familiar with their surroundings, and plot a course of action; it is an example of "static theatre"—theatre that explores the spiritual possibilities afforded by stasis—as the characters are mostly stationary and their actions are rudimentary.[42] The characters' tasks are complicated by their various ailments and conditions. Some were born blind; one man is also deaf; another can distinguish light and darkness; one of the women is "mad"; and four of the characters are described as being "very old." There is an infant among them whose senses are not impaired, but are, presumably, untrained. The character's designations are mildly absurd (the dramatis personae reads quite comically), and there is an undercurrent of farce throughout.[43] However, the general tone is serious as Maeterlinck attempts to wring sympathy for the characters' precarious existential and ontological situations.

Maeterlinck outlines a detailed sonic environment in *The Blind*. The play is rife with references to sounds of the natural world, which appear

to acquire an ominous and threatening cast as the situation develops. According to dialogue and stage directions, the "*stifled and uneasy noises of the island*" consist of such elements as the murmur of the sea against the cliffs; the sound of birds alighting and "*screaming exultingly*"; the sound of the wind in the forest; the falling of leaves; the sound of waves crashing against the cliffs; the striking of a clock in the distance; the padding and howling of a dog; as well as other sundry sounds, many made by the blind themselves (groaning, praying, sighing, etc.)[44] Although these sounds are commonplace and would typically be recognizable, Maeterlinck's characters do not always comprehend them. Their apparent ignorance of the natural world (evidently, they don't get out much) causes them not to comprehend the sources of some of the sounds they hear, as in the following section:

> *[A flight of birds alights suddenly in the foliage.]*
> SECOND BLIND MAN: Listen! Listen!—what is up there above us?—Do you hear?
> THE VERY OLD BLIND MAN: Something has passed between us and the sky!
> SIXTH BLIND MAN: There is something stirring over our heads; but we cannot reach there!
> FIRST BLIND MAN: I do not recognize that noise.—I should like to go back to the asylum.
> ...
> SIXTH BLIND MAN: We must be very far from the house. I can no longer understand any of the noises.[45]

The blind have no frame of reference for many of the sounds they hear. In addition to the natural sounds of the island, occasional reference is made to more poetic or abstract phenomena, such as the sound of the stars: "I believe there are stars; I hear them," says The Very Old Blind Woman.[46] Is this a reference to the "music of the spheres"? The blind may be experiencing aural illusions like Mathias in *The Bells*, a proposition that makes the dramatic sound world decidedly ambiguous.

At the end of the play, the blind hear another—possibly hallucinatory—sound they cannot identify, which comes toward them until it is in their midst, recalling the advance of Death in *The Intruder*. They wonder if it might be the sea moaning against the rocks, the ice breaking under the surf, the rustling of a gown against the dead leaves, or the north wind, but the sound finally appears to cohere into slow footsteps. The Young Blind Girl holds her child, who is sighted, toward the nameless sonic presence in an attempt to identify it.

THE VERY OLD BLIND WOMAN: The sound of footsteps draws nearer and nearer: listen, listen!
THE VERY OLD BLIND MAN: I hear the rustling of a gown against the dead leaves.
SIXTH BLIND MAN: Is it a woman?
THE VERY OLD BLIND MAN: Is it a noise of footsteps?
FIRST BLIND MAN: Can it perhaps be the sea in the dead leaves?
THE YOUNG BLIND GIRL: No, no! They are footsteps, they are footsteps, they are footsteps!
THE VERY OLD BLIND WOMAN: We shall know soon. Listen to the dead leaves.
THE YOUNG BLIND GIRL: I hear them, I hear them almost beside us; listen, listen!—[*to the infant*] What do you see? What do you see?
THE VERY OLD BLIND WOMAN: Which way is he looking?
THE YOUNG BLIND GIRL: He keeps following the sound of the steps.—Look, look! When I turn him away, he turns back to see... He sees, he sees, he sees!—He must see something strange!
THE VERY OLD BLIND WOMAN: [*stepping forward*] Lift him above us, so that he may see better.
THE YOUNG BLIND GIRL: Stand back, stand back, stand back. [*She raises the child above the group of blind folk.*]—The footsteps have stopped amongst us.
THE VERY OLD BLIND WOMAN: They are here! They are in the midst of...
THE YOUNG BLIND GIRL: Who are you?
Silence.
THE VERY OLD BLIND WOMAN: Have pity on us!
Silence. The child weeps more desperately.[47]

What is it the blind hear, or think they hear, which apparently comes into their midst at the play's conclusion? We can only speculate. Maeterlinck leaves the matter open ended, using sonic description to intimate the otherworldly. The American sculptor Lorado Taft rendered this scene in a plaster (later bronze) sculpture made in 1908, now held at the Krannert Art Museum at the University of Illinois at Urbana-Champaign. Taft shows Maeterlinck's characters huddled together, their heads pointed in multiple directions, their eyes closed or obscured. The infant is held up as a savior. The sculpture literally solidifies the blind's plight, but the acoustic imaginary still melts into air.

This scene presents a challenge for sound design. Is the sound of footsteps real or imaginary? It is only mentioned in the characters' speech, not the stage directions. If it is imaginary then should it be left to the audience's imagination, too? This is presumably how it was first staged at the Théâtre d'Art, with audiences straining to hear what all the fuss

was about. Patrick McGuinness observes that *The Blind* ends when both characters and spectators are caught in the same confusion. "The two modes which enable reader and audience to remain a step ahead of the characters—stage direction and visual perception—are suddenly withdrawn. Now the audience cannot see. The gap of knowledge on which dramatic irony operates is closed, not by the usual method of character possessing equal amounts of information but, in a double dramatic irony, by creating equal uncertainty in both."[48] Arguably, this "gap of knowledge" at the conclusion is an elaboration of Maeterlinck's general strategy. Readers have privileged information in the form of stage directions, and spectators may survey the *mise-en-scène* at a glance (thus making evident the body of the dead priest), but the play's acoustic imaginary is necessarily ambiguous throughout. Neither readers nor audience members can "know" the dramatic sound world completely or authoritatively because it is shaped by characters who are unsure about what they are hearing. They are *unreliable listeners*, to adapt a term (the "unreliable narrator") from literary theory.

Moreover, they are distressed listeners. Unlike Robida's illustration of the happy-go-lucky nature rambler absorbed in his own private sound world thanks to the phono-opera-graph (Fig. 1.3), Maeterlinck's characters find the natural world *unheimlich* (un-homely, uncanny); they fear their isolation in it. They are unhappy in their environment and struggle to retain equanimity in it. This recalls the situation of the symbolists in modernity. Although *The Blind* is set in a quasi-mythical locale, the auditory conditions it presents are remarkably modern. Following Hirsh, who reads symbolist painting as indirectly engaging life in modern urban society through transposition and allegory, this play may be thought to adopt the "sumptuous clothing of analogy" (a phrase used by Jean Moréas in "The Symbolist Manifesto") to evoke the insecurity caused by modern urban soundscapes.[49] Maeterlinck's blind, bewildered characters beset by noises all around them they barely understand or misconstrue may symbolize modern urban subjects. For the symbolists, disruptive sounds could stymie personal wellbeing (spiritual, physical, and emotional) and prevent the cultivation of "active" (positive, beneficial) silence. Nora M. Alter and Lutz P. Koepnick outline the challenges posed to the urban dweller in modernity:

> Urban noise ripped sights and sounds apart. It overwhelmed the urban dweller with experiences of shock and discontinuity. Unchained from their sources, industrial sounds traveled randomly and connected the incommensurable. Like train travel, they collapsed former boundaries of perception, connected dissimilar spaces, and this upset traditional demarcations.

Part of a curious dialectic of modernization, cacophonic sounds haunted modern life like a specter, relentlessly troubling the drive to re-order and rationalize the world.[50]

Maeterlinck's characters are frightened and bewildered by birds and other seemingly harmless sounds from the natural world, but their sonically inspired ontological insecurity is comparable. Is this part of the acoustic imaginary of Maeterlinck's play? Could it have informed its reception? Symbolist art is nothing if not elliptical. The play *was* performed in a major metropolis. In his essay "On Some Motifs in Baudelaire" (1939), Walter Benjamin suggests Charles Baudelaire's lyric poetry bears the traces of the shock effects of modern urbanism in a similarly indirect fashion. The shocks of modernity contained in Baudelaire's poetry are, according to Benjamin, "subterranean": the crowd, for example, "of whose existence Baudelaire is always aware," might not serve as the model for any of his works and is rarely described, "but is imprinted on his creativity as a hidden figure," existing in an implicit, "phantom" form like Proust's "*mémoire involuntaire*" (involuntary memory).[51] Maeterlinck is too readily regarded as an artist solely motivated by mystical subject matter. Artaud, of all people, makes a telling remark in a 1923 preface to Maeterlinck's *Douze Chansons* (*Twelve Songs*), stating: "Maeterlinck uses certain thought patterns whose relevance to the present day is not remarked upon enough."[52] This is a fairly cryptic comment, but so is Maeterlinck's art, which works to suggest things to the mind that may or may not have a basis in reality.

The spectral nature of Maeterlinck's dramaturgy is at least twofold. His plays present aural fantasies—sounds that haunt characters and audience members alike—but the characters themselves are spectral, too. They have a liminal quality. They are types, ciphers, floating signifiers, shadows on the stage that have little in the way of psychological interiority. This is perhaps unsurprising: Maeterlinck wrote some of these plays with marionettes in mind (beings that cannot, of course, speak "for themselves" and are thus notionally silent). Still, their construction is curious. *The Blind* plays out a modern psychodrama of ontological insecurity through symbolic means, drawing on the suggestive power of the acoustic imaginary, but the characters lack "depth." The blind rely on their sense of hearing out of necessity but this does not provide us much insight into their identities or what motivates them. Their acoustic interiority is a mirage. There is no "there there," to quote Gertrude Stein.[53] It is the role of the reader or audience member to project life, or death-in-life, perhaps, onto these characters and try to hear what they are (imaginatively) hearing. One might surmise that the acoustic imaginary is not reliant on an impression of psychological depth to be effective in theatre. The

two may, however, be productively combined, as suggested by Chekhov's symbo-realist play *The Cherry Orchard*, which ostensibly projects the characters' inner lives onto or through the sonic environment, developing Maeterlinck's aural dramaturgy.

THE "BREAKING STRING" IN CHEKHOV'S *THE CHERRY ORCHARD*

How do you solve a problem like a breaking string? If you are unsure about the type of string, its purpose, and how and why it breaks, then it is quite challenging to determine (a) what sound it should make and (b) what one should make of this sound. This may help explain the considerable commentary this sound effect has generated, the variety of claims scholars have made about it, and the diverse approaches sound designers have taken to realize it. The breaking string is the single most remarked upon sound effect in Chekhov's canon and probably in world drama. James N. Loehlin goes one step further, saying the breaking string is "arguably the most significant sound effect in world drama; in few other works does an offstage sound have such symbolic and theatrical power."[54] He may be right. The breaking string is certainly one of the few dramatic sound effects to achieve sustained critical attention and creative investigation. In 2010, the BBC radio program *Between the Ears* issued a "Chekhov Challenge" as part of BBC Radio 3's celebration of the author's 150th birthday. Directors, sound-designers, and composers discussed the relative value and possible use of guitar strings, gunshots, bird cries, whips, thunder, crackling tinfoil, wet towels, and even leeks in an endeavor to "find a resonant breaking string sound for the 21st century."[55] The search is ongoing. I once asked a freshman to give a practical demonstration of how Chekhov's breaking string might sound. I expected the student to create something weird and wonderful: an electronic wail, perhaps, full of ambiguity and existential angst. The student, not having read the whole play, and taking the most literal approach possible, did something brilliantly stupid (or stupidly brilliant), unknowingly subverting the whole artistic-critical edifice surrounding this stage direction and encapsulating the play's tragicomic nature. He simply took a small piece of string out of his pocket and snapped it on cue. It hardly made a sound. Hilarity ensued.

Chekhov's play is concerned with an indebted Russian gentry family grappling with the prospect of having to sell their estate (containing a cherry orchard) and losing their social dominance. The play speaks to the fading fortunes of the Russian aristocracy and the rising importance of

the bourgeoisie at the turn of the twentieth century. The famous stage direction occurs twice in the play, in Act II and Act IV. It first appears during an evening reverie, intruding suddenly and strangely onto the scene (outdoors on the family estate in mid-summer). Lyubov Andreevna, the family matriarch, has been arguing with Lopakhin, a serf-turned-merchant/landowner, about his plan to raze the cherry orchard and build country villas on the land. She is opposed to this idea, thinking it vulgar. A Jewish band is briefly heard in the distance. Gaev, Lyubov's brother, and Firs, the family's old servant, are also in attendance, as are Anya and Varya, Lyubov's biological and adopted daughters. Trofimov, a student, philosophizes about humankind. Yepikhodov, a clerk, passes by, strumming a guitar. Gaev attempts to rhapsodize nature; Varya implores him to desist. There is a lull in the conversation.

> [All sit, deep in thought. Silence. Only FIRS's muttering can be heard. Suddenly from far, far away, a sound is heard, as if coming from the sky, the sound of a breaking string, dying away in the distance, a mournful sound.]
> LYUBOV ANDREEVNA: What was that?
> LOPAKHIN: Don't know. Somewhere far away, deep in the mines, a bucket broke loose and fell... But somewhere very far away.
> GAEV: Or a bird of some sort.
> TROFIMOV: Or an owl...
> LYUBOV ANDREEVNA: [Shudders.] Disturbing, somehow.
> [Pause.]
> FIRS: Right before the time of trouble, it was the same thing: The owl screeched, and the samovar [a metal container used to boil water] hissed, it never stopped.
> GAEV: What time of trouble?
> FIRS: Why, before the emancipation of the serfs.
> [Pause.][56]

The moment passes. Nothing more is said about the sound. It reappears at the very end of the play. The family, unable to retain their property and about to disperse, has just left the house, which Lopakhin has purchased at auction. He has ordered the cherry orchard to be cut down. Firs is accidentally left behind, shut inside the locked house. He lies down, perhaps fatefully.

> [The stage is empty. There is the sound of all the doors being locked, and then of the carriage pulling away. It grows very still. Through the stillness comes the sound of an axe falling on a tree, a lonely, melancholy sound. Footsteps are heard. FIRS appears at the door, stage right. He is dressed, as always, in a jacket and a white waistcoat, with slippers on his feet. He is ill.]

FIRS: *[Goes to the door, tries the handle.]* Locked. They've gone... *[Sits on the sofa.]* They've forgotten about me... Never mind... I'll just sit here for a bit... And Leonid Andreich, most likely, didn't put his fur coat on, went off wearing his light one... *[Sighs anxiously.]* Just slipped my notice... These young people nowadays! *[Mutters something incomprehensible.]* And life has passed by, somehow, as if I never lived it at all. *[Lies down.]* I'll lie down for just a bit... Don't have too much strength left, now, do you, no, not much at all... You pathetic old fool, you!... *[Lies there, immobile.]*
[A distant sound is heard, as if coming from the sky, the sound of a breaking string, dying away, a mournful sound. Silence falls, and all that is heard, far off in the orchard, is the sound of an axe falling on a tree.][57]

Different translations offer semantic variations on a theme ("bursting" string, "snapping" string) and conjectural variance, but the stage direction's enigmatic quality, a feature of the original Russian, is constant.

The text indicates several ways the breaking string may be understood. On the most basic level, it may just be an incidental sound the characters hear in Act II and are unable to identify, which recurs at the conclusion. The sound may be mechanical, as Lopakhin proposes, or natural, as Gaev and Trofimov submit. In this conception, the sound does not have special meaning; it merely presents the characters with a passing peculiarity, which Lyubov happens to find disturbing. Firs thinks differently. He implies the sound might be a harbinger of social and political change. In this case, like reading tealeaves, the signifier is unimportant (bird, bucket, whatever); it is the signified that matters. The implication of Firs's proposition is that the soundscape is spookily trying to tell them something: namely, a change is going to come. Here, Chekhov may have been drawing on a pre-existing trope, one used by Tolstoy in *War and Peace* (1869). In that novel, Pierre remarks: "While you stand waiting for the string to snap every moment; while everyone is expecting the inevitable revolution, as many people as possible should join hands as closely as they can to withstand the general catastrophe."[58] The sound's potential symbolism connects Chekhov to Maeterlinck (whose work Chekhov knew and admired), reinforcing the importance of symbolism in Chekhov's work.[59] It is also possible that the characters are hallucinating the sound, having been primed by things they recently heard (the Jewish band, Yepikhodov's strumming), their previous conversation, and current contemplation (they are sitting "deep in thought"). This would be a proto-expressionistic formulation on Chekhov's part: a projection of the characters' inner lives onto or through their environment. This might seem fanciful, but the note of melancholia in the stage description, coupled with Lyubov's shuddering, suggests the sound is intimately

connected to what at least some of the characters are feeling. The sound's refrain in the final moments of the play adds to the sense that it is thematically important, not incidental. Here, the breaking string interrupts the sound of the cherry orchard being cut down. The sound's ontology remains ambiguous. Firs is the only character on stage, though he implicitly dies (or falls asleep) after his speech trails off. Is the breaking string the last thing he (imaginatively) hears? Is it instead a symbolic death rattle marking both his expiration and the passing of his masters' former existence? In this conception, the breaking string is not so much a hallucination or projection as it is an autonomous expression of the play's acoustic imaginary.

Stanislavsky exploited the dramatic sound world of the play for the premiere production at the Moscow Art Theatre in 1904, creatively expanding upon Chekhov's directions, much to the playwright's chagrin. Stanislavsky conceptualized Chekhov's characters as living, breathing people whose lives were conditioned by their social and natural environments. He used sound effects to enhance the reality of the offstage world. The production score details a plethora of sounds: creaking floorboards, howling dogs, a train whistle, a receding locomotive, boot-squeaking, barking, carriage wheels, horses, assorted shouts and cries, chirruping, lowing (of cattle), a shepherd's pipe, corncrakes (a landrail or small bird) and frogs, a bugle bell, guitar-strumming, the sound of a Jewish orchestra, billiard balls, nailing, a popping cork, harness bells, and the sound of an axe chopping trees.[60] Stanislavsky thought his sound designs for this play and others by Chekhov were justified, exclaiming: "How can you separate us, and our feelings, from the world of light, sound, and things which surround us, and which human psychology depends so much upon? We [the production team at the Moscow Art Theatre] were unjustly ridiculed for our crickets and other sound and lighting effects which we used in Chekhov's plays, when we were only following his numerous stage directions."[61] Some of these sounds are indicated in Chekhov's text; others are examples of Stanislavsky's practice of "orchestrating" Chekhov's script for the purposes of verisimilitude, mood, and theatrical effect. According to David Allen, Stanislavsky imposed a "mood" on Chekhov's plays, creating a second (meta-)text of sounds in parallel with Chekhov's original, giving them new acoustic, spatial, and environmental dimensions.[62] Stanislavsky strove to realize the acoustic imaginary of Chekhov's work in the manner of a contemporary sound designer. However, he appears to have been rather heavy-handed in his approach. This did not endear him to the author. Miffed by Stanislavsky's array of scenic effects, Chekhov famously quipped: "Listen! I will write a new play, and it will begin like this: 'How wonderful, how quiet! No birds, no dogs,

no cuckoos, no owl, no nightingale, no clock, no jingle of bells, not one cricket can be heard.'"[63] This still might not have prevented Stanislavsky from imitating or making some other noise offstage to fashion the play's soundscape!

He and Chekhov also clashed on the realization of the breaking string. Stanislavsky elaborated upon the sound effect, lending it sympathetic resonance and percussive punctuation. The production score outlines how the sound was to be made:

> Stretch from the beams to the floor three wires (probably the sound will depend on the metal the wire is made from), one thick wire (and the density of sound will depend on the thickness), a second thinner wire, and a third thinner still (perhaps made of different metals). Pass a thick piece of rope over these wires. The first sound denotes the sound of the mine-bucket falling. The others are the echo, i.e. the sound wandering over the steppe. To accompany or finish this scale of sounds, a light tremolo on the big drum (thunder).[64]

Chekhov was unhappy with the rendered effect. "Tell Nemirovich [the co-director of the Moscow Art Theatre] that the sound in Acts II and IV of *The Cherry Orchard* must be shorter, much shorter, and seem far away. How petty, they simply cannot cope with a trifle, with a sound, although everything is written down so clearly in the play."[65] Evidently, Chekhov thought Stanislavsky was bungling the stage direction: overdoing it and quashing the intended subtlety. Chekhov seems not to have appreciated the practical challenge of making a breaking string sound interesting rather than simply perfunctory (as my former student discovered). A breaking string is not necessarily sonically compelling; environmental acoustics may give it character. Contemporary sound designers can protract the sound and add reverberation, calling attention to the finer points of sonic detail, including the anticipation of the break (the string stretching, stretching . . .), the break itself, and the subsequent sonic decay. Frank Napier, stage director at the Old Vic theatre from 1931 to 1934, recommended using a musical saw to achieve an appropriately eerie effect for the play.[66] One wonders what Chekhov would have made of that.

Chekhov did not fully acknowledge the ambiguity of the breaking string. Over a century's worth of dramatic criticism testifies to the hold this sound has had over audiences' imaginations (or at least critics' imaginations). J. L. Styan has proposed that "[the] accumulated mixture of all the thousand and one ambivalent details of the play is in that sound" and "to interpret that sound is to interpret the play."[67] Critics have

attempted to do just that. The breaking string has been thought to signify the death of nature, industrialization, and the crippling of human beings (Donald Rayfield); the unhappy and disjointed lives of its characters (David Magarshack); a warning signal of sorts (Francis Fergusson); the indifference of nature (Maurice Valency); the mysterious emotional relationship that exists between human beings and the natural world (Harvey Pitcher); changing social orders and the passing of time (J. L. Styan); a moment of epochal transition and a sign of cosmic disquiet (Ross Brown); the breaking of a dialectic between life and death and a type of recondite "unmusic" linked to the inability of the characters to "harmonize" (Jean-Pierre Baricelli); Eastern slavic folklore, in particular the idea that a broken string (of an instrument or "life token") denotes a separable soul (Baricelli); an aesthetic rupture in which realism explores its perceptual seams (Stanton B. Garner); an interruption of the illusionistic surface of the action, intended to force the audience out of a fully sympathetic engagement with Chekhov's sentimental characters (W. B. Worthen); and a recollection of southern Russia, which Chekhov explored in his early work (his short stories "Happiness" and "Rolling Stone" feature similar sonic references).[68] Some critics try to shut (down) the hermeneutical trap. Edward Braun believes the sound is resolutely naturalistic. "[Notwithstanding] the espousal of the play by the Russian Symbolists and Chekhov's own regard for the mystical allegories of Maurice Maeterlinck, there is nothing 'symbolic' about the cherry orchard (or the breaking string, for that matter) in the sense of the universal, the transcendental, or the ineffable. As a signifier, it is polysemic but quite specific."[69] Other scholars have opened up the sound's significations to include subsequent intertextual connections. Miriam Handley suggests Shaw "translated" Chekhov's breaking string in *Heartbreak House* (1919) by having his characters hear the artillery explosions that occur at the end of the play in metaphorical terms, assuming the audience would hear them in kind.[70] Similarly, Nina Wieda analyzes Tom Stoppard's use of "aural intertextuality" in *Voyage*, the first play in his trilogy *The Coast of Utopia* (2002), in terms of received Chekhov tropes. She reads Stoppard's offstage sound effects, such as a reference to a "sound of an other-worldly distant pistol shot," as homage to Chekhov's breaking string.[71] The sound is a seemingly endless source of critical debate and creative inspiration.

This is itself significant. The responses generated by the breaking string suggest reception trumps intention: we (readers, audience members, directors, designers, dramatists, scholars) may be more invested in the breaking string's potential meaning than Chekhov was. We may all be "hearing into" the sound. So be it. It tickles our acoustic imaginaries. Alternatively, this might be what Chekhov hoped would happen.

Tom Morris, artistic director of the Bristol Old Vic theatre, remarks: "When Chekhov talks about a twanging string, he's not referring to a particular piece of stage machinery. If you like, he's setting a challenge to the creative team on the show. He's saying 'I want something to resonate metaphorically, and actually it's your job to solve the problem [of] how you make the noise.'"[72] Clearly, it would be reductive to delimit the sound's meaning and argue for a single, "correct" interpretation. The textual references are ultimately ambiguous and open ended in terms of their signification. They are a prompt for us to speculate, to "hear into" and translate the sound, whether it is notated (in the stage directions), described (by characters), or produced (by sound designers). Chekhov's ambiguous and ambivalent use of the acoustic imaginary has prompted a mass of speculation. Maeterlinck, by comparison, primarily employs the acoustic imaginary within the fictional worlds of his plays: it is something that concerns his characters first and foremost. They strive to make sonic sense of their situations. We do not have access to what they are hearing (in *The Blind*, there is no indication that the relevant sounds should be made in performance). In *The Cherry Orchard*, the breaking string, which occurs within both the dramatic sound world and the performance soundscape, arguably sparks *our* acoustic imaginaries more than it does the characters, who say little about it. In its second appearance, it is possible only the audience hears the sound (if Firs has lost consciousness or died). We are invited to intuit the sound's symbolic potential: its communication of something that cannot be readily articulated in language. The breaking string signals abstraction and affect; it causes Lyubov to shudder. It encourages us, the eavesdroppers on this sound, to ponder its thematic significance and identify its triggers, something the play's entropic gentry seem unable or unwilling to do.

We may recognize the sound as a marker of the characters' troubled psychological and spiritual states, a sonic articulation of their unconscious fears, which they work to repress. Like Mathias in *The Bells*, these characters seem to be sonically haunted, even though the sound in question apparently originates from the phenomenal world. Chekhov perhaps unknowingly tapped into a modern fascination with sound as a conveyor of private feeling: something that can speak to, or about, the self (recall the subjects of Khnopff's artwork). The breaking string, which has a musical quality, is an exemplar of an aesthetic phenomenon in modern drama in which an acoustic imaginary, informed by the mental and spiritual lives of its characters, is made manifest. Sound does not simply function as an index of the phenomenal world: it is not just something that happens *out there*, on or beyond the visible world of the stage as a product of everyday actions and environments. It is also a mental construct that can express

internal states of being. It can tell us what characters are feeling, even if they are unable to articulate these feelings. The acoustic imaginary may emerge during scripted pauses and silences, communicating what speech cannot. This is the art of theatre sound design, of course, and it is implicit in Chekhov's work.

The breaking string is not a freak effect, a singular oddity in Chekhov's canon and dramatic literature; rather, it is illustrative of a constellation of ideas expressed in various forms and discourses relating to sound, imagination, interiority, and aesthetics. It is indicative of a turn toward acoustic interiority that was especially apparent in modernity whereby a listening subject could become absorbed in a private sound world. Modern dramatists such as Maeterlinck and Chekhov treated this phenomenon not by scripting characters who purposefully try to evade worldly noise (like the phonophobic Morose in Ben Jonson's 1609 comedy *Epicene*) or are technologically engaged (e.g., headphone listening) but by blending soundscape and psyche, insinuating connections between characters' psychological, ontological, and situational circumstances. This chapter's circuitous investigation of the acoustic imaginary, from Mathias's hallucinated bells to Maeterlinck's sonic presences to Chekhov's psychologically inflected breaking string indicates an increasing level of semantic abstraction and a focal shift from the dramatic sound world to the performance soundscape. It becomes increasingly difficult to fathom a single meaning for these sounds; the referents become less easily identifiable and more open to interpretation. The sounds threaten to haunt *us* and obsess *our* imaginations in an outward spiral, like the tale told to the wedding guest (and by proxy to the reader) in Coleridge's poem "The Rime of the Ancient Mariner" (1817). The acoustic imaginary reaches a conceptual apex in modernist theatre in Kandinsky's stage composition *The Yellow Sound* (1912), which takes sonic abstraction and internal perception to a higher level.

"Inner Sound" in Kandinsky's *The Yellow Sound*

The Cherry Orchard features a single, perplexing (or at least contentious) sound in an otherwise lucid artistic schema; *The Yellow Sound*, as the title suggests, foregrounds synaesthesia (the mixing of the senses) and is inherently abstract. Kandinsky's work is a fascinating, quirky modernist experiment: one of a handful of color-tone compositions he sketched between 1909 and 1914 that aimed to unite theatre, dance, music, and visual art. It is not, however, completely anomalous or obscure, which is how it is sometimes considered. It draws on elements such as synaesthesia (favored by the symbolists) and the *Gesamtkunstwerk* ("total work of art,"

theorized by Wagner) that situate it in a network of artistic and intellectual ideas. One would be hard pressed to associate it with any single artistic movement given its idiosyncratic fusion of elements (one could make the case for both symbolism and expressionism), but this does not make it culturally autonomous.[73] Quite the contrary, *The Yellow Sound*, published in *The Blue Rider Almanac* in 1912 but unperformed in Kandinsky's lifetime, is very much a product of its cultural and historical moment. Like symbolist art, Kandinsky's work implicitly engages modern experience; it transfigures it using artistic means. One of the elements Kandinsky treats is the internal perception of sound, which forms the conceptual basis for the artwork. Kandinsky formulated a mode of artistic perception that privileged imagined hearing and a stage composition that proffers a sonic mode of being; both are consonant with modernity.

Kandinsky's aesthetic shift toward abstraction, which took place while he was living in Munich in the early 1900s, coincided with his endeavor to compose for the stage. Kandinsky, a self-declared synaesthete, hoped to conjoin the fine arts and the lively arts in unique arrangements of light, color, sound, and movement. No single element would be subservient to another but would interrelate and overlap. Kandinsky wanted to create a new type of performance that would body forth the principles of abstract art in time and space. He proposed to use theatre to make abstract art come alive, creating the experience of being inside a living painting that moves and has an aural dimension too. One might say Kandinsky dreamed up "live art" (a British term for intermedial performance art) before this term was invented. Indeed, his stage compositions may be considered part of the "pre-history" of what Hans-Thies Lehmann calls post-dramatic theatre, in which the dramatic text is subordinated to a more event-based experience that favors images, sounds, and the performing body as principal centers of attention and proponents of meaning.[74] In Kandinsky's aesthetic, these elements may be superficially contradictory but connected on a deeper, spiritual level.

Kandinsky's embrace of abstraction was founded upon his belief in the necessity for a renewed spirituality in artistic practice to countervail materialism and positivism. This aligns him with the symbolists. Abstraction, for Kandinsky, did not simply involve random conglomerations of artistic elements but could express the "essential" nature of an object, scene, shape, or color. He articulates his philosophy in his treatise *Concerning the Spiritual in Art*, published in 1911, and the essays "On the Question of Form" and "On Stage Composition," published in *The Blue Rider Almanac* alongside *The Yellow Sound* the following year. Kandinsky thought an artist could perceive the "inner nature" of worldly phenomena, their "inner sound," and capture them abstractly: a creative

form of X-raying (developed in the 1890s) or ultrasound imaging (first used in medical diagnosis in the late 1930s). Sound, Kandinsky writes, "is the soul of form, which only comes alive through sound and which works from the inside out. Form is the outer expression of the inner content."[75] *Sound is the soul of form.* This is a remarkable statement, and a surprising one, on the face of it, for a visual artist to make. Kandinsky is, of course, referring to conceptual sound rather than phenomenal sound: sound imagined in "the mind's ear," not the vibrational force one's actual ears may detect. Kandinsky likens it to the distinction between a real sound a trumpet might make and the sound one hears internally when one imagines saying the word "trumpet." In the latter case, "this sound is audible to the soul, without the distinctive character of a trumpet heard in the open air or in a room, played alone or with other instruments in the hands of a postilion [a herald], a huntsman, a soldier, or a professional musician."[76] Inner sound approximates a Platonic ideal. Kandinsky regarded it as a superior facilitator of emotional depth and spiritual truth.

Kandinsky advocated discounting the external reality of phenomena and identifying their internal natures instead. Children do this by drawing instinctively, he notes, but formal art training impairs this ability. "The academy is the surest way of destroying the power of the child. Even the greatest, strongest talent is more or less retarded in this respect by the academy.... An academically trained person of average talent excels in learning practical meanings and losing the ability to hear his inner sound. He produces a 'correct' drawing that is dead."[77] Kandinsky supposed that if an artist could "unlearn" what has been taught and forgo conventional forms of representation in favor of spiritual abstraction, an epiphanic realization of inner sound might be captured. Likewise, the viewer of an abstract artwork has to relinquish received ideas and predetermined notions and intuit the artwork's nonrepresentational meanings on an instinctual, affective level. Kandinsky writes:

> In order to "understand" this kind of [abstract] painting, the same kind of liberation is necessary as in realism. That is, here also it must become possible to hear the whole world as it is without representation. Here these abstracting or abstract forms (lines, planes, dots, etc.) are not important in themselves, but only their inner sound, their life. As in realism, the object itself or its outer shell is not important, only its inner sound, its life.[78]

To hear the whole world as it is, without representation, is no mean feat. This presumably entails apprehending the "core" aspect of things, not the outward show. This seems like a nebulous, if not impossible, task, rife with ontological and epistemological conundrums (rooted in the very

assumption that objects in the phenomenal world have "inner sounds"), but it nevertheless provides the basis for Kandinsky's aesthetic principles. It is a challenge for artist and viewer alike. How does one make sense of a visual translation of inner sound? The trick photography used in the silent film version of *The Bells* (see Figure 1.1) presents such a depiction without interpretive difficulties: the viewer ostensibly sees what Mathias is imaginatively hearing. Kandinsky's work, by contrast, challenges us to rethink our ways of seeing and hearing, further (con)fusing the senses.

Kandinsky put his ideas into practice in his early abstract work, such as *Impression III—Concert* (1911). (Search for the image. It's readily available online, but nothing beats seeing Kandinsky's painting in the flesh, so to speak.) This painting was inspired by a concert given by Arnold Schoenberg in Munich in January 1911 at which the composer showcased his new atonal music. Kandinsky considered this music to be "a matter not of the ear but of the soul alone," heralding "the music of the future."[79] Schoenberg's music exemplified the virtue of abstraction for Kandinsky; his painting aims to capture the inner sound of the scene through nonrepresentational means. However, it does not completely abjure figural representation. It is possible to discern an impression of an audience clustered around a piano, but Kandinsky nonetheless favors a form of expression that conveys the concert's *Stimmung*—its mood, tone, or atmosphere—as a vibrant, dynamic mélange of shapes and colors. His preparatory pencil sketches explicitly render the concert scene; the finished painting offers a sensory impression of it through studied naiveté. It is a bold composition, striking the viewer with its shock effects, similar to the imagined pianist in the scene. The painting engages the acoustic imaginary, connoting a brash, daring musical performance that stimulates new thought patterns. "Colour is the key-board," Kandinsky writes, harping on a synaesthetical theme, "the eyes are the hammers, the soul is the piano with many strings. The artist is the hand which plays, touching one key or other, to cause vibrations in the soul."[80] Kandinsky imagined these "soul vibrations," implicit in visual art and music, could also be effected in theatrical performance, which informed his conception of a stage composition.

Kandinsky was hardly ignorant about theatre. He was familiar with the work of Max Reinhardt, Edward Gordon Craig, the Moscow Art Theatre under Stanislavsky, the Russian symbolists, and Maeterlinck (he owned a copy of the first Russian edition of Maeterlinck's plays, published in 1896).[81] He was also knowledgeable about modern dance, having seen Isadora Duncan dance in Munich, and planned to work with her pupil Alexander Sacharoff on *The Yellow Sound*.[82] His connection to Maeterlinck has not received much commentary, though it has obvious

importance for this investigation. Kandinsky writes about Maeterlinck in *Concerning the Spiritual in Art*, championing him as "one of the first warriors, one of the first modern artists of the soul."[83] He notes Maeterlinck's preference for matters internal over external, spiritual over material, recognizing that the material machinery of his plays ("gloomy mountains, moonlight, marshes, wind, the cries of owls, etc.") has a symbolic function and helps to give the "inner note" (or inner sound).[84] Kandinsky identifies Maeterlinck's "principal technical weapon" as his use of words, which, he suggests, may express an inner harmony. "This inner harmony springs partly, perhaps principally, from the object which it names. But if the object is not itself seen, but only its name heard, the mind of the hearer receives an abstract impression only, that is to say as of the object dematerialized, and a corresponding vibration is immediately set up in the heart."[85] This is recognition of Maeterlinck's use of sound (in this case speech) as an evocation, a summoning of an acoustic imaginary not literally represented but potentially activated in the minds of the play's characters, readers, and audience members. Inspired by Maeterlinck, Kandinsky translated inner sound into abstract painting and fashioned a novel arrangement of artistic elements in the form of a stage composition.

Kandinsky's essay "On Stage Composition," which prefaces *The Yellow Sound* in *The Blue Rider Almanac*, continues Kandinsky's argument for inner sound and extends it beyond visual art. According to Kandinsky, every art has "its own language," its own "inner identity" that may be combined to form an artistic "complex of vibrations" connecting the artist's soul to the perceiver, whose soul may "vibrate in sympathy" and possibly excite further internal vibration unanticipated by the artist.[86] Kandinsky criticizes nineteenth-century art for being unduly focused on external matters to the detriment of the internal plane. He notes with disapproval the heightened generic separation of drama, opera, and ballet; nineteenth-century drama's lack of focus on the "spiritual life of man" and the cosmic element; and the operatic convention of making the dramatic action serve the music or vice versa.[87] Even Wagner, whom Kandinsky notes endeavored to make opera more "organic" by joining individual parts to create a "monumental work of art," ultimately concerned himself, Kandinsky thought, with *external* associations and the programmatic use of music; the inner sound played no part.[88] Kandinsky, a cellist, collaborated with the Ukrainian composer Thomas de Hartmann on music for *The Yellow Sound*. De Hartmann produced a rough draft (a few pages of a piano score, mostly fragments), though it is unclear how it might have meshed with Kandinsky's design. Kandinsky sought an artistic union that cohered according to spiritual-sensory connections rather than semantic or conventional principles (or a system of pre-established codes such

as Wagnerian leitmotifs). He describes the internal composition of *The Yellow Sound* accordingly:

> There are three elements that as external methods serve the inner value:
>
> 1. The musical sound and its movement,
> 2. The physical-psychical sound and its movement, expressed through people and objects
> 3. The colored tone and its movement (a special possibility for the stage).
>
> The drama finally consists of the complex of inner experiences (soul = vibrations) of the audience.[89]

Kandinsky's formula may seem abstruse, but his art ultimately aims for immediate, intuitive understanding. Put simply, Kandinsky hoped to use synaesthetically blended compositional elements (light, sound, movement) to express an internal, ideal perception of phenomena. Inner sound was his theoretical means of communicating directly to an audience. This dream of *sound* as a universal language (more than music) was a shared fantasy of the modernist avant-garde. It will recur later in this study.

The Yellow Sound consists of a series of short, loosely connected scenes (or pictures) containing verbal description and occasional speech. The list of participants includes five giants, vague creatures, a tenor (backstage), a child, a man, people in flowing robes, people in tights, and a backstage chorus. There is no plot or narrative per se but a series of loosely connected audio-visual-kinetic sequences. Much of the action is oblique: offstage speaking or singing; the slow simple movements of the giants; sudden intrusions onto the scene; the emergence and fluttering of a yellow flower; the huddled discourse of a group of people with white flowers in their hands; an altercation between a boy pulling a bell rope and a man commanding him to be silent; and various environmental changes. It is a little mystifying, on the whole, like suddenly wandering into someone else's dream. Take Picture 3, quoted in full:

> At rear: two large red-brown rocks, one pointed, the other round and larger than the first one. Backdrop: black. Between the rocks the giants (of Picture 1) are standing, whispering to each other noiselessly. Sometimes they whisper in pairs, sometimes they huddle. Their bodies remain motionless. From all sides come dazzlingly colored rays (blue, red, purple, green) alternating rapidly several times. Then all these rays become focused in the center and blend. Everything remains motionless. The giants are almost completely invisible. Suddenly all the colors vanish. The stage is black for

a moment. Then a faint yellow light flows onto the stage, gradually becoming more and more intense, until the whole stage is intensely lemon yellow. As the light increases, the music becomes lower and darker (these motions suggest a snail withdrawing into its shell). While these two motions occur, nothing but light is seen on the stage, no objects. When the light is most intense, the music has faded away entirely. The giants become distinct again, but motionless, and look straight ahead. The rocks no longer are visible. Only the giants are on the stage; they are now standing further apart from each other and have become taller. Backdrop and floor black. Long pause. Suddenly a shrill, terrified tenor voice can be heard from behind the stage, rapidly shrieking completely unintelligible words (*a* can be heard frequently, for example, Kalasimunafakola!).[90]

It is not immediately apparent what any of this means—or if it means anything at all. It is undoubtedly intriguing and there is some charming description (e.g., musical motion likened to a recoiling snail), but the density of detail, coupled with the opaqueness and ostensible nonsensicality of the referents (e.g., the string of indistinguishable words uttered by the offstage tenor) is mildly mind-boggling. One can see why Hugo Ball wished to stage *The Yellow Sound* at the Cabaret Voltaire (Ball created his own unintelligible utterances in his sound poetry, discussed in Chapter 3).[91]

The difficulty of analyzing the text stems from trying to make sense of individual components and their arrangement. This is like trying to decipher a code without a key. Kandinsky's color schema offers a possible solution, though its applicability is questionable. In *Concerning the Spiritual in Art*, he writes about the attributes and associations held by certain colors:

> Yellow is the typically earthy colour. It can never have profound meaning. An intermixture of blue makes it a sickly colour. It may be paralleled in human nature, with madness, not with melancholy or hypochondrial mania, but rather with violent raving lunacy.... Blue is the typically heavenly colour. The ultimate feeling it creates is one of rest.... In music a light blue is like a flute, a darker blue a cello; a still darker blue a thunderous double bass; and the darkest blue of all—an organ.[92]

Scholars have used Kandinsky's color symbolism to interpret the stage composition as a conflict between spiritual aspirations and earthly, destructive inclinations (i.e., materialism). Birgit Haas encapsulates this reading: "white and blue stand for creative, spiritual forces, yellow and red represent earthly vitality, brown and green indicate human dullness, and grey and black symbolize spiritual emptiness.... [The] main line of

conflict in *The Yellow Sound* runs between the yellow giants, symbols of inhuman disorder, and the red and white figures, who represent a positive vitality."[93] Peter Jelavich takes a similar tack, interpreting the work as a modernist allegory about the perils of de-individuation and unthinking, unfeeling action. In his reading, the differently colored figures represent the peasantry, whom Kandinsky admired for their respect for the individual, whereas the group that wears indistinct, green-gray clothes, walks in unison, and acts in a communal fashion represents the bourgeoisie, whom Kandinsky spurned. "Kandinsky considered middle-class society fully homogeneous, and tagged it with the color green, which (with its sister-color gray) represents immobility, dullness, and stupidity."[94] This is just a sample of how *The Yellow Sound* has been read using color symbolism as a hermeneutic key. Such readings are quite persuasive and certainly make the work more comprehensible. However, they run the risk of reducing its complexity and strangeness, making one less inclined to hear the forest for the trees, so to speak. External elements in Kandinsky's art are not necessarily significant for their own sake (recall: "the object itself or the outer shell is not important"); rather, they provide a means to provoke the inner sound, and this may not be categorized so easily.

In order to appreciate the internal workings and combinatory dynamics of Kandinsky's work, one arguably has to experience them in action. Kandinsky accounted for this when theorizing the stage composition, acknowledging that it "finally consists of the complex of inner experiences (soul = vibrations) of the audience" (quoted earlier). It is not something one can truly fathom as a reader (after all, it was intended to be a *stage* composition, not just a *page* composition). It is not possible to realize the cumulative effect and interaction of the principal component elements (color, sound, movement) mentally. One has to experience it in performance in order to apprehend its vibrational complex. The work's provocation is phenomenological as well as conceptual. This makes it more unstable and open-ended than Kandinsky imagined. He mistakenly thought his color scheme was universal, apparently unaware of the fact that every color hearer (synaesthete) may have an idiosyncratic set of associations. Kevin T. Dann observes: "[Kandinsky's] desire was for a sort of mathematics of color, whereby the spiritually advanced artist like himself could pluck the strings and evoke the appropriate response."[95] This is a fantasy. *The Yellow Sound* cannot but provoke unique sets of responses from audience members. It operates on a broad and shifting band of frequencies, depending on associations made by the receiver. It is neither a static entity nor a shared constant.

This was made evident to me when I attended a performance of *The Yellow Sound* at the Tate Modern in London in November 2011 as part of

THE ACOUSTIC IMAGINARY 59

Figure 1.6 *The Yellow Sound*, performed by students of the University of Glamorgan at the Tate Modern in 2011.

a centenary symposium on The Blue Rider. The performance was directed by Geraint D'Arcy and Richard Hand and featured students from the University of Glamorgan (see Figure 1.6). The production took the form of an installation: we, the audience, were ushered into a largely empty gallery space and free to sit, stand, or wander about as we pleased. The performance took place in our midst. The directors give an account of the *mise-en-scène*:

> At Tate Modern, three sides [of the gallery] were open to St. Paul's and the City of London, the Thames and the construction of the Shard to the East.... The centerpiece of the performance installation ... was a freestanding miniature proscenium arch in a vaguely art-deco style. Behind the arch was a black bordered screen with an intensely coloured backdrop created by a short-throw rear-projector providing the colour and animations required by the performance.... At the front of this performance space were small groups of floor lamps chosen for their ability to throw solid clean colour at low intensities, casting long coloured shadows into the gloom against the glass and cityscape. Throughout the room, slowly and meticulously moving and waiting in the coloured gloom were

figures clothed in flowing robes, picking their way between silent still yellow giants.[96]

This production highlighted the porous quality of Kandinsky's work. Reading the text yields an impression of aesthetic density and recondite symbology; it presents a puzzle one struggles to figure out. This production made me wonder if affective meaning is more important than semantic meaning in *The Yellow Sound*. Experiencing the work as a play of form in which light, sound, and movement freely intermingle via bodies in space highlights the challenge to the perceptual function, that is, to how one perceives. I realized the durational values of actions within each scene, and the scenes themselves, were infinitely variable (the text does not specify how long actions should take). The ability to move around a sonorous, kinetic painting and experience it from multiple perspectives made me consider the fluidity of my own subject position as a reflection of the work's flowing figures. Their unfixity became my unfixity; their dynamic exchanges, prompted and accompanied by shifting patterns of light and sound, made indeterminacy and self-dissolution felt experiences. The work's *fluxibility* has greater potential to move an audience member than a reader, especially in choreographically intricate sequences, such as this section from Picture 5:

> Several figures leave their places and walk, some fast and some slowly, to other groups. Those who stood alone form smaller groups of two or three, or join larger groups. Large groups dissolve. Some figures hurry off the stage, looking backward. At the same time all black, gray, and white figures vanish: finally only the colored figures remain on stage. Gradually everything moves in an irregular rhythm. In the orchestra—confusion. The shrill shriek of Picture 3 becomes audible. The giants shudder. Various lights sweep the stage and cross each other. Whole groups run offstage. A general dance starts.[97]

In performance, this sequence, and others like it, can shift the ground from under the participants' feet. This is perhaps one of the work's accidental provocations that only performance can manifest.

The Yellow Sound in performance offers the possibility of a radically unsettled subjective experience on the participant's part, echoing the shadowy constitution of Kandinsky's cast of characters. Attending (to) the work may destabilize the notion of the self as a strictly bounded, monadic, inward-looking entity, and instead suggest a more capacious, dispersed, subject-in-process (shades of expressionism here). This is not the model of subjectivity enabled by acoustic interiority—self-isolation in a private

sound world. Rather, it suggests a mode of being-in-the-world attuned to the cacophonous disordering of subjective experience prompted by the modern metropolis (discussed earlier in relation to *The Blind*) and ghosted by the technological extension of human sense perception in modernity. Steven Connor has theorized how hearing helped to condition the modern self, especially with the development of telecommunications technology in the early twentieth century. He dubs this self the "modern auditory I."

> The rationalized "Cartesian grid" of the visualist imagination, which positioned the perceiving self as a single point of view, from which the exterior world radiated in regular lines, gave way to a more fluid, mobile and voluminous conception of space, in which the observer-observed duality and distinctions between separated points and planes dissolve. Most importantly, the singular space of the visual is transformed by the experience of sound to a plural space; one can hear many sounds simultaneously, where it is impossible to see different visual objects at the same time without disposing them in a unified field of vision. Where auditory experience is dominant, we may say, singular, perspectival space gives way to plural, permeated space. The self defined in terms of hearing rather than sight is a self imaged not as a point, but as a membrane; not as a picture, but as a channel through which voices, noises and musics travel.[98]

Connor's description of the "modern auditory I" matches a possible perceptual experience of *The Yellow Sound* in performance. Experiencing the artwork, immersing oneself in a sonorous, kinetic painting, encourages one to imaginatively "hear the whole world as it is without representation"—to become dislocated, extended, dispersed, penetrated, simultaneously here-and-there: experiences facilitated by modernity via radiophonic and telephonic technologies and the soundscape of the metropolis. If this is a valid interpretation of Kandinsky's work—and, I freely admit, it is somewhat eccentric—then it was most likely an accidental formulation on Kandinsky's part, an unconscious osmosis, as it were. Still, modernism worked to promote eccentric (or ex-centric) feeling in addition to fantasies of monadic inwardness, as Justus Nieland argues.[99] Moreover, Kandinsky *was* affected by the epistemic crises of modernity, saying about the discovery of radioactivity in 1896: "In my soul the decay of the atom was the same as the decay of the whole world. Suddenly the sturdiest walls collapsed. Everything became unsteady, uncertain, and soft. It would not have amazed me, if a stone had melted into air before me and become invisible."[100] Obviously, radioactivity and radios occupy different orders of magnitude, but the perceptual challenges

offered by modern soundscapes and modes of hearing should not be discounted; sonic influence can be insidious. Kandinsky's stage composition blends psyche and soundscape in a more abstract manner than either Maeterlinck or Chekhov. His foray into the acoustic imaginary—his quest for inner sound—aims for spiritual elevation, but he arguably achieved this by transmuting the material conditions of sonic modernity, creating a stage composition that encourages audiences to adapt to perceptual flux and realize a new way of seeing/hearing things.

* * *

The aural dramaturgies of Maeterlinck, Chekhov, and Kandinsky indicate how these artists used sound creatively and conceptually to explore subjective experience and environmental dynamics in an innovative fashion. These dramatists recognized that sound is not merely incidental to how we understand ourselves and make sense of the world; rather, it can be integral to these processes. This was certainly the case in the *fin de siècle*. The ability to become sonically self-enclosed (acoustic interiority) was both desirable and possible. The increased density and complexity of modern soundscapes challenged auditory perception and ontological stability. Imaginary sound worlds and idealized sonic conditions (such as silence) were prized as alternatives to the material conditions of sonic modernity. Modern theatre artists used the acoustic imaginary to explore these issues, making it suit their own purposes, prompting readers and audience members to wonder about—and become absorbed by—the nebulous sounds of their creations. The fact that these sonic imaginings can be mysterious and hard to fathom is part of their artistic provocation and cultural import. These plays foreground the inscrutability of sonic phenomena: hinting at connections and hidden meanings but not fully disclosing them. They work to activate *our* acoustic imaginaries. This suggests the subjective significance of sound (i.e., the role of sound in shaping subjectivity) was not, could not, and perhaps *cannot* be completely or comprehensively understood. This might explain why sound is used in an open-ended, ambiguous manner in these works. By bringing the acoustic imaginary to the fore, these artists drew attention to the role of sound in constituting—and complicating—modern selfhood and experience, even if this makes matters increasingly uncertain and unsettling, like noises that come, peculiarly, from within.

CHAPTER 2

THEATRE SOUND IN THE AGE OF MECHANICAL REPRODUCTION

THE PHONOGRAPH MADE ITS STAGE DÉBUT NOT WITH A BANG but a whimper: a baby's cries, to be precise, specially recorded for Arthur Law's farce *The Judge*, which opened at Terry's Theatre in London's West End on July 24, 1890. This was apparently the first use of recorded sound in theatre, made 13 years after Thomas Edison patented the phonograph in 1877. Law's play concerns a nervous, hypochondriac judge who takes an imperiled married woman and her baby into his protection. The baby howls. The production used a recording of an infant made three days earlier, according to the program, which announced this as "the first use of the Phonograph for stage purposes."[1] A commentator in *The Graphic* concurred, reporting the event for posterity: "The future historian ... will not fail to note that the phonograph ... made its first appearance on the stage."[2] (Duly noted!) A reporter for the *Marylebone & Paddington Independent* playfully included the phonograph among the performers: "the phonograph ... undertook the role of a fretful baby's howls and acquitted itself admirably."[3] Not all the critics were impressed. Clement Scott, advocate of the picturesque stage and avowed antimodernist, ranted about it in the *Illustrated London News*. Hearing a *baby* cry on stage provoked his ire (likely exaggerated for comic effect); the mechanical reproduction of the sound only inflamed his opinion.

> Among the horrors of the play is a terrible reproduction of the voice of a squalling child, through one of the new diabolical inventions to perpetuate sound. What will science not do next? A screaming child is awful enough in real life, but through this ghastly machine it is infinitely worse

than nature. It sounds like a passionate infant turned into a dissipated corncrake! But why on earth perpetuate to eternity the terrors of daily life? Fancy conceiving that the nervous mother or the irritable father would be pleased or amused by hearing a child cry on the stage! For a moment they get a relief from the nursery. They want peace. But they are asked to pay money to hear a child scream! Bother the phonograph, say I, with its squeaks and howling babies! I can conceive a hard-working Londoner being soothed by the sound of a country bird or the mooing of a comfortable cow in a meadow. Sweet sound should be preserved and potted by science; harsh sounds, never. But science has no mercy. When we go down to the seaside we shall be asked to pack up in our portmanteau a machine that records the street yells of the Strand.... Oh! the horror of it! Actually paying for the pleasure of hearing a fractious child yell its little heart out! If the phonograph can do no better than this, let it be "anathema maranatha"![4]

Scott need not have fretted, at least not about the future use of the phonograph. Though modernists such as Luigi Russolo (discussed in Chapter 4) would disrupt Scott's fantasy of theatre as a sanctuary from the noise of everyday life, the phonograph played no part in this. Indeed, the phonograph—and its eventual replacement, the gramophone—seem to have had relatively little, or at least inconsistent, use in theatre, where the mechanical reproduction of sound was continually claimed to be new. In 1906, 16 years after the production of Law's farce and 19 years after Emile Berliner patented the gramophone, a caption in *Theatre Magazine* describes Herbert Beerbohm Tree's use of a "gramaphone" [*sic*] to record crowd noises and trumpet bugling for a production of Stephen Phillip's tragedy *Nero* at His Majesty's Palace in London as a "novel" effect.[5] Bertolt Brecht, writing in 1936, thought Erwin Piscator was the first person to use recorded sound in theatre in his production of *Rasputin* at the Theater am Nollendorfplatz in Berlin in 1927. Brecht claimed this practice was newly in vogue.[6] What promoted this cultural amnesia? Why didn't the mechanical reproduction of sound in theatre enjoy greater success?

This chapter addresses these questions and challenges the standard account of sound-reproduction technology in theatre, which suggests it was not until the 1980s with the advent of digital sound that sound-reproduction technology was effectively integrated into production practice as part of a complete design. This is only partially true. While modern theatre producers did fumble in their attempts to utilize new sonic technologies, their efforts were not wholly ineffective, and there is much to be learned from their ostensible failures. The history of sound-reproduction technology in theatre is, like the history of many new technologies, full of missteps, dead ends, and contingent usages, with multiple modes of

practice often overlapping. Just as early cinema was constitutively heterogeneous and tried a number of different sound-production processes (e.g., live musical accompaniment and sound effects, voices behind the screen, synchronized recordings), so did modern theatre experiment with the newfound technological possibilities of sonic modernity. For example, in the late nineteenth and early twentieth centuries it was possible to have a direct line to the major stages of Paris and London and listen to theatre on the telephone. One could be a telephonic audience member, an eavesdropper on performance.

The history of the "theatre phone," outlined in this chapter, is fascinating and little known, as are efforts by the theatrical avant-garde to incorporate—and respond to—the mechanical reproduction of sound in their art. Modern theatre provides insight into the social construction of technology: the ways in which technologies are culturally determined and shaped by human actors even as they work to inflect human behavior.[7] In other words, technology does not simply dictate human action but gains meaning in how it is used, amending existing ideas and practices in the process. This viewpoint undercuts deterministic "impact" narratives: these presume that technology establishes new, revolutionary epistemologies that fundamentally alter human perception and experience. The invention of sound-reproduction technology did not immediately change how people heard or what they thought about the auditory world. Jonathan Sterne has shown how ideas and practices associated with machines such as the telephone and the phonograph predated their invention; the origins of sound-reproduction technology are cultural.[8] Moreover, these technologies were culturally interrogated after their invention: their meanings were examined, their possibilities explored, and their significance pondered. Modern theatre contributed to this, helping to determine the role and function of sound-reproduction technology in everyday life, just as it concurrently explored the domain of the acoustic imaginary. Sound-reproduction technology may not have immediately revolutionized staging practices but theatre still engaged this phenomenon.

This chapter considers how theatrical avant-gardists such as Guillaume Apollinaire and Jean Cocteau foregrounded sonic technologies in dramaturgy and *mise-en-scène*, presenting paradigms of human-technological entanglement, experiential disjunction, and technological artifice as new norms of modernity.[9] These artists staged the social construction of technology: they took the craft of theatrical sound-making out from the wings and brought it onto the stage in the form of manipulated or embodied technology, making it a figurative co-performer. In doing so, they made theatre a site for the playful investigation of modern,

mediated experience, exploiting the conditions of ontological instability and spatio-temporal collapse that the phonograph and telephone supposedly engineered by separating sounds from their sources and mechanically reproducing them. Sound in modernity was no longer fixed to the site or moment of its first creation. Voice could be mechanically captured, suggesting a type of self-splitting and disembodiment. One could converse intimately in real time at great geographical distances. By dramatizing and presenting these dynamics in inventive ways, Apollinaire and Cocteau showcased the audiovisual disjunctions and intermedial crossovers that constituted modern technological experience. They reveled in the productive confusion of sights and sounds it produced. This was especially à propos of surrealism, which promoted sensory mismatching, significatory ambiguity, and contradictory truths. In this chapter, I present three case studies, analyzing them as works of art in the age of mechanical reproduction (a nod to the title of Walter Benjamin's famous essay): Apollinaire's *Les Mamelles de Tirésias* (*The Breasts of Tiresias*) (first written in 1903, revised in 1917) and Cocteau's ballet-drama *Les Mariés de la Tour Eiffel* (*The Eiffel Tower Wedding Party*, 1921) and his play *La Voix Humaine* (*The Human Voice*, written in 1927, first performed in 1930). I treat these works in audiovisual and intermedial terms as theatrical spectacles inspired by early cinema, phonography, and telephony, respectively. These works defamiliarize, and seem to transpose, looking and listening. They are dramatically inventive and socioculturally suggestive. They are also ripe for reconsideration.

Theatrical Aurality and the Auratic

Why didn't the phonograph become the universal technology of choice to produce sound effects and music for the stage at the turn of the century? No one publicly decried its efficacy in *The Judge*. The recording seems to have done the job of adequately conveying the sound of a crying baby, though it could not have been all that impressive given the phonograph's limitations. Still, it was sufficiently accurate to provoke a rhetorical tantrum from Clement Scott. Perhaps the phonograph was useful only for certain situations. In the case of *The Judge*, it was presumably easier to use a recording of a crying baby than have an actual baby in the wings for each performance and hope it would wail on cue with sufficient vigor (also, making it cry on purpose might have been a bit mean). Other practicalities likely militated against its widespread adoption. First, the phonograph was probably unable to reproduce sound effects with sufficient loudness and clarity to be heard consistently in an audience-filled auditorium, especially a large theatre. Secondly, the short shelf life of wax

cylinders (which quickly degrade upon use) would not have made them ideal; they would have had to be continually replaced. Thirdly, it would have been difficult—if not impossible—to have used phonograph recordings to supply multiple, composite elements of sound design with much ease, and there were already perfectly good ways of doing this.

The mechanical reproduction of sound in theatre would have paled in comparison to the mechanical *production* of sounds. There is a long-established tradition of mechanical sound-making extending back to the *bronteion* thunder devices of ancient Greek and Roman theatres, which used stones striking metal to generate the sonic resemblance. Over the centuries, theatre technicians have developed elaborate, sophisticated systems as well as simple but effective procedures for creating a wide range of sound effects, including the thunder run (a series of wooden or sheet-metal ramps equipped with resonators upon which cannon balls traverse); wind machines (paddles projecting from a wooden drum set to rub against tightly stretched silk); devices to imitate the sound of rain (tubes containing dried peas set to cascade, or a pea-filled sieve); crash machines (a drum, filled with various items such as stones and scrap metal); machines to imitate gunfire (a *saucissous*, a heavy plank embedded with pistol barrels connected with fuse); whistles; bells; devices to imitate animal sounds (also made by human imitators); slap sticks (for a whipping sound); the door-slam box; a popping-cork device; a hand-cranked machine for producing train-engine sounds; a "tin whirligig" to produce the sound of escaping steam; and a device to represent the sounds of an automobile engine and horn.[10] This craft of sound-making, conducted offstage (sometimes overhead or underneath), retained dominance in theatre at least until the introduction of electronic sound control in 1927 and the dissemination of sound effects recordings in the 1930s. Even then, the tradition of mechanically produced "noises off" continued; there was no clear cut-off point.

An article in *The Strand Magazine* in 1904 lifted the curtain on how theatre sound effects were made, drawing attention to an activity that was understood only to those in the know.

> There is, in fact, no sound which a competent stage manager, such as Mr. Jones, of Drury Lane Theatre [the columnist's informer] is not prepared to imitate. Some sounds are, of course, quite outside his domain. And the responsibility is all upon the shoulders of the stage-manager.
>
> The poor stage-manager! As if he hadn't enough care with what the audience hears actually on the stage without attending to so much that must be heard from behind the stage! And it must be borne in mind that in this respect nothing is unimportant and merely secondary, and also that it is a

difficult business to find the best manner of adapting sounds behind the stage to what is transpiring before the eye of the audience.[11]

The article is accompanied by a series of photographs that show someone (presumably a stagehand) operating wind and rain machines, imitating the clatter of horses' hooves and so forth. The last paragraph mentions the "latest recruit to stage mechanics": the phonograph, which, the author states, was recently introduced in Berlin for a production of *Henry V* (so much for Piscator's fabled firstness in this regard!). The article continues:

> One who was present declares that not a soul noticed that in place of human voices a piece of pure mechanism was at work. Instead of thirty "supers" [supernumeraries] crowded together and blocking up each other's way behind the wings there was a little table with an apparatus which could be shifted from one place to another at a moment's notice. And how faithful to his task was this new colleague! No disturbance now would arise owing to awkwardness or to the fault of some malevolent super or wag. The innovation is likely to spread, and will surely prove a considerable economy for the smaller theatre, where the outlay on stage noises of the human and musical sort is no trifle.[12]

This prediction for the utility of the phonograph in theatre was not fully realized: theatre sound in the age of mechanical reproduction still valued mechanical *production* alongside incidental music performed by offstage musicians. Evidently, productions that used the phonograph were not lastingly memorable or much known about, hence the resulting cultural amnesia.

Nevertheless, the phonograph did serve to memorialize key theatrical figures. Famous actors such as Henry Irving, Herbert Beerbohm Tree, Ellen Terry, and Sarah Bernhardt recorded speeches in order to demonstrate the phonograph's operation and to preserve their voices for posterity. Modernist authors including Apollinaire, Marinetti, Schwitters, and Joyce also made phonograph recordings. The low signal-to-noise ratio sometimes makes it difficult to discern their speech from hiss and crackle. Nonetheless, the recordings still preserve something of the vocalists' idiosyncratic speaking styles and intonations. They sound strangely mannered, declamatory, and singsong-like today, but, as Douglas Lanier notes, "the orotund, deliberate manner of these performances was surely in part a response to the demands of the recording apparatus, which required high volumes and careful enunciation to create useable recordings."[13] The recordings of the actors may not, then, be accurate depictions of late Victorian stage delivery; the authors' declamations were probably also adapted for the medium. A description of Irving making a

phonograph recording in 1888 highlights the difficulty the apparatus presented:

> I was never so amazed as to see Mr Irving attack the phonograph. He walked up to it with that air of confidence which characterizes Mr Irving when he walks. When he stopped walking, he found himself in front of the phonograph and began to talk into it, but it was not Irving in the least. Some of his old friends there said "Why, my dear Irving, it was not you who spoke" and it was not Mr Irving himself: absolutely he was frightened out of his own voice. I had actually to put him through his paces to train him for it, to make him walk backwards and forwards a bit, and when he had got into the swing, he finally came up and said something which was truly delightful, both when it went into the phonograph and when it came out of it.[14]

Irving had to undergo impromptu training to make a successful recording; he had to work to find his "own voice" (i.e., his stage voice) using the phonograph. He was not alone. When sound recordings were sold as mass-produced commodities in the late nineteenth century, the stars of British music hall and American vaudeville committed their voices to cylinder and disc. While these performers also had to accustom themselves to the new technology, their songs and routines suited the medium and the recordings enjoyed popular appeal.[15] Now the music-hall public could have a souvenir of their favorite performers and enjoy them at a time and place of their choosing, ostensibly in perpetuity. The sonic dimension of the performer's art was technologically separated—or at least transferred—from the site of theatre just as sound-reproduction technology separated sounds from their original sources.[16]

Sound-reproduction technology opened up a fissure in theatre's ontology and aesthetics, or else revealed a fissure that was not previously recognized. In his essay on the work of art in the age of mechanical reproduction, Benjamin juxtaposes theatre and film, comparing the "authentic," self-coincident nature of stage acting with the more obviously constructed and "artificial" nature of film acting. The stage actor still has an "aura," Benjamin suggests, tied to "presence." A stage actor performs in the here-and-now; consequently, theatrical performance is situationally unique and contingent on circumstances and dynamics that cannot be absolutely replicated (yes, that old chestnut). Benjamin writes: "The aura which, on the stage, emanates from Macbeth, cannot be separated for the spectators from that of the actor. However, the singularity of the shot in the studio is that the camera is substituted for the public. Consequently, the aura that envelops an actor vanishes, and with it the aura of the figure he portrays."[17] The film actor's performance is a composite

creation, a collection of shots, a technological (re)production that offers an illusion of coherence; it therefore lacks auratic wholeness, according to Benjamin. Aurality can also be a key component of an art object's "aura." Benjamin includes phonography in the types of mechanical reproduction that undermine an object's "authority" by depreciating the quality of original "presence." He writes: "the technique of reproduction detaches the reproduced object from the domain of tradition. By making many reproductions it substitutes a plurality of copies for a unique existence. And in permitting the reproduction to meet the beholder or listener in his own particular situation, it reactivates the object reproduced."[18] Sound that is made and heard in the moment and does not endure has an auratic quality. Sound that is mechanically captured and reproduced does not. Following this logic, the recording and mass distribution of popular stage songs diminished the auratic integrity of the source material, though customers may not have noticed or minded. The "aura" of theatrical aurality—the perception of "authentic" sound in performance—is inherently problematic (theatre often relies on artifice, after all), but mechanical reproduction only compounds this dilemma. Even if a rolling cannon ball and not an atmospheric disturbance makes the sound of thunder, at least it is made in the moment of performance and exists only for that time. It is auratic despite its artifice. It is uniquely crafted, though fleeting and unstable.

This may explain why the mechanical reproduction of sound in theatre did not immediately replace traditional methods. Perhaps it threatened to depreciate theatre's auratic quality. Recorded sound in theatrical performance is arguably less interesting than live sound-making, on the whole. It can be less dynamic, less responsive, and less attuned to circumstantial variance, though digital technology has enabled sound designers to operate with newfound flexibility. Analogue technology, however, may have proved aesthetically troublesome if the intent was not to highlight the means of production. Brecht, whose Epic Theatre aimed to do just that, was enthusiastic about using analogue technology in theatre for precisely this reason.

> Recently the gramophone industry has started supplying the stage with records of real noises. These add substantially to the spectator's illusion of *not* being in a theatre. Theatres have fallen on them avidly; so that Shakespeare's *Romeo and Juliet* is now accompanied by the real noise of the mob. So far as we know the first person to make use of records in performance was Piscator. He applied the new technique entirely correctly. In his production of the play *Rasputin* a record of Lenin's voice was played. It interrupted the performance.... In a parable-type play sound

effects should only be used when they further the parable, not in order to evoke atmosphere and illusion.... It is best to place the record player, like the orchestra, so that it can be seen. But if such an arrangement would shock the audience unduly or give too much cause for amusement it should preferably be dropped.[19]

Brecht's comment about sound recordings adding to the spectator's illusion of *not* being in a theatre is intriguing. Is this because the recordings were too real sounding, too convincing to have been made behind the scenes? Our perceptions of what things should sound like are guided by convention; we become accustomed to mistaking artifice for reality, which is why Foley artists are so successful (and why a punch rarely sounds as satisfying in real life as it does on the screen). Brecht, of course, wanted his spectators to remember that what they were experiencing in the theatre was a contrivance, only the illusion of the real, which is why he advocated making the technology visible. In this way, theatrical illusionism was deliberately complicated and the contradiction inherent in theatrical aurality emphasized. Technological interruption suited Brecht's aesthetic of Epic Theatre, as it did other modernists, even those without a political program, such as Cocteau. However, it may have been perceived as jarring in more mainstream theatre, which may help explain its patchy record of use.

Theatre in the age of mechanical reproduction invited a mode of perception attuned to experiential disjunctions and separations, per the dynamics of modern aurality. Sound-reproduction technology may not have instantly or completely revolutionized the way in which people heard and what they thought about the act of hearing, but it is reasonable to assume it had some impact. Benjamin's historicist conception of the senses, while sweeping and largely speculative, still merits consideration. He writes: "During long periods of history, the mode of human sense perception changes with humanity's entire mode of existence. The manner in which human sense perception is organized, the medium in which it is accomplished, is determined not only by nature but by historical circumstance as well."[20] Benjamin proposes that our sense perception is at least partially entrained by culture and society.

Gertrude Stein models a historically informed receptive sensibility in her essay "Plays," delivered as part of her 1934–1935 American lecture tour. Stein meditates on her experiences as a theatregoer, expounding upon what she "knows" about plays and querying how she knows what she knows. She observes a perceived syncopation between a scene presented onstage and the emotional disposition of an audience member

(namely herself), such that the "emotional time" of a performed play is felt to be perpetually out of sync with those in attendance. A spectator is either "behind" or "ahead of" the storyline in terms of emotional understanding. This results for Stein in a condition of nervousness and unease.[21] A corollary or potential cause of this perceptual disjunction in theatrical reception is the issue of audiovisual response: how the senses of hearing and sight function either separately or together to give an audience member a "feeling" of knowing, which may be of a different "tempo" (or order) to the onstage performance. Here she sketches a general phenomenology of theatre reception:

> And now is the thing seen or the thing heard the thing that makes most of its impression upon you at the theatre, and does as the scene on the theatre proceeds does the hearing take the place of seeing as it does when anything real is happening or does the mixture get to be more mixed seeing and hearing as perhaps it does when anything really exciting is happening.... Does the thing heard replace the thing seen does it help or does it interfere with it. Does the thing seen replace the thing heard or does it help or does it interfere with it.[22]

For Stein, the idea that hearing may relay one thing and sight another helps justify her perception of an emotional syncopation between the stage and the audience. Stein does not answer the questions she poses about the relative importance or inter-operations of "the thing seen" and "the thing heard" in theatre, but rather subsumes them into an account of her decision to write "landscape" plays, which purportedly forgo the problem of emotional syncopation by virtue of their dramatic deconstruction.[23] She does note, however, the relevance of cinema to her inquiry, given how it "changed from sight to sound" in the mid- to late 1920s; this means it "undoubtedly had a new way of understanding sight and sound in relation to emotion and time."[24] Both theatre and cinema share the same impulse to solve the problem of the relation of seeing and hearing, she observes, as well as the concomitant problem of reconciling a presented scene with the emotional disposition of an audience member. Furthermore, Stein proposes that the issue of audiovisual engagement in theatre and cinema is not just a personal idiosyncrasy, or a prompt to create a new form of drama, but is an inherent dilemma of the age: "It is in short the inevitable problem of anybody living in the composition of the present time, that is living as we are now living as we have it and now do live in it."[25] Benjamin would probably concur.

When sensory perception was separated, extended, and/or confounded by technological means in modernity, it was perhaps inevitable that processes of seeing and hearing would be re-examined and that this would

inform modernist aesthetics.[26] Determining how one knows what one knows in a technologically mediated culture of looking and listening necessarily returns one to first principles and to the kind of second guessing of sensory modalities that Stein undertakes. Stein's recognition of the interpenetration of sight and sound—their inevitable if confused mixing, as well as their mutual disruptions and doublings—calls attention to the role of theatre as a cultural intermediary for modernity: a stage upon which technological constructions could be performed and experiential conundrums highlighted. As Ross Brown remarks of sound in modern theatre: "Among all the arts, theatre, with its intermediate soundscape, was best placed to explore the dynamic effects of . . . new intermedial juxtapositions of real, realistic, live, present, virtual, placed, displaced, synchronistic, and anachronistic."[27] The theatrical avant-garde exemplifies this in dramatic and scenographical designs, showcasing the operation of sonic technologies traditional and modern, rudimentary and mechanical, as well as their integration (entanglement) with human performers. In so doing, they created spectacles of embodied sound.

Noises *On*: Apollinaire's *The Breasts of Tiresias*

Apollinaire's *The Breasts of Tiresias* is an acknowledged classic of the theatrical avant-garde and a prototypical surrealist work. The play received a one-off performance at the Théâtre Renée-Maubel in Montmartre on June 24, 1917, presented under the auspices of the artistic review *SIC* (*Sons, Idées, Couleurs*), whose founder and editor, Pierre Albert-Birot, directed the production with Apollinaire's assistance. Performed one month after the premiere of the ballet *Parade*, for which Apollinaire coined the term *sur-réalisme* on account of its dissonant artistic registers, *The Breasts of Tiresias* was intended to continue the same spirit of artistic innovation. The ostensibly natural bonds between media and the presumed logicality of commonplace ideas and everyday relations were disregarded in favor of their contrarious disunion and fracture. Hence the madcap story, in which the eponymous character ditches her husband, lets her breasts fly off like toy balloons, becomes a man, and then an army general (among other careers and guises), while her beleaguered husband single-handedly "gives birth" to 40,049 children in one day. Concurrently, an apparently unrelated duo of characters, Presto and Lacouf, continually argue about their whereabouts (Paris or Zanzibar?) and kill each other in pistol duels, only to revive repeatedly. All in all, the play celebrates life liberated from structure, convention, and gender, and is conducted in the spirit of farce and music hall, albeit on a serious theme (repopulation). The production, hastily put together on a shoestring budget, used

amateur actors; a makeshift stage design of patchwork paper arranged in a cubist style designed by Serge Férat, who also made the cubist-inspired costumes; and music composed by Germaine Albert-Birot, intended to be played by an orchestra but played instead by a pianist reportedly because of a scarcity of musicians.[28]

Typically noted as just another quirk of the play and an example of its whimsy is the "collective speechless person" referred to as the "People of Zanzibar," who functions as a type of one-man chorus, commenting on the action not with words but with sound effects he makes live onstage.[29] Apollinaire describes him in the stage directions:

> In the background, the collective speechless person who represents the people of Zanzibar is present from the rise of the curtain. He is sitting on a bench. A table is at his right, and he has ready to hand the instruments he will use to make the right noise at the right moment: revolver, musette [a small French bagpipe], bass drum, accordion, snare drum, thunder, sleigh bells, castanets, toy trumpet, broken dishes. All the sounds marked to be produced by an instrument are made by the people of Zanzibar, and everything marked to be spoken through the megaphone is to be shouted at the audience.[30]

Apollinaire's innovation of dramatizing an "effects man" and including this person (meant to represent a multitude) in his cast of characters has been overlooked in the literature on this play, which means the People of Zanzibar has faded into the (textual) background. However, when the play is considered in terms of performance, it is evident that this figure, positioned upstage at the Théâtre Renée-Maubel, was a key part of the novelty and jocularity of the production; multiple mentions are made of him in the reviews.

In the first performance, the actor/technician playing the People of Zanzibar (known only as "Howard") was costumed and wore a half-mask (other members of the cast wore full-masks). A photograph shows "Howard" as the People of Zanzibar, dressed as a "Red Indian" with a feather sticking out of the top of his head.[31] The black-and-white image does not show the redface makeup that "Howard" reportedly used (presumably, redface was a visual gag, a signifier for "Red Indian").[32] The costuming may indicate the primitivist idea that Native Americans' principal mode of communication is not speech but a specialized array of nonlinguistic sounds or noises (the racist trope of the "primitive" being closer to nature). Consequently, the perfect person to represent a chorus of people from the "distant" land of Zanzibar ("distant" from the "centre" of Paris) was imagined as another non-speaking but noise-making primitive.

The People of Zanzibar was not just a glorified stagehand but part of the artistic and intellectual program of surrealist performance jointly developed by Apollinaire and Albert-Birot. It is worth emphasizing that locating and dramatizing the production of sound effects onstage in this manner was a theatrical innovation predating related practices in postmodern/contemporary theatre. By staging the creation of sound effects in *The Breasts of Tiresias*, Apollinaire supplanted the long-standing tradition of "noises off," which relegated the *techne* of sound to the wings where it functioned as a notional offstage presence (e.g., the acoustic imaginary), and instead instantiated a practice of "noises *on*" in which sound effects were made visible, as it were, or at least *made visibly* so that their operational procedure was shown.[33] Apollinaire offered his audience insight into how illustrative sound effects were made, lifting the curtain on a long established but hitherto invisible stage tradition. In so doing, Apollinaire revealed the craft of sound-making: the practical means by which a human operator uses an instrument (manipulating it in some fashion or breathing into it) as well as the artifice of sonic conventions (e.g., shaking a sheet of metal to simulate thunder). Apollinaire staged a surrealist action by stipulating that illustrative sound effects be used transparently in the production, thereby subverting the supposed normality and logicality of sound-making. The audience heard one thing ("thunder") but saw another (a man shaking a sheet of metal), thus calling attention to the conventionality of sonic mimesis. A similar effect is achieved in *Monty Python and the Holy Grail* (1975) when King Arthur (Graham Chapman) and his knights pantomime the action of riding horses as their servants trot behind them banging pairs of coconut halves together to make the sound of horse hooves. (Ironically, a Foley artist likely dubbed this sound.) Sound may seem to be natural or authentic, but it has a singular capacity to deceive, especially when created for theatrical performance.

Apollinaire's innovation is important, not just for theatre scenography, but because of the People of Zanzibar's role as an intermediary figure that connotes a separate but related performance tradition: namely, the cinema sound-effects man, known in France as the *bruiteur* (noise-maker), whose job it was to provide sonic accompaniment for screenings of (silent) films. Typically paired with a pianist, the *bruiteur* (and the equivalent designation in other countries) functioned in the manner of a theatre "effects man" (and often came from the theatre), "punctuating" and ornamenting the events on screen in order to enhance the enjoyment of an audience by providing a sense of sonic actuality and verisimilitude.[34] The location of the *bruiteur* varied according to the specifics of the venue, but he typically operated behind the screen, in an orchestra pit, or from the wings (provided the angle of visibility allowed him to see the projection).[35] The

bruiteur was never prominently displayed but was cordoned off from view so as to focus attention on the screen and enable (or at least suggest) the illusion of synchronous sound originating from the projected image. The tradition of providing live sound effects in cinema began in the early years of the twentieth century (circa 1906/1907 in France) with the rise in popularity of narrative films, and was well established by 1917 (the year of the performance of Apollinaire's play).[36] The following is an account of *bruitage* at the Théâtre du Cinématographie Pathé in Montmartre in 1906:

> In the pit, one finds a skilful *bruiteur* by the name of Barat, an artist of his kind, a former music-hall singer. With a very simple set-up, he is able to recreate every imaginable sound without fail: the waves of the ocean with a metallic sphere containing a lead shot, all kinds of wind from a gentle breeze to a storm with strings stretched over a metal mesh, not to mention bells, gunfire, sounds of chains, and many other things. He has beside him a young assistant, a 14-year-old kid who learns the trade. "You know, boy," says Barat, talking about the spectators, "they have full eyesight, but we need to give them an earful!" ... "You must understand that I need a conscientious boy. It's not a sudden get-out ["*le coup parte*"] when the guy is dead! We need someone who can anticipate the next effect! I'll tell you, little one: it is a work of art!"[37]

The professed conscientiousness and dedication of this particular *bruiteur* seems not to have been typical, or at least it was not universally shared. There was much consternation about the role, efficacy, and competence of *bruiteurs* and their ilk at this time, with audiences complaining about effects being inaccurate, superfluous, too loud, or exaggerated.[38] Some *bruiteurs* were overenthusiastic in their efforts, or else chose to perform for laughs, "punning" or "kidding" the film in the manner of a vaudeville drummer who would call attention to himself and the whole apparatus of sonic accompaniment as part of the show, as another potential attraction (or distraction).[39] While the *bruiteur* may not have been visible to the audience, his sound-making often registered his presence (intentionally or otherwise), and the profession garnered notoriety as a result.

In the preface to the published play text of *The Breasts of Tiresias*, Apollinaire professed not to see the connection between his work and the techniques of vaudeville, though he stated this "criticism" did not disturb him.[40] The play was in fact received in the context of popular performance in Montmartre (cabaret, music-hall revue) as a type of cubist-inflected farce, and its slapdash production aesthetic was clearly inspired by variety theatre (of which Apollinaire was enamored, having

read Marinetti's 1913 manifesto on this topic).[41] Albert-Birot made the connection between the production and cinema sound practices in a note written for *SIC* in 1918: "Like the *bruiteur* of the cinema, the People of Zanzibar reacted to the events that he witnessed."[42] While the use of placards in Apollinaire's play may borrow from music hall, they might also have functioned in the manner of cinematic intertitles, especially given the People of Zanibar's involvement. He operated in the mode of a staged *bruiteur* in Albert-Birot's production and was likely interpreted as such, either in addition to or in lieu of Apollinaire's designation of him as a "collective speechless person." Whether Apollinaire intended the signification of *bruiteur* is moot. What cannot be gleaned from reading from the play, and what is now unknown and unknowable due to lack of documentation, is the manner in which "Howard" performed his role: how he interacted with the other performers, how he presented himself to the audience, what his effects sounded like, and what their impact was: in other words, how "the thing seen" interacted with or was informed by "the thing heard," to recall Stein's phraseology. Given what we know about the subversive antics of *bruiteurs* and the boisterous, rabblerousing spirit of this production, it is possible that "Howard" participated in kind (at least in part), and contributed to the unruly presentation. A reviewer commented on the production: "*It should create life*, I heard from an enthusiast. But it has created uproar. Mainly metallic sounds, syncopation, choirs of disparate voices, a shrill and practical joking tone, most of the time."[43] The text provides cues for sonic effects; one may conjecture that "Howard" elaborated upon or exaggerated his part in the manner of a *bruiteur*, and made the most of his opportunity to be a sonic prankster.

On the evidence of the play script alone, Apollinaire provided "Howard" with ample opportunity to practice his craft. The People of Zanzibar regularly underscores, punctuates, intervenes upon, and helps constitute the action, providing sound effects that often appear to have been the functional equivalent of a drummer's rim-shot or slapstick sound. Take, for example, his recurring use of the sonic trope of broken dishes (part of the *bruiteur*'s stock-in-trade) to underline the domestic argument between Thérèse and her husband, or the bass drum to emphasize one of Thérèse's insults ("Why don't you eat your old sausage feet") in 1.1.[44] The People of Zanzibar is also handy with a number of French folktype musical instruments (further muddling the Paris/Zanzibar issue), including the musette and the accordion, upon which he periodically plays tunes (unmarked and unscored), accompanying the action or offering commentary on a particular point. Sometimes, a sound effect appears

to be indicative, as in the notation for the sound of thunder that follows Tiresias's declaration to make war in 1.1 (an effect that is subsequently used in 1.7 to suggest General Tiresias's offstage exploits), but the same effect also appears to be used ironically, as in the notation for thunder following a declared invitation to sing at the end of 2.3. Similarly, the sounds used to denote the crying of a multitude of children on the stage in 2.1 (possibly made by a toy trumpet in combination with bells) were noticeably artificial, as artificial as the Belgian accent that Thérèse's husband is directed to use in the first scene of the play (only to lose it promptly when she leaves him): a feature that is only marginally less inexplicable than the occasional directions for Thérèse and her husband to imitate the sound of locomotives (in 1.1 and 1.4). Apollinaire revels in the unnaturalness of sound, in its falsity, in its occasional peculiarity, and in its capacity to deceive and perplex. He highlights the surreality of performed sound effects; the People of Zanzibar epitomizes this operation. When Presto and Lacouf perform their duel, it is the People of Zanzibar who fires the shot.

> They go up solemnly on to the stage and take positions at the rear facing each other.
> *LACOUF*: On equal terms
> *PRESTO*: Fire at will
> All shots are natural
> They aim at each other. The People of Zanzibar fire two shots and they fall.[45]

In this piece of staging, "the thing seen" and "the thing heard" are disjointed. Is the spectator meant to attribute the sound of the shot to the cardboard revolvers of the actors playing Presto and Lacouf (an obvious falsity) or to suppose instead that the People of Zanzibar has operated independently and shot them? Is the fact of Presto and Lacouf's subsequent recovery (only to be "shot" again) attributable to this bit of performed non-trickery (non-trickery because it is undisguised)? If the sound effects operator were not positioned onstage, visible to the audience, these questions might not arise; the theatrical convention would not be exposed. However, Apollinaire is keen to highlight contradictory possibilities as part of the surrealist agenda: what one sees and hears may be discrepant or contradictory truths, but they are truths nonetheless. Daniel Albright expresses this beautifully: "I may walk through a field and watch a distant cow open its mouth, and hear, at that same instant, the tweet of a bird. And the twittering cow is, I take it, the primary surrealist act: the simulation of the normal discords that exist in our negotiation of felt life."[46] Apollinaire allows for the coexistence and mutual constitution

of both acoustic and visual forms of noise (distortions of meaning) and competing discourses and claims of attention. In surrealist theatre, semantic polyphony is the ruling (dis)order; meaning is a structured free-for-all.

This helps to explain the use of music in the production vis-à-vis sound effects. The relationship between the two was reciprocal rather than dialectical; music and sound operated on a shared continuum and were plausibly mistaken for one another.[47] The pianist (Niny Guyard) also performed on the stage; though she was not costumed in the manner of the cast members, she was nonetheless visible and part of the spectacle. Scholars have largely ignored the music composed by Germaine Albert-Birot, the score of which was included as part of the first publication of the play. This is an oversight, because the music—comprising an overture, a short funeral march, a choral piece, an *entr'acte*, and an epilogue—contains its own peculiarities, and was positively received at the time. Albert-Birot's idiosyncratic, playfully discordant compositional style suited the production aesthetic. The music favors chromatic dissonance, harmonic suspensions, broken diminished chords, rhythmic disjunctions and syncopations, short angular phrases, and shock effects (such as the rattling of tourniquets or crashing glissandi); these stylistics alternate with charming, simple phrases resembling music hall, often notated in parallel octaves. Albert-Birot's music is a patchwork of short phrases of contrasting character, a collage of musical ideas in miniature, like the strips of contrasting colored paper Serge Férat used to cover the wings of the stage. It is music that aims to attract the ear by virtue of its discrete effects and charms.

The music in this production did not just provide simple background accompaniment (hardly possible given the visual prominence of the pianist); it was not merely "incidental" to the production but, like the sound effects, intervened upon it and complicated the onstage action. Moreover, it jockeyed for position and preeminence, competing with the other elements of the stage spectacle. At the beginning of Act II, Niny Guyard was still playing the entr'acte as the curtain went up, and the People of Zanzibar provided sound effects for crying children (performed live, unlike the phonographic infant discussed earlier); the husband subsequently makes a passing remark that "modern music is amazing," a possible meta-theatrical reference to Albert-Birot's music or else a sardonic comment on the abrasiveness and discordance of modernist music in general (equating it to the cries of infants).[48] In 1.4, Albert-Birot's funeral march for Presto and Lacouf—a morose series of chromatically led chord progressions—preceded the event of their duel, but in actuality accompanied the comic bit of stage business that saw Thérèse overpower

her husband, strip him of his clothing, and don it herself: a pronounced mismatch of sound and sight. Another discrepancy in the aural and visual registers is presented at the end of the play when Thérèse is reunited with her husband and releases her toy balloons (breasts) at the audience, at which point the company sings an ostensibly jolly and celebratory ditty and the People of Zanzibar accompanies with jingling bells:

> And then sing night and day
> Scratch if you itch and choose
> The white or the black either way
> Luck is a game win or lose
> Just keep your eye on the play[49]

Albert-Birot's music for this section consists of an unresolved, four-note, chromatically descending ostinato figure in octaves: an established musical trope, which in this instance appears to function as an indicator of menace rather than celebration, the purpose of which was perhaps to recall the seriousness of the play's central thesis (i.e., the French needed to have more children). It is also possible that Albert-Birot's chromatic ostinato was meant to "sour" or subvert the supposedly happy reunion of Thérèse and her husband, along with the restitution of patriarchal order and gender norms. Once again, hearing complicates sight so that the performance as a whole is made deliberately ambiguous, if not downright contradictory.

Apollinaire aimed to have competing and overlapping planes of attention as part of the aesthetic experience. As the director explains in the prologue, the aim of the production was to bring a new "spirit" into the theatre, one in which the audience was fully immersed in the experiential noise of life. The director imagines the theatre that might suit the purpose of this intent:

> A circular theatre with two stages
> One in the middle the other like a ring
> Around the spectators permitting
> The full unfolding of our modern art
> Often connecting in unseen ways as in life
> Sounds gestures colors cries tumults
> Music dancing acrobatics poetry painting
> Choruses actions and multiple sets[50]

This is understood to be a version of Pierre Albert-Birot's proposed *théâtre nunique*, a theatre of "nunism" ("nun" from the Greek for "now"), which prioritized simultaneous, multiple actions conducted on a grand scale and promised a fully immersive and dynamic theatrical experience. The

one-off performance of *The Breasts of Tiresias* only attempted this in miniature, yet it successfully expanded upon the perceptual frames of theatre to engage multiple sites of performance and modes of address.[51] As well as presenting the sights of sound onstage by way of the People of Zanzibar and the pianist, sound also came from the wings (voices of men and women shouting exultations to Tiresias in 1.7) and from the audience who reportedly offered their own verbal contributions to the proceedings. As Paul Souday remarked in the *Paris-Midi*, "The show was also in the room. It was two hours of relaxing madness."[52] Likewise, the actors' speech was sometimes delivered through a megaphone, another form of sonic barrage put on display. The totality of all this was to interrelate "the thing seen" and "the thing heard" so that the sights and sites of sound became activating principles in theatrical reception, contributing to a noisy surplus of meaning. Apollinaire used the multiplicity and variability of sound to enable a surrealist experience in which what one sees and what one hears may or may not correlate. This potential lack of correlation was presented to the audience of watching listeners as a productive, enjoyable, and deliberately mischievous irresolution, inviting them to perform audiovisual double takes.

Phonographic Spectacle: Cocteau's *The Eiffel Tower Wedding Party*

Apollinaire's *The Breasts of Tiresias* dramatizes the mechanical production of sound; Cocteau's *The Eiffel Tower Wedding Party* dramatizes the mechanical *reproduction* of sound. A generic mélange of ballet, *opéra-comique*, pantomime, *mimodrame*, music hall, revue, and farce, Cocteau's work is an example of a type of surrealist intermedia in which theatrical genres are blurred, the apparatus of mechanical reproduction is dramatized and staged, and the sense-making facility of the audience is intentionally destabilized. It was first performed by the *Ballets Suédois* at the Théâtre des Champs-Élysées on June 8, 1921, with choreography by Cocteau and Jean Borlin, a backdrop (providing a vertiginous view of Paris seen from within the Eiffel Tower) by Irène Lagut, masks and costumes by Jean Hugo, and music composed by *Les Six* (sans Louis Durey: Georges Auric, Darius Milhaud, Francis Poulenc, Germaine Tailleferre, and Arthur Honegger). *The Eiffel Tower Wedding Party* is conducted in the surrealist spirit of Apollinaire's play and features a series of fantastical events involving a camera that projects and captures bodies, an escaped ostrich, dancing radiograms, mirages, and the aforementioned camera turning into a train that finally carries off the wedding party. Cocteau's use of staged technologies has received attention (especially the camera),

as has the use of music in the production, but, like the People of Zanzibar, the two-person chorus of human phonographs on either side of the stage that narrate the action has been relatively marginalized in the scholarship on the play. The human phonographs were also part of the spectacle, and, like Apollinaire's staged "effects man," complicated the audiovisual dynamics of the onstage action by highlighting the disconnect between "the thing seen" and "the thing heard." Here, it is words rather than sound effects that are disassociated and embodied differently as Cocteau inventively fractures stage discourse.

Undoubtedly, *The Eiffel Tower Wedding Party* was visually enticing. Visual documentation of the design for the backdrop and cartoon-like masks and costumes indicates as much (see Figure 2.1); the choreography was also surely compelling. Irène Lagut's backdrop presents a forced perspective of the city of Paris as an inwardly and upwardly inclined cityscape fronted by sets of wings representing the structure of the Eiffel Tower. As a consequence, Paris is made to resemble the Eiffel Tower's architecture as the tower warps perception of the city. The audiovisual construction of the *mise-en-scène* adds to the perceptual peculiarity by precluding "simple" absorption or conventional pleasure taking in the stage spectacle. Whereas *The Breasts of Tiresias* foregrounds the sight of sound via the People of Zanzibar, *The Eiffel Tower Wedding Party* stages the sound of sight in the guise of the human phonographs that "speak" for and about

Figure 2.1 Scenographical design for Cocteau's *The Eiffel Tower Wedding Party*.
Source: Courtesy of Dansmuseet, Stockholm.

the characters. The human phonographs are also characters (of a sort) that dictate the onstage action. Cocteau's stage directions read:

> The first platform of the Eiffel Tower. The backdrop represents a bird's-eye view of Paris. Upstage, right, a camera at eye level: the black funnel forms a corridor extending to the wings, and the camera front opens like a door to permit the entrances and exits of the characters. Downstage, right and left, half-hidden by the proscenium arch, two actors costumed as Phonographs: their bodies are the cabinets, their mouths the horns. It is these Phonographs which comment on the action and recite the lines of the characters. They should speak very loudly and quickly, pronouncing each syllable distinctly. The action is simultaneous with the comments of the Phonographs.[53]

Two technologies of mechanical reproduction mediate Cocteau's scene, the camera and the phonograph, though based on photographic evidence the latter enjoyed greater visibility (ironically). The ensuing action is understood to result from these represented technological processes. The camera "produces" the bodies of the actors; the phonographs produce (supposedly reproduce) their speech: a modern updating of eighteenth-century French pantomime in which ballet was narrated from the wings. This inventive scenography helps to constitute what Cocteau referred to as "theatre poetry" or "poetry of the theatre" (as opposed to "poetry *in* the theatre"): a full realization of theatrical operations that aims not simply to "pull the wool" over an audience's eyes but to exploit artifice, knowingly and overtly (i.e., in full view of the audience and with their assistance), like Brecht's Epic Theatre only without a didactic intent.[54] For Cocteau, an exposer of stage artifice, the larger-than-life (the "theatrical") was celebrated for its own sake and for the higher "truths" it could provide.

In the first production, the heightened sensibility of the created world was signaled by the grossly exaggerated features of the character masks and costumes, which designer Jean Hugo (grandson of Victor Hugo) based on the artificial poses of models in *fin-de-siècle* magazines and from illustrations of visual commonplaces in the *Dictionnaire Larousse*.[55] The costuming indicates that the ballet-spectacle takes place when the phonograph was newly invented, lending the work historical cachet as well as a sense of ironic distance ("modern antiquity," to use Cocteau's oxymoronic phrase).[56] The phonographs consisted of façade cabinets fitted with giant horns. Actors were positioned inside these "booths." Seated, they spoke through the horn via a connected mouthpiece, thus making the phony phonograph function as a megaphone. The

human phonographs—technically, costumed actors made to resemble stage machinery—also contributed to the surreal nature of the production. Real phonographs had made backstage appearances in theatre before but human phonographs were novel. The fact that these were human phonographs was not made visually apparent (i.e., the actors remained hidden), but this gimmick was presumably made evident once they began to speak and to function as *compère* and *commère* for the proceedings (in the tradition of music hall). The artifice of conversant human phonographs was sonically apparent to the audience as a theatrical gimmick.

Cocteau's chorus of phonograph-narrators is dramatically noteworthy because of the way in which the narrative "voice" assigned to Phonograph I and II perpetually shifts. This complicates the business of reading the play, as it is not always evident who is speaking, or rather *for whom* the phonographs are speaking, or if indeed they are speaking for themselves (and in their "own voice," whatever that might be). The reader is forced to double back on the page and re-attribute voice to the represented characters. Cocteau does not facilitate this endeavor, save setting up the introduction of a new character onto the scene. The phonographs switch between different subject positions and grammatical voices with little-to-no announcement. For example, the first few lines of the play flit between second person ("You are on the first platform of the Eiffel Tower"), third person ("Look! An ostrich. She crosses the stage. She goes off."), first person, voicing an onstage character ("Hey, Mac, where do you think you are—hunting?"), and a default "narrator" voice ("Ladies and Gentlemen, the situation is getting complicated . . . ").[57] Elsewhere, the phonographs have the additional tasks of voicing passing telegrams ("MANAGER EIFFEL TOWER STOP ARRIVE WEDDING BREAKFAST PLEASE RESERVE TABLE") and verbalizing sound effects ("Bang! Bang! Bang!") and sonic environments, as in the following example, the layout of which resembles Apollinaire's concrete (visual) poetry:

> PHONO I. You
> PHONO II. could hear
> PHONO I. a
> PHONO II. pin
> PHONO I. drop.[58]

Sometimes, the phonographs are instructed to adopt a particular type of voice suitable to the represented character (e.g., "girl's voice," "burlesque comedian's voice," "voice of a burlesque queen").[59] It is unclear whether the actors serving as human phonographs in Cocteau's production were

meant to vocalize the other characters whose speech they utter in a similarly distinctive manner or if the overall goal was to provide vocal uniformity (there is no original recording and the reports of those who attended are inconclusive).

Just as the reader is forced to second-guess who is speaking, so, too, is the audience, who has to join together disparate audiovisual elements into a comprehensible whole. While Cocteau specifies that the action is simultaneous with the phonographs' speech, the phonographs dictate the order of the events and prescribe the pantomimed and danced actions. Although the characters make their entrance out of a camera, Cocteau's spectacle is sonically constituted. The audience is invited to match the words uttered by the human phonographs with the characters performed by the dancers on the stage and assume a logical and equivalent relationship between words, bodies, and actions. This is obviously not the case. As Lynette Miller Gottlieb observes:

> The lifting of others' words to create a narrative involves the act of paraphrase; when the audience members hear the phonographs speak for the characters, they should not assume that the phonographs report speech word for word. Rather, they lift words that we cannot hear and rework them. We take it in good faith that what they paraphrase is true to the original statement, but the listener can never be sure of the statement's genuineness.[60]

The dancers in this ballet-spectacle do not speak for themselves (and with one exception do not speak at all) but are spoken *for*; indeed, they are figuratively ventriloquized, and, as such, subject to a form of staged displacement.[61] Following Stein, "the thing seen" and "the thing heard" both help and hinder one another in Cocteau's work such that "the mixture gets to be more mixed" and the operations of theatrical audiovision are deliberately muddled. This extends into the use of music in this work, which, in one instance, substitutes for phonographic speech and expresses performed gesticulation:

> PHONO I. The General rises.
> PHONO II. Speech by the General.
> *The General's discourse is orchestral. He merely gesticulates.*
> PHONO I. Everyone is deeply moved.[62]

Phonograph II's reference to this orchestral interlude (music provided by Poulenc) as speech further confounds the discursive registers of the work. At another point, a phonograph narrates the staging of a photograph (by a photographer in the scene) involving a General pretending to read aloud

to a child who pretends to listen to him: a nested arrangement of poses and pretences that reflects back the artifice of the work itself (with the exception of the performer playing the role of the camera, the dancers only ever pretend to speak and hear) and reinforces the peculiarities of the scenographical arrangement, the surrealist privileging of contrarious modes of representation.

Cocteau's human phonographs underpin the epistemic insecurity of *The Eiffel Tower Wedding Party*; they provide the shaky foundation for the whole spectacular edifice, which is optically contrarious, as suggested by the topsy-turvy backdrop. They do this by virtue of their ambiguous ontological status as participant-mediators of the dramatic world. The human phonographs are not just a modern updating of a Greek chorus. Their pretend mechanicality raises questions about how it is that the theatrical spectacle unfolds, in other words how "the thing heard" relates to "the thing seen," and how it is constituted in the first instance by a human actor performing the function of a mechanical device. Doubtless, it would have been practically impossible to use real phonographs for this task, and perhaps also undesirable; the presentation of a (disguised) human phonograph is more intriguing. In *The Eiffel Tower Wedding Party*, Cocteau presents the spectacle of performed "schizophonia": the pretence of separating sound from source and of disembodying the voice.[63] In reality, of course, the human phonographs do not reproduce prerecorded sound but generate it anew, and simply send their voices through the horn of the stage phonograph. The actor-phonographs—embodied technologies functioning as co-performers—are meant to *imitate* the mechanical reproduction of sound, a function that Cocteau presumably intended to make evident to the audience by directing the actors to speak in a heightened, stylized form of enunciation (indicated by way of mixed metaphor in the stage directions: "a diction black as ink, immense and clear as the lettering of a billboard"), which may have misfired and further confused the audience, or not have been executed properly.[64]

However, despite the pretence of schizophonia—or rather because of it—Cocteau still stages acts of vocal disembodiment as the phonographs are understood to speak for the characters represented by the dancers. According to this scenographic logic, the voices of the onstage characters are "emitted" from the human phonographs through a process of technological mediation. Their voices are phonographically represented; their speech has been separated from their selves (or at least from their bodies). This leads to further semantic density, for if audience members suppose that the phonographs' speech is recorded (as it must be in order to be considered phonographic) then the pantomimed movements of the dancers become reenactments of prior events. In this conception,

phonography ("sound writing") precedes choreography. However, since the audience presumably knows that Cocteau is presenting *phony* phonography—megaphones masquerading as phonographs—the spectacle is a performance of a recording, the *playing* of a live recording, so to speak, undertaken by actors who are pretending not to be present (usefully obscured to this end by phonographic fronts). What is more, this staging not only blurred the categories of the live and the recorded in theatrical performance (without in fact using recording), it also toyed with an operating procedure of silent cinema, namely attempts at artificially synchronizing sight and sound using phonographic technology or actors' voices behind the screen. As a result of being ventriloquized by the staged phonographs, the performers in *The Eiffel Tower Wedding Party* were made to resemble a cross between those of *mimodrame*—a form of nineteenth-century melodrama in which action was mimed or otherwise physically enacted—and silent film actors. Cocteau's disjunctive characters predate the eponymous figure in Samuel Beckett's *Krapp's Last Tape* (1958), who listens back to recordings of his old self, now estranged, on magnetic tape. Cocteau's characters, by contrast, are either unaware of or unfazed by their technological estrangement.

Cocteau deliberately tampers with the presumed ontological order and stability of theatrical performance, making it "jitter" like a film projector or "skip" like an audio recording so the artifice of its construction is presented for all to see and hear. Allan Pero remarks:

> What Cocteau is asking the audience to witness... is a creative process inherent in the destruction of a kind of theatre that had hitherto remained relatively stable in its use of media and technology. In Benjamin's terms, one could argue that we are watching a magnified moment in the ongoing decay and transformation of theatricality's aura.[65]

Cocteau's play, a theatrical madhouse of mechanical reproduction (or representations thereof), compounds the live with the "recorded," the original with the copy, the synchronous with the schizophonic, and presents the resulting semantic muddle and perceptual confusion as a surrealist mêlée. Considered as a phonographic spectacle (a spectacle of sonically informed sight as well as a spectacle of phonography) that relates the antics of a malfunctioning camera, Cocteau's work stages the technological dynamics and epistemic crises of modernity with a knowing wink and an implicit acknowledgment that theatrical audiovision was informed by modern technology: one hears/sees according to modern modalities of perception, which allowed for split output and attention, promoting perplexity. The cultural milieu of avant-garde theatre was full

of crossed wires. The telephone played an important—and too easily forgotten—part in this.

RECALLING THE THEATRE PHONE

At the turn of the twentieth century, new sonic technologies promoted new ways of making meaning at the theatre as well as making meaning *of* theatre. This is true of the phonograph and also the telephone, which had a special connection to theatre. Over a century before the live streaming of theatre and opera in cinema, and before radio broadcasting of performance, theatre was transmitted telephonically. The early development of the telephone included adapting it for use as an entertainment system, dubbed the "pleasure telephone" by a contributor to *The Strand Magazine* in 1898: a Victorian smartphone, so to speak, but one without multitasking capability or wireless connectivity (figure 2.2).

A notable example of this was the *théâtrophone*, invented by Clément Ader and first demonstrated at the International Electricity Exhibition in Paris in 1881.[66] Ader's invention allowed attendees of the exhibition to connect telephonically either to the Opéra or to the Théâtre Français, where, between the hours of eight and eleven o'clock at night, three evenings a week, they could listen to snatches of performances for a few minutes at a time. The system consisted of a series of carbon microphones positioned on either side of the stage, behind the footlights, at the Théâtre Français, and arranged on either side of the prompter's box at the Opéra, connected by telephone cable that ran through the sewers to rows of telephone receivers housed in a suite of rooms at the Palais de l'Industrie at the Exhibition. (Might this technological mediation at either side of the stage have informed Cocteau's arrangement of the stage phonographs in *The Eiffel Tower Wedding Party*?)[67] Ader's invention used dual output to create the effect of "binauricular audition" or proto-stereophonic sound (before this term was invented) and used two earphones, each connected to either side of the stage.[68] Despite its technical limitations, the device created a novel auditory and theatrical experience whereby Parisians could become telephonic audience members: located from afar, both "inside" and outside an event, creating the stage in auditory terms, involved yet simultaneously removed. Not only was this a great novelty, it was a great business opportunity.

In 1890, the *Théâtrophone* Company of Paris was formed, marketing the device for home use; thus "pay per listen"—predating "pay per view"—technology was borne. For an annual subscription fee of 180 francs, as well as 15 francs per use, subscribers received their own *théâtrophone*, complete with headset and transmitter to enable them to

Figure 2.2 Illustration from Arthur Mee, "The Pleasure Telephone," *The Strand Magazine* (September 1898), p. 340.
Source: Courtesy of Special Collections, University of Exeter Library.

contact an operator and select a program. Subscribers, of whom there were reported to be over 1,500 by 1893, could choose between a number of Paris theatres and concert halls, including the Opéra, the Opéra Comique, the Comedie Français, and the Concerts Colonne.[69] Additionally, coin-in-the-slot *théâtrophones* were installed in clubs, cafes, restaurants, and hotel lobbies and lounges throughout Paris, where, for the cost of a *franc*, one could connect to a selected theatre for five minutes' listening pleasure. Theatre-by-telephone was not limited to Paris. In 1894 the Electrophone Company, formed by H. S. J. Booth, launched a similar telephonic service

in London, offering connections to over a dozen theatres, churches, music halls, the Royal Opera House, and, eventually, transmissions from the Paris Opera, initially for an annual rent of £10. It is estimated that the company had some six hundred subscribers by the turn of the century; Queen Victoria is reported to have used the device on at least one occasion.[70] The company's subscription, never especially large, peaked at just over 2,000 in 1923.[71] However, the company had coin-operated machines installed at the Earl's Court entertainment grounds and also ran an Electrophone salon on Gerrard Street in Soho (figure 2.3). Similar telephonic enterprises were launched in Belgium, Portugal, Italy, the United States, and Hungary at this time. In its various iterations, the "pleasure telephone" enjoyed a not-inconsiderable operational history of roughly 40 years (the Electrophone and *Théâtrophone* companies finished operations in 1925 and 1932, respectively, due to the newfound success of radio broadcasting).

Newspaper reports and anecdotal information suggest that listeners enjoyed the theatre phone despite its provision of just the audio component of performance. Marcel Proust, who was a devotee of the *théâtrophone*, subscribed to the service in 1911 while working on his novel

Figure 2.3 Illustration from George Sims, *Living London* (London: Cassel and Company, 1902–03), Vol. 3, p. 115.
Source: Courtesy of University of Exeter Library.

A la recherche du temps perdu (published 1913–1927). In his biography of the novelist, William C. Carter observes that the *théâtrophone* was a great boon to Proust, who loved theatre and opera but rarely felt well enough to attend performances. Proust often listened to the device, keeping it right beside his bed, even though the sound quality sometimes did not enable him to discern the words. If the opera were by Wagner, he would supply the missing words as he listened. The *théâtrophone*'s imperfections seem not to have deterred Proust, who listened to broadcasts avidly and claimed to have fallen in love with Debussy's *Pelléas et Mélisande* after hearing it telephonically, though he admitted to having once mistaken a noisy crowd for an aria: "I thought the rumblings I heard agreeable, if a trifle amorphous," Proust quipped, "until I suddenly realized it was the interval!"[72] The contemporary British poet Jane Draycott captures the scene of a bedbound Proust listening to Debussy's opera on the telephone in her poem "Theatrophone":

> He is banked on a hotbed of pillows,
> buried in eiderdowns, caught in between
> the minute to come which runs towards death
> and the minute just passed which is dead.
>
> Now into his ear, like the sea from a shell,
> Young Pelléas calls from the depths of a vault
> made of cardboard: *J'étouffe*... The air here
> is stifling. *Sentez vous l'odeur de mort?*[73]

Can you perceive the odour of death? (Draycott truncates this line from Maeterlinck's libretto.) The connection between the theatre phone and ill-health, especially among the wealthy, recalls the Victorian and modernist association of sound-recording technology with death, though the theatre phone seems to have buoyed its listeners' spirits and kept them connected to cultural activities.[74] According to an article in the *San Francisco Call* in 1898, Albert Edward, Prince of Wales (later King Edward VII), initiated the introduction of the electrophone to England as a result of being invalided; the author mentions that the electrophone was a bedroom favorite of non-invalids as well, especially women. "The electrophone manager says he notices a largely increased demand for bedside installations, as opposed to installations in dining rooms and drawing rooms. He says that many women go early to bed, and then lie and listen to song and music, which ... is conveyed to their brain centers by the simple indiarubber tubing, ending in a pair of ear caps, which fit neatly, and need not be held up."[75] Is there a suggestion of aural eroticism here, stimulation and private fantasy through acoustic vibration in the bedchamber?

Mark Goble, writing about the 1932 MGM film *Grand Hotel*, notes that Greta Garbo's signature declaration of erotic inaccessibility—"I want to be alone"—takes on a different meaning altogether in the age of the telephone, when isolation itself becomes "a state of intense arousal and promiscuous connectedness."[76] One cannot, of course, know the extent to which this informed the reception of the "pleasure telephone," though it remains an intriguing possibility.

The fact that the theatre phone lasted as long as it did and became a commercial venture in a number of countries suggests that it had more than a novelty value and that telephonic auditorship offered its own rewards, even if one of its end results was to supplement or encourage theatre attendance. An 1891 report on the *théâtrophone* in *The Times* notes that

> some people at first imagined that this invention would injure the attendance at the theatres, and that those who could listen to a piece at home would not take the trouble to visit the theatre. Experience has proved quite the contrary, and during the short existence of the theatrophone the theatres which are in this way attached to the instrument have been rather benefited than hurt. Moreover, all who have used a theatrophone will affirm that after hearing a piece they are beset with a desire to see it as well, and that they then understand all the better what they have previously listened to attentively without being distracted by the complicating impressions of the eye. Many foreigners unfamiliar with the French language now take the precaution of hearing first through the theatrophone the piece they wish to see, and then when they go to the theatre they understand all the better the whole of the dialogue.[77]

Reminiscence provided by a former electrophone user in a 1957 article in *The Times* further highlights the reciprocity between theatre attendance and home listening; furthermore, it indicates that theatre attendance could be supplemental to telephonic listening rather than vice versa:

> The Electrophone did not, as some people might have thought, keep us away from the theatre—nothing could have done that in our family. On the contrary it made us want to go even more. If a new play or revue appealed to us on the Electrophone then we dashed off to fill the blanks in our imagination with a visual supplement. And having seen it in the theatre we had the added pleasure of "seeing" it again through our imagination while sitting comfortably by the fire at home—with or without the mending [of stockings]! And we could switch off the dull bits—if any.[78]

Presumably, listening to a snatch of a theatre performance on a public theatre phone would have provided a qualitatively different experience

than listening to a complete performance from the comfort of one's own home or at a salon. Despite the fact that the microphones were positioned on or near the stage the theatre phone transmitted the sonic environment of the auditorium (at least in part), which may have been a contributory factor to its appeal. For the first time, theatrical reception was wholly reliant on a soundscape for a performance to become meaningful. Was there, perhaps, a vicarious enjoyment to be had in listening to the responses of the "real" audience, connecting to that soundscape, yet having a private, unidirectional encounter with the event? According to the reminiscer in *The Times*, "there was something very satisfying about listening to a live broadcast from a real theatre, by actors and actresses playing to and having contact with their own audiences and probably unaware that we at home were eavesdropping."[79] The domestic telephone auditor, at his or her own leisure, "eavesdropped" on the proceedings without being able to take part or contribute in the manner of a conventional audience member. The restrictions imposed by the theatre phone enabled a new form of theatrical reception. Telephonic auditors could construct a private, imaginary sound world, even in the company of others, as the photograph of the proxy theatre audience with their vacant expressions in the Electrophone salon suggests. Like the solitary reader of a play text, the telephonic audience member could fashion his or her own "mental theatre" complete with personalized *mise-en-scène*, actor type, and choreography, based upon the sounds that came through their earphones (alternatively, these functions could be left blank and the performance could be experienced as a discrete form of audio theatre).

Conceivably, users of the theatre phone might also have intuited a connection to the other telephonic auditors listening to the same broadcast. In this way, the theatre phone expanded upon the theatrical event by giving rise to a network of secondary "shadow" audiences who existed virtually (telephonically), connected by means of modern telecommunications. The theatre phone separated the soundscape of a performance from its source and proliferated it telephonically to a myriad of geographically disparate locations. This was as potentially confusing, at least initially, for audience members as it was for performers. Annegret Fauser notes that telephonic auditors at the 1889 Paris World's Fair were socially alienated by not being able to join in with the transmitted applause. Moreover, the performer was cut off from part of the audience: "[thus] the feedback loop of live performance [was] cut irrevocably by the interpolation of the new medium, even though performers perform and listeners listen simultaneously."[80] The theatre phone further confounded conceptions of the ontological singularity of theatrical performance by allowing each individual listener to transpose the stage events onto or though the

mediatized site of reception (i.e., wherever one happened to be listening). Theatre-by-telephone was temporally synchronous (or near-synchronous) with the site of broadcast but was, as a matter of course, spatially discontinuous and dispersed. The phenomenon of the theatre phone indicates that modern theatre *took places*; it did not simply take (a) place.[81] Moreover, it insinuated the mechanical reproduction of sound into the minds and homes of its users, promoting aural fantasy and escapism: a technological realization of the acoustic imaginary, which enamored artists. Coincidentally, an early *théâtrophone* transmission was of Erckmann-Chatrian's play *Le Juif Polonais*, upon which Lewis's melodrama *The Bells*, discussed in the previous chapter, was based.[82] It is pleasing to know Mathias's aural hallucinations were broadcast over the telephone to worm their way into listeners' imaginations!

TELEPHONIC SPECTACLE: COCTEAU'S *THE HUMAN VOICE*

The history of the "pleasure telephone" provides a useful context in which to consider Cocteau's play *The Human Voice*, which stages the crossover between telephony and human desire. It showcases the dark side of the telephone's ability to provide—or prohibit—pleasure. In *The Eiffel Tower Wedding Party*, Cocteau conducts the displacement of "the human" by technologies of mechanical reproduction in a contrived, complicated, but still whimsical fashion. Despite the intervention of the human phonographs and the specter of a camera gone awry, the play does not engage the human-technology relationship in a combative or dualistic manner. Rather, Cocteau constructs a symbiosis of human and machine, of sound and spectacle, rejecting strict divisions. He continued this approach in *The Human Voice*, first performed by Berthe Bovy at the Comédie-Française on February 17, 1930. It is a one-woman telephone monologue that involves an extended conversation between the protagonist—a jilted woman—and her former lover. Notably different in terms of tone and style to Cocteau's earlier work, it is written in a realist vein inflected by melodrama. Cocteau referred to it as an "unesthetic act," "a scandal of banality" that was intended to rebuke the pretensions of his fellow avant-gardists and break the "prejudice" surrounding state theatre.[83] Cocteau suggests it was scandalous to write a play that consists of one side of a telephone conversation, especially by an artist who was known for more "high-brow," provocative fare such as *The Eiffel Tower Wedding Party* and *Parade*. Intentionally written in a pared-down, straightforward style with no theatrical tricks or gimmickry (unless one counts the use of the telephone), Cocteau's play was favorably received and remains one of his most popular and well-known works. Despite, or

perhaps because of, its popular success, the play has received little critical attention (Samuel Beckett dismissed it as "not merely a banality, but an unnecessary banality.")[84] This is unfortunate, for despite the play's occasional mawkishness, the conceit of creating a drama out of one side of a telephone conversation is quite clever. It presents the audience with the spectacle of pretend listening and conversing: the paradoxical non-sight of a sonic space. Moreover, it is significant in terms of modern theatre's engagement with sonic technology. In staging telephony, Cocteau makes the medium the message, to paraphrase Marshall McLuhan's famous dictum, and calls attention to the newfound entanglement of this technology, which was still being used to transmit theatrical entertainment, in everyday life.[85]

While *The Human Voice* was not the first play to feature a telephone, it was one of the first to use the device in such a prominent fashion to constitute a drama; moreover, it helped to found the sub-genre of works about women and telephones that include Lucille Fletcher's one-act play *Sorry, Wrong Number* (1948) (made into a film noir starring Barbara Stanwick in 1952) and the Alfred Hitchcock film *Dial M for Murder* (1954, based on a stage play by Frederick Knott).[86] In the preface to *The Human Voice*, Cocteau referred to the telephone in a blasé fashion as that "banal property [prop] of modern plays."[87] This presumably made it the perfect device to bring about his proposed "scandal of banality." However, despite Cocteau's depiction of the telephone as a modern convenience, a thing of no special novelty, it had only begun to be widely adopted in French society in the mid-1920s (hitherto it had not been much valued but resisted in some quarters).[88] Cocteau's estimation of the banality of the telephone may have been an affectation or else an indication of his socialite status. He created his scandal of telephonic banality by setting his play in a dreary, unkempt bedroom that the protagonist moodily occupies in a series of fixed poses. The author outlines these bodily dispositions in his stage directions. From the moment the telephone rings, he writes,

> [S]he will speak standing, seated, full-face, profile, back-view, kneeling behind her chair, her head cut off by the chair as she leans on the backrest; she will pace up and down the room trailing the wire, till the end when she will fall flat on the bed. Then, her head will droop and she will drop the receiver like a pebble. Each pose should be used for a phase of the monodialogue.... The woman's nervous state should be indicated not so much by haste as by the succession of poses each of which should be like a statue to discomfort.[89]

In effect, Cocteau wished to stage a type of tableaux vivant of woman and telephone, a modernization of Maeterlinck's static theatre that

glamorized, fetishized, and made a spectacle out of telephony, despite the drabness of the scene and the alleged banality of the device. While the sight of someone speaking on a telephone carries limited visual interest, Cocteau strove to make the most of the telephonic spectacle: for example, generating dramatic irony by setting the presented scene against the version given of it by the unnamed female protagonist (at one point in the play she tells her lover on the telephone that she cannot find his gloves while holding them against her cheek).

The principal irony (such as it is) of Cocteau's play is the fact that the audience is presented only with one side of the exchange, and can neither hear nor see the person on the other end of the line. Such a construction is not, on the face of it, especially suitable for dramatic representation as much of the "action" is missing or is implied rather than shown (another possible throwback to Maeterlinck). A telephone monologue in the theatre is equivalent to staging a radio play, making visuality subservient to vocality (and verbality), and for this reason may be construed as an anti-theatrical endeavor in which the mimetic is overshadowed by the diegetic.[90] Cocteau's play requires one to piece things together from the gaps in the presented scene. Cocteau claimed the play was inspired by the memory of a conversation heard on the telephone "with all the strange, deep tones which the voice assumes in that instrument, and the age-long silences."[91] The text of *The Human Voice* is full of gaps, ellipses, and notated silences, marking the unheard contributions of the woman's interlocutor as well as the communication breakdowns between the two speakers (sometimes prompted by interference, being cut off, or having a crossed connection). The following example is illustrative of the interrupted and fragmentary nature of Cocteau's text, which punctures speech with silence:

> Hello *Priceless*, and I don't regret I don't I don't regret anything You're You're wrong. You're You're. You're wrong. I .. Hello! I've got what I deserved. I wanted to throw everything to the winds and be madly happy darling listen. hello! darling let me hello let me speak.[92]

Cocteau labeled his drama a "monodialogue" (an ostensible oxymoron) in the understanding that the interlocutor's contributions, though unheard, structure the scene and may be discerned from the manner in which the actor performs her part. For this reason, the situation provides the actor with the opportunity to act two parts, "one when she is speaking, the other

when she is listening and delineating the character of the invisible person who expresses himself by silences."[93] The "invisible person" is audible to the protagonist of the play (one assumes), but not to the actor or audience, for whom the telephonic interlocutor can only ever be an imagined sound. Similar to the plays discussed in the last chapter, *The Human Voice* relies on imagined sound to help create the effect of an invisible scene partner (an "un-scene partner," so to speak) that motivates the drama and establishes a sense of acoustic exteriority (a sonic subject outside the self).[94]

The protagonist of this play fantasizes the existence of her erstwhile lover; the audience is encouraged to imagine him in kind. The woman says she has "eyes in the place of ears," which enables her to visualize her former lover simply by listening to the sound of his voice; she begs him not to do the same with her (she does not want him to "see" her in her true state of disrepair).[95] Indeed, such is the woman's gloom that she does not even want to see her own reflection in the mirror or to acknowledge her real, phenomenal existence (her life in the room), preferring instead the nebulous reality proffered by the telephonic connection. In her sorry, deluded state, she imagines that the world of her auditory imagination is more substantive than her actual surroundings: "we talk and talk and don't think we'll ever have to stop, ring off, and fall back into space and darkness..."[96] The woman finds refuge in the disembodied, inchoate, and unstable nature of telephony, despite its recurrent disruptions and misconnections and the plethora of other voices on the line that harangue and distress.

Steven Connor refers to the surrendering of oneself to the impersonal distributional networks of the telephone system as the "switchboard experience," one of the abstract constructions of modern life that models a type of disintegrative selfhood based on auditory principles.[97] By indulging in and privileging an imaginary switchboard (telephonic) "space," the protagonist of Cocteau's play attempts an act of self-dissolution, losing herself in a sound world, just as she has attempted to commit suicide by overdosing on sleeping tablets (she confesses this to her interlocutor). The existence of this telephonic "space" is signaled by the multiple ellipses and silences in the character's speech and by her disposition and behavior. In Cocteau's stagecraft "the thing seen" and the "the thing heard" help to construct an idea of "the thing imagined," a collusion (confusion) of sound and spectacle that works to dislocate the stage action. In this play, Cocteau stages the virtual existence of a private acoustic and imaginary world. This had previously been the province of users of devices such as the theatre phone, for instance, or else it was a speculative undertaking (e.g., the acoustic imaginary). He makes

a virtue of the necessary limitations of a telephonic spectacle by making the unseen and unheard visually and sonically apparent (a seeming paradox) and by turning the audience into a collection of peeping toms and eavesdroppers.

Notwithstanding Cocteau's pronouncement that the telephone is an instrument "least suitable for treating matters of love," his play is founded upon the premise and potential of telephonic intimacy, the last connection the woman can enjoy with her former lover.[98] To this end, Cocteau formulated an erotic aesthetics of telephone usage, suggested by a publicity photograph of Berthe Bovy in a pose of tangled telephone wire, stretched out limbs, and closed eyes. The telephone functions as a surrogate lover for the stricken woman, the extended (albeit interrupted) conversation as a form of aural sex.[99] The woman relates how she has taken the telephone to bed with her (like owners of the theatre phone) "because, after all, we are connected by the telephone. It goes into your flat, and there was this promise that you would give me a ring. So you can just imagine I counted the minutes and dreamed all manner of things."[100] She impresses upon her former lover the power of the human voice as a bearer of meaning and authenticity despite the technological mediation ("you could tell by my voice," she reiterates), as well as an erotic pleasure, likening their telephone conversation to pillow talk: "You know, dear, sometimes when we were in bed and I had my head in its little place with my ear against your chest and you were talking, I heard your voice exactly the same as this evening in the telephone [*sic*]."[101] At work here is the notion that the telephone may provide a vocal co-penetration of listening bodies, an aural eroticism that derives not just from the familiar intimacy of the voice but from the sensation of audio-haptics, the physical connection between sound and touch. Cocteau's play derives an erotic charge from the suggestion of a "synaesthetic spilling" between the faculties of hearing and touching, so that the telephonic discourse becomes a spectacle of "tactile" aurality in line with protagonist's fantasy world: the audience watches and listens to this woman be figuratively touched by sound, further enriching the intersensorial operations on display.[102]

This fantasy-spectacle of aural sex is later crossed with the protagonist's death wish in a familiar pairing of *eros* and *thanatos*. The woman dreams of "a different and dangerous kind of [telephonic] ring—a wring of the neck which strangles, a ring of a boxing match I couldn't get out of—the bell rang, you hit me and I was counted out."[103] She endeavors to enact this scenario at the end of the play when, moaning in misery, she winds the telephone wire around her neck ("Your voice is round my neck") and begs her former lover to "break off," to sever the connection

(in the French, *coupe*, meaning not only to disconnect but to cut or stab), as though attempting a form of auto-erotic asphyxiation:

> *(She lies down on the bed, hugging the receiver to her.)*
> My darling......... my dear darling..................... I'm brave. Be quick. Break off. Quick. Break. I love you, I love you, I love you, I love you, I love you...............
> *(The telephone receiver falls to the floor.)*
> CURTAIN[104]

Cocteau uses an animalistic analogy to describe the figurative demise of the protagonist, stating that "[he] would like the actress to give the impression of a woman who is bleeding, losing her life-blood, like a maimed animal, that she is finishing the Act in a room full of blood," aping the stylistics of Strindberg, perhaps, or else proposing a spectacle of victimization and injury that uses female hysteria as a vehicle for homosexual unrest.[105] Indeed, the gaps and silences in Cocteau's text could be interpreted as a voicing of same-sex desire on the part of the author; the telephonic spectacle, in which much is undisclosed and left to the imagination, allows for alternative readings even with the realist frame. The surrealist Paul Eluard reportedly disrupted a preview of *The Human Voice* by shouting out "Obscene! Enough! Enough! It's Desbordes on the other end of the line," referring to Jean Desbordes, Cocteau's then lover.[106] *The Human Voice* is ultimately a play about substitutions and sublimations: of reality for fantasy, the visible for the audible, the verbal for the tactile, and the phenomenal for the liminal.

* * *

The Human Voice subverts the visual primacy of the stage spectacle in a manner similar to *The Eiffel Tower Wedding Party* and *The Breasts of Tiresias* by drawing continual attention to the faculty of hearing, to the unheard and unseen, as well as the inter-sensorial. It activates a curious dialectic of intimacy and distance in which a private telephone conversation (a markedly small-scale event) serves as the primary focus of attention for an entire theatre, a difference in scale made evident in the first production by the size and grandeur of the auditorium of the Comédie-Française. In this way, the central dynamic of the drama—the paradoxical closeness and distance of the woman and her telephonic interlocutor—was replicated in performance by the spatial relationship of the audience to the performer (near but still separated). Cocteau dramatizes the experiential dynamics of telephony and makes them conditional for theatrical production, reversing the procedure of telephonic broadcasting in which

theatre was rendered telephonic on account of technological mediation. In the three plays discussed in this chapter, avant-gardists transform what had previously been adjunctive or supportive uses of sonic technologies by foregrounding them, demonstrating their newfound integration into the bourgeois quotidian and their enmeshment with human desires and perceptions. This entanglement is literally depicted in *The Human Voice* when the protagonist wraps the telephone cord around her neck. For this character, the telephone is a dubious source of pleasure, unlike the theatre phone, which apparently offered straightforward entertainment, though home users of this device may also have exploited its aural fantasies. In using mechanisms of sound production and reproduction to structure their dramatic and scenographical conceptions, avant-gardists demonstrated the embodied, performative nature of technological interaction, which had previously primarily taken place offstage but was now increasingly taking center stage in the mediated soundscapes of modernity.

CHAPTER 3

REINVENTING LANGUAGE: SENSE AND NONSENSE

IMAGINE A THEATRE WHERE PLAYS ARE PERFORMED in multiple languages at the same time, catering to audience members of different nationalities and language competencies. Foreigners and tourists might pick out their mother tongue—partially or completely—and follow the action, focusing on a single aspect of the soundscape, similar to a guest at a cocktail party who tunes out background noise to hear selected speakers. Bi- or tri-lingual attendees might alternate between presentations, getting a flavor of the play in one language, then another, or might listen to multiple languages simultaneously, appreciating their aesthetic and semantic overlap or just the sounds of the different languages. Who needs surtitles, or linguistic clarity for that matter?

Theatre of this sort existed in the cultural imaginary of the *fin de siècle* and related to contemporaneous ideas about multilingual and multinational modernity. It appears in Albert Robida's quirky, strangely prescient novel *Le Vingtième Siècle* (*The Twentieth Century*), a work of early science fiction published in 1882. The novel is set in Paris in 1952 and describes the lives of a wealthy family in a world of new technologies, cultural experiences, and social possibilities. In one chapter, the Ponto family hosts a party. A "phono-announcer" is used to mark the guests' arrival: a keyboard apparatus equipped with a phonograph horn that announces names with varying degrees of loudness depending upon how heavily the syllabic keys are pressed. A potpourri of popular themes from international operas is electrically piped in from the Great Music Company of Paris, a music factory (think: Muzak) that has rendered musicians nearly extinct. The guests are mainly French, albeit of mixed heritage.

This is not peculiar. Progress in communication technology has bridged differences of language and culture, the narrator remarks, effectively merging all the people of Europe into one nation (Euro-skeptics' worst nightmare!). Cultural fusion is a topic of conversation among the guests, who include a Belgian-Russian-Italian diplomat, a French politician of Portuguese-Italian-British-French descent, and a German-Greek-Swiss-French scholar. Their conversation (presented here in English translation) is worth quoting at length. The diplomat begins:

> "This fusion of peoples," the diplomat maintained, "shall inevitably lead to a corresponding fusion of languages. No language will emerge as the winner of this competition. The eclectic character of the present evolution indicates, on the contrary, that all the current languages will eventually combine into a single idiom. Further evidence of this can be found in the number of foreign words that have infiltrated the French language for the last hundred years. The most basic conversation is already peppered with English, German, or Italian terms. And the same is true for all languages."
>
> "Indeed," the scholar replied. "The current cosmopolitanism is such that theaters have started to present plays in several languages simultaneously. Already, the Porte-de-Saint-Martin Theater has two companies: a British one and a French one. Two leading men and two leading women occupy the stage simultaneously; they move about and speak their lines at the same time. However, the leading man in one of the couples does so in French while the other one performs in English. In scenes requiring a large number of actors—a king's court, an army, or a crowd—one half speaks in French and the other half repeats the same lines in English."
>
> "It's so much fun!" said the diplomat. "One gets twice the emotion during scenes of duel or murder . . . not to mention scenes of passion or seduction!"
>
> "What about the Gymnase Theater?" an enthusiastic Ponto added. "It's even better than at the Porte-de-Saint-Martin: I hear they are going to perform in three languages!"
>
> "I happened to be there last night. They had an old play from last century, *Antony*, by Alexandre Dumas *père*, in English, German, and French. The stage was divided into three floors: on the upper one was a French Antony, a German one on the lowest level, and an English one in the middle level. It is quite an unusual spectacle and this experiment proved to be a complete success. The three troupes all speak their lines at the same time."
>
> "This must result in a complete cacophony! That's not theater any more, that is the Tower of Babel!" exclaimed the politician.
>
> "Not at all, mind you. Five minutes into the show, everyone gets used to this mixture of three languages. You just follow the play in your own idiom, without being distracted the least bit by the other Antonys. Indeed,

what a triumph it was when, at the end of act 5, the three Antonys—Sirs Landesberg, Caillot, and Blackson—stabbed to death the three Adèle d'Herveys—Ladies Frisch, Mailly, and Mansfield—while delivering the play's heartrending final lines to three colonels in three languages: 'She resisted me ... I killed her!' " [...]

"Indeed I must see this play!" decided the diplomat. "I am well versed in all three languages; so, I shall have thrice the pleasure." "In that case," joked Ponto, "I shall have to report you to the theater manager. You'll have to pay triple price, since you'll enjoy three shows!"[1]

Robida's accompanying illustration depicts the dénouement of Dumas's melodrama (Figure 3.1). The audience members look enthralled by this spectacle of trilingual theatre. A figure in a first-level box uses a pair of opera glasses to espy the top-level action. Although the presented scenes are mostly identical, there are some differences in the *mise-en-scène* and the actors' gestures and positions (e.g., the French Adèle, who has died awkwardly with her legs upturned). Note also the four circular markings in the orchestra pit, above which the words "*bouches d'orchestre*" (orchestra vents) are written, suggesting piped music.[2] It all seems perfectly straightforward, despite its apparent preposterousness. This scene, like many others in Robida's book, may have struck initial readers as fanciful but not wholly outlandish. Robida's imagined future is an extrapolation of *fin-de-siècle* modernity. Its legibility was dependent upon recognition. (Today, we have phonographs; tomorrow, we will have phono-announcers. Today, we have the *théâtrophone*; tomorrow, we will have piped music in homes and theatres. Today, we have increased loan words from other languages; tomorrow, we may have a single, fused language.)

The fact that linguistic play should take place in a theatre is noteworthy. Theatre—especially of the postcolonial variety—has a history of linguistically mixed audiences and discourses. Nevertheless, theatre is customarily understood, and often operates, as linguistically homogenous, with dramatist, performers, and audience all sharing a common language. This system acquired ideological force in the nineteenth century, Marvin Carlson notes, as nationalism in continental Europe promoted "cultural and linguistic solidification" (i.e., protectionism) over language mixing.[3] He writes:

> The rise of nationalism and of national theatres devoted to the promotion of a particular language, culture, and history during the nineteenth century provided a powerful disincentive for the sort of dramatic mixing of languages often found in the Renaissance, and to a lesser extent in the baroque theatre. During the nineteenth century, as modern national consciousness

Figure 3.1 Illustration from Albert Robida, *Le Vingtième Siècle* (Paris: Montgredien, 1882), p. 128.
Source: Courtesy of Charles Deering McCormick Library of Special Collections, Northwestern University Library.

developed, it was often closely tied to the celebration of a national language, which in turn was connected to the development of a new national theatre. Thus a Czech language theatre was established in Prague as a national alternative to the earlier German language-theatre, a Norwegian theatre in Christiana (today Oslo) as an alternative to the earlier Danish language theatre, a Gaelic theatre in Dublin as an alternative to the earlier English language theatre, and so on.[4]

In this light, Robida's late-nineteenth-century visions of trilingual theatre and pan-national European identity seem provocative, perhaps even avant-garde. Robida's utopian linguistic fantasies derived, at least in part, from a perceived communication crisis associated with modernity. Language, tied to nationalism, was thought to constitute a modern Babel that promoted division, discord, and mutual unintelligibility.[5] Increased contact enabled by communication technologies (such as the telephone) and modern modes of travel supposedly compounded this situation, as did the modern metropolis with its often-heterogeneous mixture of different nationalities and speech communities.[6] This rekindled the invention of artificial languages: projects intended to reduce miscommunication and unite people of different nations. Over 200 languages, generally derived from the roots of European languages, were invented from 1880 to the beginning of the Second World War—a remarkable statistic.[7] The most famous of these is Esperanto, introduced by Dr. Lazar Ludwik Zamenhof, a Jewish ophthalmologist from Bialystok (then an area of Polish Lithuania) who was committed to world peace, in 1887.

This chapter situates linguistic experimentation by avant-garde theatre artists in the contexts of the communicative "crisis" of modernity, language invention, and transnationalism. I argue that these phenomena were culturally connected and not just temporally coincident with the avant-garde. Avant-gardists undertook linguistic fusion (and confusion) in performance: testing new ideas and sounding out communicative possibilities in a playful, self-reflexive manner. They privileged the sonority of language over its semantic, referential functions, making new sounds out of words and new words out of sounds. They explored using phonemes (basic speech sounds) as a universal language, aiming to connect with listeners on a rudimentary level. In so doing, they staged the modern fascination with invented languages and invited audiences to appreciate the sense in nonsense (so to speak). In the discussion that follows, I survey the so-called language crisis of modernity, outlining the development of, and cultural engagement with, Esperanto in particular. I analyze the performative babble of the dadaists Tristan Tzara (in his plays and "simultaneous" poetry), Hugo Ball (in his 1916 cycle of sound poems, or *Lautgedichte*),

and Kurt Schwitters (in his elaborate sound poem "Ursonate," composed between 1922 and 1932). The chapter concludes with a consideration of the Russian futurist Velimir Khlebnikov's play *Zangezi: A Supersaga in 20 Planes* (1922), which features the invented language of "zaum." This play dramatizes a human endeavor that can alternately be regarded as serious and silly—a recurring theme of the chapter.

LANGUAGE IN MODERNITY: PROBLEMS, SOLUTIONS, FANTASIES

The most commonly noted aspect of modernity's linguistic "crisis" is the philosophical supposition that language was no longer able to represent perception of lived experience adequately. Language could not capture the "real" if the "real" was fundamentally chaotic, unknowable, and unstable, as scientific revelations about the universe, such as Planck's theory of quantum mechanics (1900) and Einstein's General Theory of Relativity (1905 and 1915) indicated, and as anti-theist positions such as Nietzsche's "God is dead" proclamation (1882) implied.[8] Henri Lefebvre characterizes the linguistic crisis of modernity accordingly:

> Because language has been thought of as an absolute, and because that assumption has failed, we begin to distance ourselves from it. We can see it, we can get to know it, we can change it into an object, but at the same time it begins to break up. Its inadequacies become apparent. It is not the human absolute.... Language is no longer seen as the perfect medium (for communication) but as a deficient medium incapable of mediating (of communicating) the immediate (the lived). It is not transparency, it is obstacle, opaqueness. It does not deliver reality, it distorts it.[9]

This philosophical crisis is thought to have underpinned the outlook of modernists of this period. Sarah Bay-Cheng observes:

> With cause and effect, reason, and scientific understanding thus challenged, the avant-garde theater was faced with representing a chaotic and incomprehensible universe in which humanity could find no direction. Language itself could no longer adequately represent the world of objective reality, nor, as a communication device, could it enable human beings to transcend their own existential isolation. Not only had humanity lost faith in its divine origins and secular reasoning, but it had also lost faith in its linguistic ability to describe those twin losses.[10]

Indeterminism and ontological insecurity certainly informed modernist linguistic experimentation, but they do not fully account for it. Language

in modernity was also motivated by practical, ideological, and political concerns. Irrespective of its ability to represent modern epistemology, language was thought to represent the essence of nationality—the spirit of a people—better than anything else. It was employed as part of modern European nation building. In this respect, language was thought to be deeply meaningful. It could bond a group of people together; distinguish them from others; function as a medium and storehouse for their cultural or ethnic uniqueness; and connect them with an ancestral past. Language nationalism, as articulated by the eighteenth-century German philosopher Johann Gottfried von Herder, equated the mother tongue with the soul or spirit of a nation so that the two were inextricably (and "naturally") linked: "Without its own language, a Volk is an absurdity, a contradiction in terms."[11]

Language revival was a vital part of efforts to restore or reinvigorate national consciousness. In the case of the Zionist movement, Hebrew—rather than Yiddish, which was associated with the Ashkenazi Jewish diaspora—was transformed into a secular vernacular in service of an "imagined community."[12] It functioned as a medium, assertion, and proof of Jewish national identity. Alain Dieckhoff writes:

> Using Hebrew made it possible to give people who belonged conceptually to European culture a mark of authenticity and timelessness. What happened in the field of language was a mirror of what Zionism was carrying out politically by drawing up a Jewish version of the principle of national self determination, which had sprouted on Western soil. The ideological function of the language was symptomatic of the functioning of nationalism which, while claiming to act in the name of largely mythified primordial allegiances (ties of blood, religion, custom, world vision, language) was in reality a process of accession to modernity.... Hebrew, the sacred language of the religious congregation, became that of the national community. It had once been in the service of God, now it was in the service of the nation.[13]

The secularizing of Hebrew also meant that it was taught to women for the first time, which was crucial in making it a working language for everyday use.[14] The symbolic power of language helped to solidify national identity; this had the predictable knock-on effect of fostering tension between different groups of language users, both within a single (often multilingual) nation state and with the people of other nations. Robert McColl Millar comments:

> Identification of a particular language (or language variety) with a particular nation became a central part of the nationalist project in many

places—particularly Europe. The problem, inevitably, was that the question of what language, what language variety, was most representative of the nation would be asked. Since even today it is rare to find a nation where the citizenry share one mother tongue (and it is practically impossible to find a majority population, all speaking the same language, where there is no dialectal or sociolectal variation, tension between users of one language (variety) and another was (and is) inevitable.[15]

In addition to consolidating internal regional dialects into notionally stable national linguistic norms, modernity's colonial powers forced their subjects to adopt the language of the colonizer, as happened in Ireland, for instance, with pernicious and pervasive effect. In his 1972 poem "A Grafted Tongue," the Irish poet John Montague describes Britain's foisting of the English language onto the Irish people as an act of cultural barbarism that robbed them of their natural fluency. It begins:

> (Dumb,
> bloodied, the severed
> head now chokes to
> speak another tongue:—[16]

The punctuation at the end of the stanza evokes a glottal stop, a catching in the throat, a sign of being tongue-tied.

If the reality of language in modernity was the advancement of national ideology alongside colonial and imperial endeavors (and their opposites: anti-colonialism and anti-imperialism), then the fantasy was a return to a prelapsarian world (pre-Babel, as it were) in which language no longer divided humankind but rather unified it or at least facilitated international understanding and cooperation. In Robida's *The Twentieth Century*, Mr. Ponto and his guests turn from discussing "mélange theater" to discussing "mélange language," which, the scholar observes, is being developed. As the name suggests, mélange language is a fusion of the main European languages and is intended to replace existing languages. The scholar comments:

> It is very simple. In fact, listen to this sentence—the traditional phrase used in all grammar courses; it opens the mélange language grammar book: "La grammar e l'arte of sprichablar y scribir correctement." As you can see, this can be understood nearly everywhere. The scholars came up with an excellent system for conjugation: Ich bin, tu es, he is, siamo, este, sono. They adopted only the simplest and easiest forms to remember in each language, eliminating difficult and obscure words. This is not unlike a competition between languages: whenever the English term to designate

a thing is better than the same word in the other tongues, the English word is selected. Occasionally, they merged two words together: a French root and an English ending.

"Let's hope that this will not end up as some pidgin dialect," laughed Ponto. "Let us be spared such sentences as 'Voilete permit offrir mio corazon and ma main? Go chez maire!'"

Why? That doesn't sound so bad at all! It does have a nice ring to it, and, moreover, it has the advantage of being understandable in three or four different countries.... Before twenty years go by, only backward country-dwellers will cling to the current languages.

"Don't forget scholars," Ponto prompted.[17]

Mélange language may seem even less plausible than mélange theatre, yet it did emerge briefly, ridiculously, in the form of "Europanto," a parodic, mish-mash, European pidgin language with no formal rules invented by a translator for the EU Council of Ministers in Brussels in 1996.[18] Importantly, there were precedents for mélange language outside of Robida's imagining. In 1880, two years before the publication of Robida's novel, Johann Martin Schleyer, a German priest, introduced the artificial language of Volapük ("world speak"), allegedly having been instructed by God in a dream to create a universal language.[19] Volapük has an invented morphology but Indo-European grammatical categories. Although its vocabulary is drawn from the major European languages and is mainly German in structure, the words are so changed as to render them unrecognizable often. Nevertheless, Volapük was the first modern artificial language to achieve some measure of success, which it did in the years following its creation, first in south Germany and France and then throughout the world.[20] By 1889, three world congresses had been held; there were 283 Volapükist clubs in Europe, America, and Australia, which published journals, organized courses, and gave diplomas.[21] This community of enthusiasts strove to make Volapük a working language (especially for commercial correspondence), but Schleyer did not appreciate their efforts to improve it, and the movement collapsed after a few short years.

Whereas Enlightenment-era language inventors sought to enact universality (by dint of reason, one ought to be able to invent a language to improve upon and replace existing, imperfect languages) the language inventors of the late nineteenth and early twentieth centuries typically stressed the practical importance and necessity of the undertaking. They proposed that an artificial language could supplement rather than supplant existing languages, thus shifting the proposition from a single

language everyone could speak to a shared international language coexisting with national languages and functioning as an auxiliary. Some of these languages have marvelous names, like Sprachwissenschaftliche Kombinatorik (1887), Kosmos (1888), Adam-Man Tongue (1903), Geoglot (1916), Universalspråket (1918), and Transcendent Algebra (1921).[22] The languages invented in this period vary considerably in terms of their development, complexity, and level of completion; few acquired many speakers despite their inventors' aspirations.[23]

In a study of the "social problem" of multilingual modernity conducted in 1931, the American sociologist Herbert Shenton offers the following reasons for inventing an auxiliary language: economic relations; global travel; radio-telephony (avoiding the specter of "linguistic imperialism"); the distribution of "talking" pictures in foreign markets; international conferences; international scientific research; and the cost and inefficiency of modern language education.[24] The internationalist ethos of language inventors was part of a growing sense of international interdependence (coexistent with nationalism) in the latter half of the nineteenth century, which led to an increase in the number of newly formed international organizations, both governmental and nongovernmental. These include the First International Labour Association (est. 1864), the Telegraphic Union (est. 1865), the International Postal Union (est. 1874), the Universalist Peace Bureau (est. 1892), and the International Socialist Bureau (est. 1900).[25] Modern language inventors sought to unite people of different nationalities through adopting a new language, recalling other large-scale social engineering projects of the time, such as Communism.

Esperanto is the only artificial language to achieve lasting success, even if it, too, fell short of its goal of global adoption as an auxiliary language. First published in Russian in 1887, Esperanto was the most popular invented language of its day. It uses European languages as the basis for its vocabulary; its grammar and word-building system resemble Chinese, Turkish, and other non-Indo-European languages; and its syntax and style are largely Slavic.[26] Zamenhof, its inventor, claimed to have been inspired by the ethnic tensions and linguistic divisions in Bialystok, where the main ethnic groups (Jews, Russians, Poles, and Germans) each spoke their own language. At the age of ten, he wrote a five-act tragedy on the story of the tower of Babel with the scene set in Bialystok.[27] His invention spawned a dedicated journal (*La Esperantisto*, first published in 1889); the formation of over 1,500 Esperanto societies by 1912 (mostly in Europe); a series of world congresses (the first of which was held in Boulogne in 1905 and attracted 668 delegates from 20 countries); and its own literature (both translations of literary classics and original works). According to a survey conducted in 1928, it had over 126,000 speakers.[28] In 1922, the

League of Nations conducted a report entitled Esperanto as an International Auxiliary Language, delivered at its third general meeting.[29] The report presents a favorable account of Esperanto, arguing for its practical basis and easiness to learn (relative to natural languages). "Esperanto is certainly the most widely spoken artificial language in universal congresses and in gatherings of all kinds, in travelling, in international offices, and even in the theatre," it states. "This makes it a living language—a characteristic not possessed by any of the systems which are only written and not spoken."[30] The authors note that Esperanto fosters a spirit of international solidarity in accordance with the aims of the League; they propose it should be taught in schools (as was already happening) and used internationally as a telegraph language. The report was accepted, but the proposal to introduce the language officially into school curricula was not approved.[31] A proposal made at the general meeting of the League in 1924 to adopt Esperanto as a telegraphic language was also accepted, and ratified by the Universal Telegraph Union the following year.[32]

This brief account of Esperanto in the early twentieth century indicates that the language and its potential uses were taken seriously at the time. The Esperanto movement was not a mere fad or flight of fancy but was, on the whole, a credible attempt to institute a neutral, auxiliary, international language that could be of global practical benefit. While it did not succeed in this regard (though it continues to flourish), its scope and longevity—far exceeding any other artificial language—point to its cultural significance. Easy to learn, especially for speakers of Romance languages, and ostensibly politically neutral, Esperanto held the promise of fulfilling what its advocates thought to be a vital need in the modern world. This may be one of the reasons it was adopted so widely and endured beyond an initial, passing fascination, which is the most other artificial languages (such as Volapük) received.

This is not to discount the utopian idealism and, shall we say, eccentricity that characterized aspects of the Esperanto movement, which also formed part of its appeal and helped to garner it public attention. These aspects partially derived from Zamenhof, who, like Schleyer and countless other language inventors, had high hopes for his creation. He imagined Esperanto might prefigure a shift from "national chauvinism [exaggerated patriotism]" to international brotherhood or even possibly nation-less neutrality and equivalence.[33] Writing under the pseudonym Dr. Esperanto (the word means "one who hopes") in his initial treatise on the subject, Zamenhof states:

> If we were to suppose that there will happen at some time a confluence of people into one race-embracing community, the blame for this "misfortune" (as the national chauvinists will term it) will not rest upon the

international language, but upon the altered convictions and opinions of mankind. Then the international language will facilitate man's attainment of that which he will have already decided upon in principle as desirable; but if the movement towards confluence does not originate among men independently, the international language will certainly not wish of its own accord to impose such a union upon men.[34]

Zamenhof's next project was a single world religion. This was first called "Hillelism" (after the first-century B.C.E. scholar Rabbi Hillel) in 1901, then renamed "Honaranismo" (an Esperanto word roughly meaning "humanism" but without the atheist implication) in 1906. Zamenhof hoped cross-faith speakers of the international language who subscribed to a set of shared beliefs (neutrality, equality, anti-ethnic division and hierarchy) would adopt this religion and one day fuse into a single neutral-human people. Zamenhof's religious fantasy was not well received and came to naught, though he maintained Horaranismo was the enlightened, "inner idea" behind Esperanto.[35] Zamenhof thought his dream of religious-linguistic neutrality was taking shape in the Esperanto World Congresses, which he described according to the analogy of a nation state (albeit one that is conceptual and borderless) as "Esperanto-land."[36]

This fantastical, visionary element of Zamenhof's philosophy appears in distorted form in a 1908 *Strand Magazine* article outlining a proposal to found an Esperanto-speaking state in the territory of Neutral Moresnet: a small condominium wedged between Germany, Holland, and Belgium that existed from 1816 to 1920. According to the article, a proposal was made to found "Esperanta" (elsewhere designated "Amikejo" or "friendship place") at the 1908 Esperanto World Congress in Dresden by Wilhelm Moly, a German doctor resident in Neutral Moresnet, and Gustave Roy, a French professor, supposedly on account of the size and geographical location of the territory and its concentration of Esperanto speakers.[37] A demonstration was reportedly held in Neutral Moresnet in 1909 to proclaim the territory a new Esperanto nation, but it is unclear if this performative action had official effect (or really took place).[38]

In the article, Dr. Carl Hoffender, an Esperanto enthusiast who is cited as an authority on the subject (but may well be fictitious), provides his ideas about the architecture and culture of the new proposed city, seemingly oblivious or indifferent to what was already present in Neutral Moresnet. Hoffender's vision is of an idealized, idiosyncratic synthesis of classical and modern Western culture (with some elements drawn from the East), prioritizing beauty and clarity and striving to avoid excess and disruption of any sort. Hoffender relates his architectural eclecticism

to the synthetic nature of Esperanto (along with its unacknowledged European bias):

> My idea has been to take from every school and order of architecture its most agreeable and effective features. It is, like the language we speak, an eclectic. You will find Greek, Roman, Gothic, Renaissance, and the purely modern as well as Byzantine. If there was any especial advantage in Indian, Chinese, or Japanese architecture I would borrow that also.[39]

Hoffender's proposed mode of dress for the male Esperantists of this new city is more inclusive of Eastern elements, consisting of "a cap, black jersey with a wide sash around the middle, Turkish trousers, and ordinary stockings, with white or brown boots as the Esperantist's sense of beauty suggests" (see Figure 3.2).[40]

Figure 3.2 Illustration by Warwick Goble from "An Esperanto City," *The Strand Magazine* (December 1908), p. 520.
Source: Courtesy of The Exeter and Devon Institution.

Hoffender further proposes that the new Esperanto city affords the opportunity for an Esperanto school of painting; a new school of Esperanto music ("carefully avoiding the extremes of Wagner on the one hand and Rossini on the other"); Esperanto cookery ("which will offer mankind something better suited to its alimentary needs than dead birds, fish, and quadrupeds"); and an Esperanto-specific form of drama and school of acting.[41] Hoffender, who claims to have translated *Hamlet* into Esperanto, is opposed to indoor theatre ("a dark, stuffy, confined dungeon") and desires to bring theatre back into the open air and light of day where it will be a "wholesome, hearty, and healthful recreation."[42] The illustration of Hoffender's plan for an open-air theatre reveals a curious combination of Roman arena and Spanish bullring, with actors entering in procession from one of the vomitoria. Hoffender's vision of an Esperanto city is clearly fantastical, in the mode of Robida's *The Twentieth Century*, excerpts from which would easily have found a place in *The Strand Magazine* (the author of the article cites literary utopias and the "Jules Verne school of speculative fiction" at the outset).[43] It is also probably bogus. There is little evidence that Esperantists attempted to realize such a plan and it seems unlikely that they would have wished to do so—at least not in this manner. Zamenhof's conception of Esperantoland was not literal, even if Hoffender's plan does superficially resemble Zamenhof's dream of a single neutral-human people. Most likely, this article is a piece of whimsy authored by one of the magazine's contributors, though it may have been based on a real, more manageable, proposal.

The *Strand* article demonstrates the apparent crossover between fact and fiction, or fact and fantasy, with respect to Esperanto at the beginning of the twentieth century, along with its existence in the cultural imaginary (in this case the *Strand*'s middle-class readership) as a potential realization of both age-old utopian ideals and modernity. The Esperanto movement was a cultural phenomenon as well as a social movement. It promised practical advantage and utility, but it also inspired the imagination. Esperanto prospered as an artificial language because of its associated culture. Esperanto World Congresses featured performances of plays written in the language as social entertainment; furthermore, Zamenhof included poetry written in Esperanto as part of the first publication about the language.[44] As the premier invented language of modernity, Esperanto was more than the sum of its parts. It was not just a linguistic construction, a set of grammatical rules and made-up words: rather, it was a way of thinking and being (whether or not one subscribed to Zamenof's philosophy) and a medium for self-expression.[45] How better to identify oneself as a citizen of modernity, if not futurity, than to learn and speak the new proposed international language? Esperantists could—in the manner of

an actor taking on a role—slip out of prescribed national or ethnic identities when performing speech acts in Esperanto and adopt an invented, international or politically neutral identity instead, at least according to Zamenhof. In repeating these actions and "restoring" behavior, people rendered their identities as Esperantists performative, and thus ostensibly natural (in theory).[46]

Language inventors like Zamenhof resemble avant-gardists in their desire to disrupt the status quo and transform society, leading the way with their revolutionary ideas. To speak an invented language and adopt its ethos (if it has one) is to align oneself with a "minoritarian formation that challenges power in subversive, illegal, or alternative ways, usually by challenging the routines, assumptions, hierarchies and/or legitimacy of existing political and/or cultural institutions," to quote Mike Sell's expansive definition of the avant-garde.[47] Zamenhof and his fellow Esperantists were not militant in their pursuits; they simply strove to encourage others to participate in their social engineering initiative through discourse, instruction, and example. They hoped people would be swayed by the logic and idealism of their endeavor. Ironically, and fascinatingly, the U.S. army perverted Esperanto's peaceful philosophy by claiming it as the language of "Aggressor": a fictitious European nation-state used in army training exercises of the 1950s and 1960s. In so doing, they tapped its performative potential. According to a U.S. army field manual, Esperanto was "adopted by Aggressor because of its international flavor. It is therefore consistent with the neutral or international identification implied by Aggressor."[48] The U.S. army war office provided all the salient details for its troops to perform the role of Aggressor soldiers in elaborate field manuals, outlining costumes (i.e., military dress), language particulars (i.e., grammar, vocabulary), and documentation (in Esperanto), and even made a training film in which U.S. army personnel interrogate an Aggressor prisoner in the invented language.[49] Zamenhof surely would not have approved (he died in 1917). Still, linguistic innovation and performative action are often intertwined. Avant-gardists played upon this intertwining. They sought their own universal language, responding to modernity's linguistic "crisis" by turning Babel into creative babble. Enter the dadaists.

A "Universal" Language of Sound: Tzara, Ball, and Schwitters

Dada's first incarnation at the Cabaret Voltaire in Zurich in 1916 featured a conglomeration of styles and genres rather than a single, overarching aesthetic. It was based on platforms of opposition, playful antagonism, anti-rationalism, primitivism, flippancy (mixed with seriousness), and

structured anarchy along with light entertainment. The dadaists highlighted the failings and limitations of conventional language, creatively amplifying communicative disorder. In this way, they staged modernity's linguistic "crisis" and offered a "universal" language of basic speech sounds intended to function as a common denominator. This is indicated in the word "dada" itself, which has no single meaning but variously translates as "yes, yes" in Rumanian and Russian, "rocking horse" and "hobbyhorse" in French, "get off my back" and "goodbye" in German, and "father" in English (this list is not exhaustive).[50] According to dadaist Richard Huelsenbeck, "Dada is a word that exists in all languages—it expresses nothing more than the international nature of the movement; it has nothing to do with the childlike stammering with which some have tried to link it."[51] The dadaists' use of language was not merely intended to frustrate meaning and rile audiences, nor was it simply the expression of a shared ideology of philosophical nihilism and modern discontent; rather, it demonstrates a burgeoning transnational poetics, an attempt to use sonic utterance as a lingua franca, thereby fashioning an artistic Esperanto, so to speak.

Tristan Tzara, whose real name was Gabriel Rosenstock ("tzara" means "trouble" in Hebrew), used language to promote illogicality and nonsensicality—favorite dadaist conditions. In Tzara's plays, strangely named characters speak mostly impenetrable dialogue composed of seemingly random words, numbers, and formulae strung together, along with the occasional intimation of primitive utterance. The title of his play *La Première Aventure Céleste de Monsieur Antipyrine* (*The First Celestial Adventure of Mr. Antipyrine*, 1916) signals its quirky and inscrutable nature, which is mostly composed of gibberish. This is immediately established:

> MR. SHRIEKSHRIEK: masks and rotting snows circus pskow i push factory in the circus pskow the sexual organ is square is iron is bigger than the volcano and flies off above mgabati offspring of distant mountain crevasses tropical portugal wharf and parthenogenesis of lung iron hiding things dschilolo mgabati bylunda
> THE PREGNANT WOMAN: toundi-a-voua soca bgye affahou...
> MR. ANTIPYRINE, FIRE EXTINGUISHER: door sealed without brotherhood we are bitter fel twist to cede centipede of the eiffel tower enlarge lard lord and lard mechanism without pain 179858555 yeyo bibo bibi aha my god oh my god along the canal the fever of childbirth laces and SO2H4[52]

Tzara's language resembles a garbled or badly translated version of an original, coherent text, except this is not so: Tzara's language is itself

"corrupt," and although it reads better in French (i.e., less disjunctive sounding, its internal and external rhymes intact), it is still full of non-sequiturs and nonsense statements. It is as though the characters' speeches derive from overheard or misheard conversations, joined together with stray references (or fragments of telegram messages?), similar to James Joyce's densely allusive style of writing (in *Finnegans Wake*, for instance) only without an apparent ordering principle.

Tzara's *Le Couer a Gaz* (*The Gas Heart*, written in 1920 and first performed in Paris the following year) is not as linguistically indecipherable as *Mr. Antipyrine*, though it is more obviously absurd with its dramatis personae of named body parts. Tzara implies the inadequacy or failure of language by repeating words and phrases until their meaning is eroded (just as pronouncing a word over and over again in quick succession may make it sound strange).

> *EYE*: Statues jewels roasts Statues jewels roasts Statues jewels roasts Statues jewels roasts Statues jewels roasts And the wind open to mathematical allusions cigar pimple nose cigar pimple nose cigar pimple nose cigar pimple nose cigar pimple nose cigar pimple nose cigar pimple nose he was in love with stenographer[53]

Mouth and Eye make the banality of their speech a recurrent topic of conversation, prefiguring Hamm and Clov's exasperated exchanges in Beckett's *Endgame* (1957).

> *MOUTH*: The conversation is lagging, isn't it?
> *EYE*: Yes, isn't it?
> *MOUTH*: Very lagging, isn't it?
> *EYE*: Yes, isn't it?
> *MOUTH*: Naturally, isn't it?
> *EYE*: Obviously, isn't it?
> *MOUTH*: Lagging, isn't it?
> *EYE*: Yes, isn't it?
> *MOUTH*: Obviously, isn't it?
> *EYE*: Yes, isn't it?
> *MOUTH*: Very lagging, isn't it?
> *EYE*: Yes, isn't it?
> *MOUTH*: Naturally, isn't it?
> *EYE*: Obviously, isn't it?
> *MOUTH*: Lagging, isn't it?
> *EYE*: Yes, isn't it?
> *MOUTH*: Obviously, isn't it?[54]

The repetition and rearrangement of words and phrases suggest speech for the sake of it: an attempt to mask silence and fill an ontological void. If we take seriously—a tricky venture, given the play's billing as "the greatest three-act hoax of the century"—Eye's statement that its speech is intelligible to those who have experienced the war, then Tzara's play may be understood as an attempt to articulate a shell-shocked, post-war mentality:

> *EYE*: Have you felt the horrors of war? Do you know how to slide on the sweetness of my speech? Don't you breathe the same air as I do? Don't you speak the same language? ... What music filtered by what mysterious curtain prevents my words from penetrating the wax of your brain? Certainly, stone grinds you and bones strike against your muscles, but language chopped into chance slices will never release in you the stream which employs white methods.[55]

According to Eye, "language chopped into chance slices" (a good description of Tzara's method) is the choice mode of expression for the post-war subject: a linguistic breakdown to match the seeming chaos of human folly.

The dadaists' exploration of the failure of language to communicate meaning (or alternatively the communication of failure through linguistic non-meaning) also encompassed the Babel problem, which they addressed in miniature. In the simultaneous poem "L'Amiral cherche une maison à louer" ("The Admiral Looks for a House to Rent"), composed and performed by Tzara in collaboration with Huelsenbeck and Marcel Janco at the Cabaret Voltaire in 1916, the dadaists foregrounded language difference by turning it into a performance piece. Huelsenbeck reports of the performance:

> Tzara, Janco, and I recited a "simultaneous poem." We came out on stage, bowed like a yodeling band about to celebrate lakes and forests in song, pulled out our "scores," and, throwing all restraint to the wind, each of us shouted his text at the bewildered spectators. This was the first simultaneous poem ever performed on a European stage.[56]

The work consists of three vocal lines, one for each of the performers, written in German, English, and French, respectively, all declaimed or sung at the same time to the accompaniment of a large drum, a wooden rattle (a cliquette), and a whistle. The poem, which first appeared in print in the 1916 review *Cabaret Voltaire* (subsequent to its recitation), is presented as a hybrid dramatic text and musical score, complete with dramatis personae, coordinated words (and blank spaces), a "rhythmical

intermezzo" that features dynamic markings and a mixture of words and notated sounds, and an appended program note by Tzara. The only obvious point of connection between the three speakers occurs at the end of the poem in the final unison declaration "L'Amiral n'a rien trouvé" ("the admiral found nothing"); otherwise, the lines are independent of one another and largely nonsensical, to boot. In addition to being unpunctuated and ungrammatical, the text includes words with non-normative spelling (possibly aping the orthography of regional speech), for example, in Janco's sung (English) part: "Where the honny suckle wine twines ilself around the door a swetheart mine is waiting patiently for me I can hear the weopour will arround arround the hill"; nonsense words are also interposed with conventional words, as in "in der Natur chrza prrrza chrrrza im Kloset" in Huelsenbeck's (German) part.[57]

The poem's blending of words and sounds may represent the experiential flux of the searching subject (the admiral): a crisis of meaning that marks a fundamental inability to make sense of the world or locate a single, stable referent in it (i.e., a house to rent). However, the titular admiral may just be a framing device, which would make this interpretation superfluous. Hugo Ball considered the simultaneous poem to be an allegory for the plight of the modern subject (gendered male) whose "voice" and agency are threatened by the force of mechanical industry.

> The "simultaneous poem" has to do with the value of the voice. The human organ represents the soul, the individuality in its wanderings with its demonic companions. The noises represent the background—the inarticulate, the disastrous, the decisive. The poem tries to elucidate the fact that man is swallowed up in the mechanistic process. In a typically compressed way it shows the conflict of the vox humana [human voice] with a world that threatens, ensnares, and destroys it, a world whose rhythm and noise are ineluctable.[58]

Ball's interpretation (which is frequently cited and has become critical orthodoxy) is likely informed by his belief in the need for spiritual renewal in modernity. It offers an explanation for the arrangement of voices and noisemakers but does not strictly address the small-scale Babel the poem engenders. It is surely not coincidental, as commentators have noted, that the featured languages of the poem are those of nations that were then at war with one another.[59] In this light, the poem may be read as a critique and linguistic enactment of the current political situation (delivered in neutral Zurich), in which each vocalist disregards the other, speaks at cross-purposes, and only succeeds in confounding listeners and generating a form of acoustic violence. The poem lends itself to a variety of

possible interpretations, of course. In his "Note for the Bourgeois," Tzara advances the hermeneutical position of the "open," poststructuralist text, the meaning of which is individually composed in the act of reception as much as the act of creation. He does not explain the poem but proposes each listener has the opportunity to make his or her own "suitable" associations of meaning based on the way in which the poet has "channeled" the various textual fragments and woven them together.[60]

Nevertheless, the organizing principle of simultaneous language utterance should not be overlooked. It is the defining element of the simultaneous poem, which was an aesthetic innovation, at least in practice, for the poem recalls Robida's late-nineteenth-century fantasy of trilingual theatre, discussed earlier. In Robida's imagining, audience members are presented with three sets of actors speaking the same lines at the same time in different languages and follow their language of choice. In the dadaist simultaneous poem, the listener is presented with discrepant languages and texts, in addition to non-linguistic sounds, and is invited to make sense (or not) of the resulting cacophony. The simultaneous poem is designed to prevent, or complicate, the task of following any one line. This is especially apparent when one hears the poem performed.[61] One can visually delineate individual lines on the page; it is much harder to disentangle verbal polyphony in audio form. Unlike Robida's trilingual theatre, the simultaneous poem draws attention to the cross-purpose interference of multilingualism and equates it with noise, recalling the debilitating and corruptive effects of multilingual modernity as espoused by advocates of a single, shared language. Tzara was characteristically flippant about the subject of a universal language, mischievously saying in a 1920 manifesto: "The good Lord created a universal language, that's why people don't take him seriously. A language is a utopia. God can allow himself not to be successful: so can Dada."[62] The simultaneous poem makes intelligible languages seem unintelligible: rather than reinforce a common meaning, as happens in Robida's fantasy, it fractures linguistic integrity and generates general semantic and aural confusion. It succeeds at failing.

The inspiration for the dadaists' creation of simultaneous poetry is easily discerned. The conscription-avoiding, self-exiled artists who took refuge in neutral Zurich during the war and performed at the Cabaret Voltaire spoke a number of different languages between them but not with equal proficiency. Hans Arp was bilingual in French and German; Tzara spoke Romanian, some French (reportedly with a thick Romanian accent), and a little German; Janco spoke Romanian; while Huelsenbeck, Ball, and Emmy Hennings principally spoke German. Communication with the German-speaking Swiss populace could not have been entirely

straightforward. Presumably, some linguistic muddling and communication problems were not uncommon; the miniature Babel presented in the simultaneous poem may reflect this. Historical circumstances, Zurich's political neutrality, and the linguistic proficiencies of the dadaists combined to create a polyglot environment and, hence, an opportunity for artistic experimentation (cf. Zamenhof's upbringing in Bialystok). The simultaneous poem presented and exaggerated the linguistic and national differences of the group, making rough music—an artistic babble—out of it.

Like other exiled modernists, the dadaists cultivated a "transnational poetics" that promoted dialogical energies and interstitial identities over unitary myths of belonging (i.e., the prevailing nationalist ethos of the time). Jahan Ramazani considers this phenomenon:

> Although national labels impute singularity and coherence, poets make and remake their often interstitial citizenship... through formal and ideological rewritings, through mutations of sound and trope that can span nationalities. More than norms of literary citizenship based on either political jurisdiction and place of birth (demos) or on their filiative counterpart (ethnos), a concept of poetic citizenship allows for poems formed by both unwilled imaginative inheritances and elective identifications across national borders.[63]

Dada, an international movement par excellence, accords with this conception. "Dada was necessarily an international product," Huelsenbeck stated in 1918. "We had to find common ground among the Russians, Roumanians, Swiss, and Germans.... [That's] how Dadaism originated, [it was] a focal point for international energies."[64] In his autobiography, Huelsenbeck says he enjoyed the foreign milieu, the "lack of German substance" in his life ("Here in Zurich, I was a foreigner, and I wanted to remain one").[65] Similarly, Hugo Ball effectively renounced his German nationality in the editorial he wrote for the *Cabaret Voltaire* publication of 1916, saying the cabaret aimed to demonstrate that "there are, outside of the war and nationalism, independent men who live for other ideals."[66] The simultaneous poem performs the dadaists' linguistic homelessness, notes T. J. Demos:

> No single language could achieve dominance in order to orient the poem, no official voice could operate as a grounding frame of reference. Instead, the poem became a cosmopolitan stage for multilingual interactions, non-hierarchically intermingling the plural speech of displaced subjects—words inevitably mixed with others from different languages, each continually

invaded by an otherness not only foreign but also an integral part of the poem.[67]

Demos argues that the Zurich dadaists strove to operate outside of nationalist structures of belonging by adopting, or rather creating, politically neutral artistic identities. "Exiled to Zurich," he writes,

> the dadaists *expatriated* language in turn, uprooting it from semantic value, estranging it from everyday meaning, freeing it from official discourse.... By severing ties to the home—suggesting a matrix of tradition, habit, familiarity, and comfort—dadaists promised a new openness to the world, like sailors on an open sea of possibilities.[68]

Like the imagined inhabitants of Esperanta, the Zurich dadaists sought to invent cultural identities for themselves that were not nationally specific but derived from a mishmash of sources (including the non-Western, notional primitive, which inspired the infamous "negro" poetry of Tzara and Huelsenbeck). These performative identities were essentially plural, commingled, and always-already othered (i.e., constituted by transnational influences).[69]

One of the ways the dadaists attempted to find common ground with each other and their audience was through sonic utterance instead of, or alongside, conventional language.[70] Here again is the trope of sound as a universal language. In the polyglot environment of the Cabaret Voltaire, a basic language of phonemes was something the assorted participants could share, and was, like wartime Zurich, ideally neutral.[71] Moreover, phonemic expression—a language of "pure" sound—helped loosen individual national affiliations and project a conceptually fluid trans- or supra-national artistic identity. This offers insight into the dadaists' fascination with sound poetry in performance, most notably that of Hugo Ball and Kurt Schwitters (the latter of whom was not involved with Zurich dada but his work demonstrates an aesthetic affinity with it).

Ball's attitude toward language was imbued with religious feeling. For him, the word was also logos, as this diary entry suggests:

> The word has been abandoned; it used to dwell among us.
> The word has become commodity.
> The word should be left alone.
> The word has lost all dignity.[72]

Ball sought to recuperate the spiritual component of "the word" by exploring its phonemic possibilities, excavating a rudimentary language of speech sounds. He did this by composing sound poetry that abjured

recognizable words in favor of common phonemic elements ("isolated vocables") that were meant to evoke a sacred, magical, or originary form of expression.

> We tried... to give the isolated vocables the fullness of an oath, the glow of a star. And curiously enough, the magically inspired vocables conceived and gave birth to a new sentence that was not limited and confined by any conventional meaning. Touching lightly on a hundred ideas at the same time without naming them, this sentence made it possible to hear the innately playful, but hidden, irrational character of the listener; it weakened and strengthened the lowest strata of memory. Our experiments touched on areas of philosophy and of life that our environment—so rational and so precocious—scarcely let us dream of.[73]

Ball suggests this new type of poetic utterance does not negate language per se but re-imagines it and recuperates its "hidden" or "forgotten" meanings. He imagines this to be a quasi-mystical undertaking that will restore the "invulnerability" of the word by way of poetic divination: seeking out, arranging, and declaiming a phonemic language that might stimulate the listener's primordial acoustic imaginary. Ball proposed to devise or divine new word formations that had inherent, affective resonances. He imagined his listeners might grasp his spiritualized sonic utterances even though—or perhaps because—they had no fixed meaning.

Ball prioritized the oral and aural dimensions of his poetry and considered recitation to be superior to reading; he was also committed to staging his sound poetry in a theatrical manner, giving it a religious cast. The iconic, widely reproduced image of Ball in his cubist "magical bishop" costume, which he wore when reciting his poems at the Cabaret Voltaire, is indicative in this regard. In his diary, Ball writes of how he had to be carried onto the stage because of his cylindrical cardboard costume and how he then "officiated" at each of the music stands, which held the manuscript of his poems. Despite the peculiarity of his outfit and poetry, he wished to remain serious and find a mode of expression suitable for the staged pomp. He harked on the cadence of priestly lamentation: the liturgical singing style of a Roman Catholic priest.

> I do not know what gave me the idea of this music, but I began to chant my vowel sequences in a church style like a recitative, and tried not only to look serious but to force myself to be serious. For a moment it seemed as if there were a pale, bewildered face in my cubist mask, that half-frightened, half-curious face of a ten-year-old-boy, trembling and hanging avidly on the priest's words in the requiems and high masses in his home parish.

Then the lights went out, as I had ordered, and bathed in sweat, I was carried down off the stage like a magical bishop.[74]

Ball's reported mimicking (or channeling) of priestly intonation marks an attempt to restore faith in the power of words to affect directly and spiritualize perception, even if the words in question are mostly gobbledygook. Ball's description of his poetry recitation invokes the tradition of religious glossolalia (speaking in tongues), in which a speaker, supposedly captivated by the Holy Spirit, vocalizes a string of nonsense syllables meant to have deistic significance. The glossolalist is understood to be speaking automatically or unconsciously (i.e., in a state of possession or religious ecstasy), the utterances comprised of syllabic strings taken from a native language, unstructured and lacking referential meaning (in the absence of someone gifted with the "interpretation of tongues"). In his performance at the Cabaret Voltaire, Ball read from a prepared script and his vocalizations were not unstructured, but he nevertheless professed to have enacted the role of a "magical bishop" and to have spoken with sincerity and devotion.[75]

Ball recited three of his sound poems at the Cabaret Voltaire on the evening of July 14, 1916: "Gadji Beri Bimba," "Wolken," and "Karawane" (with a subsequent reprise of "Gadji"). Three more poems complete the sequence. The poems are short, phonemically inspired word paintings that are especially effective when heard. No recording exists of Ball speaking his verse, but they have been variously interpreted, adapted, and recorded by other artists.[76] Ball's poetry occupies a nebulous territory between connotative abstraction and (occasional) denotative clarity. These poems do not aim to flaunt an absence of stable meaning, like Tzara's work; rather, they aim to re-acquaint the reader or listener with the "forgotten known," operating under the conceit that the poet's "magical" language reaches back to an earlier or intrinsic form of human understanding (similar to what language inventors posited as the "Adamic" language). The combination of the poems' titles (written in German, with the exception of "Gadji") and the phonemic substance of the verse provide the reader/listener with an intimation of each poem's subject. For instance, "Gadji Beri Bimba" is likely meant to evoke a type of primitive chant or ritualistic invocation:

> gadji beri bimba glandridi laula lonni cadori
> gadjama gramma berida bimbala glandri galassassa laulitalomini
> gadji beri bin blassa glassala laula lonni cadorsu sassala bim
> gadjama tuffm i zimzalla binban giligla wowolimai bin beri ban
> o katalominai rhinozerossola hopsamen laulitalomini hoooo
> gadjama rhinozerossola hopsamen
> bluku terullala blaulala looooo[77]

There are too many phonemic repetitions and variations, as well as poetic devices such as alliteration (e.g., beri bimba, laula lonni) and assonance (gadjama gramma... galassassa), to suppose this is just a random hodgepodge of words (like Tzara's *Mr. Antipyrine*). These words have been carefully considered, even if they are nonsensical. The first line of the following stanza—"zimzim urullala zimzim urullala zimzim zanzibar zimzalla zam"—contains the word "zanzibar," an apparent reference to the island off the coast of Africa (previously encountered in Apollinaire's *The Breasts of Tiresias*). Zanzibar presumably represented something strange, far-flung, and exotic to avant-gardists. It is another indicator of Ball's primitivist intentions (in his diary, he notes that a witch doctor's hat was part of his costume).[78] His "magical" language was meant to rebuke rational discourse and function as an unmediated, instinctual expression of elementary perception: a supposedly authentic, "un-invented" universal language.

The remaining poems in the sequence showcase this "primal" language, connoting, with varying degrees of clarity, a range of invocations, scenes, and figures: for example, a rain chant in "Wolken" ("Clouds") based on onomatopoeic "liquid" sounds ("gragluda gligoda glodasch"); a passage of elephants in "Karawane" ("Caravan"), suggested by a combination of plosives and broad vowel sounds ("jolifanto bambla o falli bambla /... blago bung blago bung"); figurative caterwauling in "Katzen und Pfauen" ("Cat and Peacock") emphasized by diacritical marks ("mâ mâ/ piaûpa/ mjâma"); a ragged lament for the dead (or a death rattle) in "Totenklage" ("Dirge": an old musical form), suggested by elongated vowel sounds ("o kla o auw/ kla o auwa/ la—auma/ o kla o ü/la o auma"); and an animated encounter with sea life in "Seepferdchen und Flugfische" ("Seahorse and Flying Fish"), connoted by a trail of sibilance and short "darting" sounds ("tressli bessli nebogen leila/ flusch kata/ ballubasch/ zack hitti zop").[79] Listening to vocal interpretations of these poems makes their programmatic content matter apparent. The poems are word paintings (or phoneme paintings) that utilize sound symbolism—the analogical association of letter groupings with meanings—to connect poetic patterns to recognizable images and actions, while largely avoiding denotative or referential language.[80] Linguists have shown how front vowels ("i" and "e") tend to represent light things in words across language groups whereas back vowels ("o," "u," and "a") tend to denote heavier, rounder things (this has special application in naming food products).[81] Ball's poetry relies upon these associations to convey sense impressions. Even still, it cannot truly function as a universal language because sound symbolism is a variable component that can signify differently from one language to the next (hence the truism that different languages often have different words for the same sound, such as the sounds that represent

various animal utterances, for example). Besides, it is necessary to know the title of Ball's poems (most of which are written in German) in order to hear (i.e., identify) each phonemic word painting; it is unlikely (or at least not definite) that one would guess the evoked images otherwise, despite Ball's belief that these "vocables" touched the "lowest strata of memory" known to man.

Kurt Schwitter's monumental sound poem "Ursonate" (alternatively titled "Die Sonate in Urlauten," or "Sonata in Primal Sounds," composed between 1922 and 1932, is a further example of avant-garde experimentation with "primal" language. It extends the semantic drift of Ball's poetry by disregarding denotative meaning and exploiting purely phonemic sounds. Since the work is not "about" anything, per se, there is nothing much to misunderstand; as such, it functions as a plausible universal language, equally (mis)understood by all, even if German speakers have an advantage in appreciating its phonemic character and inflections. This aspect of Schwitters' poem was emphasized in a stage adaptation directed by Katrin Kazubko that was presented at the International Federation of Theatre Research (IFTR/FIRT) World Congress at the Prinzregentheater in Munich in July 2010. The artistic rationale for the staging highlighted the work's communicative possibilities, which are not immediately apparent if the poem is not spoken aloud or performed. The program stated: "The artistic form of the Ursonate does not depend on the meaning of a specific language and is therefore 'understandable' for an international audience. Whether you speak Arabic, French or Spanish, you will grasp just as much as the German performers on stage."[82] Schwitters' sound poem was narrativized and presented in a language no one could understand but everyone could potentially appreciate: a realization of the apparently global reach of Schwitters' dadaist creation.

In "Ursonate," Schwitters adopts the structure of a classical sonata: a prelude, followed by a first movement rondo, a second movement largo, a third movement scherzo and trio, a fourth movement presto (with improvised cadenza), and a finale. The score is notated phonetically and contains specific, marked themes, transitions and developments, tempo and meter indications, occasional pitch directions, interpretive suggestions, and dynamic markings. It is a work of considerable length and formal complexity (it typically takes approximately 40 minutes to recite, depending on the tempo). With the exception of a handful of words and an alphabetic finale, the work is entirely based on strings of phonemes, taking as its inspiration and opening line Raoul Hausmann's 1918 poster poem "fmsbwtözäu," which Schwitters heard Hausmann recite at a soirée in Prague in the autumn of 1921.[83] The phonemes, which are based on the German language (and were intended to be pronounced as such), are

arranged not for the purposes of semantic meaning (which is nonexistent) or sound symbolism (which is limited) but for musical qualities. Schwitters uses them to formulate motifs and themes, which he develops with formalist precision, and with a keen ear for how speech sounds may generate an effective (and affective) combination of syllabic variance, correspondence, and cohesion. Schwitters' compositional technique involves building up small phonemic units using repetition, gradually changing the pattern of the sound shapes.

Bö	böwörötääböpö
bö	böwörötääböpö
bö	böwörötääböpö
bö	böwörötääböpö
bö	böwörötääzääböpö
bö	böwörötääzääböpö
böwö	böwörötääzääböpö
böwö	böwörötääzääböpö
böwö	böwörötääzääböpö
böwö	böwörötääzääböpö
böwö	böwörötääzääUu böpö
böwö	böwörötääzääUu böpö
böwörö	böwörötääzääUu böpö
böwörö	böwörötääzääUu böpö
böwörö	böwörötääzääUu böpö
böwörö	böwörötääzääUu böpö
böwörö	böwörötääzääUu pögö
böwörö	böwörötääzääUu pögö
böwöböpö	böwörötääzääUu pögö
böwöböpö	böwörötääzääUu pögö
böwöböpö	böwörötääzääUu pögö
böwöböpö	böwörötääzääUu pögö
böwöböpö	böwörötääzääUu pöggiff
böwöböpö	böwörötääzääUu pöggiff
böwöröböpö	böwörötääzääUu pöggiff
böwöröböpö	böwörötääzääUu pöggiff
böwöröböpö	böwörötääzääUu pöggiff
böwöröböpö	böwörötääzääUu pöggiff
böwöröböpö	fümmsböwötääzääUu pöggiff
böwöröböpö	fümmsböwötääzääUu pöggiff
böwörötääböpö	fümmsböwötääzääUu pöggiff
böwörötääböpö	fümmsböwötääzääUu pöggiff
böwörötääböpö	fümmsböwötääzääUu pöggiff

fümmes bö wö tää zää Uu, kwiiee
pöggiff, kwiiee
kwiiee kwiiee
kwiiee kwiiee.[84]

On the page, the poem resembles the work of someone practicing typing exercises. Schwitters said "[it] is better to hear the sonata than to read it," suggesting his linguistic experimentation was more phonic than visual; this is not to disregard the significance of the typography and layout.[85]

"Ursonate," like Arnold Schoenberg's serial (twelve-tone) technique, evinces mathematical exactitude and elaboration of combinatorial possibilities, such that its formal schema is not just an incidental device (an homage to a classical sonata) but a way of ascribing order to—and investigating the communicative potential of—speech sounds, recomposing them in a novel manner. The finale is a microcosm of this approach: it is constructed as a retrograde alphabet (in German) that denies expectations by not finishing on the first letter of the alphabet.

> Zätt üpsiilon iks
> Wee fau Uu
> Tee äss ärr kuu
> Pee Oo änn ämm
> Ell kaa Ii haa
> Gee äff Ee dee zee beee?[86]

This block (stanza) is repeated four times. In the third iteration, the final phoneme is "Aaaaa," but not the fourth, which ends like the first two blocks on "beee," and is marked "dolefully." Schwitters writes that one "senses" the inverse sounding of the alphabet and waits with much expectation for the a, but that ending with b allows the poet to avoid the "banality" of "necessary resolution" (ending with the figurative tonic key).[87] Schwitters is fascinated by phonemic and alphabetic patterns, but this fascination is directed toward breaking patterns as much as fulfilling them, teasing the listener's expectations. Hence his notated directions that successive lines in the largo should be spoken a quarter tone lower than the last, the themes of the third movement are to be performed in "distinguishably different ways," and the fourth movement cadenza should be ad-libbed though based on the preceding themes. Schwitters aimed to make music out of abstract sound shapes and create tension between unity and contrast, order and chaos.

Listening to Schwitters' recording of "Ursonate" (made in 1932 but only discovered in the early 1980s) makes this delicate balance apparent.[88]

Schwitters' style of recitation is controlled and even-keeled throughout (possibly to aid the recording). Overall, he speaks in a carefully modulated pitch range that favors long, sustained notes with occasional rising and descending inflections (e.g., a slowly rising pitch range in the development section, quoted above, and a falling inflection for the repeated "kwiiee" utterances in the first movement), either for distinguishing effect or to mark the conclusion of a section. Schwitters uses particular intervallic pitch ranges for some motifs ("Juu Kaa," "Rrummpff tillff tooooo"), roughly approximating the interval of a perfect sixth, but this only reinforces the measured nature of his delivery, which even at its highest points (e.g., the "screeched" interrogative "Fümmes bö wö täää???" at the end of the first movement) is still restrained.[89] One is mostly struck by the clarity of his diction and the ease with which he rattles off this virtuosic tongue twister. Schwitters is adept at distinguishing the expressive characters of the various themes, and does exaggerate slightly for effect: most notably, the gentle crooning vowel sounds in the trio ("Ziiuuu iiuu/ ziiuu aauu/ ziiuu iiuu/ ziiuu Aa") and the intimations of a tribal war dance in the fourth movement presto ("Tilla loola luula loola/ Tilla luula loola luula/ Tilla loola luula loola/ Tilla luula loola luula"), but this is exceptional.[90] In general, his declamation impresses with its quiet, careful control, which eventually works to cast a hypnotic spell or appreciative thrall over the listener, lulling one into collusion with the organized play of phonemes, the gentle babble.

This is indicated by a description of Schwitters' public reading of "Ursonate" at the home of publisher Gustave Kiepenhauer in Potsdam, Brandenburg in 1924/1925 as part of a joint recital with the pianist Nelly van Doesberg. Schwitters, who gave a series of poetry recitals in various German cities in the early 1920s, performed before an audience largely composed of local gentry. Hans Richter provides an account:

> Schwitters stood on the podium, drew himself up to his full six feet plus, and began to perform the Ursonate, complete with hisses, roars, and crowings, before an audience who had no experience whatever of anything modern. At first they were completely baffled, but after a couple of minutes the shock began to wear off. For another five minutes protest was held in check by the respect due Frau Kiepenhauer's house. But this restraint served only to increase the inner tension. I watched delightedly as two generals in front of me pursed their lips as hard as they could to stop themselves laughing. Their faces, above their upright collars, turned first red, then slightly bluish. And then they lost control. They burst out laughing, and the whole audience, freed from the pressure that had been building up inside them, exploded in an orgy of laughter. The dignified old ladies,

the stiff generals, shrieked with laughter, gasped for breath, slapped their thighs, choked themselves.

Kurtchen [Schwitters] was not in the least bit put out by this. He turned up the volume of his enormous voice to Force Ten and simply swamped the storm of laughter in the audience, so that the latter seemed almost to be an accompaniment to the Ur Sonata.... The hurricane blew itself out as rapidly as it had arisen. Schwitters spoke the rest of his Ur Sonata without further interruption. The result was fantastic. The same generals, the same rich ladies, who had previously laughed until they cried, now came to Schwitters, again with tears in their eyes, almost stuttering with admiration and gratitude. Something had been opened up within them, something they had never expected to feel: a great joy.[91]

The combination of seriousness (formal rigor) and silliness (nonsense sounds) that marks Schwitters' work gives it a peculiar charm, which, in this instance, seems to have enabled the audience to experience a type of cathartic pleasure in enjoying phonic nonsense. The babble of "Ursonate," which Schwitters tightly controls (as poet and performer), allows its listeners to enjoy figurative regression and let go of inhibitions, bodily dispositions, and behavioral decorum. In Richter's account, Schwitters caused the audience at Kiepenhauer's house to lose control: unable to cover up their own laughter, and helpless in the enjoyment of their own bad behavior ("choking themselves"), they reportedly turned into a mass of writhing, laughing, teary-eyed bodies, before pulling themselves together again.[92]

The "primal" sounds of Schwitters' sonata, which may tickle an audience's collective fancy, arguably have more to do with infantilism than primitivism, or may perhaps conflate these categories. In fashioning a type of artistic babble (alternately reduplicating and variegating vowel and consonant sounds), Schwitters demonstrates the phonic plenitude of this form of utterance, which far surpasses the repertoire of sounds contained in any given language. Remarkably, infants (etymologically derived from infans: "without speech") have an unparalleled capacity for a type of articulation that successfully operates outside of linguistic constraints. Roman Jakobson observes: "a babbling child can accumulate articulations which are never found within a single language or even a group of languages: consonants with the most varied points of articulation, palatalized and rounded consonants, sibilants, affricates, clicks, complex vowels, diphthongs, and so forth."[93] According to Jakobson, all manner of articulations are possible for the infant at the "apex" of babble; it is the entry into language that restricts and ultimately shunts one's articulatory prowess. "Ursonate" might be construed as an attempt to

remember or recover the sound worlds of infantile prattle.[94] The long lists of phonemes that Schwitters compiles and assembles into various shapes may connote the lost-but-potent babble of youth. By composing a full-length sonata of babble sounds, Schwitters investigates the articulatory repertoire of the pre-linguistic domain and champions its potential for proto-semantic meaning and musical affectivity, indicating the relative paucity and constriction of conventional speech by comparison.[95] Although "Ursonate" might initially alienate listeners by virtue of its expressive abstraction, its babble also has the capacity to transcend linguistic barriers and competences, proffering a type of phonemic lingua franca. Indeed, infant-directed speech (baby talk) has been shown to contain common cross-cultural and cross-linguistic elements relating to the prosodic contours of intention categories (the tones of voice in which directives are given to infants).[96] Moreover, infant babble itself is not culturally or linguistically specific up until the age of about nine months.[97] Schwitters' "Ursonate," an artistic corollary of the practical ambitions of modern language inventors, exploits the potential universalism of babble as a means of communicating non- or proto-semantic meaning; it works to unite audiences through subconscious engagement with a shared system of vocable sounds.

"THIS IS ALL A LOT OF GABBLE!": KHLEBNIKOV'S *ZANGEZI*

Perhaps the most overt example of avant-garde linguistic experimentation paralleling the efforts of inventors like Zamenhof is the work of the Russian futurist Velimir Khlebnikov, who, together with Alexei Kruchenykh, devised a "transrational" mode of linguistic expression called "zaum." Zaum is a neologism based on the Russian root "um" (mind, wit, intellect) and the prefix "za-" (beyond) that refers to a mode of expression with indefinite or indeterminate meaning.[98] The English translation of the term that has enjoyed most usage is Paul Schmidt's coinage "beyonsense," which connotes the dimension of transrationality as well as the tendency to deform or defamiliarize words. Zaum cannot be strictly defined. Its creators used it to accommodate a wide range of linguistic play, modifying their usage over time. Both Kruchenykh and Khlebnikov sought to expand the connotative potential of words by articulating them in novel and seemingly irrational fashions, examining the bonds between signifier and signified and going "beyond" traditional associations made by the mind. Kruchenykh favored the use of neologisms, puns, non-sequiturs, fragments, hybrids, and other linguistic devices to dislocate meaning and suspend common sense, while Khlebnikov adopted a more scientific approach of linguistic dissection and reconstruction,

endeavoring to invent (purportedly to recover) a type of fundamental proto-language with universal significance. Khlebnikov made this claim explicitly; it is ever only an implication of the work of Ball and Schwitters. Khlebnikov knew of Esperanto (which enjoyed some popularity in Russia at this time, despite official disapproval), and was favorably disposed toward it.[99] He is reported to have found it "very well structured, light and beautiful, but poor in sounds and not very varied," with "an excess of homonyms and a poverty of synonyms."[100] Evidently, he thought he could do better. "The language of zaum is the seed of the future universal language," he declared. "It alone can unite people."[101]

Khlebnikov articulates his universalist conception of zaum in an essay that distinguishes him as a language inventor. The essay "To the Artists of the World, A Written Language for Planet Earth: A Common System of Hieroglyphs for the People of Our Planet" (1919), is, as the title suggests, a rallying call for artists to assist Khlebnikov in creating graphic signs to denote the meanings of common phonemic elements the author claims to have discovered. Khlebnikov, aping Zamenhof and his ilk, grandiosely declares that his goal "is to create a common written language shared by all the peoples of this third satellite of the sun, to invent written symbols that can be understood and accepted by our entire star, populated as it is with human beings, and lost here in the universe."[102] Khlebnikov laments the contemporary state of affairs, in which sounds "serve the purposes of hostility," dividing "multilingual mankind into different camps" and serving to "disunite mankind and wage spectral wars."[103] He contrasts this modern, violent linguistic Babel with the purported linguistic unity of pre-historic times ("a union of those who shared one single auditory instrument for the exchange of values and ideas") and draws a positive comparison with the single written language of the Chinese and Japanese (disregarding regional, spoken varieties and seemingly oblivious to imperial history).[104] Language inventors of the time commonly used these rhetorical and ideological positions to justify their creations: the language invention project was pitched as a reconstruction or re-discovery of something approximating the *lingua adamica* (or indeed the thing itself), and the Chinese language was held up as an exemplar of linguistic integrity and directness (as though it preserved a connection to a lost unity).[105] Khlebnikov, championing the unifying potential of written language, proposes that "[mute] graphic marks will reconcile the cacophony of languages," thus eliminating the contrariety of oral communication.[106] In this version of zaum's mooted universalism, the act of visual decipherment is paramount, though the poet did not discount hearing and imagination. Khlebnikov fantasized, Robida-like, that the "radio of the future"—which would take the form of radiolibraries (books broadcast

over the radio), radioauditoria (spaces designed for the communal reception of radio), radio exhibitions (of paintings, using visual signals) and radioclubs (social gatherings conducted in radiophonic space)—would unite world consciousness in one will: "Thus the Radio will forge continuous links in the universal soul and mold mankind into a single entity."[107] Presumably, zaum would have served as the ideal language for the radio of the future, as Esperanto (nominally) did for early-twentieth-century telegraphy. However, it would have had to have been readily comprehensible, which might have been a problem.

Khlebnikov claimed to have discovered an inherent meaning for alphabetic sounds (specifically consonants), postulating that letters articulate spatial configurations and patterns of movement in the universe. Although this esoteric theory of sound symbolism was based on a study of Russian characters, Khlebnikov believed the alphabetic code was common to the languages of a multitude of peoples and could be construed as a shared, universal (proto-) language. The first five entries of Khlebnikov's alphabetic dictionary of the spatial world are as follows (the Cyrillic character is given first, followed by the Latin equivalent in parentheses):

1. В (v) in all languages means the turning of one point around another, either in a full circle or only part of one, along an arc, up or down.
2. Х (kh) means a closed curve that shields the location of one point from the movement toward it of another point (a protective line).
3. З (z) means the reflection of a moving point from the surface of a mirror at an angle equal to the angle of incidence. The impact of a ray upon a solid surface.
4. М (m) means the disintegration of a certain quality into infinitely small parts (within certain limits) equal as a whole to the original quality.
5. Ш (sh) means the merging of several surfaces into a single surface and the merging of boundaries between them. The striving of the one-dimensional world of any given dimension to describe a larger area of a two-dimensional world.[108]

So far, so peculiar. Khlebnikov appears to have developed his system by finding correlations between the meanings of words that begin with a particular letter sound. For example, he suggests that because there are 20 names for buildings that begin with the letter x (kh) this letter has a protective signification. Khlebnikov likens a word's initial sound (syllable) to the chairman of a small workers' collective that directs the rest of the word's sounds, claiming "[if] we assemble all the words that begin with

the same consonantal sound, we observe that, just as meteors often fall from one single point in the sky, all these words fly from the single point of a certain conceptualization of space."[109] According to Khlebnikov, the shape words take is not wholly arbitrary, even if they contain "meaningless," unrelated parts—semantic dross. The signifier and the signified are connected by a type of "deep" structure revealed by a detailed consideration of linguistic roots, which are the true bearers of meaning. These "alphabetic verities" provide the essential kernel of meaning for words in multiple languages and are present even if unacknowledged or hidden by conventional semantics or verbal texture, as daylight obscures our vision of the ever-present stars.[110]

Khlebnikov alternates between characterizing zaum as a scientific project, and therefore an exercise in reason (albeit of an eccentric and probably misguided type), and propounding its transrational and primeval aspects, as something one intuits even if one does not quite fathom, like Ball's phonemic word-painting. In his essay "On Poetry" (1919–1920), he writes:

> If we think of the soul as split between the government of the intellect and a stormy population of feelings, then incantations and beyonsense language are appeals over the head of the government straight to the population of feelings, a direct cry to the predawn of the soul or a supreme example of the rule of the masses in the life of language and intellect.[111]

This is a classic formulation of an avant-gardist's faith in sonic affectivity, but it does rather muddle the case for Khlebnikov's alphabetic dictionary. Is zaum a product of rational consideration or does it involve an instinctual process anterior to reason? Khlebnikov seems to suggest both propositions are true. In his view, beyonsense language holds the possibility of universality by arranging semanticized phonemes (sounds that have inherent meaning) in a creative fashion: a curious combination of structure and anti-structure, reason and whimsy. Khlebnikov explains:

> if we take a combination of... sounds in an unrestricted order, such as *bo beh o bee*, or *dyr bul shchyl*, or *manch! manch!* or *chee breo zo!*, then we obtain words that do not belong to any particular language but that do say something; something elusive but real nevertheless.[112]

Elsewhere, Khlebnikov resurrects the Aristotelian idea, also theorized by the medieval philosopher William of Ockham, of a conceptual mental language that precedes verbal representation, which linguists have dubbed

"mentalese."[113] In an historical irony, what is apparently modern and new is actually quite old and has a long intellectual history, possibly unknown to the "re-originator" of the idea. In his essay "The Warrior of the Kingdom" (1913), Khlebnikov writes:

> [Besides] the language of words there is the silent language of concepts formed by mental units (the tissue of concepts that controls the language of words). Thus the words Italia, Taurdia, Volynia (all of which mean "the land of the bulls"), which have separate verbal existences, are one and the same thing—a rational existence that casts its shadows upon the surface of verbal expressions and political entities.[114]

Khlebnikov's aspirations for zaum's universality rest in part upon the supposition that it accords with an essential language of thought, which is theoretically shared by all humans regardless of nationality or linguistic capability. In articulating (or approximating?) this basic language of mental concepts, zaum might restore an apocryphal pre-Babelian linguistic unity and operate across linguistic divides. The task of the zaumnik (practitioner of zaum) is to identify the root meanings of language, isolate them, and fashion them into a new expressive mode that will touch the minds of readers (and listeners) by accessing the "hidden" meanings of linguistic sound shapes—similar to Ball's magical language, only taxonomic.

Khlebnikov concludes his missive to world artists by providing initial examples of beyonsense language ("universal" characters intermixed with standard Russian words). One of the examples reads like a statement culled from the manifesto of a language inventor. First, in embryonic zaum interspersed with Russian (here the Russian words are translated into English but the zaum words are left as is):

> Ve So of the human race Be Go of languages Pe of our minds Ve so SHa language, Bo Mo of words Mo Ka of thought Cha of sounds Po So Do Lu earth Mo So language, Ve earth.[115]

Khlebnikov provides a full Russian translation (here translated into English):

> Intent upon uniting the human race, but meeting the barrier of the mountain chains of languages, the fire storm of our minds resolves around the idea of a communal beyonsense language and achieves the atomization of words into units of thought contained in an envelope of sounds and then rapidly and simultaneously proceeds toward the recognition throughout the earth of one single beyonsense language.[116]

Even in nascent form, Khlebnikov's zaum suggests a condensed, more economic mode of expression suitable for the modern world, in line with the Italian futurists' advocacy of brevity and speed.[117] Notwithstanding the zeal of Khlebnikov's declaration, it is unclear if he genuinely thought zaum could be used as a practical universal or auxiliary language in the manner of Zamenhof et al. More likely, he regarded it as a primarily artistic pursuit. Khlebnikov used zaum to explore the Russian traditions of magical incantation and glossolalia, to articulate a heightened perception of historical events, and to flex the boundaries of (non)sense and reason. Like other Russian futurists (but unlike Zamenhof), Khlebnikov was a proud nationalist and wished to renew Russian culture with his artistic creativity, which explains why his purportedly "universal" language used Russian linguistic roots. For Khlebnikov, unification of people, revelation, and mystification were not mutually exclusive functions, which marks him out as an atypical language inventor (inventors are generally keen to stress the comprehensibility of their creations, even if they end up not being widely understood). The complexity and obliqueness of Khlebnikov's conceptions is made manifest in the dramatization of his proposed universal language.

Khlebnikov showcased zaum in his play *Zangezi: A Supersaga in 20 Planes*, written in 1922 (incidentally, the same year Schwitters began work on "Ursonate" and the League of Nations made its report on Esperanto), a few months before his death from malnutrition at the age of 36. The play consists of "a stack of word planes": illustrations of various aspects of Khlebnikov's linguistic and numerological theories, largely expressed by the protagonist, Zangezi, a Zarathustra-like figure who acts as Khlebnikov's alter ego and is a mouthpiece for his cosmological worldview and ideas. Khlebnikov defines a supersaga as a conglomeration of independent sections (or first-order narratives), each of which has "its own special god, its special faith, and its special rule."[118] The form allowed Khlebnikov to present selections of his artistic, pseudo-scientific, and mystical work—which he had developed over the course of several years—in the guise of a loosely connected, oftentimes opaque dramatic narrative. It also enabled him to experiment with the communicative potential of different types of zaum ("the varicolored blocks of the Word, each with its own different structure").[119] The play is not wholly written in zaum; rather, zaum is interspersed throughout as a heightened mode of expression (recalling the previously quoted example of embryonic zaum). *Zangezi* was first performed at the Petrograd Museum of Artistic Culture in May 1923 as part of a posthumous homage to Khlebnikov, and featured untrained student-performers. Vladimir Tatlin directed and designed the production, and took the title role.[120] Tatlin created material constructions to correspond with Khlebnikov's verbal constructions and

used a projector to showcase the scenography (which included visual lettering) and direct the spectators' attention. His declared goal was "to make Khlebnikov's work comprehensible to the masses": an ironic enterprise, given the subject matter, and difficult to boot.[121]

The plot involves a group of people coming to a clearing in the mountains (presumably somewhere in Russia) to hear the self-styled prophet Zangezi speak. Zangezi addresses his audience, some of whom are classified as believers, others as passers-by, using different formulations of zaum to expound upon his linguistic and numerological-historiographical theories. Zangezi's zaum-speech seems to make the gods depart and aggravates and confuses those in attendance, possibly causing one person to have an epileptic seizure. Zangezi leaves, having already sensed his end is near, trumpeting his powers of prognostication and his insight into the inter-operations of the word and the world. Zangezi, who claims to have divined the secrets of the universe, is the only human character in the play that speaks Khlebnikov's universal language. He imagines himself as a prophet and seer, the first human to speak the lingua franca of the future. Zangezi, like Khlebnikov (and Zamenhof), is a linguistic avant-gardist.

The first "plane" (section) of the play features the utterances of different species of birds (Khlebnikov was an expert ornithologist), which the author presents in onomatopoeic form (recalling Ball's sound poetry):

> Chaffinch (from the very top of the fir tree, puffing out its silver throat):
> Peet páte tveechan! Peet páte tveechan! Peets páte tveechan!
> Yellow Bunting (quietly, from the top of a walnut tree):
> Kree-tee-tee-tee-tee-ee—tsuey-tsuey-tsuey-ssueyee.[122]

This bird language may not strictly be considered zaum, but it establishes an expressive connection between the various orders (or planes) of Khlebnikov's imagined world. For example, Plane Two depicts the assembly of the "gods of all nations" in their encampment in the mountains; their speech, while not identical to that of the birds, shares some phonemic elements with it. The gods, some of whom are named (e.g., Tiens, Shang-ti, Juno, Unkulunkulu, Eros, Veles), have different origins but appear to speak the same language (a form of zaum) and understand one another (a Khlebnikovian ideal), even if the meaning of their phonemically charged speech is incomprehensible (to non-zaumniks). For example:

> *Eros*: Emch, amch, oomch!
> Doómchee dámchee dómchee,
> Makaráko keeochérk!

> Tseetseeleetsee tsee-tsee-tseé
> Kookareékee keekeekoó.
> Reéchee cheéchee tsee-tsee-tseé.
> Olga, Elga, Alga.
> Peets, patch, pótch! Ekhamcheé![123]

The "tsee" phonemic string recalls the Yellow Bunting bird's utterance from the previous plane. Khlebnikov's language might appear to be nonsensical but it has its own internal logic, even if it is unlikely that unspecialized readers or audience members would readily understand it: a crux Khlebnikov addresses in the action that follows.

Zangezi elucidates the logic of zaum, upon the urging of the people to speak to them "in that beyonsense language of yours."[124] He expounds upon Khlebnikov's theory of alphabetic verities, drawing a connection between specific phonemes and historical agents: the "alphabet war-makers" of R, K, L and G, which he transposes into participants from the 1917 revolutions and the subsequent Civil War (e.g., the Ruriks, the Romanovs; Kaledin and Kornilov; Lenin; Germany). The implication of this fictive exegesis is that phonemic sounds are indices (or echoes) of worldly phenomena. In other words, patterns in world events may be construed from alphabetic discourse; sounds, according to Zangezi/Khlebnikov, have universal (i.e., far-reaching) significance. In Plane Eight, Zangezi delivers a song composed in "star-language," which includes core phonemic elements he predicts will one day unite all people in the form of a universal language. The zaum phonemes, which are the primary points of interest, have sounds that are not language-specific. They are presented in italicized, upper case letters (Cyrillic characters in the original):

> Within a haze of green KHA, two figures,
> The EL of their clothes as they move,
> A GO of clouds above the games they play,
> The VE of a crowd that circles an unseen fire,
> The LA of labor and the PE of games and songs.[125]

The elements of zaum featured here are still in draft form, as they are in the examples that Khlebnikov provides in the essay "To the Artists of the World." The implication is that eventually one might communicate using these fundamental linguistic elements alone, doing away with the need for standard words (in this case, Russian). Khlebnikov believed the zaum phonemes held a type of hieroglyphic, semantic clarity. "Someday this language will unite us all," Zangezi assures his listeners, "and that day may come soon."[126] Plane Nine features a possible concentrated

("pure") version of zaum similar to the language of the gods, as Zangezi lists the permutations of the phonetic root "oom" (which means "mind" in Russian in addition to being a well-known constituent of an Indian mantra).

> Sound the alarm, send the bell through the mind!
> Here is the bell and here is the bellrope.
>
> IV. DULL-OOM
> FROM-OOM
> IN-OOM
> ON-OOM
> DVOO-OOM
> DE-OOM
> BOM!
> OZ-OOM!
> OK-OOM
> OK-OOM
> WITH-OOM
> OP-OOM
> AGL-OOM
> AR-OOM
> NO-OOM
> DAY-OOM
> FREE-OOM
> BOM!
> BOM! BOM, BOM![127]

The published text provides a gloss of some of these words, using Khlebnikov's notes for this section. Evidently, "DULL-OOM" means "halfwit"; "WITH-OOM" means "collaborative"; "DAY-OOM" means "commanding," and "FREE-OOM" means "escaping from the bonds of stupidity."[128] Zangezi offers no explanation to those who are listening to him, assuming the intrinsic meaning of the sounds will be directly intuited, like the vibrations of a tolling bell.

The various articulations of zaum Khlebnikov presents throughout do not obviously cohere (except perhaps to Zangezi himself) or become more comprehensible as the play progresses. The planes of the supersaga do not always even intersect. For example, the penultimate section involves a personified exchange (in the mode of a morality play) between Sorrow and Laughter seemingly unrelated to the main narrative. Indeed, there are arguably more points of conflict and missed contact than overlapping points, which is a curious situation for a play that ostensibly aims to promote communicative accord. However, *Zangezi* is a tonally mixed play: it

alternates between seeming to take itself very seriously (e.g., Zangezi's meditations on recent Russian history and his prognostications of world events) and not seriously at all (in its incidental jocularity and sarcastic commentary, typically provided by Zangezi's audience), thereby periodically undercutting its pretensions. In the play's epilogue, two unnamed people read a newspaper article about Zangezi's apparent suicide and lament his death. Zangezi promptly enters, proclaims he is alive and states "[it] was all just a stupid joke!," presumably referring to the report of his demise, though one might consider it a meta-textual jibe—the play making fun of itself.[129]

From the outset, Zangezi's status as a legitimate prophet is questioned. The passersby refer to him in private as an idiot, as the "fool of the forest," and it appears at least some of them have come in search of amusement rather than edification.[130] Although an occasional listener claims to be "hooked" by Zangezi's beyonsense language, the crowd as a whole grows increasingly vocal in its disapproval of Zangezi's speeches and in its desire for a more easily comprehensible form of entertainment:

> What a mad muddle!
> This is all a lot of gabble!
> This is vain bibble-babble,
> Zangezi! What language are you trying to talk?[131]

It is unlikely Khlebnikov is criticizing the crowd for their failure to appreciate Zangezi's theories and utterances (Khlebnikov famously traveled among the people and drew on Russian folklore for his work). Rather, he seems to wish to undercut the very theories he has himself developed, or at least highlight their receptive difficulties. While Khlebnikov makes little of the fact that his purported universal language is derived from Russian phonemes or that his associated numerological historiography relates principally to Russian events, neither does Zangezi make a strong case for the utility of zaum as a practical universal language, or for the very idea of a universal language. Indeed, if anything, zaum serves to promote discord and confusion within the world of the play (e.g., the gods fly away, one person has an attack, the crowd rejects Zangezi). While Zangezi appears to have wanted to drive the gods away and is content with this occurence, the people are not so sure ("The power of our voices has terrified the gods! Is that good? Is that bad?")[132] Moreover, as Andrew Wachtel points out, the version of zaum presented by Zangezi and that spoken by the gods are not equivalent. Zangezi's zaum is based on the Russian language but theirs is not, which casts doubt on its supposed universality. Wachtel remarks:

Rather than ushering in a new era of universal understanding, Zangezi seems to have created a tower of Babel in reverse. As humans rediscover a single language, it serves not as a link to the gods, but as a means to exile them, leaving the gap between humankind and the divine intact.[133]

One of the surviving photographs of the first production indicates the tower of Babel may have influenced Tatlin's scenography, or else his own famous proposed Monument to the Third International (a.k.a. Tatlin's Tower), designed in 1919. In the photograph, Tatlin is perched on top of a precarious, balcony-cum-tower-like structure composed of what appears to be irregular, one-dimensional shapes.[134] Words from the "oom" sequence of the text are printed on a scroll or banner that hangs before him. He looks down on a row of people on lower planes, both visually and figuratively. "Everything Zangezi is saying," Tatlin states, "is like a ray moving slowly downwards from the thinker to the uncomprehending crowd."[135] Tatlin-as-Zangezi is removed from them, as the gods are from humankind, the avant-gardist from the bourgeoisie (notionally, as a member of an artistic advance troupe), and the language inventor from everyday speakers. In its cubist- (or perhaps constructivist-) like assemblage of different planes of action and perspectives—a supersaga of independent sections, techniques, and theories—Khlebnikov's play raises the possibility of universal linguistic communication and proffers ways in which it might be realized while simultaneously critiquing this project and highlighting its flaws. This gives the work a degree of self-reflexive complexity.

In *Zangezi*, Khlebnikov implies the project of inventing a universal language, which he had advocated three years prior, is a rarefied, utopian, and possibly misguided endeavor that will likely not be widely adopted.[136] Indeed, considered in the context and future history of modern attempts to fashion a worldwide language, Khlebnikov was correct in this implicit assumption. In this respect, *Zangezi* functions as a dramatic allegory for the age-old desire, compounded by modernity, to solve the Babel problem by devising or rediscovering a commonly shared human tongue. Whereas Zamenhof aspired to simplify the process of communication and create a neutral language, Khlebnikov ultimately revealed the complexity of the relationship between the word and the world and the invariability of linguistic confusion and discursive plurality. In dramatizing his theory of linguistic universalism and imagining its effects on potential speakers (audience members), Khlebnikov highlighted, and perhaps came to realize, the inevitable noise of human communication. He acknowledged the impossibility of his ideals in a way that practically oriented language inventors such as Zamenhof did not. Khlebnikov played out his

linguistic fantasy in a mental theatre and foresaw the inevitability—and permanence—of the state of Babel.

* * *

Avant-garde theatre functioned as a type of performance laboratory for testing communicative possibilities associated with language in modernity. Avant-gardists staged modernity's babble and added to it in kind, riffing on its verbal soundscapes and idealist projects. Unlike the vast majority of language invention initiatives, which never got off the page, avant-gardists had the opportunity to realize unconventional forms of verbal expression, distinguishing themselves in the process as extraordinary subjects—visionaries, harbingers of the linguistic future who operated on society's fringes, modeling neutral, trans- or supra-national identities. In this, avant-gardists overlap with language inventors as peripheral figures who try to alter or subvert the status quo by the force of their example. The comparison is mutually illuminating, because just as language inventors can fail to attract a speech community, so can avant-gardists flummox their audiences and end up "speaking" primarily to themselves. The linguistic avant-garde—broadly considered—embraced both artists and non-artists alike. Zamenhof and Khlebnikov were kindred spirits, committed to their respective dreams. Avant-garde art can be just as rarefied and esoteric as the most obscure artificial language project, failing to make much sense to anyone other than the artists who created it. Khlebnikov's variety of zaum arguably falls into this category, but the linguistic play of Tzara, Ball, and Schwitters is entirely unpretentious and only requires audiences to enter into the spirit of nonsense sound-making in order to appreciate the linguistic confusion. Moreover, Khlebnikov's *Zangezi* satirizes its own high-mindedness, winking at the irony of an ostensibly incomprehensible "universal" language. Avant-gardists' linguistic experimentation did not simply entail nonsensical sound-making for the sake of it but was implicated in modernity's "Babel problem." Avant-gardists offered funhouse versions of legitimate artificial language projects such as Esperanto, but the distortions they provide are instructive nonetheless. They offer artistic insight into modernity's communicative "crisis" and its potential solutions, demonstrating a continuing belief in the unifying power of rudimentary speech sounds to cut through the noise of modern babble.

CHAPTER 4

HEARING *AFFECTIVELY*: THE NOISE OF AVANT-GARDE PERFORMANCE

WHAT DOES IT MEAN TO HEAR AFFECTIVELY? If one hears *effectively*, one hears well, or at least well enough, relatively speaking. If one hears *affectively*, one hears in such a way as to be physically moved or disturbed; hearing affectively means experiencing sound viscerally, not just with one's ears but one's whole body. Rave-goers hear affectively: the dance music pulses through them with vibrational force, promoting communal ecstasy. People who live near train lines may feel the rumble of passing trains underfoot. If you stand in a bell tower while bells are rung, the sound of the tolling can vibrate through your body. We sometimes forget about the tactile dimension of sonic apprehension, or else we have conditioned ourselves not to notice it. This is a diminishment of our perceptual faculties and a reduction of our cognitive understanding. After all, there is more to sound than hearing; indeed, there are whole frequency ranges that cannot be humanly perceived. In her essays and public speeches, Dame Evelyn Glennie, the virtuoso percussionist, calls attention to the audio-haptic nature of vibratory perception. Hearing, Glennie insists, is not just a single-sensory process restricted to sound waves detected by the ears but a whole-body phenomenon in which one can touch, feel, and respond to sound as vibration. She writes:

> Hearing is basically a specialised form of touch. Sound is simply vibrating air which the ear picks up and converts to electrical signals, which are then interpreted by the brain. The sense of hearing is not the only sense that can

do this, touch can do this too. If you are standing by the road and a large truck goes by, do you hear or feel the vibration? The answer is both.... For some reason we tend to make a distinction between hearing a sound and feeling a vibration, in reality they are the same thing. It is interesting to note that in the Italian language this distinction does not exist. The verb "sentire" means to hear and the same verb in the reflexive form "sentirisi" means to feel.[1]

Glennie relates how as a profoundly deaf 12-year-old (who had perfect pitch) she worked with her percussion teacher to learn different instruments—especially the timpani—through hearing-feeling the sounds they made. She could register sounds in various parts of her body, distinguishing pitches by locating their sites of resonance, which might be on her hands, wrists, face, neck, chest, lower body, or feet, depending on the frequency of the vibration.[2] Glennie now plays barefoot in order to heighten her audio-haptic connection to sound, lending her performances a dance-like quality. For Glennie, listening to sound in a holistic manner enables her to experience the vibrating world, to feel its resonances, and, ironically, to listen more sensitively than so-called hearing-enabled people.

Glennie's ability to touch and be touched by sound is remarkable, and highlights the connection between sound and affect. Although definitions of the term vary, "affect" denotes a pre-cognitive, bodily force (or "intensity") that results from activation of the autonomic nervous system.[3] Affect is an "in the moment," instinctive, uncontrollable physiological response to environmental stimuli—wincing at the sound of fingernails on a chalkboard, for instance, or jumping out of one's skin at the unexpected appearance of a loud sound in one's vicinity (BOO!). According to theorists, it is only when affect is consciously processed and/or physically expressed in a recognizable manner that it is registered as an emotion. Erin Hurley usefully summarizes distinctions between affect, mood, and emotion:

> Affect happens *to* us (remember, it is out of our conscious control) and yet happens *through* us (it is the body regulating itself via the activation of certain organs, processes, or responses, as when we shiver in the cold). Mood is a disposition or background state that orients us to certain kinds of emotional responses and reactions. And emotion names our sensate, bodily experience in a way that at once organises it and makes it legible to ourselves and consonant with others' experiences or emotional lives.[4]

Affect is primal feeling, and sound is a prime means by which it can be induced. This happens easily. As frequently stated by noise campaigners,

we have no earlids to block out the vibratory forces surrounding us; we cannot avert our ears from sonic situations without absenting ourselves, and even then sounds may persist in our auditory imaginations.

Sounds perceived as noise (in short: unwelcome, incidental, intrusive, disorganized, meaningless, loud, and/or unpleasant acoustic phenomena) can affect us physically, not only irritating but also unsettling us. The connection between noise and bad feeling is suggested in the word's etymology: one of its possible derivations is from the Latin *nausea*, meaning seasickness. Noise can make one feel queasy, depending on its sort, the context of its sounding, and one's disposition. There is a long, varied history of human noise, so it would be wrong to identify this phenomenon with modernity alone. Nevertheless, noise was (and is) a vital part of modern (post-industrial) soundscapes, achieving increased intensity and omnipresence. The modern metropolis gave rise to abundant noise from crowds, trams, buses and automobiles, aircraft, mechanical sounds, construction, foghorns, sirens, factories, street criers and musicians, vendors, and amusement halls, disciplining city-dwellers to negotiate the low-fidelity (i.e., low signal-to-noise ratio) urban soundscape.[5] R. Murray Schafer decries post-industrial urban soundscapes on account of their congestive composition, high-decibel levels, and drone effect. He laments:

> [In] all earlier societies the majority of sounds were discrete and uninterrupted, while today a large portion—perhaps the majority—are continuous. This new sound phenomenon, introduced by the Industrial Revolution and greatly extended by the Electrical Revolution, today subjects us to permanent keynotes [sounds associated with a particular environment] and swaths of broad-band noise, possessing little personality of sense of progression.... We may speak of natural sounds as having biological existences. They are born, they flourish and they die. But the generator or the air-conditioner do not die; they receive transplants and live forever.[6]

Like it or not (and many do not), noise is a keynote of modernity: an inevitable, seemingly intractable, conditioning element of everyday life that one either learns to accept (and possibly even enjoy) or else tries to limit or ignore.

Theatre has, in the past, embraced noise. It is, arguably, an innately noisy art form that brings together different disciplines and participants in a shared space, ideally for a common cause, yet the results are not always harmonious. Theatre can engender noise (hubbub, multiple input, mixed signals) as a matter of course, which can be pleasurable or frustrating depending on one's bent (i.e., one's attitude toward stage noise

and auditorium noise). As a friend once remarked to me: "I want to hear the tap dancer's feet; I do not wish to hear the tapping feet of the person next to me, especially if they have no sense of rhythm." Yet, curiously, as the modern world got noisier, bourgeois theatre got progressively (or prescriptively) quieter, or at least more regulated, on the whole. Audiences became better behaved (i.e., less vocal), which meant that theatre soundscapes were more disciplined affairs. Noise was anathema to bourgeois theatre—but not to avant-gardists, many of whom valued its transgressive, agitational potential. Avant-gardists, particularly but not exclusively associated with futurism and dadaism, strove to create noisy performance soundscapes, like those of popular and proletariat forms, in order to affect the physiological, emotional, and psychological constitutions of audience members. They used sound not just as a supportive, scenographical element of the *mise-en-scène* but as a means by which audience members could be activated (politically, emotionally, imaginatively, or otherwise) and brought to—or taken out of—their senses. They orchestrated soundscapes to achieve this end, encouraging audiences to join in with the deliberately provocative generation of noise by contributing to it and/or becoming absorbed in it. In this way, avant-garde theatre replicated the affective force of sonic modernity, re-staging the noise of the street in the auditorium and deploying its shock effects to initiate skin-level—but not skin-confined—reactions (i.e., sounds that make one shiver, tremble, or pulsate).

This chapter analyzes some key examples of affective, noisy soundscapes in modernist avant-garde performance, situating this activity in the context of contemporaneous attitudes toward silent spectatorship and noise reduction in theatre and society. Noise is a problematical term in that it has multiple, shifting meanings, and is, in a nonscientific sense, subjective, as in the old saw "one person's music is another person's noise." Even still, the term is useful; its contrariety is stimulating and can be intellectually productive. Its value as a non-pejorative analytical object for performance scholars has only begun to be explored.[7] The noise attended to in this chapter is eclectic and disparate: it includes the rowdy soundscapes of Italian futurist *serate* (theatrical "evenings") and dada cabaret; the "explosive" poetry performances of F. T. Marinetti and Richard Huelsenbeck; Antonin Artaud's cacophonous sound design for his 1935 production of *Les Cenci* (*The Cenci*); and Arseny Avraamov's mass concert *Sinfoniia Gudkov* (*The Symphony of Sirens*) performed in Baku in Azerbaijan in 1922, which used the city's soundscape to celebrate the Russian Revolution and advance the Soviet cause. The chapter surveys a range of avant-garde activity, including theatrical and musical examples, and builds to a mighty crescendo. Amid the din, I query the *effectiveness*

of affective hearing in avant-garde performance, and consider the cultural significance of this raucous sound-making.

Shh! (Silent Spectatorship, Focused Listening)

What composer would want an audience to ignore his or her music? Answer: Erik Satie—on one occasion, at least. An amusing, instructive episode in Satie's career draws attention to the listening habits of modern bourgeois theatre audiences—habits that some avant-gardists were keen to undermine. On March 8, 1920, Satie performed *musique d'ameublement* ("furniture" music) during the intermissions of Max Jacob's (now lost) comedy *Ruffian toujours, truand jamais* (*Always a Ruffian, Never a Bum*) at the Galerie Barbazange in Paris. Satie wished to provide music that was functional, like a piece of furniture, to fill silences or commingle with ambient sound, thereby creating a general, musically inflected mood (a precursor to Muzak). It was music intended to have minimal (or perhaps subliminal) effect and be largely ignored. Fernand Léger recalls its inception:

> We were having lunch, Satie and some friends, in a restaurant. The music was so loud we simply couldn't stand it and left. But Satie said: "Even so, there's room for a *musique d'ameublement*, that is to say, music which would be part of the noises around it and would take account of them. I think of it as being tuneful, softening the noise of knives and forks without overpowering them or making itself intrusive. It would fill in the silences which can sometimes weigh heavily between table companions. It would banish the need to make banal conversation. At the same time it would neutralise street noises, which can be tactless in their behaviour." It would, he said, be responding to a need.[8]

Satie tried to put this idea into practice with the help of fellow composer Darius Milhaud. Together, they directed a small ensemble of musicians—a pianist, a trombonist, and three clarinetists—to occupy different positions of the Galerie Barbazange and repeatedly play selections from Ambroise Thomas's opera *Mignon* (1866) and Camille Saint-Saëns's tone poem *Danse Macabre* (1874)—two composers whom Satie supposedly disliked—during the intermission of Jacob's play.[9] The audience was directed by the master of ceremonies *not* to pay attention to the music:

> We earnestly beg of you not to attach any importance to [the music] and to behave throughout the interval as if it did not exist. This music, specially written for the play by Max Jacob... claims to contribute to life in the same way as a private conversation, as a picture in the gallery, or the

chair on which you may or may not be sitting. You can test it out for yourself. Messieurs Erik Satie and Darius Milhaud are at your orders for all information and commissions.[10]

Much to Satie's vexation, the audience at the gallery did not, as he intended, mill about and treat the music as a figurative item of furniture, but rather re-took their seats and paid it dutiful attention, as they would a typical concert work. This reportedly led to Satie bustling among them, exhorting them to continue talking and moving about, saying things like "Whatever you do, don't listen!," which may well have been the first time a composer or arranger ever made such a demand upon an audience.[11] Milhaud provides this account:

> Contrary to our expectations, however, as soon as the music started up the audience began to stream back to their seats. It was no use for Satie to shout: "Go on talking! Walk about! Don't listen!" They listened without speaking. The whole effect was spoilt... Satie had not bargained for the charm of his own music. This was our one and only experiment with this sort of music.[12]

If only Satie's "furniture music" had been less "charming," it might have been heard (or not heard, rather) as he intended. The audience at the Galerie Barbazange was seemingly habituated to listening attentively and not "talking over" music or else was not inclined to switch between listening modes (the evening's program also contained pieces by Stravinsky and *Les Six*, which were not billed as "furniture" music). Alternatively, the audience may have been hazy about the concept of "furniture" music or leery of it.

The incident suggests that silent, attentive listening was the expected form of conduct by bourgeois theatre audiences at the time, akin to modern concert or opera attendance. Audiences for "art" music and bourgeois theatre discriminated against "extraneous" noise during performance—especially noise of their own making. This was, in part, a legacy of musical idealism: a set of social and cultural tendencies that acquired preeminence in the mid-nineteenth century.[13] Musical idealism venerated an *idea* of music over the material conditions of its production, which were to be ignored. Private, individual attention was thought to be the optimal means of appreciating music's higher, spiritual qualities (depicted in Khnopff's painting *Listening to Music by Schumann*, see figure 1.4). Wagner helped consolidate this aesthetic ideal at Bayreuth, where he launched his *Festspielhaus* (an opera house for a festival theatre) in 1876, rarefying music as an art object. Wagner worked to concentrate audience

attention on the aesthetic experience, not the social event. He strove to overwhelm his audience with sublime force, engaging them completely in the world of the opera and diminishing the sociality of the occasion for the duration of the performance (save the intermissions, of course). In so doing, Wagner hoped to circumvent the type of audience behavior that took place at Italian opera, for example. He writes:

> In the opera house of Italy there gathered an audience which passed its evenings in amusement; part of this amusement was formed by the music sung upon the stage, to which one listened from time to time in pauses of the conversation; during the conversation and visits paid from box to box the music still went on, and with the same office as one assigns to table music at grand dinners, namely, to encourage by its noise the otherwise timid talk. The music which is played with this object, and during the conversation, fills out the virtual bulk of an Italian operatic score; whereas the music that one really listens to makes out perhaps a twelfth part thereof.[14]

This type of socially engaged listening in which only intermittent attention is paid to the musical performance was also common in Parisian opera houses and elsewhere in the eighteenth century.[15] However, it should be noted that socially engaged listening was not inherently inferior to the rapturous, absorbed listening proposed by nineteenth-century musical idealists such as Wagner; it merely served different ends and admitted disturbances and distractions (i.e., noise) into its modus operandi. Indeed, it might be considered a more open, honest, and less precious form of listening, one suited to theatre's inevitable noise, its "continual oscillation between engagement and distraction," as Ross Brown puts it.[16]

Nevertheless, Wagner strove to eliminate socially engaged attendance at Bayreuth by directing attention to a single-authored musical vision of ecstatic transcendence on the stage. His staging techniques included turning off the house lights during performances to focus audience members' attention on the stage rather than on one another, concealing the orchestra in a sunken pit to prevent the musicians from being seen, and enhancing the spectacularity of the *mise-en-scène* to form a carefully stage-managed, immersive audiovisual experience.[17] Here is Wagner's account of an audience member at his opera house in Bayreuth:

> His seat once taken, he finds himself in an actual "theatron," that is, a room made for no purpose other than his looking in, and that for looking straight in front of him. Between him and the picture to be looked at there is nothing plainly visible, merely a floating atmosphere of distance, resulting from the architectural adjustment of the two proscenia; whereby

the scene is removed as it were to the unapproachable world of dreams, while the spectral music sounding from the "mystic gulf," like vapors rising from the womb of Gaia beneath the Pythia's tripod, inspires him with that clairvoyance in which the scenic picture melts into the truest effigy of life itself.[18]

Whether or not actual audience members at the Bayreuth *Festspielhaus* gave themselves over in the manner here described is debatable.[19] What is apparent, however, is that the auditory and behavioral regimes that Wagner strove to inculcate at Bayreuth became the norms for modern opera, concert performance, and bourgeois dramatic theatre. It is not surprising that Satie had difficulty in getting an audience to mistreat his "furniture" music; they were too well house trained.

Musical idealism continues to inform concert performances of classical music, the behavioral etiquette of which presupposes physical restraint, "engaged" listening, regulated applause, limited vocalization by the audience, and (inevitably) intermittent coughing and throat-clearing between movements. Elias Canetti describes audiences at classical music concerts pitch perfectly in his 1963 study *Crowds and Power*:

> The contrast between the stillness of the listeners and the din of the apparatus inflicting itself on them is even more striking in *concerts*. Here everything depends on the audience being completely undisturbed; any movement is frowned on, any sound taboo. Though the music performed draws a good part of its life from its rhythm, no rhythmical effect of any sort on the listeners must be perceptible. The continually fluctuating emotions set free by the music are of the most varied and intense kind. Most of those present feel them and, in addition, must feel them together, at the same time. But all outward reactions are prohibited. People sit motionless, as though they managed to hear *nothing*. It is obvious that a long and artificial training in stagnation has been necessary here. We have grown accustomed to its results, but, to an unprejudiced mind, there are few phenomena of our cultural life as astonishing as a concert audience.[20]

The parallel silencing and behavioral "improvement" of bourgeois theatre audiences in the late nineteenth century resulted from efforts to enforce middle-class values (i.e., manners, decorum, aesthetic appreciation) and establish theatre as a site of respectability. Like art music, dramatic theatre could be *ennobling* if audiences behaved appropriately. Contemporary disgruntlement about theatre noise—both from actors about audiences and from audience members about each other, generally having to do with whispering/talking, eating, spluttering, shuffling, and using smartphones (which glow in the dark as well)—signals the institutionalization of the

ideologies of silent spectatorship and focused listening in theatre, allied to the (frankly unreasonable) expectation that a theatre soundscape should have a comparable signal-to-noise ratio as one's living room.

Despite the supposition that a marked shift toward the visual typified modern engagement in theatre so that one no longer went to "hear" a play but rather to "see" it (an expression that persists), this hypothetical epistemic shift was neither total nor complete.[21] Nicholas Ridout speculates that modern theatre, "with its electric light and its darkened auditorium, may...be understood to have facilitated a vibratory mode of sensory communication between actors and groups of fully active, even perhaps electrified spectators," and therefore functioned as a "vibratorium."[22] Audience silence does not necessarily mean audience passivity. As theatre audiences became (more) silent in bourgeois theatres in the mid- to late nineteenth century, and the lights were dimmed in the auditorium, they were encouraged to become not only obedient spectators but also *active* listeners, trained to focus on the "legitimate," intentional sounds of performance (primarily speech) while sensing a collective audience dynamic. This dynamic was ideologically motivated. Bourgeois theatre was notionally a "civilized" (i.e., classed) affair in which worldly noise (including the "noise" of the notional "other") was disallowed and audience behavior was regulated in the service of bourgeois ideals, including "great" works of art. Noise, commonly associated with the working class, was actively discouraged. Disruptions by audience members, while not uncommon, were frowned upon, which is why now-famous scandals and riots—such as that which supposedly greeted the first production of Alfred Jarry's *Ubu Roi* at the Théâtre de l'Oeuvre in 1896 and the first performance of *Le Sacre du Printemps* at the Théâtre des Champs-Élysées in 1913—are understood to have been exceptional occurrences.[23] It is precisely because of the insular, regulated, *sanitized* acoustic environment of modern bourgeois theatre that members of the avant-garde strove to reintegrate—or foreground—noise in performance and reveal the vibratory nature of audience reception.

THE STAGE AND THE STREET

The modernist avant-garde was rife with attempts to engender acoustic crossover between the theatre and the outside world, thus promoting praxis between art and life or rendering this distinction moot. Some of these attempts were notional, others practical. An example of the former appears in an essay published by the Italian artist Alberto Savinio (born Andrea Francesco Alberto de Chirico, brother of the painter Giorgio de Chirico) in *Les Soirées de Paris* in 1914 entitled *"Le Drame et la Musique"*

("Drama and Music"). Savinio, active in the Parisian avant-garde in the early 1910s, prefigures John Cage in advocating the aesthetic worth of everyday sound. In this essay, he suggests that "theatrical music" should be informed by the performance environment and not be artificially controlled or purpose-composed. He writes:

> [In] considering the movement on a street as a *dramatic action*, one could find a musical element, if not in the cries and voices of the same street, in the sound of a piano coming from a nearby house, or even better in wishing to place the *dramatic element* in the interior of a room, one could make a car horn [*trompe*] participate like a musical element, rising from the street to traverse the open window; workers who accomplish their manual labors by accompanying themselves with songs constitute, without a doubt, the essence of drama in music.[24]

Savinio recognizes the potential musicality and theatrical value of incidental, environmental sound: sound that when interpreted in a performance context (i.e., rendered as a theatrical "sign") acquires new or added meaning. Today, if you go to some theatres in Chicago, you will hear/feel the sound of an "El" (elevated) train rumbling past at periodic intervals, informing the performance soundscape (sometimes directors integrate the sound into their shows). Savinio would surely approve. The idea that "extraneous" sound might disrupt imaginative engagement with a dramatic representation is foreign to his thinking. As Christopher Schiff observes, Savinio accepts sound (or noise) as an a priori condition of performance, not as something to be ignored or managed. For Savinio,

> music is sound that is exotic to the performance situation but that at the same time defines the performance situation. It is the element that crosses between two different spheres of influence meaningfully, uniting two separate theaters—the theater of the salon and the theater of the street—into a single metatheater.... The artist is a facilitator of a political dialectic, literally leaving the door open to the transmission of ideas.[25]

In Savinio's schema, sound either may intentionally be admitted into performance or will be present by chance; in either case, the soundscape will not be fixed in advance but will remain open ended.

Savinio's conception of theatre as a permeable site for the transmission and reception of worldly sound is exemplary of an avant-garde aesthetic that embraces street noise. In this regard, avant-gardists were aligned with the barkers and ballyhoo of early cinema and other popular attractions, in which there was deliberate aural crossover between performance localities. Rick Altman describes the soundscapes of American nickelodeons:

A clear and impermeable barrier between the inside and the outside of the theater did not yet exist during the early nickelodeon years. Just as the French have traditionally accepted a certain transitivity between the inside and the outside, using no window screens and regularly throwing their windows and doors wide open to air sheets on the windowsill, to talk to people in the street, or just to let in fresh air, so nickel theaters treated the auditorium and the street as a single continuous sound space, with music produced in one area easily penetrating into the other. This process worked in both directions. Not only did streetside ballyhoo music regularly reach spectators, but owners also expected musicians performing inside the theater to play loud enough for their music to be heard in the street.[26]

The principal aim of barkers and ballyhoo was to drum up passing trade; avant-gardists who wished to transpose the noise of the street into the theatre (and vice versa) did so not only for monetary but for aesthetic and political reasons as well. These avant-gardists did not wish to maintain theatre as a rarefied space that keeps the world outside the darkened auditorium at a remove. Rather, they wished to incorporate the stuff of the street, the noise of the world, the clash of ideologies, and the richness of the everyday into their performances.

Sonic crossover of this sort runs contrary to modern archaeoacoustics, which, as Emily Thompson has shown, was founded upon a desire to control the effect of sound in space and eliminate sounds perceived to be unnecessary and/or unwelcome.[27] Two of the major sonic characteristics of modernity were urban noise and manufactured indoor silence. Perceptions of noise and silence were engaged dialectically: each made the qualities of the other more apparent, and more vital (noise made silence more valuable; silence made noise more pressing). In order to limit urban noise and promote sonic clarity, modern acousticians and architects strove to block the sounds of the outside world (thus breaking the connection between sound and place) and cancel the natural acoustics of buildings, fetishizing non-reverberative, "neutral" sonic environments.[28] The archaeoacoustical "soundscape of modernity" (Thompson's term) was an artificial construct, a triumph of engineering that demonstrated how an acoustic environment could be refashioned to provide maximum clarity and minimum disruption. Curiously, this harked back to the auditory conditions of the pre-industrial era in which the signal-to-noise ratio allowed for greater sonic discrimination on the part of the listener. However, modern acoustics abjured the natural sonic characteristics of places—what Schafer calls "soundmarks" (sonic landmarks)—and gave rise to worlds of sonic similitude instead, making different places sound alike.[29]

The Italian futurists defied the prohibition of noise in bourgeois theatre as well as its increasing elimination in archaeoacoustical design. The futurists, led by F. T. Marinetti, established noise as a principal component of the *serate*, theatrical evenings held in the playhouses of various Italian cities in the early 1910s to promote futurism. The futurists strove to admit "aggravating" noise in the theatrical event, thus echoing, or perhaps replicating, the sonic conditions of urban modernity. The *serate* exemplify performative provocation in the theatrical avant-garde: riling spectators into actively participating in the performance by disrupting it in some fashion. In order to generate notoriety and distinguish their brand of avant-gardism, which was rhetorically founded upon a rejection of the culture of the past (*passéism*) and bourgeois mores in favor of an "artificial optimism" about the technological present and future, the futurists embarked upon promotional tours of the country, devising sensational theatrical performances intended to reach the largest possible audiences (the audiences at these events ranged from 2,000 to 5,000 people, and included all societal strata).[30] The *serate* did not feature drama per se, but followed a relatively loose-structure program of declaimed manifestos, lecture-demonstrations, poetry recitations, musical performances, artwork displays, and improvised exchanges.

The reason for the success of the *serate*, as Günter Berghaus has shown, was not the nature or quality of the performed material but rather the relatively novel theatrical experiences they provided.[31] The futurists transformed the auditorium into a major site of performance along with, or instead of, the stage (similar to mid-nineteenth-century pantomime and melodrama). Making noise was the means by which the futurists publicized and popularized their aesthetic, and the *serate* audiences were more than willing to help them achieve this end. The *serate* allowed audiences to behave "badly" in the theatre and make a lot of noise, performing their affrontedness, as it were, as a response to the artistic provocations of the performers, and for their own amusement. At the *serate*, audiences could let loose and forgo the strait-laced conventions of bourgeois theatre, restoring, in the process, a rowdy, rambunctious form of engagement that promotes contrarious participation instead of obedient, silent spectatorship (or focused listening). Typically, audiences did not just holler, boo, laugh, and whistle at Marinetti and his fellow futurists, but threw vegetables and other missiles at them (brought especially for the occasion), set off firecrackers, honked horns, blew on whistles and pipes, struck cow-bells, and got into fights with the performers and with each other, giving rise to a violent, carnivalesque affair. People who genuinely wished to hear what the futurists had to say were frustrated in

their efforts, more often than not, and reportedly turned on their fellow audience members.[32]

Marinetti and his collaborators set out to generate this kind of reaction (at least in principle). Berghaus outlines how the futurists orchestrated the noise of these events by manipulating audience response, alternately goading, insulting, and ostensibly placating those in attendance, who were all too ready to cause havoc. If a *serata* generated hullabaloo and enraged audiences, the futurists were pleased—at least publicly, in the first years of undertaking these events. In an open letter to the magazine *Lacerba*, the futurist Aldo Palazzeschi provides this account of a *serata* that took place in Florence in 1913:

> I saw gentlemen who did not feel it beneath their dignity to put two fingers in their mouth and whistle like a shepherd or take out of their silken pockets onions, chestnuts, potatoes, eggs, etc. There were professors who for an instant forgot the heavy weight of their own solemnity and gave in to a healthy rocking of their body and performed some animating pirouettes. Young aristocrats shook of all the burden of their toilsome etiquette and false education. And noble and beautiful ladies remained unshocked and smiling in the face of this spectacle.... 6,000 spectators at the Teatro Verdi felt nothing but the intoxication of one moment of divine madness and rebellion against all slavery. We Futurists managed to unleash the best forces that lay hidden inside you. Only in confrontation with us could you find the best in yourself... You, all of you, are Futurists![33]

Palazzeschi impishly asserts that the futurists managed to convert their audiences into versions of themselves by making them act uproariously in public, out of keeping with their stations in life, giving them license to express themselves individually and as a collective.

Although such behavior was uncommon in Italian bourgeois theatre, it was not remarkable in European variety theatre (music hall, cabaret, *café-chantant*, nightclubs, circuses), whose spirit and audience-performer dynamics Marinetti wished to adopt. In his manifesto on the subject, Marinetti declares: "The Variety Theatre is alone in seeking the audience's collaboration. It doesn't remain static like a stupid voyeur, but joins noisily in the action, in the singing, accompanying the orchestra, communicating with the actors in surprising actions and bizarre dialogues. And the actors bicker clownishly with the musicians."[34] Marinetti also appreciates the "anti-academic, primitive, and naïve" aspects of variety theatre, as well as the fact that it did not engage in "stupid analyses of feelings" like bourgeois theatre, but rather worked to effect what he calls "body madness."[35] Marinetti provides some humorous but also practical suggestions for ways of promoting "body madness" in performance,

at least some of which the futurists undertook. These included spreading a powerful glue on some of the seats in advance, selling the same ticket to ten people, offering free tickets to people who are known to be mentally disturbed and will provoke others, and sprinkling the seats with dust to make people itch and sneeze. Marinetti and his colleagues seized upon any means to provoke sensation (literal and figurative) and prohibit contemplative, unidirectional spectatorship. Distraction, outrage, clamor, and confusion were the reactions they sought and received. Turning spectators into co-performing, noisy bodies capable of generating violent cacophony was considered an effective means of achieving these ends.

As a form of sonically induced "body madness," the noise of the *serate* worked to turn the structured form of an audience into the less structured form of a crowd that delighted in its own volatility and ability to transgress social norms. The fact that audience members brought things to throw (vegetables and the like) and make noise with (e.g., rattles) into the theatre indicates that they came to the *serate* not to be shocked or edified but to cause and experience a ruckus. To borrow a line from Palazzeschi, audience members used the *serate* as a means of acting out but also of discovering their own performative power and collective potential. This was something the futurists ostensibly wanted, even though it meant their onstage presentations were not given their due. The noise of the *serate* was not just an attempt to generate uproar and notoriety; it transferred urban din into the notionally reserved or restrained space of the theatre, thereby capitalizing on the potentially anarchic energies of both the stage and the street.

The desire to express modern dynamism is fundamental to futurism. Futurist painters attempted to capture the sensorial effects of modernity in a way that inculcated the viewer into its represented flux. Umberto Boccioni's painting *La Strada Entra Nella Casa* (*The Street Enters the House*, 1911) illustrates the permeability of modern sonic environments, especially those that are notionally public and private, as the noise and bustle of a street is observed by people standing on verandas (figure 4.1). The principal figure in the painting cranes over a veranda railing and inclines toward the street below (as do two of her neighbors at either side). The street is a hive of construction activity, with workers engaged in manual labor while a team of horses careens past. It is difficult to make out the scene because of the visual busyness: the merging of different elements, corruption of boundaries, and cubist perspective. The horses in the bottom left-hand corner of the painting appear to be moving *through* the principal figure on the balcony, or to share the space with her, as the distinction between "above" and "below" blurs and the street seems to run

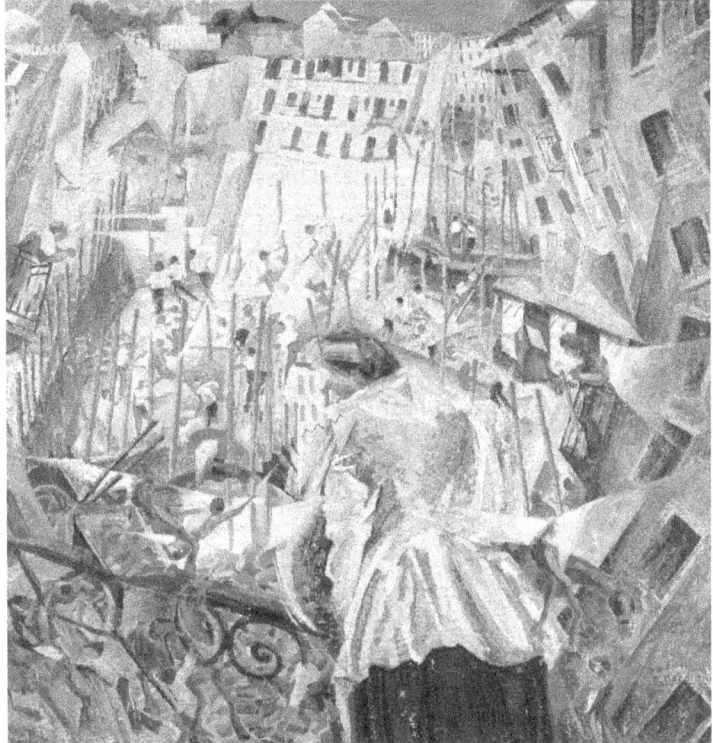

Figure 4.1 Umberto Boccioni, *La Strada Entra Nella Casa* (1911).
Source: Courtesy of Bridgeman Art Library.

like a river. The woman's head is only partially depicted; it is as though she has become transparent and has been infiltrated by the activity of the street, merging with a distortion of the building opposite her. The surrounding buildings are, in turn, angled downward in a cubist-inflected, funhouse-mirror style, as though they are also taking in the sights, sounds, and smells of the street action. In the "Technical Manifesto of Futurist Painting," written in 1910 by Boccioni in conjunction with a group of futurist painters, the authors state:

> To paint a human figure you must not paint it; you must render the whole of its surrounding atmosphere.... Our bodies penetrate the sofas upon which we sit, and the sofas penetrate our bodies. The motor bus rushes into the houses which it passes, and in their turn the houses throw themselves upon the motor bus and are blended with it.... The construction of pictures has hitherto been foolishly traditional. Painters have shown us

the objects and the people placed before us. We shall henceforward put the spectator in the center of the picture.... The time has passed for our sensations in painting to be whispered. We wish them in future to sing and re-echo upon our canvases in deafening and triumphant flourishes.[36]

Boccioni's painting demonstrates this interpenetration of dynamic elements by depicting the vibrancy of the street scene in its riot of shapes and colors as something that swarms the viewer (both *in* the painting and *of* the painting) and crosses structural and ontological divides (i.e., the city dweller "enters into" the street and vice versa). The composition has a focus, nearly dead center, in the principal veranda figure; however, the directionality is exceptionally diverse in terms of vectors of movement. The painting suggests the noise of the street is uncontainable and transforms one's perception of the environment into its likeness by way of sensorial overload and crossing (synaesthesia). Daniel Albright muses that the painting indicates "what the world would look like if the ear, not the eye, were the organ of vision, capable of assimilating a spatially organized field of perception in all directions at once."[37] In light of the painting and manifesto, the futurist *serate* may be conceived as efforts to make a visceral, imagined, proletarian version of "the city" enter the theatre, sonically as well as physically, through the fractious behavior of audience members who refused to keep their place but performed their disobedience and supposed discontent, making riotous noise that transgressed boundaries and divided attention.

Given the noise that *serate* audiences generally made, it was probably optimistic if not naïve of the futurists to expect that the presentation of "noise music" at these events would be favorably received and not taken as another excuse to make a racket. However, this was the standard reaction that greeted Luigi Russolo's specially created noise machines (*intonarumori*), designed to produce his "art of noises," which aimed to refashion the soundscape of modernity in musical-mechanical terms. Russolo, a painter turned musician, advocated a type of music that bypassed systems of tonality in favor of the wide array of "noise-sounds" that characterized the modern sonic environment. In his manifesto on the subject (written in March 1913), Russolo argues that the sounds offered by a symphony orchestra are a poor match for the acoustic force and timbral complexities of a modern city. He writes:

> Let's walk through a large modern capital with our ear more attentive than our eye and find pleasure in distinguishing between the gurglings of water, air, and gas inside metallic pipes, the grumbling of motors that breathe and pulse with an indisputable animality, the throbbing of valves, the rising

and falling of pistons, the screeching of mechanical saws, the jumping of trams on their rails, the cracking of whips, the waving of awnings and flags. We shall amuse ourselves by ideally orchestrating together the rattle of a store's rolling shutters, banging doors, the hubbub and patter of the crowds, the different rackets of the railway stations, of the textile mills, of the printers, of the electrical plants, and of the subways....

Every manifestation of our life is accompanied by noise. Noise is, therefore, familiar to our ear and has the power to recall us immediately to life. Whereas sound, foreign to life, always musical, a thing in itself, an occasional element that is not necessary, has come by now to strike our ears no more than an overly familiar face does our eye. Noise, instead, coming confusedly and irregularly from the irregular confusion of our life, is never totally revealed to us and keeps innumerable surprises for us. We are certain, therefore, that in choosing, coordinating, and dominating all noises, we are enriching mankind with a new unsuspected voluptuousness.[38]

For Russolo, it is not a question of merely imitating or reproducing these noise-sounds in music using traditional instruments but of actively fashioning these noises anew, orchestrating them into an artistic unity, and spiritualizing them.[39] To this end, Russolo devised a system of enharmonic notation for scoring purposes, and, with the help of the painter Ugo Piatti, constructed the *intonarumori* that were to constitute the new Futurist orchestra. Russolo's noise instruments consisted of plywood boxes containing motorized mechanics that activated a stretched diaphragm, which made sounds through a horn that an operator (musician) could manipulate in terms of pitch by pulling on a lever. The orchestra of *intonarumori* included such instruments as the exploder, crackler, buzzer, stamper, gurgler, screamer, rustler, whistler, thunderer, and the croaker. Russolo proposed to adapt not only the sounds of the metropolis but also the noise of the natural world and modern warfare.

Russolo's *intonarumori* achieved considerable notoriety over the next few years, though performances of his noise music were often met with incomprehension and derision. The first presentation of a single noise-intoner (an "exploder," which produced a sound similar to an automobile engine) at a *serata* at the Teatro Storchi in Modena in June 1913 provoked customary din from the audience, which ironically overpowered the noise of the noise machine, and prompted caustic—but fair—remarks such as "Why listen to a fake noise when we can hear the original sound every day in the street?"[40] A subsequent *serata* held in Milan's Teatro dal Verme in April 1914 that featured Russolo's first compositions for the *intonarumori*, including *Risveglio di una città* (*Awakening of a City*) and *Convegno di automobili e di aeroplani* (*A Meeting of Motorcars and Aeroplanes*), was also

poorly received and precipitated a major brawl, police interventions, and a widespread revolt from an already hostile audience. Russolo was unhappy with the reaction:

> The immense and tumultuous mass of spectators was already extremely noisy half an hour before the concert began. The first projectiles came hailing down from the gallery against the still closed curtain. The audience did not hear anything that evening, simply because they preferred to make their own, unharmonized, noise. Okay, I can understand if an audience whistles, boos and throws projectiles... after having heard something they do not like. However, to go to the theatre, pay for a ticket, and then *not wanting to listen*, is beyond my comprehension.[41]

Twelve matinee concerts of Russolo's noise music were presented at the Coliseum Theatre in London in July 1914, accompanied by lectures by Marinetti. A critic in *The Times* wrote:

> It is impossible to say that the first of the "noise spirals" performed, "The Awakening of a Great City," was as exhilarating as Futurist art usually is; on the contrary, it rather resembled the sounds heard in the rigging of a channel-steamer during a bad crossing, and it was, perhaps, unwise of the players—or should we call them the "noisicians"?—to proceed with their second piece, "A Meeting of Motorcars and Aeroplanes," after the pathetic cries of "No more!" which greeted them from all the excited quarters of the auditorium.[42]

A subsequent European tour of this program had to be abandoned because of the onset of the First World War, but Russolo presented his *intonarumori* again in a series of concerts in Paris in June 1921, attracting the attention of some preeminent composers of the day, including Igor Stravinsky, Arthur Honegger, Maurice Ravel, and Edgard Varèse. It is practically impossible to assess the quality of Russolo's music as it is no longer extant (save the opening seven bars of *Awakening of a City*) and the original *intonarumori* were destroyed in Milan in the Second World War; moreover, the sole recordings of compositions that feature them—*Corale* and *Serenata* (1921), composed by Luigi's brother, Antonio—are of poor quality and use the instruments as supplements to a standard orchestra, which is not what Luigi Russolo intended.

Despite the futurists' cultivation of audience unrest at the *serate* (and the attendant "pleasure of being booed"), they also wished their art to be taken seriously, which, in the case of Russolo's noise music, meant listening to it attentively and respectfully despite its unusual properties.[43] Indeed, Russolo's preferred mode of response for his noise music (as indicated by his report on the audience's behavior, quoted above) was,

in the tradition of musical idealism, focused listening. This is further evident from the fact that Russolo adopted the organizational structure of symphonic music (i.e., orchestra with conductor) as well as a system of scored music (his notation dispenses with notes, replacing them with continuous lines, but still has bars, clefs, time signatures, and staves). He wished his audiences to attend to noise music as they would a Wagner opera or some other work of art music, recognizing its aesthetic value when presented in a performance context while ignoring unintentional ambient noise and refraining from making competing sounds themselves. The fact that Russolo's audiences (particularly the *serate* audiences) were more interested in making their own noise rather than listening to his was unfortunate (for Russolo, at least) but to be expected given the general tenor of the *serate* and the reputation the futurists enjoyed—and cultivated—as troublemakers.

The futurists endeavored to avoid the rowdiness of the *serate* in their program of "synthetic" theatre: a collection of short plays (*sintesi*) that they toured in Italy between 1915 and 1920. Synthetic theatre was intended to stimulate audiences with a new kind of theatrical form: a drama that would deliver a short, sharp, shock to the system, akin to the experience of living in a modern city.[44] The authors of the accompanying manifesto, Marinetti, Emilio Settimelli, and Bruno Corra, trumpet the virtues of synthesizing ideas and situations into extremely compressed forms. They juxtapose this new aesthetic with the static, drawn-out, and pedantically psychological formulae of "*passéist*" theatre, claiming the force and brevity of the synthetic form will outmatch even cinema in this regard. The authors propose a type of dramatic theatre that is willfully reductive: forgoing explanation, clearly defined motivation, and unities in favor of dynamism, simultaneity, novelty, improvisation, and illogical occurrences.

> It's stupid to want to explain with logical minuteness everything taking place on the stage, when even in life one never grasps an event entirely, in all its causes and consequences, because reality throbs around us, bombards us *with squalls of fragments of interconnected events, mortised and tenoned together, confused, mixed up, chaotic.* E.g., it's stupid to act out a contest between two persons always in an orderly, clear, and logical way, since in daily life we nearly always encounter mere *flashes of argument* made *momentary* by our modern experience, in a tram, a café, a railway station, which remain cinematic in our minds like fragmentary dynamic symphonies of gestures, words, lights, and sounds.[45]

Synthetic theatre was not intended to allow audience members to sit back and enjoy proceedings comfortably or with complete comprehension;

neither was it intended to give them license to make a general commotion. Rather, the synthetic form was designed to excite and affect the audience by presenting modern sensory-perceptual experience in novel dramatic form, which would ideally initiate "nets of sensation" between the stage and the audience.[46]

Acoustic shocks and disturbances feature in several *sintesi*, staging the sounds of the street in miniature. Francesco Cangiullo's play *Detonazione* (*Detonation*, 1915), subtitled "synthesis of all modern theatre," consists of a single sound made by the "character" of a bullet (listed as such in the text). Once a shot is fired, the play ends.

> Road at night, cold, deserted.
> A minute of silence.—A gunshot.
> CURTAIN[47]

The minute of silence stipulated in advance of the gunshot may provide an audience member with an impression of non-action ("nothing" is happening on the stage), followed by expectation that something *will* happen, which, when it does (in the form of a gunshot) presumably has a startling effect. In a similar fashion, *Sintesi delle Sintesi* (*Synthesis of Syntheses*, 1920), written by Gugliegmo Jannelli and Luciano Nicastro, presents a sequence of sounds and lighting effects indicating the occurrence of an offstage, overheard scenario, not readily comprehensible.

> Empty stage: a long dark corridor at the end of which a small red lamp flashes off and on, a long way off. Then, a streak of white light appears like a carpet along the corridor.
> Five seconds.
> A revolver shot. Scream. Noises. Confused cries.
> Pause.
> The fresh burst of a woman's laughter.
> Simultaneously a door at the back is thrown open by a blow, blinding the audience with a huge, powerful light.
> The curtain detaches,
> and falls.[48]

The bursts of sound and light in this play are designed to be unnerving, replicating the haphazard, sometimes disjointed nature of modern urban experience, referenced by the authors of the manifesto on the synthetic form, in which one may only ever have fleeting impressions of situations. Unlike Boccioni's *The Street Enters the House*, which is busy with figures, *Synthesis of Syntheses* depicts the shadow side of modern urban life in which signs of activity may be detected but not the agents of that activity.

In Remo Chiti's *Parole* (*Words*, 1915), a crowd gathers in protest outside a government palace. The dialogue consists of snatches of their utterances, murmurs from the crowd's "innumerable mouths," which emerge not in unison, but in polyphony.[49] An excerpt:

> THE CROWD (from various points):
> ...and why ARE THEY also a...
> ...exactly! And in FIFTY YEARS not...
> ...go there! THAT IS enough...
> ...of him who WAITS some more...
> ...that is SOMETHING that doesn't work...
> ...he put it BY THE DOOR and he said...
> ...he has a PALACE for...
> ...and you UNDERSTAND that it isn't...
> ...prove he doesn't INTEREST YOU AT ALL that...
> ...yesterday...TODAY...tomorrow...
> ...and FINALLY he said...[50]

There is no obvious point of connection between the speech fragments; each one appears to represent a discrete utterance. Both reader and audience member are presented with flux, a verbal barrage that dislocates meaning and proffers fragmentary utterances as the shifting ground of perception. At the end of the play, the gatekeeper, who has been the focal point of the crowd's "unrestrainable irritation," wavers and falls to the ground, "stricken by a strange and sudden illness."[51] It is implied that the crowd's babble caused his collapse. Likewise, in Angelo Rognoni's play *Weariness* (1916), subtitled "physical state written as a script," an exhausted man is depicted in an environment full of vaguely threatening sounds (reminiscent of Maeterlinck's symbolist plays) and proto-surrealist actions such as punctuation marks that inexplicably descend into view.

> Stage: a gray background.
> A MAN enters. He is visibly tired. He stretches out in an armchair.
> He closes his eyes.
> Sound of a violin; a dirge without a well-defined tune.
> Humming far off.
> From above a transparent curtain descends that blurs the environment.
> Lengthy hissing far off, insistent.
> The sound of the violin ceases.
> A faint howling.
> From above a black exclamation point descends at left.
> The howling becomes more sinister.
> Blue lights.
> The humming increases in intensity.

A second, very tall exclamation point descends at center.
All the noises cease.
Absolute silence.
The MAN reclines his head. (He is asleep.)
Darkness.
CURTAIN[52]

This play adopts the symbolist habit of using offstage sounds to infiltrate the scene and affect the characters' emotional stability. The double descent of the exclamation points might be read as an ironic comment on the man's unfortunate condition: tired, but still plagued by seemingly random sounds, some of which grow in intensity and negativity (e.g., the howling becoming more sinister). The exclamation point is an amplifier, a "screamer" in British English, notes Jennifer DeVere Brody in her study of punctuation and play; "it pumps up the (visceral) volume."[53] The man is only noted as being asleep once the noises have ceased. It follows (as per the play's subtitle) that the preceding stage directions are indices of his physical and emotional state and may denote the visual perception of entopic phenomena (after-images and "floaters" seen when one closes one's eyes), along with related auditory after-sounds heard in "the mind's ear" courtesy of the acoustic imaginary. Rognoni's play may thus be read as a symbolist-inspired, synthetic (i.e., condensed) depiction of overheard, unwanted noises, a bugbear of urban living.

Futurist synthetic theatre aimed to present its audiences with snatches of modern life that integrated experiential dynamics into its modus operandi. It sought to aestheticize sense impressions, defamiliarize them, and turn them into art, thus making audiences attend to modern life anew, interrupting it in the process. The futurists wanted their audiences to appreciate modern distraction without becoming distracted themselves and causing commotion, as had been customary in the *serate*. Unfortunately, technical limitations as well as the exigencies of touring worked against their aesthetic designs (for example, the long set-up intervals between the short plays tried audiences' patience), and, in many cases, audiences were still primed to respond vociferously and to brawl, as they had done in the *serate*.[54] Although the futurists were proficient at provoking and orchestrating audience noise, they were less able to get their audiences to appreciate noise as an aesthetic, beyond that which the audience themselves generated in the hullabaloo of reception. This did not stop them from trying, however, or from varying their efforts. The futurist campaign to affect audiences using sonic warfare was also conducted in the traditionally sedate context of poetry recitation, which Marinetti was

keen to revolutionize. Indeed, avant-garde poetry performances, of both futurist and dadaist varieties, used sonic boom(ing) to affect audiences, and not for the better. Avant-gardists did not merely wish to *replicate* the effects of sonic modernity; they wished to *appropriate* it, compounding its noise and making it serve sometimes-ambiguous ideological ends.

Explosive Poetry: Marinetti and Huelsenbeck

Marinetti announced *parole in libertà* (words-in-freedom) in his "Technical Manifesto of Futurist Literature," published in 1912.[55] He was apparently inspired to reinvent linguistic expression while traveling in an airplane—that uniquely modern mode of transport. Marinetti says the bird's-eye view obtained by flying altered his perception of the world and allowed him to contemplate it anew. "It was revealed to my spirit, high up in an airplane. Seeing things from a new perspective, no longer frontally or from behind, but straight down beneath me, and thus foreshortened, I was able to break the age-old fetters of logic and the leaden wire of traditional comprehension."[56] Marinetti proceeds to outline a futurist mode of expression in which syntactic structures are abolished in favor of a random scattering of nouns, as though words are topographical features in a landscape viewed from a great height. Nouns should not be adorned by adjectives but should retain their "essential color"; likewise, verbs should be used in the infinitive so as to "capture the continuity of life and the flexibility of the intuition that perceives it," and not be modified by adverbs, which would impose a "tone" on a sentence.[57] Furthermore, Marinetti suggests perception through analogy has become more natural as a result of knowledge gained by air travel. He therefore advocates doubling nouns to form compound word blocks without using conjunctions or punctuation; instead, mathematical signs and musical notation may be used to indicate the direction of particular shifts in expression. "Words freed from punctuation will radiate out *toward* one another," he writes contradictorily (radiating *toward*?), "their diverse magnetism will intersect, in proportion to the continuing dynamism of thought."[58] Marinetti wishes to capture the "essential" aspects of material objects— things "in themselves." To this end, he focuses attention on the materiality of language. He proposes that writers and poets develop associated chains of images and analogies, which may ostensibly seem incongruous, in order to reveal the successive movements of an object or the welter of impressions that one may receive in a turbulent environment such as a battleground or a modern city. This is intended to result in an ostensibly illogical, non-explanatory, but intuitive poetic sequence (like the *sintesi*).

He offers an excerpt from his war poem "*Battaglia, Peso + Odore*" ("Battle, Weight + Stench," 1912) as an illustration:

> Noon ¾ flutes groans dogdays bangbang alarm Gargaresch crash crackling march Clanking backpacks rifles hooves hobnails cannons manes wheels caissons jews fritters bread singsongs cobblers whiffs glistening rheum stench cinnamon mildew flux reflux pepper brawls vermine whirlwind orange-flowers filigree misery dice chess cards jasmine + nutmeg + rose arabesque mosaic carrion stingers cobblingmachineguns + gravel + backwash + frogs Clanking backpacks rifles cannons rusty-iron-atmosphere = lead + lava + 300 stenches + 50 perfumes[59]

This futurist poem (as it is called) conjoins words, images, and sense impressions with willful abandon. Marinetti's reinvention of language does not involve the creation of new words, per se, or grammar but a new form of expression that aims to "liberate" the connotative potential of words, making them resound anew. This led to him rejecting traditional poetic conventions such as meter and rhyme and instead using unpunctuated juxtapositions, unusual spelling, fused words, numbers, and mathematical symbols. In short, Marinetti's way of sounding modern involves abolishing traditional, semantic, sense-making structures and putting words into connotative free flow.

Marinetti's poetry has been lauded for its typographical inventiveness but critiqued for perceived overreliance on poetic devices such as onomatopoeia.[60] However, this line of criticism downplays or even ignores the performance aspect of these poems, which Marinetti was keen to exploit. In his manifesto "Dynamic, Multichanneled Recitation," published in 1916 (but written in 1914), Marinetti derides the "age-old, static, pacifist, and nostalgic type of recitation," which, according to the author, "always ends up being a monotonous series of high and low points, a hodgepodge of gestures which time and time again wash over the inveterate stupidity of lecture audiences in floods of boredom."[61] In its stead, Marinetti proposes a "new, dynamic, synoptic, and warlike form of recitation," part of the futurists' project of "enlivening and quickening the spirit of our race, making it more manly."[62] The author offers himself as an exemplar of the new style of recitation, claiming to have successfully seduced and stirred up audiences' emotions more effectively than any other reciter in Europe. "I've done this by ushering the most astonishing images into their dull minds, caressing them with studied modulations of my voice, with velvety softness and brutality until, cowed by my look or mesmerized by one of my smiles, they have felt the effeminate urge to applaud that which they neither understood nor appreciated."[63]

Alongside his characteristic pomposity and self-regard, the strain of male chauvinism in Marinetti's writing is unmistakable (and is possibly exaggerated for effect). He describes reciting poetry as a masculine endeavor in which the speaker commands the acoustic space of the performance and subdues (or "seduces") the audience with performative vigor. He writes: "I've had plenty of experience of the effeminacy of crowds and their virginal vulnerability when hammering Futurist Free Verse into them."[64] Futurist recitation is presented as an overtly physical activity. Performers are expected to manipulate a variety of noise-making instruments (e.g., hammers, trowels, motor horns, drums, tambourines, saws, electric bells) and move between different points in the performance space, making the dynamism of the verse visually and kinesthetically apparent. They are also directed to gesticulate geometrically, making arms rigid like railway signals or lighthouse beams so as to express the dynamic nature of futurist poetry and differentiate themselves from the "flailing around" of the traditional verse speaker, which Marinetti, eager to rebrand poetry recital as a macho pursuit, likens to the "languid actions of the prostitute as she moves her hands over the body of her worn-out client."[65]

Marinetti's ideal speaker is an impregnable (pun intended) force of nature that can "disappear" into the work being performed. He writes: "In the new Futurist lyricism which expresses geometrical splendors, our literary 'I' is burnt up and destroys itself in the superior vibrancy of the cosmos, so that the one who recites must also disappear, in a manner of speaking, in the dynamic, multichanneled revelation of the Words-in-Freedom."[66] This signals a familiar desire for modernist abstraction: a privileging of "the thing itself"—the artistic work—over the means of production. Marinetti suggests several ways to achieve this including wearing self-effacing clothes (maybe an evening suit), avoiding clothes that may suggest particular situations; "dehumanizing" the voice completely, removing all modulations or nuance and making it "metallic, liquefied, vegetalized"; and "dehumanizing" the face, shunning all expression and movement of the eyes.[67] However, Marinetti's proposed dehumanization of the speaker (reminiscent of Edward Gordon Craig's proposal that the actor be replaced by an "über-marionette") does not accord with either the descriptions of his own vocal performances or the recordings of them, which leads one to assume that he changed his mind about this aspect of futurist recitation. The vocal performance of words-in-freedom cannot simply replicate the printed text (an impossible task); it must inevitably transform it.

Marinetti briefly describes a performance of Francesco Cangiullo's poem *Piedigrotta* that took place on March 29 and April 5, 1914, at the Sprovieri Gallery in Rome and a recitation from his own *Zong Toomb*

Toomb performed at the Doré Gallery in London on April 28, 1914. The performance of Cangiullo's poem is the most detailed. Marinetti writes of several homemade musical instruments used to accompany the scene of the poem (a Neapolitan street festival), including a *tofa*, which he describes as a large seashell that makes a tragi-comic moaning sound; a *putipù*, a metallic box with an internal reed covered with hide that supposedly makes a comical sound when rubbed; a *scetavaiasse*, a "fiddle bow" that consisted of a wooden saw with bells and pieces of tin that was intended to parody the violin; and a *triccabballacche*, a type of wooden lyre with wooden strings tipped with square hammers, intended to satirize both the processions of Greco-Roman priests and the lyre players found on the friezes of old-fashioned buildings. Marinetti has little to say about the manner of the recitation but notes the generally positive response of the audience.[68] He provides further clues about his recitation in London later that month of passages from *Zong Toomb Toomb*, a work based on the siege of Adrianople during the Balkan War (observed by Marinetti as a war correspondent in 1912). He provides information about the staging of his recital, including his use of a telephone, some boards, and "the right sort of hammers" to act out the orders of the Turkish general and simulate artillery fire; off-stage drums (played on cue in another room by an assistant) to suggest the thunder of cannon; and three blackboards positioned at different points in the room, upon which Marinetti made "rapid chalk sketches of some analogy or other."[69] Again, Marinetti does not describe his vocal performance but only its reported effect on the audience, which was, of course, sensational: "[my] audience, continually turning so as to follow all of my movements, was utterly enthralled, their bodies alight with emotion at the violent effects of the battle described by my Words-in-Freedom."[70] Newspaper accounts of Marinetti's recitation in London are also cursory; they principally describe the futurist style of poetry and not Marinetti's performance of it. Arguably, the best way to assess Marinetti's vocal performances is by listening to the phonograph recordings made of his work.

There are at least three extant recordings of Marinetti reading short excerpts from *Zong Toomb Toomb*, dating from 1924 to 1935 (available online for your aural delectation).[71] Although these phonograph recordings may not be taken as documentary evidence of Marinetti's poetic recitations of the previous decade, it is reasonable to assume they provide insight into Marinetti's performance style (albeit amended for recording purposes). The extract that Marinetti recites in the recordings is taken from the closing section of the poem, which documents the bombardment of Adrianople by Serbian and Bulgarian forces in 1913. It appears to be the same excerpt he recited in London in 1914 (and may have

served as his "party piece"). Marinetti's recorded recitations are striking for the range of vocal expression he uses, which completely contradicts his direction in the manifesto that the voice of the speaker of words-in-freedom should be flat and dehumanized. The recordings show Marinetti exploiting a full range of vocal effects, including sweeping pitch variation; glissandi (slides); dynamic contrasts; guttural effects; tonguing effects (e.g., rolled r sounds); focused resonation ("head" voice for the whinnying of a horse, "chest" voice for that of a Turkish general); marked articulation of consonants and phonemes (e.g., ra-ta-ta-ta-ta); and stretching of vowel sounds. It is a vocalic tour de force, equivalent to an operatic aria. Marinetti figuratively sings the text, relishing its expressive possibilities, and delivers it with acoustic brio. Like a coloratura singer, he ornaments the words, varies the tempo of his delivery, shapes phrases, builds and releases tension, and impresses the listener with his vocal dexterity and command. These are common aspects of oratory, of course, but Marinetti exaggerates these features. Words are not simply articulated; they are forcefully exploded like small bombs in quick succession. Onomatopoeic words, such as the "kroook-kraaak" of the Bulgarian battalions on the march or the incidental warbling of birds ("cheep-cheep zzeep-zzeep"), are given full—if not excessive—measure of vocal color, making them independent objects of interest.

Indeed, the recordings make the polyphony of sounds and voices in Marinetti's work evident in a way the printed text does not. What appears to be a dense list of sometimes seemingly random words on the page is revealed in the recordings as a figurative soundscape composed by vocalic means. Marinetti creates the soundscape of the besieged city using just his voice (no other sound effects are used, unlike his staged recitals). In so doing, he lends the impression of being a human phonograph (predating those of Cocteau's *The Eiffel Tower Wedding Party*), reproducing acoustic events verbally and vocally. In the recordings, a snatch of a telephone conversation ("hello Ibrahim Rudolf hello hello") alternates with a snippet of a patriotic Bulgarian song ("Choumi Maritza o Karavena"), which Marinetti sings, in addition to various onomatopoeic intrusions of artillery fire and animal sounds. Marinetti makes these transitions so abruptly that it seems as though the various sounds overlap and there is no single point from which to judge the action (unlike the bird's-eye view from the airplane or indeed the reader's visual inspection of the page). Rather, the soundscape Marinetti connotes in his recordings seems to immerse—or perhaps possess—the perceiver; he gives voice to the disparate elements of the sonic environment, embodies them, and is transfigured in kind (speaker-as-exploding-bomb, speaker-as-whinnying-horse, speaker-as-marching-battalion). As a speaker, he is put under

pressure, stretched by the intensity and chaotic nature of the scene in question, and made to expand (not disappear) into new sonic and experiential registers. Perhaps this is what Marinetti means in his manifesto when he writes that the speaker should "make his voice metallic, liquefied, vegetalized, be turned to stone and electrified, fusing it with the very vibrations of matter itself, expressed by means of words-in-freedom."[72] His recitation style—boisterous, exaggerated, and affected—departs from the ethos of verse recitation of the time (at least that which was promoted in Britain) and from the symbolist tradition.[73] Rather than eschew theatrical touches in favor of cultivated neutrality, Marinetti made a virtue of artifice and positively indulged in vocal pyrotechnics (explosive plosives) and shock effects. Marinetti's phonograph recordings show that his proclaimed verbal liberation was matched by vocal liberation that "othered" the voice, defamiliarized expression, and blurred the boundaries between speech, music, and noise.

Hearing Marinetti's recordings alerts us to his exploitation of the phonic and paralinguistic powers of speech. In Marinetti's performance of *Zong Toomb Toomb*, the manner of the delivery is arguably just as important as—and maybe even more important than—the content. In these recordings, style is substance: even if one cannot discern everything that Marinetti is saying (because of the quality of the recording, the speed of Marinetti's delivery, or one's linguistic proficiency), one may still appreciate the sonorous dimension of the speech, quite aside from its semantic meaning. Marinetti was a skilled orator, deploying the classical rhetorical ideal of *enargeia*—linguistic vigor that "moves" the mind of the listener—in order to captivate attention, stir the passions of those in attendance (including himself), and foment the expressive potential of speech as sound. It is perhaps for this reason that he repeatedly mentions that the audiences for the public performances of words-in-freedom were physically "enthralled" by the recitations; they were not to be persuaded by argument but affected by sheer acoustical energy. Marinetti worked to achieve this by emphasizing the paralinguistic aspects of speech (nonverbal elements of communication, such as pitch, volume, intonation, tone, and tempo). By using an extensive pitch range, wide intervals, a dynamic mixture of disjunctive and connective articulations (self-contained, fragmented utterances and long, drawn-out vocalizations), and vocal granularity, Marinetti highlighted both the fluidity and the disruptions of speech sound.

Although we typically do not register it, human speech production constitutes a stream of sonic elements that surpasses alphabetic and phonemic systems. According to the principle of coarticulation, vowel

sounds and consonant sounds are acoustically merged in speech; we train ourselves to delineate phonemic patterns. Additionally, speech contains a plethora of technically nonsignifying elements relating to the mechanics of utterance (mispronunciations, slurring, stuttering) that one may hear, mishear, or disregard entirely. It is the same with speech pitch: even in non-tonal languages, speech may have a range of inflections, intonations, and melodic components that one may use without realizing. As a matter of course, we attempt to ascribe order to speech, screening out articulatory noise, only half-hearing tonal patterns, and wresting sounds into meanings (words) in accordance with our linguistic proficiency. Marinetti's recordings of his words-in-freedom suggest an alternative conception of speech in which paralinguistic elements vie for importance with semantic content, and there is copious crossover between constituent elements of the acoustic field. Rather than uphold distinctions between speech, sound, music, and noise, Marinetti instead toys with their collapse, or at least proposes their collusion. Just as the represented soundscape of the besieged city of Adrianople lacks clear distinctions and forms a sonic mêlée, so too does Marinetti's recorded recitation work to crisscross channels of communication and promote a reverberative model of speech-as-action.

This, then, is Marinetti's brand of linguistic modernism: a mode of expression that is dismantled and creatively rearranged ("words-in-freedom") to suit the expansive spirit of the age, then delivered in machismo fashion to captivate listeners' attention and demonstrate the speaker's command of the sonic environment, past and present. Marinetti championed the power of language—visually, sonically, and structurally transformed—to convey the dynamic flux of modern experience and the continued ability of the (male) perceiving subject to capture and communicate it. Marinetti believed he could bend language to his expressive and communicative needs by virtue of his artistic brilliance and the power of sonic utterance. This was, of course, a posture and a bluff, as was his machismo. He was not alone among avant-gardists in attempting to use poetry performance to impress acoustic energy upon audience members and stir their passions. Richard Huelsenbeck, one of the Zurich dadaists creatively inspired by the futurists, conducted a similarly strident enterprise; his attempt to stoke up an audience, sonically, was informed by modernist primitivism rather than the shock of the new.

Popular with students, foreign tourists, and curious Swiss burghers (slumming it in the old quarter of Zurich, on the *Spiegelgasse*), the Cabaret Voltaire, which operated from February to July 1916, was reputedly a

place of skulduggery and loutishness. Marcel Janco provides this likely romanticized account of the cabaret's clientele:

> It became a meeting place for the arts. Painters, students, revolutionaries, tourists, international crooks, psychiatrists, the demimonde, sculptors, and police spies on the lookout for information, all hobnobbed with one another. In that thick smoke, in the middle of the noise occasioned by declamations or some popular ditty, some sudden apparition would loom up every now and then, like the impressive Mongol features of Lenin, or Laban, the great dancer with his Assyrian beard.[74]

Janco painted the dadaists' scene of performance in a work entitled *Cabaret Voltaire* (1916). The painting conveys a sense of chaotic liveliness with multiple planes of action occurring simultaneously both on and off the stage. It is a "sight of sound": indeed, of seeming cacophony.[75] The room is densely packed: a jumble of limbs, chairs, and angular figures, with patrons crowding the tables and hugging the walls, overseen by a primitivist mask on the wall above the stage. There is a general sense of things being *askew* (Jean Arp refers to the style of the painting as "zigzag Naturalism") and of patrons and performers being in each other's faces, literally as well as figuratively.[76] The stage is a bare platform; there is little to separate those performing from those attending, and all are depicted in a caricaturist fashion. Arp describes the painting:

> On the stage of a gaudy, motley, overcrowded tavern there are several weird and peculiar figures representing [Tristan] Tzara, Janco, Ball, Huelsenbeck, Madame [Emmy] Hennings, and your humble servant. Total pandemonium. The people around us are shouting, laughing, and gesticulating. Our replies are sighs of love, volleys of hiccups, poems, moos, and miaowing of medieval *Bruitists*. Tzara is wiggling his behind like the belly of an Oriental dancer. Janco is playing an invisible violin and bowing and scraping. Madame Hennings, with a Madonna face, is doing the splits. Huelsenbeck is banging away nonstop on the great drum, with Ball accompanying him on the piano, pale as a chalky ghost.[77]

It is difficult, even with this description (the factual accuracy of which is uncertain), to discern the identities of the figures therein.[78] Even still, the painting does lend credence to the apparent homosociality of the Cabaret Voltaire. Emmy Hennings, who sang and was a main draw of the cabaret, appears to be the only woman in attendance, which would corroborate Huelsenbeck's statement that "[there] were almost no women in the cabaret. It was too wild, too smoky, too way out."[79] Elsewhere, Huelsenbeck remarks: "[The cabaret] was a witches' Sabbath the likes

of which you cannot imagine, a hullabaloo from morning to night, a frenzy of kettle-drums and tom-toms, an ecstasy of two-step and Cubist dances."[80] By these accounts and others, the Cabaret Voltaire typically constituted a rowdy environment of masculine rambunctiousness and spirited, or drunken, behavior.[81]

One of the chief instigators of such antics and main contributors to the soundscape of disruption was Huelsenbeck, who held the soubriquet "the dada drummer" (or the "drummer of dada") on account of the large tom-tom drum that was his instrument of choice to accompany his poetry recitals, which featured his self-composed *poèmes nègres* ("negro" poetry).[82] The drum lent to Huelsenbeck's reputation as a loud, pugnacious, and energetic young man (he was 23 in 1916) who wished to make his presence felt and to do things with a bang. Hugo Ball marked his arrival at the cabaret on February 26, 1916, with the blunt pronouncement: "Huelsenbeck has arrived. He pleads for stronger rhythm (Negro rhythm). He would prefer to drum literature into the ground."[83] Huelsenbeck championed an aggressive, confrontational style of performance to offset the lighter entertainment of the cabaret (e.g., Hennings's *chansons*, Ball's piano playing) and advocated the use of percussion to achieve this end. It is not known if Huelsenbeck played prepared rhythms when drumming or if he just improvised. The latter is more likely given the loose, "inspired" manner in which his *poèmes nègres* were composed.[84] The drum lent a faux authenticity and creative impetus to Huelsenbeck's poetic efforts, which appear to have been designed with sonic orchestration in mind.[85]

The symbolic associations of the drum for the avant-garde are powerful. They include a call to arms (in line with the signification of the avant-garde as the advance troops of an army); a marshalling of bodies into a prospective march; strength, resistance, and aggression; masculine engagement; a force of potential energy; and direct and immediate action. Even so, the symbolism of drumming may occlude as much as it reveals, in that it does not fully take into account the affective, vibratory experience of hearing/feeling percussive sounds: the phenomenology of meaning-making, which may contradict, or at least complicate, narratives of symbolic unity and communicative coherence proffered by artists and scholars alike. Based on accepted symbolic associations, the critical orthodoxy about Huelsenbeck's drumming—and about dada *bruitism* (noise-making) in general—is that it was intended to provoke audiences but was also meant as a rebuke to the political situation of the time (the First World War) and the perceived crises and decadence of modern Europe. Unlike the noise of the Italian futurists, which ostensibly celebrated modernity, technological progress, and modern warfare, dadaist noise was

supposedly intended as an expression of discontent with world affairs and the legacy of positivism. In this conception, Huelsenbeck was not modernity's drummer boy; rather, he was announcing modernity's collapse. Karin Füllner characterizes Huelsenbeck's drumming as an attempt to use the activity of the body to combat rationality ("fighting off reason that might harm it"), connecting drummer and listener to the immediate experience, variety, and chaos of life, and ridiculing the discourse and pretensions of "talking man."[86] This accords with Ball's interpretation of the Cabaret Voltaire and with Huelsenbeck's ruminations on their activities in his later life. Ball, whose assessment of the cabaret is informed by his own artistic and personal philosophies (which were not shared by others, such as Tristan Tzara, who assumed leadership of the dada movement once Ball retired from it in 1917), writes in his diary:

> Our cabaret is a gesture. Every word that is spoken and sung here says at least this one thing: that this humiliating age has not succeeded in winning our respect. What could be respectable and impressive about it? Its cannons? Our big drum drowns them. Its idealism? That has long been a laughingstock, in its popular and its academic edition. The grandiose slaughters and cannibalistic exploits? Our spontaneous foolishness and our enthusiasm for illusion will destroy them.[87]

Likewise, Huelsenbeck, speaking in 1972 (and by that time a psychiatrist), remembered Zurich dada as being broadly nihilist and reactionary: "We were full of revolution, we were full of protest, not only against the politics of the German Empire but against the ordinary man, against progress, against pollution, the growing pollution... not only of water and air, but the growing pollution of man as well, who massed together with a rising buying rate and rising crime rate and less of humanity every day."[88] However, Huelsenbeck articulated a completely different rationale in a lecture that he gave in Berlin in 1918, stating: "We [the dadaists at the Cabaret Voltaire] were against the pacifists, because the war had, after all given us the opportunity to exist in all our glory [on account of Zurich's neutrality].... We were pro-war and Dadaism is still pro-war today. Collisions are necessary: *things are still not cruel enough.*"[89] Unless Huelsenbeck was merely being provocative by aping Marinetti, and did not mean what he said, we have cause to question the received explanation for dada *bruitism*, especially explanations given decades after the fact. Füllner also suggests that "[the] selection of a big drum, which was unavoidably associated with militarism, as a noise instrument in the middle of the First World War was conscious provocation in neutral Switzerland. The audience certainly saw it that way... [making] the

drumming a parody of militarism."[90] This contradicts Huelsenbeck's comment in his memoir that "[in] the liberal atmosphere of Zurich, where the newspapers could print whatever they pleased, where magazines were founded and antiwar poems recited, where there were no ration stamps and no 'ersatz' food, we could scream out everything we were bursting with."[91] While Ball may have understood their noise-making to be an act of artistic rebellion, one suspects that Huelsenbeck, at least, had less high-minded aspirations and was driven to bang on his drum for baser reasons: as shtick for his primitivist poetics and for the purpose of rabble-rousing. This is not to negate accounts of Zurich dada as, on the whole, antiwar and antimodernity but rather to reveal an aspect that has been obscured by generalizations about its use of noise. What has been lost in critical accounts is the importance of percussive affectivity in dada performance: the way in which sound was used in the form of tactile vibrations to strike the bodies of those present, including the performers: stimulating them, riling them up, appealing to their baser instincts, and potentially provoking combative reactions. As a vibratory activity, Huelsenbeck's drumming sought to activate the soundscape of racket and disruption at the Cabaret Voltaire for politically ambiguous ends.

The content of Huelsenbeck's verse aided this scenario. Huelsenbeck's drum-driven poetry is typically nonsensical and appears to follow a stream-of-consciousness style of writing. Take, for example, his poem "Flüsse" ("Rivers"), from the collection *Phantastische Gebete* (*Fantastic Prayers*, 1916), which he liked to recite at the Cabaret Voltaire. An extract (in translation):

> the Indian ocean climbed up from its divan its ears stuffed with cotton wool
> the hot waters creep from their huts and scream
> they have erected tents over your ardour from morning till night and hordes of phonographs wait for the whimpering of your lust
> a calamity has befallen the world
> the breasts of the giant lady went up in flames and an Indian rubber
> man gave birth to a rat's tail
> Umba Umba the negroes tumble out of the chicken hutches and the
> froth of your breath skims their toes
> a great battle passed over you and over the sleep of your lips
> a great carnage filled you up full[92]

Huelsenbeck's percussive poetry performances were arguably less about the communication of semantic sense than physical sense, beating the drum while uttering his lines to create an air of primitivist invocation but also to affect physiologies, touching people skin to skin (drum to human).[93] The drum, as an instrument that enables the generation of

tactile vibrations, was especially suited to this task, and the relatively confined space of the cabaret would have concentrated its impact. Describing the affective potential of the drum as a percussive instrument, Brandon LaBelle writes:

> The drummer produces not only the beat, but also a pounding that extends inward just as much as it fills space with rhythm. The drumming body, in beating skins, generates an entire field of tactile and psychic energy—the beat returns to the drummer, as trails of energy cutting through the body, moving up from the arms and through the shoulders, down the spine and into the pelvic area, as sensations that also fill space with their driving movements, as sound pressures against other skins.... Drumming is not only the literal action of instrument playing, but the incorporation of the rhythmic into the body, and returning in acts of making contact.... The skin, as a shared border between a subject and its exterior, activates a resonating, signifying field locating percussive contacts as points of powerful exchange.[94]

It follows that Huelsenbeck's percussive performances may have required that patrons *felt* his actions. It may not have mattered whether or not they were listening to the words he recited, or could understand them (though one suspects their combined effect would have been optimum), or if they were even paying attention. If they were within his vicinity while he was playing the drum then they were likely contained within the "percussive field" of the performance and were made to feel its vibratory effects.[95] For this reason, and despite the rhetoric to the contrary, Huelsenbeck's drumming was arguably more of an incitement than a critique, though the nature of the incitement is equivocal. In drumming up energy, Huelsenbeck's percussive performances could easily have been interpreted as expressions of primitivism or as celebrations of a warring instinct, especially by a male audience given to drunkenness. To suppose that dada *bruitism* was altogether critical of the onward march of modernity and of its ideological programs is to discount its own involvement in them, such as the dadaists' reliance on the primitive as a notional Other for "modern man." Furthermore, it ignores the phenomenological reality of their noise-making, which did not just disrupt meaning for the sake of it but worked to affect attendants on a physiological level, provoking them to potentially violent states of feeling. Huelsenbeck encouraged haphazard collisions of sense and meaning as well as collisions between participants. This led to a theatre of chaos that was more likely to instantiate rather than subvert the warring climate of the day. Huelsenbeck's statement about the necessity of collisions and further cruelty in the world is disturbing and foreshadows Artaud's theatrical aesthetic. It signals the

ambiguous ends to which avant-garde theatre sound could be put: using sound-as-vibration to strike the bodies of those present, moving participants to heightened states of feeling, and making them vulnerable to political-aesthetical designs.

CRUEL VIBRATIONS: ARTAUD'S *THE CENCI*

Artaud's production of *The Cenci* at the Théâtre des Folies-Wagram in Paris in 1935 has been regarded as a notorious failure in theatre history, a precipitating event in the collapse of Artaud's mental health, and proof that Artaud was unable to realize his proposed "theatre of cruelty" in practical terms. The sonic elements of this production have largely evaded critical attention, though. This is an oversight, because sound provides insight not only into Artaud as a theatre theorist and practitioner but also into the larger history of affective hearing in modernist performance and modernity. Artaud has traditionally been treated as *sui generis* in theatre history or else positioned in neat political-aesthetical opposition to Brecht. This, happily, is changing, and a more nuanced, complicated picture of Artaud has emerged, primarily due to Kimberly Jannarone, who has made the case for Artaud's capability as a theatre maker and shown how his aesthetic philosophy was shaped by right-wing sociopolitical ideologies (e.g., fascism).[96] Artaud's ideas about the manipulative potential of sound in theatre are connected to related avant-garde undertakings, traced in this chapter, and, arguably, to forms of right-wing noise. *The Theatre and Its Double* contains the following meditation in which Artaud announces his (vaguely sinister) sonic aspirations for theatre:

> Snakes do not react to music because of the mental ideas it produces in them, but because they are long, they lie coiled on the ground and their bodies are in contact with the ground along almost their entire length. And the musical vibrations communicated to the ground affect them as a very subtle, very long massage. Well, I propose to treat the audience just like those charmed snakes and to bring them back to the subtlest ideas through their anatomies.[97]

Artaud describes himself as a theatrical snake charmer. Would one want to be "massaged" by Artaud in this manner? How might one feel during and after this activity? By attending to Artaud's use of sound in *The Cenci*, we may be able to hazard answers to these questions and better understand his theatrical enterprise.

Artaud's play (after P. B. Shelley's 1819 verse drama and Stendhal's 1837 novella) is based on the life and crimes of the sixteenth-century

Italian nobleman Count Francesco Cenci, a tyrant who plots the murder of two of his sons and beats, confines, and rapes his daughter, Beatrice. Artaud, who performed the role of Cenci, proposed to place the audience in the center of a "network of sound vibrations" that would make audible, and sensible, the "incarnation of great forces,... beings roaring,... passing like great storms in which a sort of majestic fate vibrates."[98] To accomplish this, Artaud pioneered the use of stereophonic sound in theatre, employing four loudspeakers at cardinal points in the auditorium (or "vibratorium," to use Ridout's term). He enlisted the aid of Roger Désormière, a musician who, in collaboration with Artaud, devised pre-recorded sound cues (a mixture of short pieces of music, vocalizations, and sound effects) billed as music featuring cathedral bells; echoing footsteps used to underscore the actors' movements; metronomes running at different speeds; recorded voices and whispers; wind and thunder effects; flutes; a viola or other stringed instrument; percussive "factory" sounds made by various metal objects; tam-tams; and an *ondes martenot* (a recently invented monophonic electronic instrument that allowed for wide-ranging tonal manipulation, glissandi, and vibrato effects). Artaud referred to Désormière's "musical interventions" as a "resonant, grandiose organization of musical themes," decreeing that Désormière "knows everything about the communicative power of noise," which was for both Désormière and Artaud "an unleashing of nature."[99] Here, Artaud invokes the spirit, if not the name, of Russolo.

The Cenci's text provides indications for types of sounds to be made. Some are abstract, as in the direction "a thick heavy sound spreads out then dissolves, as though stopped by some obstacle which makes it rebound in sharp ridges," or the description of the vocal utterance of the word "Cenci," which is likened to the pendulum of a clock and then to "countless birds whose individual flights have converged together."[100] Artaud makes special use of acousmatic sound in the play (inspired by Maeterlinck?), linked to the mysterious powers and affective force of Cenci, whose actions are meant to elicit the unconscious impulses central to Artaud's philosophy of cruelty and his notion of theatre as a communicative "delirium," like the plague.[101] In a crucial scene, Cenci enchants Beatrice with the power of his voice, but his conjuration is also linked to the play's acoustic imaginary:

> BEATRICE and old CENCI remain face to face. They stare at each other steadily for a long moment. CENCI goes to the table and pours himself a fresh glass of wine. Several torches flicker out suddenly. The bells can be heard; their tone has become sepulchral. An extraordinary calm descends upon the scene. *Something like the sound of a viola vibrates*

very lightly and very high up. BEATRICE sits down in a chair and waits. CENCI approaches her gently. His attitude is completely transformed; it radiates a sort of serene emotion. BEATRICE looks at him and it seems that her own misgivings too have suddenly vanished.[102]

The vibration of the viola-like sound forms part of an omnipresent vibrational network that Cenci activates and Artaud, in concert with Désormière, realized through recorded sound broadcast over loudspeakers.

The production featured sonic elements intensively and extensively. Act I, sc. iii, featured the loud playback of a recording of the bells of Chartres Cathedral meant to denote the bells of Rome; later, a mêlée at Cenci's party was set to the accompaniment of metronomes, recorded voices, and the *ondes martenot*. In Act III, sc. ii, thunder and wind effects were used to illustrate a storm preceding the assassination attempt on Cenci's life; additionally, a recorded arrangement of voices declaiming "Cenci, Cenci, Cenci, Cenci" was used as the murderers approached. In Act IV, sc. iii, the mechanistic sounds of the prison ("like a busy factory") where Beatrice is set on a Catherine wheel were made by anvils, screw nuts, files, winches, and other metal objects.[103] Abstract, acousmatic sounds made *physical* sense in that their vibrations were likely felt as well as heard (a result of the volume and loudspeaker placement) even if their semantic sense was unclear (cf. Huelsenbeck's poetry performances). This was Artaud's attempt to plunge the public into a "bath of fire," making an audience member "participate with his soul and his nerves."[104] In the world of the play, Beatrice functions as a surrogate participant of Artaud's theatre of cruelty: she is terrorized by the sounds she hears and imagines, which are inextricably associated with her father and his threatened actions:

> *BEATRICE*: Has he passed this way? Have you seen him, mother? *She listens attentively.* There! I hear his step on the staircase. Is that not his hand at the door? Since yesterday, I feel his presence everywhere. I am exhausted, Lucretia. Help us, mother, help us. I cannot go on fighting any longer. *LUCRETIA takes BEATRICE's head between her hands. Silence. Outside, the shrill cry of birds. Very high overhead, there is a sound like a footstep.* Oh! this footstep which the walls echo. His footstep. I see him as if he were there: his dreadful face.... His living image is within me like the conscience of a crime.[105]

Artaud hoped powerful acting, transgressive subject matter, daring *mise-en-scène*, and invasive sound design would work to induce sensations of catastrophic ecstasy in his audience. This may have been wishful thinking on Artaud's part, a result of cultural appropriation.

It is well known that the performance of Balinese dance theatre Artaud witnessed at the Paris Colonial Exhibition of 1931 helped him formulate his theatre of cruelty. However, scholars have elided the potential significance of the soundscape of this event: namely, the gamelan music that accompanied the dancers. Artaud was struck not only by the dancers' exquisite gestural symbology but by the rhythms of the gamelan ensemble, its range of percussive effects, the variety of timbres the musicians produced, and, most importantly, perhaps, the way the dancers' movements interacted dynamically with the musical elements rather than functioning as background accompaniment.[106] Artaud's conception of Balinese music and dance helped him develop his theatre philosophy and aesthetic; it may also have influenced *The Cenci*'s sound design.

The recording of Désormière's music for the production, which is approximately 21-minutes long and consists of 24 sound cues interspersed throughout the production, supports this hypothesis.[107] The sound cues are predominantly percussive, and include drumming, foot stomps, cymbal crashes, bells and gongs, and metallic noises. One cue in particular features a short ostinato (repeated) figure built on a compound time meter that generates a patterned, rhythmic syncopation between a drum and a mechanical horn-like sound, over which a fluctuating melody is played on the *ondes martenot*.[108] This is likely the music that accompanied Beatrice's execution at the end of the play when she is set upon a Catherine wheel as punishment for having Cenci murdered. Artaud's stage directions make reference to her execution march, set to "the sound of an Inca seven-part time rhythm" and to "[a] kind of human voice [that] mingles its desperate tone with the music's compulsive rhythm" (the "kind of human voice" possibly orchestrated by Désormière using the *ondes martenot*).[109] The "Inca seven-part time rhythm" is ostensibly a misnomer; no such musical figure exists, to my knowledge. This reference likely signals a familiar modernist coupling of the exotic and the primitive (as with Huelsenbeck's drumming). The music arguably owes more to Balinese gamelan than to Incan music. It resembles the Balinese colotomic (cyclical gong) structure of *Batel*, used for intense action scenes in dance theatre, in which gongs and drums provide a steady (but alternating) ostinato framework over which the *suling* (flute) may improvise.[110] Désormière's instrumentation is obviously different (the electronic *ondes martenot* lending a modern and technological sensibility, even as its glissandi approximate the "wide tuning" of Balinese melodies and its warbling timbre that of the Indonesian flute), and his music is much less complex than the Balinese form, but it suggests an intriguing parallel, nonetheless. Did Artaud and Désormière deliberately make this association? Might audience members have made the connection, too? One reviewer, Armory, in the newspaper *Comoedia*,

cryptically likened the music of the production to the so-called "black fanfares of the colonial exposition."[111] However, would Artaud have wanted his audience to make such a connection given that he intended the production to be a *felt* experience, not something rationally understood?

Almost all the reviews of *The Cenci* mention its sonic elements and *mise-en-scène*, and while no reviewer claims to have had the earth-shattering, metaphorical-plague-inducing experience to which Artaud aspired, many note the increased use and impact of the sonic elements, even if they profess not to understand the reason for their usage. One critic disputes the musical credentials of the production ("these roars, stampings and wheezing that Désormière calls 'music'"), another damns it with faint praise ("the music... stays within the confines of a shriek and a railroad disaster"), and one is ambiguously indifferent ("[the] music had the same qualities and faults as the play").[112] Several reviewers register their discomfort with the intensity of the production, inadvertently crediting Artaud's efforts. Fortunat Strowski of the *Paris-Midi* writes: "Everything is a paroxysm from beginning to end. No longer is there a rhythm created by a succession of strong and weak moments and by comings and goings. There is a continuity that is exhausting and at the end of which, if I dare use the expression, one remains inadequately 'cencible.'"[113] (Recall Schafer's comments about the undying, permanent keynote sounds of modernity, quoted in this chapter's introduction.) Similarly, Gerald D'Houville, writing in *Le Petit Parisien*, asks and answers his own question: "Our ears tortured by deafening music produced by loudspeakers (Why? The talented M. Désormière could have done well to avoid this), we were in a state of alert as if we were hearing the wail of sirens during an evening of 'air raids'. Without doubt, we were warned in this manner that this was an evening of massacres. But we resigned ourselves to it."[114] Pierre-Jean Jouve (a colleague of Artaud) offered the most positive review in *La Nouvelle Revue Française*, saying Artaud's *mise-en-scène* continually "animated" the space in a creative manner: "Here we are constantly working. The complex lights, the movements of individuals and masses, the noise, and the music reveal to the spectator that space with time forms an *affective* reality."[115] The word *affective* (Jouve's emphasis) is key.

Artaud wrote a defensive note about the production in *La Bête Noire* citing the "clash of contradictory and divided judgments" the production had engendered—"cheers and laughter, enthusiasm on the most part, sarcasms from a few, and even doubts from the Press"—before concluding grandiloquently that "the French public is not mature enough for a feast of the Gods."[116] In this note, he reproduces two letters extracted from his "abundant mail" as "proof" of the fact that more than one spectator

recognized the "unprecedented atmosphere" of the production as being "dangerous." One letter-writer, Eugène Gengenbach (address provided), declares: "I am disgusted by your rudeness and impertinence.... You don't seem to give a damn. Continue. But don't think that you are launching such diabolical vibrations and spells over Paris with impunity. You are playing with fire... Around me spectators were laughing like lunatics, trembling with hysterical laughter.... My poor Artaud, there is nothing more to be done for you."[117]

Even though Artaud eschewed direct political engagement (hence his parting with the surrealists), he still wished to bridge the stage and the street, at least acoustically.[118] Artaud announced this aspiration in his production plans for the Alfred Jarry Theatre in the 1920s, which show the attention and consideration Artaud gave to sound, even in the planning stages. In the production plan for *Le Coup de Trafalgar* (*The Coup of Trafalgar*) by Roger Vitrac, Artaud intended to convey the din of a Paris street—"the sound of voices, footsteps, cries, panic-stricken trampling, exploding bombs, sirens, fire bells, ... sudden wind"—thereby replacing the "arbitrary silence" of the theatre with the "constant presence of life outside"[119] (echoes of Savinio). He proceeds to write about how he intends to use pre-arranged, amplified, recorded sounds to elicit the effects that he seeks. The Alfred Jarry Theatre ended up not producing *Le Coup de Trafalgar*, but its designs were evident in *The Cenci*, though the "noise" of this production was valued for its affective powers not just its lively properties.

As it happened, Artaud may have got more noise than he bargained for with *The Cenci*. Or should that be the wrong *type* of noise? In his review for the *Paris-Midi*, Raymonde Latour calls attention to the location of the Folies-Wagram Theatre and the pre-performance activity:

> The play had begun as early as nine o'clock on the [footpath] of Avenue Wagram. Fervent followers of *Solidarité Française*, meeting next door, stopped, stupefied, before the white rose bushes and sheaves of arums that attentive and excited friends had sent the new star [Iya Abdy, who played Beatrice]. And Antonin Artaud's guests, as they stopped at the theatre door, seemed visibly upset when they were obliged to slip through fifty or so policemen to go and applaud *Les Cenci*. I'm quite certain that at the same time there were some bystanders who assumed that the lilies and orchids were intended for the ardent orators [of the *Solidarité Française*], and that the policemen were tasked to protect Mr. Fortunat Strowski or Paul Reboux [theatre critics], given over to the perils of an excessive and tumultuous dramatic art.[120]

The *Solidarité Française* was a fascist organization modeled after the Nazi party; it helped stage the major street demonstrations and riots of

the 1930s.[121] Latour's observation about *The Cenci* beginning, on the night he attended, on the pavements of Paris with some awkward bustle, sidestepping, and confusion is telling. It is ironic that Artaud, dogged by the right-wing critics of *L'action Française* for not being suitably "French," staged *The Cenci* (out of economic necessity) at a venue that happened to house a right-wing, nationalist organization next door.[122] The noise Artaud sought was artistic (as part of the production's sound design), experiential (for his auditors), and discursive (a *succès de scandale*), yet was potentially crossed with the political dissension and acoustical violence of right-wing organizations like the *Solidarité Française*. Indeed, the noise of Artaud's *Cenci* was perhaps unintentionally divisive: as such, it suggests certain problematical elements and misapprehensions in Artaud's poetics of theatre sound that merit closer attention.

Artaud thought sound could be used as a tactile force to affect the nervous systems of those present, to break down their constitutions, and attune them to the stage spectacle and one another. Hence the importance of the proto-stereophonic loudspeaker system: the audience was to be buffeted on all sides by waves of vibrations, overloaded with sounds, in a manner not dissimilar to modern techniques of sonic assault and torture. Artaud believed a "soul" could be "physiologically reduced to a skein of vibrations" in his theatre of cruelty: attendees would not just hear incidental sounds in a disinterested fashion but experience vibration viscerally in their own bodies and sympathetically in relation to the bodies of other audience members.[123]

The humanist (and leftist) interpretation of Artaud's theatre of cruelty, which emerged in the counterculture of the 1960s, proposes that the destructive instincts and drives Artaud wished to activate in the subconscious were meant to be purged by the act of enduring a "cruel" theatrical spectacle. In this reading, an audience member at an Artaudian theatrical event would be less likely to harbor criminal desires or commit violence in the street having experienced catharsis of these repressed impulses in the theatre. Jannarone argues that this received interpretation of Artaud disregards the historical context in which Artaud developed his aesthetic theories, in particular the reactionary, right-wing politics of interwar Europe, which effectively mirror (or "double") his aesthetic of cruelty.[124] Indeed, Artaud's conception of a "cruel" auditory event—sonic bombardment intended to provoke communal *ekstasis*—resembles the way in which the Nazis utilized music and sound in public spaces in Germany in the 1930s, particularly in urban street environments and *Thingspiele* performances. In documenting this phenomenon, Carolyn Birdsall has coined the phrase "affirmative resonances" to refer to the way in which sensory overstimulation and rituals of sonic dominance worked to delineate patterns of belonging (and exclusion), reinforce group

identity, and ultimately affirm the legitimacy of the Nazi party.[125] Did Artaud similarly deploy affirmative resonances in his production? His use of overpowering sonic force in his sound design for *The Cenci* is suggestive. Yet it is not clear if this affective hearing was ultimately *effective*.

Artaud proposed to treat the audience like "charmed snakes" whose bodies react to the musical vibrations communicated to the ground (and not to the "mental ideas" of music). Prefiguring modern sonic warfare and arguably rave music in his desire to break down an individual's defenses, Artaud held that sonic vibrations could provoke ecstatic, trance-like states and manifest an embodied perception of cruelty. The physicality of sound, aided by technological diffusion, enabled Artaud to touch the bodies of audience members with violent sensations, to immerse them in a vibratory complex, operating on the levels of physiological excitation and sympathetic resonance. Vibrations were to be channeled in such a way as to unite participants in a communal sensation that was felt, if not completely understood—a process that privileges affect over cognition.[126] Artaud derived this aesthetic in part from Balinese theatre, but it also accords with Romantic and modernist idealizations of music as a universal language. Artaud understood the sounds, gestures, and movements of the Balinese form to function in the manner of a hieroglyph, providing an instantaneous grasp of meaning linked to the subconscious. He writes: "These mental signs have an exact meaning that only strikes one intuitively, but violently enough to make any translations into logical, discursive language useless.... There is no transition from a gesture to a cry to a sound; everything is connected as if through strange channels penetrating right through the mind!"[127] In this model of auditory perception, the *interpretation* of sounds is beside the point: what principally matters is the "essential," "instinctive," "spiritual" nature of the music—its vibratory basis—which Artaud professed to intuit in Balinese dance theatre and hoped to replicate in *The Cenci*.

Balinese gamelan music has, in fact, been discovered to be rich in ultrasonic frequencies, some of which cannot be consciously perceived but still have physiological effects on listeners, enhancing neuronal activity.[128] Artaud was therefore correct in his assumption that a network of vibrations could affect audience members physiologically, so that, for example, the Balinese-type music that accompanied Beatrice's execution might theoretically instill a hypnotic, trance-like state among the attendees, generating a type of ritualistic fervor appropriate for his theatre of cruelty. Indeed, Artaud may have succeeded in affecting his audiences through their anatomies, making them *feel* the vibrational force of the production even they could not fathom (or did not appreciate) its usage. The critical

response to the production indicates this may have been the case (the anecdote about spectators "laughing like lunatics" is suggestive in this regard). Does this not dispute—or at least qualify—the production's purported failure? In an admittedly circular logic, the fact that Artaud's critics noted the sonic force but professed not to understand it may be interpreted as a partial vindication of Artaud's theory that "cruel" vibrations in the theatre should be a function of sense perception rather than "cognitive" listening (listening for meaning). Artaud did not intend his audience members to understand his use of sound, and, lo and behold, they (or at least the critics) seem not to have done so. Success *and* failure! In comparison, Satie's experiment with "furniture" music apparently failed because audiences listened to it "improperly" (for Satie's purposes) despite being instructed; Artaud's critics, like those of Russolo, seem not to have known *how* to listen to the "music" of *The Cenci*.

Artaud wanted his immersive sound design to *unify* the audience and promote a centripetal heightening of collective sensation formed around his performance as Cenci—like Marinetti's charismatic poetry performances—that would enact his philosophy of aesthetic cruelty.[129] For this reason, Artaud wished to adopt Wagner's model audience of focused listeners, not the interactional dynamic of the futurist *serate*. There is no evidence to suggest that the audiences for *The Cenci* bonded in this manner; rather, it appears they made sense of his "cruel" vibrations idiosyncratically or not at all. In hindsight, this was to be expected. After all, this production took place in a former music hall and had a premiere that was something of a high-society affair. Without specific cultural networks of knowing and feeling—what ethnomusicologist Judith Becker calls the "habitus of listening"—the synaptic connections necessary to create a trance-like, musical perception in the brain will not take place; the "electrical storm" of neurons will misfire.[130] Consequently, Artaud's production could not elicit the hieroglyphic clarity, the "direct seizure of transcendental knowledge" to which Artaud aspired, because the sounds it deployed multiplied or confounded meaning rather than "spiritually" concentrating it.[131] The likelihood of cognitive dissonance increases with the degree of abstraction involved and with the relative novelty and difficulty of the auditory input. The sound design for this production mixed and matched sonic elements and drew on potentially unfamiliar aspects of avant-garde musical experimentation (e.g., the expansive, electronic sonorities of the *ondes martenot*). Despite Artaud's intent, the audiences of *The Cenci* could not be attuned to a collective wavelength: there were too many potential distortions of meaning, too many signal carriers that could refer to the sounds both inside and outside the theatre. Affective hearing is not always effective, much to avant-gardists' chagrin, and performance

noise invariably confounds efforts to define its meanings. This is a crux of avant-garde theatre sound, and it is played out on an even grander scale in this chapter's final case study, which ventures into different territory geographically and generically, but not thematically. It recombines elements discussed throughout this chapter into a thunderous symphony of sound that theatricalizes noise and strives to give it political purpose.

SONIC REVOLT: AVRAAMOV'S *THE SYMPHONY OF SIRENS*

The Symphony of Sirens, performed over the course of half a day on November 7, 1922, in Baku, enjoys notoriety as perhaps the most grandiose expression of proletarian music-making. A mass concert designed to celebrate the fifth anniversary of the October Revolution, it recreated, or rather re-imagined, the soundscape of the storming of the Winter Palace in St. Petersburg in 1917, when the Bolsheviks seized power, transposing this event onto the capital city of the Azerbaijan Soviet Socialist Republic (SSR), established in 1920. This was a major experiment in soundscape design *avant la lettre*, transforming the sonic environment of Baku into a giant, conjoint stage-auditorium of performers/hearers. *The Symphony of Sirens*, which featured the sounds of industry and technology—factory sirens, artillery batteries, hydroplanes, airplanes, foghorns, and locomotives—and was conducted across an entire geographic region, theatricalized and politicized the city's soundscape. Avraamov aimed to consolidate the Soviet takeover of Azerbaijan, re-inscribe the founding narrative of the October Revolution, advance the cause of the international proletarian movement, and celebrate "liberated" modern industry, technology, and the urban environment.

The Symphony of Sirens is genealogically related to a series of mass outdoor spectacles sponsored by the Bolshevik government between 1917 and 1921 (the years of the civil war following the October Revolution), the purposes of which were to promote proletarian theatre, consolidate Bolshevik power and authority, unify different segments of society, and establish a new social ritual.[132] These mass spectacles typically involved thousands of people as direct participants (sometimes conscripted Red Army "volunteers," but also workers, students, and party members) and tens of thousands of spectators, and were organized by avant-gardists, who were given license to implement their aesthetic designs (e.g., constructivism and futurism) for a mass audience. The spectacles were held on festive occasions and were thematically related to the events of the recent revolution or the civil war, sometimes using actors to represent historical figures. Perhaps the most well known of these spectacles is *The Storming of the Winter Palace*, which took place in the titular premises

in St. Petersburg on the third anniversary of the October Revolution. Chiefly directed by Nikolai Evreinov, it featured some 8,000 participants and an estimated 100,000 spectators stationed in Utritzky Square. *The Storming*, as with other mass spectacles, used sound effects and music to help engineer the historical reenactment. This included machine-gun fire, artillery discharge, cannons, rockets, sirens, and massive choral renditions of revolutionary songs.

The outdoor spectacles operated under the auspices of *Proletkult*, an acronym for "proletarian cultural-educational organizations," which was established at the time of the October Revolution with the aim of democratizing the arts by creating a unique proletarian culture led by, intended for, and principally about the workers.[133] Proletkult, inspired by the theories of the Bolshevik intellectual Alexander Bogdanov, aimed to create cultural forms for the masses that were ideally universal and classless. Art was to be available and relevant to all. This was to reflect the social ideology of the workers' state. Consequently, the main aim of the proletarian music movement was to create a "dictatorship of the proletariat" in musical life, which involved attempts to make music out of items workers knew and could "perform" themselves, such as factory whistles, guns, and modes of transportation: in short, the noises of machinery and the modern urban environment.[134] Invariably, proletarian music also involved choral singing—a cultural staple and a key part of Russian elementary education. Choral singing was associated with workers' prerevolutionary lives, the revolutions and demonstrations of 1917, and subsequent political gatherings (it was customary in the new Bolshevik state to close political meetings by singing the de facto anthem "The Internationale").

Avraamov, who worked in the music department of Moscow Proletkult's Scientific Technical Section, favored an experimental approach to proletarian music-making, positing the sounds of modern industry as exemplars of a type of music that surpassed and made redundant conventions of Western tonality and pitch regulation. This explains the prominence of industrial instruments in *The Symphony of Sirens*, which fused avant-gardism and populism in its combination of revolutionary songs and the industrial "noise music" of factory sirens, weapons fire, and transports (recalling Russolo's *intonarumori*). Proletarian music does not completely account for Avraamov's work, though, which has multiple performance genealogies. The performance of Avraamov's symphony in Baku had a strong theatrical component as well, employing the pomp of military procession, aerial display, the entire Caspian flotilla, and a massed choral body. These forces were conducted as a theatre of sound and spectacle, as Avramov presented a citywide audio reworking of the October Revolution.

Avraamov first proposed to stage *The Symphony of Sirens* in Petrograd in 1918 but was met with only a "lukewarm response," according to the composer.[135] An attempt in Nizhny Novgorod the following year was hampered by technical problems, Avraamov stated, as was a 1923 performance in Moscow to mark the sixth anniversary of the October Revolution. Avraamov judged the 1922 performance in Baku to be the most successful iteration of the work, presumably because it had no major technical hitches. Avraamov's score consists of a set of military-style instructions, published in Baku's newspapers (*Baku's Worker*, *Communist*, and *Labor*) on the day before the performance. The instructions, worth quoting in full, are as follows:

> On the morning of the Fifth Anniversary, on 7th November, all the ships of Gokaspa [State Caspian Shipping Company], Voenflot [the Navy], and Uzbekcasp [the Office of Navigation Safety] on the Caspian Sea, including all small boats and vessels, will gather near the dock of the railway station at 7:00 a.m. All boats will receive written instructions from a group of musicians, who will board the ships, which will take their specified places in the vicinity of the customs wharves. The destroyer Dostoyny, with the main steam whistling machine [magistral'] and the small boats, will be anchored further up, in front of the tower.
>
> At 9:00 a.m., the whole flotilla will be in place.
>
> By that hour, all unused locomotives (shunting, local transport, armored trains, and even those in repair) will arrive at the pier.
>
> Cadets of the four Armavir academies, students of the Higher Communist Party School of the Baku region, students of the Central Revisionary Committee, students and musicians of the Azerbaijani State Conservatory, and professional musicians will be on the dock no later than 8:30 a.m.
>
> At 10:00 a.m., the infantry, artillery, machine guns, and armored cars and trucks will be in position according to the order of the garrison. Airplanes and hydroplanes shall also be ready.
>
> At 10:30 a.m., the district station and dock whistles will be taken over by a bugler. Those in charge of making the signals will take their positions at the regional and railway terminals.
>
> The midday cannon is cancelled.
>
> Upon the first cannon shot, Zykh, Belyi Gorod (White town), Bibi-Eibat, and Bailov [Sabayil] will begin to sound the siren alarms.
>
> The fifth shot will signal the first and second region of the Chernyi Gorod [Black town].

On the tenth shot—the whistles of the customs control of Az-neft [Azerbaijani Oil] and the docks.

On the fifteenth shot—the mountain region [districts]. Planes take off. Bells.

On the eighteenth shot—the whistles of the railroad depot and the locomotives left at the station. (At the same time, the first company of the fourth army of Komkursy [Military Cadets], led by the United Brass Band, will leave the square for the docks, playing the march "Varshavianka").

All the sirens sound, ending at the twenty-fifth cannon shot. Pause.

A threefold chord of sirens. "Hurray" from the pier.

An "all-clear" signal from the steam whistle machine [magistral'].

"The Internationale" (four times). On the second half-verse, unite with wind orchestra and automobile choir playing "The Marseillaise." On the repeat, everyone in the square joins in the singing.

At the end of the four verses, the cadets and infantry return, where they are met with an answering "hurray!" from the square.

In the end, an overall solemn chord with all whistles and sirens sounding for the course of three minutes, accompanied by the ringing of bells.

An "all-clear" signal from the steam whistle machine.

Ceremonial march.

Artillery, fleet, trucks, and machine guns receive signals directly from the conductor on the tower. The red flag with white reverse is for the batteries; the yellow with dark blue is for the sirens; the four-coloured flag is for the machine guns; and the red is for the solo ships, locomotives, and the automobile choir.

"The Internationale" is repeated twice more during the final procession. Boiler furnaces are obligatory wherever there are signal whistles.

All of the above is directed to the leadership and is to be strictly carried out under the responsibility of governing institutions: the military authorities, Azneft, Gokaspa, and the relevant educational institutions.

All participants are obliged to have this mandate with them during the execution of the celebrations.[136]

The instructions indicate that *The Symphony of Sirens* is a composition in the sense of combination and synthesis: an arrangement of pre-existing (known) items brought together to form a unique whole. The composition does not merely comprise notes (which, in the case

of the known tunes, are left "as is" and not rearranged) but a panoply of everyday and ceremonial sounds, ranging from cannon fire, foghorns, fireworks, bells, sirens, automobile engines, gunfire, cheering, and so forth, in addition to a specially built steam whistle machine (in this case, placed on the destroyer *Dostoyny*), which was used to pipe the notes of "The Internationale." Avraamov's objective in using and combining these sounds was not simply to make a grand din but to create "differential music" in which the specific tone qualities of each "instrument" (e.g., the hum of car motors or the droning of planes, or indeed the various types of sirens) participated individually and were registered as such while still contributing to the work as a whole.[137]

The areas of the city mentioned in the instructions indicate the symphony's scope, which called for sonic activity from the southwestern district of Bibi Heybat to the eastern district of Zykh and the northern district of Bely Gorod.[138] Avraamov clearly wished to involve as much of the city as he could (business, commercial, residential, industrial, docklands), giving the work the greatest possible acoustic range (according to one commentator, it could even be heard beyond the city walls) and breadth, operating at ground level, at sea, and in the air.[139] D. D. B. Wendel observes that the sounds emanating from the square would have been amplified as a result of their concentration in the city center, which, because it lies in a topographical depression, would have created "a sonic effect similar to an oversized gramophone horn."[140] Avraamov conducted the symphony from a specially built tower originally designed to mount radio antennae in a public square near the harbor.[141] He used an assortment of flags, a field telephone, and a megaphone, initiating prearranged sound cues. Avraamov is depicted conducting his soundscape spectacular in the illustration that features on the front cover of this book.

In *The Symphony of Sirens*, Avraamov activated different areas of the city at specified points in the order of events, re-orchestrating the city sonically, cue by cue. The main area of sonic activity was around the harbor, but the directional impetus of the work was toward the main square where the climax took place: the singing of "The Internationale" four times by a 1,000-strong choir to the accompaniment of sirens, cannon shots, and a 200-piece military orchestra playing "The Marseillaise" in an arranged counterpoint. The use of different geographic locations was built into the work, which was intended to function as a type of symphonic tone poem about the October Revolution enacted across an urban environment. Avraamov delineated a tripartite form for his "sound picture": "anxiety (industrial suburbs), ensuing battle, and the victory of the International Army."[142] The sounding of factory sirens (prompted by cannon shots) along discrete points of Baku's harbor served as the call to alarm

(escalated by bell ringing and aircraft departure); the "battle" (or "unrest") was presumably represented by the full sounding of all the factory sirens in the city by the twenty-fifth cannon shot (though the march of the army from the square to the docks on the eighteenth cannon shot might have been meant to represent the original storming of the Winter Palace); and victory was signaled (following the "all-clear" report of the steam whistle machine) by the celebratory mass-singing of "The Internationale" at the apex of the work's protracted crescendo.

Although Avraamov used keynote sounds (sounds particular to Baku) in this work, they were meant to represent the sounds heard on the night of the Bolshevik takeover in St. Petersburg five years earlier. This was a calculated attempt to provoke or perform *anamnesis*, a recollection of a past situation or occurrence drawing on associations between sound and memory.[143] This attempted anamnesis was fuzzy, though, as the extent to which the sonic elements of Avraamov's symphony actually resembled, or were a fair imitation of, the soundscape of the original storming is debatable. Avraamov did not attest to the accuracy or realism of his sonic reconstruction of the October Revolution but rather stressed its retrospective symbolic importance, commenting on how his work was intended to *improve* upon the original soundscape of the revolution, which he considered unfortunately disorganized. He writes:

> [We] had to arrive at the October Revolution to achieve the concept of the *Symphony of Sirens*. The Capitalist system gives rise to anarchic tendencies. Its fear of seeing workers marching in unity prevents its music being developed in freedom. Every morning, a chaotic industrial roar [gagged] the people.... But then the revolution arrived. Suddenly, in the evening—an unforgettable evening—a Red Petersburg was filled with many thousands of sounds: sirens, whistles, and alarms. In response, thousands of army lorries crossed the city loaded with soldiers firing their guns in the air.... At that extraordinary moment, the happy chaos *should have had the possibility* of being redirected by a single power able to replace the songs of alarms with the victorious anthem of *The Internationale*. The Great October Revolution!—once again, sirens and cannon work in the whole of Russia without a single voice unifying their organisation.[144]

In *The Symphony of Sirens*, Avraamov offered an artistic version of the events of the October Revolution, recomposed after the fact and given a more satisfying musical (and dramatic) structure, complete with a full-scale choral coda with instrumental accompaniment. Moreover, Avraamov supposed the sounds of modern industry (factory sirens), which, under capitalism had been the call of captivity, were now "the song of the future," to quote the proletarian poet Aleksei Gastev, whose

1913 poem "Gudki" (Factory Whistles) provided inspiration for the composer.[145] Avraamov's symphony offered a "theatricalization of history" (in the manner of the earlier mass spectacles) in which the October Revolution was imagined to be an unquestioned triumph, roundly supported, as jubilant and popular an affair as the February Revolution that ousted the Tsarist regime, and thus a marker of legitimacy for the Bolshevist movement.[146] The soundscape of Avraamov's symphony was intended to be uplifting and celebratory, despite, or rather because of, the almighty wail and racket it generated; his symphony worked to "liberate" (glorify) the sounds of modern industry and make the organizational structure of alarm-battle-victory, adapted from the official narrative of the October Revolution, seem inevitable and just.

The Symphony of Sirens was unquestionably a propagandist work that endeavored to legitimate the October Revolution and advance the cause of the international proletarian revolutionary movement, which Lenin hoped would spread throughout the capitalist countries of Europe. The October Revolution would again be the sound that was figuratively heard around the world, inspiring workers to revolt and seize control. Hence the prominence given to "The Internationale" with its directive to the "enslaved masses," the "wretched of the earth," to rise up and join together, but also the sounds of modern industry and mechanization, which were thought to have special significance for the world proletariat. The workers of the world understood the sound of sirens and even appreciated them, according to Avraamov, which theoretically gave his symphony broad appeal and allowed it to be performed in different cities with a predetermined, shared effect. One did not need to be "cultured" in order to recognize the value of such noise-music (in fact, this might be an impediment). The proletariat already had the requisite aural training and sensitivity to understand this music; after all, it was their "song" and universal language (thus recalling Zamenhof, Khlebnikov, et al.)

For this reason, performances of the *Symphony of Sirens* would work to bond the proletariat in different cities and countries, effecting a figurative transposition of place through a redesigned soundscape. The city of Baku "echoed" St. Petersburg as Avraamov enacted an aural fantasy (re-imagining) of the revolution, performatively solidifying the ties between Azerbaijan and Russia, as well as the recently formed Azerbaijan SSR, a political designation that gave the country a semblance (or an illusion) of national identity and independence.[147] Avraamov was attempting to achieve what Benedict Anderson has termed "unisonality" with this mass concert: the "echoed physical realization of the imagined community," the nation imagined or brought into being in sonic terms, as

the singing of national anthems may accomplish.[148] In this instance, it was not nationalism that was trumpeted (either Azeri or Russian) but international proletarianism, a class-based imagined community ideally unimpeded by national borders or ethnicity. Avraamov was acutely aware of the power and efficacy of music as an instrument of social organization.[149]

As a member of the music department of Moscow Proletkult's scientific technical division, Avraamov studied the physical, physiological, and psychological aspects of music in addition to technological and theoretical music problems; consequently, he would have been aware of the potential effects of a mass concert on participants and over-hearers.[150] In describing the event, Avraamov stated the city of Baku was "*overwhelmed* with a music wholly appropriate to this historic moment" (the fifth anniversary of the October Revolution).[151] This verb choice is telling, as whatever about the comprehensibility of Avraamov's organizational structure of alarm-battle-victory (its "legibility" as a sonic narrative of the storming of the winter palace), the cumulative *affective* power of the work cannot be discounted; the sheer scale of the forces deployed must have overwhelmed the audience, especially at the climactic moments of the symphony. The staggered activation of all the sirens of the city, plus the foghorns of the Caspian flotilla, plus the sounds of locomotives, automobiles, hydroplanes and airplanes, plus the steam whistle machines, plus the church bells, plus the military orchestra, plus the 1,000-strong choir undoubtedly created an enormous din that blanketed the city in an industrial-technological-musical glut of sound intended to herald the glory of the proletarian past and future via an artistically transposed present.

Avraamov's symphony worked to envelop its listeners, encouraging them to participate (if not to sing, then to hear), overwhelming their sense faculties with a type of sonic sublimity.[152] A potential result of this mass sound-making (a loose contemporary parallel is the stadium chanting of sports fans) was to disable the boundaries of the self, thereby enacting what William Benzon calls "interactional synchrony": coupling together the brains and nervous systems of the massed bodies in attendance, uniting them in musical *flow*, binding individuals to the group experience.[153] Artaud's theatre of cruelty attempted something similar, albeit at the other end of the political spectrum. Indeed, there is arguably sympathetic resonance between the fascist undertones of Artaud's theatre of cruelty and the communist overtones of Avraamov's *Symphony of Sirens*, revealing the ostensibly divergent but plausibly convergent ends to which avant-garde sonic orchestrations could be put. Avraamov's work encouraged participants to "lose" themselves in a sea of sound, to join in with the musical *ekstasis* and delight in the performance of widespread sonic

power. Seemingly ubiquitous loud sound emanated from multiple points simultaneously, manifesting power in the acoustic realm. Unlike the performance of power in spectacle, which defines the objects and agents of attention relatively clearly (e.g., soldiers on parade), a sonically engineered event such as this would have *displaced* attention, obscuring sources of power.

The Symphony of Sirens utilized what Jean-François Augoyard and Henry Torgue refer to as the "ubiquity" effect, in which sound seems to come from everywhere and nowhere at the same time, or from a singular source and many sources, presenting as diffused, unstable, and omnidirectional.[154] Although Avraamov's instructions lend the impression of an orderly and organized chain of events neatly punctuated by cannon fire and signaled by flags, this is a prescriptive illusion, a bird's-eye view of the proceedings only notionally available to the conductor. Even with their instructions in hand (as participants were requested to have), the reality of Avraamov's designed soundscape was likely much denser and more oblique in practice, received and understood (or misunderstood) uniquely depending upon the location of the listener and the fidelity of his or her acoustic situation (i.e., the signal-to-noise ratio). It was probably not as neat as the instructions suggest.

A 2008 recording of a reconstruction of Avraamov's symphony, undertaken by Leopoldo Amigo and Miguel Molina that uses simulated and sampled sounds to approximate the Baku performance, makes evident not just the awful (as in awe-inspiring) force and dynamic heft of this work, but its blurring, fluidity, and overlap of sounds.[155] Even following the score, it is often difficult to identify distinct sounds and determine their imaginary provenance and direction. Listening to the recording with headphones on, it is easy to become immersed in its sonic shock and awe, which may mentally resound after the recording has ended. The recorded reconstruction doubles Avraamov's arrangement of sonic history: it is a twenty-first-century reconstruction of Avraamov's 1922 arrangement of the soundscape of the October Revolution (as he imagined it). This doubling was an intended feature of the 1922 performance, too, which strove to re-signify Baku's soundscape to effect *déjà entendu*—the impression that one has heard a sound before (as though "hearing" history)—in those present despite the fact that the vast majority (if not all) of Baku's citizens were not present at the event to which the sounds referred.

The recorded reconstruction disallows what was arguably the most important aspect of Avraamov's mass concert: the ability of those present to participate in it. Avraamov's work was a musical manifestation of the Bolshevist ideal of shared, dispersed power: ideally not located in any single source but in a collective that may be either seen or unseen and

is greater than the sum of its parts (hence the use of sonic ubiquity). In theory, to experience the *Symphony of Sirens* was to hear—and to feel in one's bones—the sound of a united proletariat and to *be* that proletariat by making sounds, as the individual was absorbed into—or made synchronous with—the group. The group was to express the dynamic power and potential of the modern, industrial environment and the "song" of the revolutionary past, present, and future (hence the potential impact of sonic remanance). The proletariat class in Baku could join in with the singing of "The Internationale" at the conclusion of the symphony and in doing so become both senders and receivers in the communicative matrix: contributors to and recipients of the mass performance of communist power. Here, however, is the rub: in the imagined unison (or unisonality) of Avraamov's work—a cacophonous paean to international proletarianism—there was no allowance for discord of the non-Bolshevist variety as any dissenting voices would have been drowned out.

To what extent did Avraamov's audience in Baku share the composer's dream of a united proletarian mass concert celebrating the October Revolution? The audience must have been at least partially resistant. The instructions for the symphony outline some of the parties involved, including military personnel, naval officers, and students of the Higher Communist Party School of Baku, who presumably were sympathetic to the Soviet cause, as well as other organizations (the State Caspian Shipping Company, the Office of Navigation Safety, students from the Azerbaijani State Academy, and professional musicians), whose members' allegiances are unknown, and who may have been volunteered for the occasion. The fact that the instructions were published in Turkish-language newspapers suggests Avraamov aspired for a broader participation of Baku's inhabitants, including its Turkish population. The three major ethnoreligious communities of Baku at the time were Muslim Turks, Orthodox Russians, and Gregorian Armenians, with the Muslims dominating the labor force.[156] Wendel notes that Muslims accounted for about 35–45 percent of Baku's population in 1922 (the urban population was recorded at just under a half million in 1926); approximately one-third of the city was Orthodox Russian and one-fifth was Gregorian Armenian.[157] Avraamov, ethnically a Russian Jew, had cause to expect that the Russians in Baku and some of the urban proletariat would support his symphonic spectacular. Baku had been a seedbed of the communist movement since 1907 when Joseph Stalin agitated there for the workers' movement; the Bolsheviks had built a relatively strong organization in the city (though the countryside was hostile to them).[158] Even so, the political situation in 1922 was far from stable and not entirely amenable to Bolshevization. Indeed, an effort was made to form an independent

Azerbaijani Democratic Republic (ADR) from 1918 to 1920, with Ganja as a temporary capital; the ADR professed neutrality in the Russian Civil War and sought international recognition for Azeri independence. The republic lasted until April 1920 when the Red Army invaded Azerbaijan, took the streets of Baku, occupied government buildings, and imposed martial law on the city, thereafter proclaiming the (theoretically independent) Soviet Republic of Azerbaijan.[159] Although Baku fell swiftly to the Bolshevists, Azeri nationalists mounted resistance to the new regime, to which the Red Army responded brutally by way of mass executions, persecutions, detention centers, and deportations. According to the most conservative estimates, over 100,000 Azeri citizens were killed in purges between 1920 and 1925; Baku was not immune from this.[160]

The utopian rallying call and cooperative sentiment of "The Internationale" rings hollow and sticks in the throat when considered in the context of Soviet oppression and Azeri resistance in the early 1920s; the symphony's general boom resembles a form of sonic warfare (even if Baku had a pro-Bolshevist proletarian base). The heterogeneous ethnic population of Baku, separated into ethnically homogenous city quarters and sharply divided by socioeconomic status (the center of the city was occupied by the wealthy business and merchant class, and was mainly Christian; the poor lived in the industrial suburbs and the oil field districts, and was mainly Muslim) gave rise to intercommunal tension and antagonism, not collective brotherhood; it is difficult, therefore, to imagine that all the city's inhabitants gamely sang along to Avraamov's symphony or lent it a sympathetic ear.[161] Moreover, Baku was home to long-seated hostilities between Azerbaijani Turks and Armenians, who variously advanced the causes of Armenian nationalism, pan-Islamism, and pan-Turkism, which did not accord with a celebration of Bolshevist international proletarianism or a new Union of Soviet Socialist Republics.[162] Avraamov's *Symphony of Sirens* registered none of these tensions, extolling the international and supposedly universal over the local and particular by activating Baku's soundscape in such a way as to unify it: artistically overwhelming—or masking—the city's divides for the purpose and duration of the work, blanketing it in revolutionary-inspired sounds, turning Baku into a would-be *Gesamtkunstwerk* (a "total" work of art).

It stands to reason that *The Symphony of Sirens* was not appreciated by all of Baku's inhabitants, who may have only tolerated the symphonic performance or passively resisted it, as was the enduring tactic of the Azerbaijanis in relation to the Russians.[163] Alternatively, they may have resented the proceedings and actively dissociated themselves from it (while still hearing it), objecting to the sonic barrage as well as its

ideological underpinning. This would amount to spectatorial *dédoublement* or theatricality, explained by Tracy Davis as "sympathetic breach (active disassociation, alienation, self-reflexivity) effecting a critical stance toward an episode in the public sphere, including but not limited to the theatre."[164] In this case, members of Avraamov's audience may have recognized the symphony as a militarist cooptation of the sonic environment and an instance of Bolshevist power performatively quashing Azeri nationalism. These audience members would not have been inclined to participate in the interactional synchrony proposed by the symphony whereby a mass of individuals is sympathetically coupled together in musical flow. They would have been alert to the propagandist nature of the work, its demonstration of sonic power, and perhaps also the similarity between the politics of proletarian internationalism and the policies of supposedly defunct Russian imperialism implicit in the execution.[165] Despite the Proletkult rhetoric of proletarian music operating as the "dictatorship of the proletariat" (music made by the workers, for the workers), this mass concert had autocratic components, with signals initiated from on high in the form of Avraamov-as-conductor in his tower. In this light, the work suggests a dictatorship *of* the proletariat (i.e., governing the proletariat) rather than a political formulation belonging *to* the proletariat. It is impossible to know, and yet one wonders: how many of Baku's inhabitants "heard through" Avraamov's designs and blocked their ears, like Odysseus's men in Homer's tale, to the sound of the sirens?

* * *

This chapter has examined how the modernist avant-garde utilized the affective power of sound in performance. As modern urban soundscapes became noisier and more experientially demanding, so did those of avant-garde theatre, which tried audiences' auditory tolerance by making noise a pervasive and invasive element. This took various forms: energizing and/or enraging audiences to the point of revolt through provocation (the futurist *serate*, dada cabaret); disrupting the notional silence of the auditorium and reconnecting theatre to street noise (the *serate*); showcasing the aesthetic qualities of noise as music (Russolo, Artaud, Avraamov); demonstrating the auditory effects of modern soundscapes through short-form dramatic representation (the *sintesi*); impressing acoustic energy upon audiences through energetic, impassioned poetry performances (Marinetti, Huelsenbeck); highlighting the impact of sound on the body through vibrational force in audience reception (Huelsenbeck, Artaud); fashioning an immersive, intrusive theatre sound design (Artaud); and attempting to enact embodied politics through large-scale soundscape

redesign (Avraamov). Attempts to deploy sound as an affective force were power trips for avant-gardists, who sought to impose auditory regimes on audiences and create unified bodies of listeners attuned to their wishes (a legacy of Wagner's *Gesamtkunstwerk*). The fact that these efforts sometimes misfired (or were plausibly resisted, as in *The Symphony of Sirens* in Baku) suggests a disconnect between intention and reception and a problematic prompted by noise in performance. It is never a certainty that sound design will have a fixed, predetermined effect upon a listener, let alone an entire audience, as Satie learnt with his attempt at "furniture" music. This is compounded when noise is actively encouraged. Avant-gardists, in their hubris, tried to turn performance noise to their advantage. They were not always successful, however, and intended effects got subsumed—masked, ironically—by the chaos, waywardness, and general intractability of noise.

Conclusion: A Resounding...

I WAS ONCE ASKED why I had chosen to focus on avant-garde theatre *sound*. Why write a sense-specific cultural history? "What about the *smell* of the avant-garde?" I was asked non-facetiously, "Isn't that equally valid?" I said it was and joked that this would be my next project, provided we were talking about the use and historicity of scent in performance and not the smell of avant-garde artists. As it happens, scholars have already written about the creative use of olfaction in performance, including theatrical works by symbolist artists, though this type of sensory experimentation is relatively rare in the modernist avant-garde.[1] I am unsure if one could write an extensive study on the subject. Sound, on the other hand, provides a surplus of examples—more than can be usefully analyzed in a single study, in fact. This is partly due to its conceptual breadth: sound incorporates related phenomena such as noise, voice, speech, and music, which are all elaborate domains. Silence is also potentially sonorous, as John Cage's famous "silent" piece *4'33"* (1952) reveals. The category of imaginary hearing should not be discounted either; it plays a part in drama even if it is not actually sounded. It is practically impossible, then, to avoid sound in performance if one is hearing enabled. Theatre is arguably a quintessentially noisy art form. The modernist theatrical avant-garde exploited this, even the noise-phobic symbolists, who harped upon silence and forced audiences to strain their ears to hear it.

Furthermore, sound did not simply accompany modernity; on the contrary, it helped determine it. Being "modern" in the *fin de siècle* meant hearing a variety of sounds, many involving industry and urbanization, and having novel auditory experiences facilitated by newly developed sonic technologies. Sound suffused modern life and shaped perceptions of it in ways that were not all immediately apparent. "Sonic modernity" is a recent critical coinage, not a buzzword of the age, but this does not mean that people did not consider how their lives were being affected by sonic developments; the history of noise-abatement campaigns proves

otherwise.[2] Assessing more abstract issues, however, such as the impact of sound on selfhood and subjectivity, is not easily determined. It is common to ignore the sonic environment unless it is either especially pleasing or displeasing. We are also prone to disregard how our identities are shaped by what we hear and the manner in which we hear it unless we have deliberate cause to think about it (e.g., a hearing impairment). This is what makes modern art, and art in general, so valuable: it captures impressions that may be only partially understood or dimly intuited by the perceiving/creating subjects.

This is especially true of modernist avant-garde theatre, which can readily evoke an unknowing or unknowable quality (e.g., Kandinsky's *The Yellow Sound*). Artists, especially avant-gardists, often create work they do not fully comprehend and that may not be fully comprehensible, though it may feel appropriate for that particular historical moment. Their art transmutes experience, but the "experience" of modernity, including sonic modernity, is, on the whole, too colossal and inchoate to be neatly circumscribed. This is why avant-garde theatre artists staged sonic modernity in a variety of fashions, both directly and indirectly, by design and happenstance. The historical significance of this aspect of their work is more evident in retrospect. Avant-garde theatre may, on the face of it, strive to mystify, shock, and/or aggravate audiences, but it also engages with contemporaneous social debates, philosophical ideas, and current modes-of-being. It takes propositions that may only be notionally understood and presents them as artistic provocations, as an ideational complex that poses problems of understanding for those in attendance. These problems are worth trying to solve even if there is no single solution. They provide insights into how we make sense of the world, even if our comprehension is necessarily incomplete.

In this book, I have sought to correct the notion that the modernist theatrical avant-garde used sound in the form of loud and obnoxious noises, weird disturbances, nonsense vocalizations, and the like, simply to rattle and provoke audiences. I have argued instead that these practices were consonant with, and borne out of, sonic modernity, and should be interpreted in kind. Modern dramatists' exploration of imaginary sounds evokes acoustic interiority and subject-centered listening; dramatizations of sound-reproduction technologies drew attention to how these devices altered users' sense- and self-perceptions; experiments with invented and nonsense languages re-staged modernity's mooted Babel problem; and performances of noise co-opted urban modernity's affective acoustics. In some cases, this led to "failed" experiments, but these "failures" are still instructive. In a conversation about the avant-garde, James Harding remarks: "Failure usually suggests something went wrong, but thinking

of vectors of the radical and the concept of experimentation, we know that's not the case. In science, failed experiments are a valuable source of information, right?"[3] Kimberly Jannarone concurs: "What we're often drawn to with the avant-garde isn't so much polished works of art, but the impulse that animates them."[4] In the case of the artistic examples discussed in this book, the animating impulses are manifold. They include ideas about subjectivity, identity formation, public and private realms, psychology, ontologies of liveness and presence, social constructions of technology, the limitations and possibilities of language, behavioral norms, modes of attention, environmental considerations, aesthetic formulations, and political ideologies. Framed accordingly, the modernist theatrical avant-garde generated more than just sound and fury, signifying nothing. On the contrary, it strove to *sound out* modern life in all its contrarious discord. That is the ultimate proposition of this study.

This is my conceptual framing, not one that avant-gardists themselves proposed. Avant-gardists mostly staged sonic modernity individually and idiosyncratically, not by collective design. Some may have engaged it unknowingly. This recalls a classic historiographical conundrum. Does the historian fictionalize history by narrativizing it or should this be understood as an act of recovery? Hayden White is one of the main proponents of the literary conception of historiography in which histories are constructed, not found. According to White, historical narratives are verbal fictions that historians "emplot" through the use of recognizable story types so as to give shape to past events, thereby making them comprehensible.

> In the process of studying a given complex of events, [the historian] begins to perceive the *possible* story form that such events *may* figure. In his narrative account of how this set of events took on the shape which he perceives to inhere within it, he emplots his account as a story of a particular kind. The reader, in the process of following the historian's account of those events, gradually comes to realize that the story he is reading is of one kind rather than another: romance, tragedy, comedy, satire, epic, or what have you. And when he has perceived the class or type to which the story that he is reading belongs, he experiences the effect of having the events in the story explained to him. He has at this point not only successfully *followed* the story; he has grasped the point of it, *understood* it, as well. The original strangeness, mystery, or exoticism of the events is dispelled, and they take on a familiar aspect, not in their details, but in their functions as elements of a familiar kind of configuration. They are rendered comprehensible by being subsumed under the categories of the plot structure in which they are encoded as a story of a particular kind. They are familiarized, not only because the reader now has more *information* about the

events, but also because he has been shown how the data conform to an *icon* of a comprehensible finished process, a plot structure with which he is familiar as a part of his cultural endowment.[5]

White's account of historical emplotment has a ring of truth to it, though it is arguably too neat and all-encompassing, despite its postmodernist bent.[6] The constructed nature of history is surely indisputable, but White's proposal that a history will necessarily follow a single plot structure or generic form is not. This book is a case in point. What is the main story or story type of *Avant-Garde Theatre Sound*? The largely self-contained chapter style militates against telling a single narrative, but certain themes recur. Is it a tragic account of previously unrecognized artistic genius? A satire of artistic folly? A comedy about misunderstood perceptions? A romance about grand ambitions? As far as its author is concerned, this book has a central argument, stated above, but does not have a single story or story type; instead, it has multiple, interweaving "emplotments." Perhaps that makes this a bad or unsatisfying history. Alternatively, maybe the history in question is "bad" in that it resists grand narrativization. The efforts of the theatrical avant-garde to sound out modernity were made tentatively, speculatively, and for various ends. It follows that an account of these practices should not necessarily "be encoded as a story of a particular kind," and made readily comprehensible, but may be shown to contain multiple narratives and story types, seemingly contradictory truths (in the vein of surrealism), non-meaning (à la dada), and lingering mystery (apropos of symbolism).

First, there is the "emplotment" of romance, in which the avant-gardist, figured as harbinger ("advance guard") of a new society, is on a quest to explore the sonic potential of modernism and modernity (e.g., Kandinsky in his exploration of "inner sound"; Cocteau in his dramatic and theatrical integrations of sonic technologies; Khlebnikov in his artistic versioning of invented language; and the authors of the futurist *sintesi* in their depictions of short, sharp, sonic shocks inspired by the modern metropolis). This is a positive, celebratory story type. The avant-garde is not simply opposed to bourgeois society, exiled or self-exiled to the margins, but is altogether implicated in it; moreover, avant-garde provocation is intellectual and experiential rather than simply boorish or jejune.

One might also discern a tragic emplotment in this history, in which the sonic modernism of the theatrical avant-garde appears to entail inevitable, recurrent failure (noble failure, if one is feeling charitable). Audiences tend not to appreciate what artists are trying to accomplish (they do not "get it," or if they do "get it" they do not altogether

like it) and the performance misfires, generating disgruntlement, laughter, and/or confusion (e.g., Maeterlinck's efforts at subtle aural dramaturgy frustrated by audiences not being able to hear what the actors were saying; Schwitters's sonata of "primal" sounds that reportedly prompted audience guffaws; Satie's attempt at "furniture" music, which the audience responded to "incorrectly"; Russolo's noise music, which left many listeners nonplussed; Artaud's intended use of vibrations to activate audiences' anatomies and provoke a trance-like state, which left critics scratching their heads; and Avraamov's attempt to bolster the Bolshevik cause by staging a mass concert in Baku, which may have alienated those it was seeking to persuade). This emplotment suggests the theatrical avant-garde's sonic modernism was often unsuccessful, which may be why its history is so scrappy and dispersed, with ideas and enterprises flourishing and fading in quick succession only to be taken up in a related form elsewhere.

Allied to this is the emplotment of comedy, in which modernists continually bungle their attempts to delimit the meaning of particular sounds and sonic situations, generating semantic noise even where none is intended. This is a narrative of artistic hubris, a comedy of errors in which artists attempt to wrest control over sound in performance but end up being undone by sonic polyvalence in the form of unwanted significations, unexpected resonance, and mishearings (e.g., Stanislavsky's treatment of Chekhov's "breaking string" and the subsequent raft of interpretations it engendered; Ball's attempt to invoke a universal language while retaining referential fluidity and relying on language-specific sound symbolism; the futurists' attempts to engage *serate* audiences in their onstage presentations while also encouraging them to misbehave; Artaud's possibly inadvertent appropriation of Balinese gamelan music; and Avraamov's attempt to re-signify and unify auditory responses to his symphony of sirens). Finally, this history has an ironic cast, as many avant-gardists thought their experiments were novel but they were often iterations of projects undertaken by others and had a longer genealogy than they supposed. In an ostensibly oblivious fashion, avant-gardists recycled ideas and declared them to be modern and innovative; in retrospect, these claims are disputable.

None of these emplotments dominate this study. They are all presented herein, sometimes in conjunction with one another. Is this hedging? An evasion? Have I fashioned an incomplete history, one that does not successfully "explain" its subject matter? Hayden White might think so, but according to him the historian's goal is to dispel the "original strangeness, mystery, or exoticism" of the presented events and make them function "as elements of a familiar kind of configuration." This was not my goal.

Rather than dispel the "strangeness" of the avant-garde, I have sought to offer possible explanations, without, I hope, misrepresenting it or foreclosing its many perplexities.

If anything, this book reveals the modernist avant-garde to have been stranger, or at least less familiar, than has previously been supposed. One of the advantages of using sound as a primary point of consideration is that it suggests new connections and associations between avant-garde artists, movements, aesthetics, and discourses. It is all too easy to make the avant-garde function "as elements of a familiar kind of configuration." Avant-gardists are quick to arrange themselves into discrete groups and disavow outside influence. Critical accounts of their work can reproduce their narratives without questioning or complicating them. Attending to sound, which, in a phenomenal sense, is not always readily locatable or containable, facilitates a more capacious understanding of the avant-garde, revealing its involvement in a wide variety of discourses, not just aesthetics and politics. This study has aimed to demonstrate the usefulness of juxtaposing artists of different nationalities from various avant-garde movements, locating hitherto unrecognized resonance in their work. Moreover, it has connected avant-garde theatre to sonic experimentation across the arts, indicating the value of integrated histories of modernism that follow the collaborative, sometimes wayward, nature of artistic enterprise. The result of this has been to expose and undermine some mainstays of modernist historiography: namely, ideological distinctions between modernism and the avant-garde, the relative marginalization of theatre in modernist studies, arguments about artistic autonomy, and conventional artistic genealogies. The history of the modernist theatrical avant-garde should remain unfixed, or at least open to revision (re-hearing). Attending to avant-garde cacophony on the page and in performance makes evident the richness, complexity, and significance of this artistic legacy. Noise can complicate communication and comprehension but it can also increase interpretive possibilities. We need to keep this in mind and let it resound.

Notes

Introduction

1. Audrey Yoshiko Seo and Stephen Addiss translate Hakuin's phrase "*sekishu no onjō*" as "the sound of one hand" because the Japanese phrase does not contain a word for "clapping." Audrey Yoshiko Seo and Stephen Addiss, *The Sound of One Hand: Paintings and Calligraphy by Zen Master Hakuin* (Boston, Mass.: Shambhala, 2010), xiii.
2. Aoife Monks suggests actors perform "realness" in curtain calls but audiences see a spectral entity, "a composite and ambivalent figure who is neither one thing nor the other, neither character nor real actor, neither costumed nor out of costume." Aoife Monks, *The Actor in Costume* (Basingstoke: Palgrave Macmillan, 2010), 136. Monks develops a point made in Bert O. States, *Great Reckonings in Little Rooms: On the Phenomenology of Theater* (Berkeley: University of California Press, 1985), 200.
3. "In *the art of theatre* not only do we expect the audience to be silent, we demand it of them, we demand it as the confirmation of our intentions. We concede there are many silences, but we *discriminate* among the silences." Howard Barker, *Death, the One and the Art of Theatre* (London: Routledge, 2005), 17.
4. Marinetti's 1911 manifesto "The Pleasure of Being Booed" appears in Lawrence S. Rainey, Christine Poggi, and Laura Wittman, *Futurism: An Anthology* (New Haven, Conn.: Yale University Press, 2009), 96–98.
5. T. J. Pinch and Karin Bijsterveld, *The Oxford Handbook of Sound Studies* (Oxford: Oxford University Press, 2012), 7.
6. R. Murray Schafer, *The Soundscape: Our Sonic Environment and the Tuning of the World* (Rochester, Vt.: Destiny Books 1993).
7. Ari Y. Kelman, "Rethinking the Soundscape: A Critical Genealogy of a Key Term in Sound Studies," *The Senses & Society* 5, no. 2 (2010): 214.
8. See, for example, Philipp Schweighauser, *The Noises of American Literature, 1890–1985: Toward a History of Literary Acoustics* (Gainesville: University Press of Florida, 2006).
9. Wes Folkerth, *The Sound of Shakespeare* (London: Routledge, 2002), 7.
10. Bruce R. Smith, *The Acoustic World of Early Modern England: Attending to the O-Factor* (Chicago: University of Chicago Press, 1999).
11. Ibid., 208.

12. Lynne Kendrick and David Roesner, eds., *Theatre Noise* (Newcastle: Cambridge Scholars, 2011), x.
13. Ross Brown, *Sound: A Reader in Theatre Practice* (Basingstoke: Palgrave Macmillan, 2010).
14. The title of the conference at the University of Montreal, held in association with the *Centre de recherche sur l'intermédialité*, was "*Le Son du Theatre*— Towards a History of Sound in Theatre (from the 19th to the 21st Century): Acoustics and Auralities." The title of the conference at the University of Bayreuth, held under the auspices of the German Society for Theatre Studies, was "Sound and Performance."
15. Matthias Rebstock and David Roesner, *Composed Theatre: Aesthetics, Practices, Processes* (Bristol: Intellect, 2012).
16. Mladen Ovadija, *Dramaturgy of Sound in the Avant-Garde and Postdramatic Theatre* (Montreal: McGill-Queen's University Press, 2013). I have not read Ovadija's book at the time of this writing.
17. Emily Ann Thompson, *The Soundscape of Modernity: Architectural Acoustics and the Culture of Listening in America, 1900–1933* (Cambridge, Mass.: MIT Press, 2002), 1–2.
18. Steven Connor, "Rustications: Animals in the Urban Mix," http://www.stevenconnor.com/rustications/. Accessed 10 August, 2013.
19. Steven Feld, "Waterfalls of Song: An Acoustemology of Place Resounding in Bosavi, Papua New Guinea," in *Senses of Place*, ed. Steven Feld and Keith H. Basso, (Santa Fe, N.M.: School of American Research Press, 1996), 91–135.
20. Veit Erlmann, *Hearing Cultures: Essays on Sound, Listening, and Modernity* (New York, NY: Berg, 2004), 4.
21. James Joyce, *Ulysses* (New York: Vintage, 1986), 26.
22. See, for example, Alexander G. Weheliye, *Phonographies: Grooves in Sonic Afro-Modernity* (Durham Duke University Press, 2005); and Juan Antonio Suárez, *Pop Modernism: Noise and the Reinvention of the Everyday* (Urbana: University of Illinois Press, 2007), 119.
23. Stuart Hall, "Introduction," in *Modernity: An Introduction to Modern Societies*, ed. Stuart Hall, et al. (Oxford: Blackwell, 2000), 11, 10. See also Susan Stanford Friedman, "Periodizing Modernism: Postcolonial Boundaries and the Space/Time Boundaries of Modernist Studies," *Modernism/Modernity* 13, no. 3 (2006): 425–443; and S. N. Eisenstadt, *Multiple Modernities* (New Brunswick, N.J.: Transaction Publishers, 2002).
24. Jonathan Sterne, *The Audible Past: Cultural Origins of Sound Reproduction* (Durham: Duke University Press, 2003), 2.
25. See John M. Picker, *Victorian Soundscapes* (Oxford: Oxford University Press, 2003).
26. Jessica R. Feldman, *Victorian Modernism: Pragmatism and the Varieties of Aesthetic Experience* (Cambridge: Cambridge University Press, 2002).
27. Laura Marcus, Steven Connor, Garrett Stewart, and James Donald gave the keynote presentations. The conference program may be accessed here: http://www.aal.asn.au/conference/2013/program/index.shtml.

28. Sam Halliday, *Sonic Modernity: Representing Sound in Literature, Culture and the Arts* (Edinburgh: Edinburgh University Press, 2011), 3.
29. Ibid., 13, 15.
30. Anthony Enns and Shelley Trower, eds., *Vibratory Modernism* (London: Palgrave 2013), 2.
31. See James Harding, *Contours of the Theatrical Avant-Garde: Performance and Textuality* (Ann Arbor: University of Michigan Press, 2000); and James Harding and John Rouse, *Not the Other Avant-Garde: The Transnational Foundations of Avant-Garde Performance* (Ann Arbor: University of Michigan Press, 2006).
32. Mike Sell, *Avant-Garde Performance and Material Exchange: Vectors of the Radical* (New York: Palgrave Macmillan, 2011).
33. Ibid., 219.
34. Frantisek Deak, *Symbolist Theater: The Formation of an Avant-Garde*, PAJ books (Baltimore: Johns Hopkins University Press, 1993), 132, 136.
35. Douglas Kahn, "Introduction: Histories of Sound Once Removed," in *Wireless Imagination: Sound, Radio, and the Avant-Garde*, ed. Douglas Kahn and Gregory Whitehead, (Massachussetts: MIT Press, 1992), 2.
36. Sterne, *The Audible Past*: 5.
37. I discuss performances by Sophie Täuber and Mary Wigman elsewhere. See Adrian Curtin, "Vibration, Percussion and Primitivism in Avant-Garde Performance," in *Vibratory Modernism*, ed. Anthony Enns and Shelley Trower, (Basingstoke: Palgrave, 2013), 227–247.
38. Jacky Bratton, *New Readings in Theatre History* (Cambridge: Cambridge University Press, 2003), 6.
39. Martin Puchner, "From the Editor," *Theatre Survey* 48, no. 2 (2007): 227.

CHAPTER 1

1. Kate Covington, "The Mind's Ear: I Hear Music and No One Is Performing," *The College Music Society* 45 (2005): 25–41. Some theorists differentiate between recollected sound (anamnesis) and newly imagined sound (phonmnesis). See Jean-François Augoyard and Henry Torgue, *Sonic Experience: A Guide to Everyday Sounds* (Montreal; London: McGill-Queen's University Press, 2005), 21–25, 85–86.
2. Ross Brown, *Sound: A Reader in Theatre Practice* (Basingstoke: Palgrave Macmillan, 2010), 75.
3. See Marie Agnew, "The Auditory Imagery of Great Composers," *Psychological Monographs* 31 (1922): 268–278.
4. Ibid., 285. The speculation about Schumann is reported in George Foy, *Zero Decibels: The Quest for Absolute Silence* (New York: Scribner, 2010), 166.
5. Jonathan Sterne, *The Audible Past: Cultural Origins of Sound Reproduction* (Durham: Duke University Press, 2003), 11.

6. British artist Dot Young has a project entitled *The Aurality of Objects* that explores "the dynamism between visual and aural outcomes" of object production. http://www.dotyoung.com/fine-art.html. Accessed March 1, 2013.
7. Andrew Sofer, "Spectral Readings," *Theatre Journal* 64, no. 3 (2012): 330.
8. Leopold Lewis and David Mayer, *Henry Irving and The Bells: Irving's Personal Script of the Play by Leopold Lewis* (Manchester: Manchester University Press, 1980), 55.
9. Ibid., 69.
10. Elinor Fuchs, "Reading for Landscape: The Case of American Drama," in *Land/Scape/Theater*, ed. Elinor Fuchs and Una Chaudhuri (Ann Arbor: University of Michigan, 2002), 30.
11. Ibid.
12. Sterne, *The Audible Past*, 95.
13. Ibid., 24.
14. Ibid., 160.
15. Michael Bull, "Thinking about Sound, Proximity, and Distance in Western Experience: The Case of Odysseus' Walkman," in *Hearing Cultures: Essays on Sound, Listening, and Modernity*, ed. Veit Erlmann (New York, NY: Berg, 2004), 189. I am grateful to Susan Hollis Clayson for bringing Robida's illustration to my attention and suggesting the phrase "the iPod *avant la lettre*."
16. Octave Uzanne, "The End of Books," *Scribner's Magazine* 1894, 227.
17. Gertrude Stein, *The Autobiography of Alice B. Toklas* (New York: Harcourt, 1933), 1–2.
18. For a discussion of acoustic interiority in the novels of Jean Paul, see Nikolaus Bacht, "Jean Paul's Listeners," *Eighteenth Century Music* 3, no. 2 (2006): 201–212. I developed this term independently of Bacht.
19. Georg Wilhelm Friedrich Hegel, *Aesthetics: Lectures on Fine Art*, trans. T. M. Knox, vol. 1 (Oxford: Clarendon Press, 1975), 527.
20. Agnew, "The Auditory Imagery of Great Composers," 281.
21. Daniel Albright, *Modernism and Music: An Anthology of Sources* (Chicago: University of Chicago Press, 2004), 230.
22. Richard Wagner, *Wagner on Music and Drama: A Compendium of Richard Wagner's Prose Works*, ed. Albert Goldman and Evert Sprinchorn (New York: E.P. Dutton, 1964), 181.
23. Ibid., 186.
24. Walter Benjamin, *The Arcades Project* (Cambridge, MA: Belknap Press, 1999), 19.
25. The point about the heavy, sound-absorbing furniture in Khnopff's painting is made in Sharon L. Hirsh, *Symbolism and Modern Urban Society* (Cambridge, UK: Cambridge University Press, 2004), 232.
26. John M. Picker, *Victorian Soundscapes* (Oxford: Oxford University Press, 2003), 43.
27. Justus Nieland, *Feeling Modern: The Eccentricities of Public Life* (Urbana, Ill.: University of Illinois Press 2008), 18.

28. Maurice Maeterlinck, *The Treasure of the Humble*, trans. Alfred Sutro (New York: Dodd, 1925), 12, 17, 15.
29. Ibid., 18–19. My emphasis.
30. Ibid., 11.
31. Donald Flanell Friedman, *An Anthology of Belgian Symbolist Poets* (New York: Garland Pub., 1992), 23.
32. Hirsh, *Symbolism and Modern Urban Society*: 14.
33. Ibid., 220.
34. Quoted in Claude Schumacher, *Naturalism and Symbolism in European Theatre, 1850–1918* (Cambridge, England: Cambridge University Press, 1996), 90.
35. Maurice Maeterlinck, "The Intruder," in *Symbolist Drama: An International Collection*, ed. Daniel Charles Gerould (New York: Performing Arts Journal Publications, 1985 [1890]), 55.
36. Ibid., 56.
37. Ibid., 65.
38. Ibid.
39. Quoted in Frantisek Deak, *Symbolist Theater: The Formation of an Avant-Garde*, PAJ books (Baltimore: Johns Hopkins University Press, 1993), 161.
40. Maurice Maeterlinck, *The Princess Maleine: A Drama in Five Acts*, trans. Gerard Harry (London: William Heinemann, 1892), 114–115.
41. Maurice Maeterlinck, *Alladine and Palomides, Interior, and The Death of Tintagiles: Three Little Dramas for Marionettes* (London: Duckworth & Co., 1899), 121–125.
42. For an outlining of "static theatre," see "The Tragical in Daily Life" in Maeterlinck, *The Treasure of the Humble*.
43. Patrick McGuinness, *Maurice Maeterlinck and the Making of Modern Theatre* (Oxford: Oxford University Press, 2000), 131.
44. Maurice Maeterlinck, *The Plays of Maurice Maeterlinck*, ed. Richard Hovey (Chicago: Stone & Kimball, 1894), 266–301, passim.
45. Ibid., 279–280.
46. Ibid., 298.
47. Ibid., 318.
48. McGuinness, *Maurice Maeterlinck and the Making of Modern Theatre*: 186.
49. Quoted in Mary Ann Caws, *Manifesto: A Century of Isms* (Lincoln: University of Nebraska Press, 2001), 50.
50. Nora M. Alter and Lutz P. Koepnick, *Sound Matters: Essays on the Acoustics of Modern German Culture* (New York: Berghahn Books, 2004), 6.
51. Walter Benjamin, "On Some Motifs in Baudelaire," in *Illuminations*, ed. Hannah Arendt (New York: Schocken Books, 1968), 166, 167, 169.
52. Antonin Artaud, *Collected Works [of] Antonin Artaud*, ed. Victor Corti, vol. 1 (London: Calder & Boyars, 1968), 236.
53. Gertrude Stein, *Everybody's Autobiography* (New York: Random House, 1937), 289.
54. James N. Loehlin, *Chekhov: The Cherry Orchard* (Cambridge, UK: Cambridge University Press, 2006), 23.

55. "BBC Radio 3, Between the Ears: The Chekhov Challenge: The Sound of a Breaking String": http://www.bbc.co.uk/programmes/b00qbzg5. Accessed 11 March, 2013.
56. Anton Chekhov, "The Cherry Orchard," in *The Wadsworth Anthology of World Drama*, ed. W.B. Worthen, trans. Carol Rocamora (Andover: Cengage, 2004), 610.
57. Ibid., 619.
58. Leo Tolstoy, *War and Peace*, trans. Anthony Briggs (London: Penguin, 2006), 1332–1333. This connection is made in Donald Rayfield, *The Cherry Orchard: Catastrophe and Comedy* (New York: Twayne Publishers, 1994), 225.
59. See Laurence Senelick, "Chekhov's Drama, Maeterlinck, and the Russian Symbolists," in *Chekhov's Great Plays: A Critical Anthology*, ed. Jean Pierre Barricelli (New York: New York University Press, 1981), 161–180.
60. See Nick Worrall, "Stanislavsky's Production Score for Chekhov's *The Cherry Orchard* (1904): A Synoptic Overview," *Modern Drama* 42 (1999): 519–540.
61. Quoted in David Allen, *Performing Chekhov* (London: Routledge, 2000), 17.
62. Ibid., 21.
63. Ibid., 19.
64. Quoted in Rayfield, *The Cherry Orchard: Catastrophe and Comedy*: 74.
65. Quoted in Allen, *Performing Chekhov*: 44.
66. Frank Napier, *Noises Off: A Handbook of Sound Effects* (London: F. Muller, 1936), 86.
67. J. L. Styan, *Chekhov in Performance: A Commentary on the Major Plays* (Cambridge Eng: University Press, 1971), 337.
68. Rayfield, *The Cherry Orchard: Catastrophe and Comedy*: 74; David Magarshack, *Chekhov, the Dramatist* (New York: Auvergne Publishers, 1952), 286; Francis Fergusson, "The Cherry Orchard: A Theatre-Poem of the Suffering of Change," in *The Idea of a Theatre* (Princeton: Princeton University Press, 1949), 170; Maurice Valency, *The Breaking String: The Plays of Anton Chekhov* (New York: Oxford University Press, 1969), 286; Harvey J. Pitcher, *The Chekhov Play: A New Interpretation* (London: Chatto and Windus, 1973), 183; Styan, *Chekhov in Performance: A Commentary on the Major Plays*: 337; Brown, *Sound: A Reader in Theatre Practice*: 74, 75; Jean Pierre Barricelli, "Counterpoint of the Snapping String: Chekhov's The Cherry Orchard," in *Chekhov's Great Plays: A Critical Anthology*, ed. Jean Pierre Barricelli (New York: New York University, 1981), 116, 120; Stanton B. Garner, "Sensing Realism: Illusionism, Actuality, and the Theatrical Sensorium," in *The Senses in Performance*, ed. Sally Banes and Andre Lepecki (New York: Routledge, 2007), 120; Chekhov, "The Cherry Orchard," 598. I am indebted to the synopsis of interpretations of the breaking string presented in Loehlin, *Chekhov: The Cherry Orchard*: 24–25.

69. Edward Braun, "The Cherry Orchard," in *The Cambridge Companion to Chekhov*, ed. Vera Gottlieb and Paul Allain (Cambridge: Cambridge University Press, 2000), 115.
70. Miriam Handley, "Chekhov Translated: Shaw's Use of Sound Effects in *Heartbreak House*," *Modern Drama* 42 (1999): 565–576.
71. Nina Wieda, "The Ominousness of Chekhovian Idyll: The Role of Intertextuality in Stoppard's *The Coast of Utopia*," in *Ot "Igrokov" do "Dostoevsky-trip": intertekstual'nost' v russkoi dramaturgii XIX–XX vv.* (Moskva: Izdatel'stvo MGU, 2006), 59–68.
72. "Between the Ears."
73. "*The Yellow Sound* in its pure form cannot be identified with any avant-garde movement: instead, it is sui generis, presenting its own form and perhaps its own movement." Bert Cardullo and Robert Knopf, *Theater of the Avant-Garde, 1890–1950: A Critical Anthology* (New Haven, CT: Yale University Press, 2001), 172.
74. See Hans-Thies Lehmann, *Postdramatic Theatre* (London: Routledge, 2006).
75. Wassily Kandinsky, "On the Question of Form," in *The Blaue Reiter Almanac*, ed. Wassily Kandinsky and Franz Marc (Boston: MFA publications, 1974 [1912]), 149.
76. Wassily Kandinsky, *Concerning the Spiritual in Art*, 1st ed. (Boston: MFA Publications 2006), 55.
77. Ibid., 176.
78. Kandinsky, "On the Question of Form," 164–165.
79. Kandinsky, *Concerning the Spiritual in Art*: 35.
80. Ibid., 52.
81. Jelena Hahl-Koch, *Kandinsky* (London: Thames and Hudson, 1993), 143–151.
82. Birgit Haas, "Staging Colours: Edward Gordon Craig and Wassily Kandinsky," in *Textual Intersections: Literature, History and the Arts in Nineteenth-Century Europe*, ed. Rachael Langford (Amsterdam: Rodopi, 2009), 42, 46.
83. Kandinsky, *Concerning the Spiritual in Art*: 108.
84. Ibid., 30–31.
85. Ibid., 31.
86. Wassily Kandinsky, "On Stage Composition," in *The Blaue Reiter Almanac*, ed. Wassily Kandinsky and Franz Marc (Boston: MFA Publications, 1974 [1912]), 190, 191.
87. Ibid., 194.
88. Ibid., 196.
89. Ibid., 201, 205.
90. Wassily Kandinsky, "The Yellow Sound: A Stage Composition," in *The Blaue Reiter Almanac*, ed. Wassily Kandinsky and Franz Marc, (Boston: MFA Publications, 1971 [1912]), 219.

91. See Erdmute Wenzel White, *The Magic Bishop: Hugo Ball, Dada Poet* (Columbia, S.C.: Camden House, 1998), 96.
92. Kandinsky, *Concerning the Spiritual in Art*: 75–76.
93. Haas, "Staging Colours: Edward Gordon Craig and Wassily Kandinsky," 49.
94. Peter Jelavich, *Munich and Theatrical Modernism: Politics, Playwriting, and Performance 1890–1914* (Cambridge, MA: Harvard University Press, 1985), 228–229.
95. Kevin T. Dann, *Bright Colors Falsely Seen: Synaesthesia and the Search for Transcendental Knowledge* (New Haven: Yale University Press, 1998), 56.
96. Geraint D'Arcy and Richard J. Hand, "Open Your Eyes/Shut Your Eyes: Staging Kandinsky's *The Yellow Sound* at Tate Modern," *Performance Research* 17, no. 5 (2012): 59.
97. Kandinsky, "The Yellow Sound," 223–224.
98. Steven Connor, "The Modern Auditory I," in *Rewriting the Self: Histories from the Renaissance to the Present*, ed. Roy Porter (London: Routledge, 1997), 206–207.
99. Nieland, *Feeling Modern: The Eccentricities of Public Life*: 17.
100. Hajo Düchting, *Wassily Kandinsky 1866–1944: A Revolution in Painting* (Köln: Taschen, 2000), 10.

Chapter 2

1. Quoted in the program for Arthur Law's *The Judge*, held in the Victoria and Albert Theatre & Performance Collections.
2. Quoted in Jane W. Stedman, "Enter a Phonograph," *Theatre Notebook* 30, no. 1 (1976): 3.
3. "Terry's Theatre," *Marylebone & Paddington Independent*, July 24, 1890.
4. Clement Scott, "The Playhouses," *The Illustrated London News*, August 2, 1890, 131.
5. *Theatre Magazine* (v. 6, April 1906), p.94. Edison's phonograph used tinfoil—later waxed—cylinders to transcribe sound; it was used to make personal recordings (often for posterity). Berliner's gramophone used hard plastic discs and was designed to play commercially produced discs. Walter L. Welch and Leah Brodbeck Stenzel Burt, *From Tinfoil to Stereo: The Acoustic Years of the Recording Industry, 1877–1929* (Gainesville: University Press of Florida, 1994), 96–97. The writer in *Theatre Magazine* may have confused the terms or considered them synonymous.
6. Bertolt Brecht and John Willett, *Brecht on Theatre: The Development of an Aesthetic* (New York: Hill and Wang, 1992), 102–103.
7. Thomas J. Misa, "The Compelling Tangle of Modernity and Technology," in *Modernity and Technology*, ed. Thomas J. Misa, Philip Brey, and Andrew Feenberg (Cambridge,MA: MIT Press, 2003), 10.
8. Jonathan Sterne, *The Audible Past: Cultural Origins of Sound Reproduction* (Durham: Duke University Press, 2003).

9. My use of the word "entanglement" derives from Chris Salter, *Entangled: Technology and the Transformation of Performance* (Cambridge, MA: MIT Press, 2010). Salter uses the term to suggest that "human and technical beings and processes are so intimately bound up in a conglomeration of relations that it makes it difficult, if not impossible to tease out separate essences for each." Ibid., xxxii.
10. This list is indicative, not exhaustive, and is derived from Max Keith Culver, "A History of Theatre Sound Effects Devices to 1927" (Ph.D. dissertation, University of Illinois at Urbana-Champaign, 1981).
11. Harley Vincent, "Stage Sounds," *The Strand Magazine* 1904, 418.
12. Ibid., 422.
13. Douglas Lanier, "Shakespeare on the Record," in *A Companion to Shakespeare and Performance*, ed. Barbara Hodgdon and William B. Worthen (Oxford: Blackwell, 2005), 423.
14. Quoted in Richard Bebb, "The Voice of Henry Irving: An Investigation," *Recorded Sound: The British Institute of Recorded Sound* 68 (1977): 729.
15. Laurence Senelick, "'All Trivial Fond Records': On the Uses of Early Recordings of British Music-Hall Performers," *Theatre Survey* 16 (1975): 135–149.
16. Recordings made in situ (e.g., "live at the London Palladium") *are* informed by the site of performance. This is a selling feature and may factor into reception, especially if one is familiar with the theatre or has been to the show in question. Thanks to Claire Warden for making this point.
17. Walter Benjamin, *Illuminations* (London: Pimlico, 1999), 223.
18. Ibid., 215.
19. Brecht and Willett, *Brecht on Theatre: The Development of an Aesthetic*: 102–103.
20. Benjamin, *Illuminations*: 216.
21. Gertrude Stein, *Lectures in America* (New York: Random House, 1935), 99.
22. Ibid., 103.
23. One of Stein's objectives in her lecture tour was to promote her own work, not to bolster her academic credentials. I am indebted to Sarah Bay-Cheng for this observation.
24. Ibid., 103–104.
25. Ibid., 104.
26. See Sara Danius, *The Senses of Modernism: Technology, Perception, and Aesthetics* (Ithaca: Cornell University Press, 2002).
27. Ross Brown, *Sound: A Reader in Theatre Practice* (Basingstoke: Palgrave Macmillan, 2010), 32.
28. Guillaume Apollinaire, "The Breasts of Tiresias," in *Modern French Theatre: The Avant-Garde, Dada, and Surrealism*, ed. Michael Benedikt, trans. Louis Simpson, (New York: Dutton, 1964), 64; Annabelle Melzer, *Latest Rage the Big Drum: Dada and Surrealist Performance* (Ann Arbor, MI: UMI Research Press, 1980), 128.

29. Apollinaire, "The Breasts of Tiresias," 67. As the "People of Zanzibar" constitutes a single performer, I use singular pronouns to describe him, despite the apparent incorrectness this causes.
30. Ibid., 67–68.
31. Victor Basch, in his review for *Le Pays*, referred to the People of Zanzibar as a "Red Indian" ("une sorte de peau-rouge"). "Extraits de la Presse Concernant la Représentation des 'Mamelles de Tirésias' le 24 juin 1917," *SIC* 19–20 (1917).
32. The redface detail is provided in Melzer, *Latest Rage the Big Drum: Dada and Surrealist Performance*: 128.
33. A caveat: In theatres constructed in the round or on thrust apron stages, sound effects may be manufactured in view of some of the audience. Brown, *Sound: A Reader in Theatre Practice*: 63.
34. Stephen Bottomore, "An International Survey of Sound Effects in Early Cinema," *Film History* 11, no. 4 (1999): 490.
35. Jean Jacques Meusy, *Paris-palaces, ou, Le Temps des Cinémas (1894–1918)* (Paris: CNRS Editions, 1995), 251. To the best of my knowledge there were no female *bruiteurs*; hence my use of sex-specific language.
36. Bottomore, "An International Survey of Sound Effects in Early Cinema," 487.
37. Meusy, *Paris-palaces*: 144. My translation.
38. Stephen Bottomore, "The Story of Percy Peashaker: Debates about Sound Effects in the Early Cinema," in *The Sounds of Early Cinema*, ed. Richard Abel and Rick Altman, (Indiana: Indiana University Press, 2001), 129–142.
39. Rick Altman, *Silent Film Sound* (New York: Columbia University Press, 2004), 237.
40. Apollinaire, "The Breasts of Tiresias," 57.
41. On this point, see Jeffrey S. Weiss, *The Popular Culture of Modern Art: Picasso, Duchamp, and Avant-Gardism* (New Haven: Yale University Press, 1994), 247–252.
42. Further on, Albert-Birot remarks "Cinema has already given us Charlie Chaplin (why he didn't play *The Breasts!*), Apollinaire gave us *Tiresias*" "Le 24 Juin 1917," *SIC* 18 (1917).
43. "Extraits de la Presse Concernant la Représentation des 'Mamelles de Tirésias' le 24 juin 1917."
44. Apollinaire, "The Breasts of Tiresias," 69.
45. Ibid., 73.
46. Daniel Albright, *Untwisting the Serpent: Modernism in Music, Literature, and Other Arts* (Chicago: University of Chicago Press, 2000), 248.
47. In his review of the performance, Victor Basch supposed that the People of Zanzibar was playing the music of Germaine Albert-Birot. "Extraits de la Presse Concernant la Représentation des 'Mamelles de Tirésias' le 24 juin 1917." In his book on Parisian picture palaces, Meusy notes that the role of the musician and that of the *bruiteur* were very close and that their functions often overlapped. Meusy, *Paris-palaces*: 388.

48. Apollinaire, "The Breasts of Tiresias," 80.
49. Ibid., 91.
50. Ibid., 66.
51. See Arnold Aronson, "Avant-Garde Scenography and the Frames of the Theatre," in *Against Theatre: Creative Destructions on the Modernist Stage*, ed. Alan Ackerman and Martin Puchner (London: Macmillan, 2006), 21–38.
52. "Extraits de la Presse Concernant la Représentation des 'Mamelles de Tirésias' le 24 juin 1917."
53. Jean Cocteau, "The Eiffel Tower Wedding Party," in *The Infernal Machine, and Other Plays*, trans. Dudley Fitts (New York: New Directions, 1963), 161.
54. Ibid., 156.
55. Pascale De Groote, *Ballets Suédois* (Ghent: Acad. Press, 2002), 44; Albright, *Untwisting the Serpent: Modernism in Music, Literature, and Other Arts*: 281.
56. Quoted in Bengt Nils Richard Häger, Isaac Albéniz, and Alexandre Alexeieff, *Ballets Suedois: The Swedish Ballet* (New York: H.N. Abrams, 1990), 148.
57. Cocteau, "The Eiffel Tower Wedding Party," 163, 164.
58. Ibid., 169, 170.
59. Ibid., 166, 171.
60. Lynette Miller Gottlieb, "Images, Technology, and Music: The Ballets Suédois and *Les Mariés de la Tour Eiffel*," *The Musical Quarterly* 88, no. 4 (2005): 546.
61. Near the end of the play, The Camera speaks a few words for itself (in a "distant voice"). This is the only instance in the play when non-phonographic speech is uttered. Cocteau, "The Eiffel Tower Wedding Party," 177.
62. Ibid., 165.
63. R. Murray Schafer, *The Soundscape: Our Sonic Environment and the Tuning of the World* (Rochester, VT: Destiny Books 1993), 90–91.
64. Cocteau, "The Eiffel Tower Wedding Party," 157.
65. Allan Pero, "The Feast of Nemesis Media: Jean Cocteau's *The Eiffel Tower Wedding Party*," *Modern Drama* 52, no. 2 (2009): 194.
66. I use the term 'theatre phone' to refer to the technology and elsewhere specify particular iterations of it (e.g., the *théâtrophone* and the electrophone).
67. Thanks to Kara Reilly for this suggestion.
68. "The Telephone at the Paris Opera," *Scientific American* (1881): 423.
69. The subscription statistic is provided in "The Electrophone," *San Francisco Call*, September 3, 1893, 8.
70. "The Queen and the Electrophone," *The Electrician*, May 26, 1899, 144.
71. Denys Parsons, "Cable Radio—Victorian Style," *New Scientist* 23, no. 30 (1982): 794.
72. Quoted in William C. Carter, *Marcel Proust: A Life* (New Haven: Yale University Press, 2000), 498.

73. Jane Draycott, *Prince Rupert's Drop* (Manchester: Carcanet, 2004), 34.
74. Sebastian D.G. Knowles, "Death by Gramophone," *Journal of Modern Literature* 27, no. 1/2 (2003): 1–13.
75. "Music, Singing and Dialogues Brought Direct to Your Bedside by Wire," *San Francisco Call*, August 28, 1898, 23.
76. Mark Goble, *Beautiful Circuits: Modernism and the Mediated Life* (New York: Columbia University Press, 2010), 132.
77. "The Theatrophone," *The Times*, May 29, 1891, 5.
78. "Theatre-Going by Telephone: A Forgotten Amenity of London in the 1920s," *The Times*, May 9, 1957, 3.
79. Ibid.
80. Annegret Fauser, *Musical Encounters at the 1889 Paris World's Fair* (Rochester: University of Rochester Press, 2005), 290. Fauser also highlights the imaginary relocation of the telephonic listeners from the stage (where the microphones were placed) to the auditorium (i.e., to a more naturalized, familiar situation). Ibid., 293.
81. Julia Kristeva, "Modern Theatre Does Not Take (a) Place," *SubStance* 18–19 (1977): 131–134.
82. The broadcast of *Le Juif Polonais* featured as part of a double-bill from the Théâtre Français on Tuesday, December 20, 1892, according to a program listing for the *théâtrophone* held at the Charles Deering McCormick Library of Special Collections, Northwestern University Library.
83. See Frederick Brown, *An Impersonation of Angels: A Biography of Jean Cocteau* (New York: Viking Press, 1968), 268.
84. Samuel Beckett, *Proust* (New York: Grove Press, 1970), 26.
85. See Marshall McLuhan, *Understanding Media: The Extensions of Man* (New York: McGraw-Hill Book Company, 1966).
86. See John Brooks, "The First and Only Century of Telephone Literature," in *The Social Impact of the Telephone*, ed. Ithiel de Sola Pool (Cambridge, MA: MIT Press, 1977), 217–218.
87. Jean Cocteau, *The Human Voice* (London: Vision, 1951), 7.
88. See Jacques Attali and Yves Stourdze, "The Birth of the Telephone and Economic Crisis: The Slow Death of the Monologue in French Society," in *The Social Impact of the Telephone*, ed. Ithiel de Sola Pool (Cambridge, MA: MIT Press, 1977).
89. Cocteau, *The Human Voice*: 18.
90. See Michael Issacharoff, *Discourse as Performance* (Stanford: Stanford University Press, 1989), 67; Martin Puchner, *Stage Fright: Modernism, Anti-Theatricality, and Drama* (Baltimore: John Hopkins University Press, 2002).
91. Cocteau, *The Human Voice*: 7.
92. Ibid., 25–26.
93. Ibid., 8–9.
94. Jean-François Augoyard and Henry Torgue, *Sonic Experience: A Guide to Everyday Sounds* (Montreal; London: McGill-Queen's University Press, 2005), 85.

95. Cocteau, *The Human Voice*: 30.
96. Ibid., 33.
97. Steven Connor, "The Modern Auditory I," in *Rewriting the Self: Histories from the Renaissance to the Present*, ed. Roy Porter (London: Routledge, 1997), 211.
98. Cocteau, *The Human Voice*: 8.
99. See John Corbett and Terry Kapsalis, "Aural Sex: The Female Orgasm in Popular Sound," *TDR* 40, no. 3 (1996): 102–112.
100. Cocteau, *The Human Voice*: 39.
101. Ibid., 24, 36–27. "In the telephone" is consistent with the original text: "j'entendais ta voix, exactement la même que ce soir *dans l'appareil.*" Jean Cocteau, *La Voix Humaine, Pièce en Un Acte* (Paris: Stock, 1930), 50, my emphasis. In the preface, Cocteau requests that the intentional grammatical mistakes of the text be retained. Cocteau, *The Human Voice*: 19.
102. I borrow the phrase "synaesthetic spillings" from Steven Connor, "Edison's Teeth: Touching Hearing," in *Hearing Cultures*, ed. Veit Erlmann (New York: Berg, 2004), 153.
103. Cocteau, *The Human Voice*: 39.
104. Ibid., 47, 48.
105. Ibid., 19.
106. James S. Williams, *Jean Cocteau* (London: Reaktion, 2008), 147.

Chapter 3

1. Albert Robida, *The Twentieth Century*, trans. Philippe Willems (Middletown, CT.: Wesleyan University Press, 2004), 100–103.
2. Elsewhere in the novel, Robida remarks (in a footnote):

 The Opéra is one of the rare theaters to have kept its own orchestra. Obviously, no music hall can do without one, but other theatres have worked out an agreement whereby they share a common orchestra, located in a special room designed according to scientific principles and linked to all theaters through telephonic wires. Each evening, the orchestra plays four pieces transmitted through the cables to the subscribing venues. Theaters are not required to play them all at the same time. Thanks to a special phonographic system, the music is kept in tubes until the stage's prompter turns on the valve in his box. (Ibid., 55)

3. Marvin A. Carlson, *Speaking in Tongues: Language at Play in the Theatre* (Ann Arbor: University of Michigan Press, 2006), 3.
4. Ibid., 42–43.
5. The story of the Tower of Babel is found in Genesis 11:1–9. Humanity, united by a common language, builds a city with a tower that reaches unto the heavens. God, fearing their unity, confounds their speech and scatters the people over the face of the earth.

6. This is not to suggest that modern technologies did not also facilitate communication, a claim that would patently be untrue (e.g., the use of morse code in telegraphy), or that the multilingualism of the metropolis was necessarily impairing and divisive, or unique to this period (cf., medieval Jerusalem, early modern Rome, the east end of London in the eighteenth century, etc.) The mulilingualism of modern cities was thought to have compounded the age-old Babel problem, not invented it anew (as the biblical reference suggests). Nevertheless, the linguistic crisis of modernity was also a rhetorical construction, a state of affairs decried by those who wished to correct it.
7. Arika Okrent, *In the Land of Invented Languages: Esperanto Rock Stars, Klingon Poets, Loglan Lovers, and the Mad Dreamers Who Tried to Build a Perfect Language*, 1st ed. (New York: Spiegel & Grau, 2009), 135.
8. For a discussion of the ontological and experiential "crises" of modernity, see Günter Berghaus, *Theatre, Performance, and the Historical Avant-Garde*, 1st ed. (New York: Palgrave Macmillan, 2005), 26–35.
9. Henri Lefebvre, *Introduction to Modernity: Twelve Preludes*, September 1959–May 1961, trans. John Moore (London; New York: Verso, 1995 [1962]), 176.
10. Sarah Bay-Cheng, *Mama Dada: Gertrude Stein's Avant-Garde Theater* (New York: Routledge, 2004), 10.
11. Quoted in Joshua A. Fishman, *Language and Nationalism: Two Integrative Essays* (Rowley, MA: Newbury House Publishers, 1972), 48. Fishman's study has informed my account of language nationalism.
12. The conception of the nation as imagined community derives from Benedict R. Anderson, *Imagined Communities: Reflections on the Origin and Spread of Nationalism* (London: Verso, 1983).
13. Alain Dieckhoff, *The Invention of a Nation: Zionist Thought and the Making of Modern Israel* (New York: Columbia University Press, 2003), 103, 105.
14. See Naomi Seidman, *A Marriage Made in Heaven: The Sexual Politics of Hebrew and Yiddish* (Berkeley: University of California Press, 1997), 2.
15. Robert McColl Millar, *Language, Nation and Power: An Introduction* (London: Palgrave Macmillan, 2005), 200.
16. John Montague, *The Rough Field* (Dublin: The Dolmen Press, 1972), 34.
17. Robida, *The Twentieth Century*: 103. The editor of Robida's text, Arthur B. Evans, glosses the two examples of mélange language (or faux mélange language, in the case of Ponto's sentences) as "Grammar is the art of speaking and writing correctly" and "Will you allow me to offer you my heart and my hand? Let's go to the Mayor [for a civil marriage ceremony]!"
18. The Europanto website (www.europanto.be) provides an account and samples of the language. Europanto has nothing to do with British "panto" (pantomime), except in its silliness, perhaps. Vielen Dank to Katie Zien pour me parler per Europanto.
19. Tomasz Kamusella, *The Politics of Language and Nationalism in Modern Central Europe* (Basingstoke; NY: Palgrave Macmillan, 2009), 978, n. 952.

20. Umberto Eco, *The Search for the Perfect Language* (Oxford: Blackwell, 1995), 319.
21. Ibid.
22. See Appendix A in Okrent, *In the Land of Invented Languages*.
23. This overview and assessment derives from Herbert N. Shenton, Edward Sapir, and Otto Jespersen, *International Communication: A Symposium on the Language Problem* (London: K. Paul, Trench, Trubner & Co., 1931), 99–100.
24. Ibid., 13–33 passim.
25. J. A. Large, *The Artificial Language Movement* (London: B. Blackwell; A. Deutsch, 1985), 87–88.
26. "Discovering Esperanto: A Fascinating Language," ed. E@I/International League of Esperanto Teachers, 6.
27. Peter G. Forster, *The Esperanto Movement* (The Hague; New York: Mouton, 1982), 50.
28. The exact number of worldwide Esperanto speakers according to the 1928 survey conducted by J. Dietterle (and published in an Esperanto journal) was 126,575. 87 percent of these speakers were European. These figures may not, of course, be accurate; estimates of Esperanto speakers vary considerably. Ibid., 24. My summary of Esperanto's achievements derives from Forster's study.
29. Esperanto as an International Auxiliary Language. *Report of the General Secretariat of the League of Nations Adopted by the Third Assembly, 1922* (Paris: Impr. des Presses universitaires de France, 1922).
30. Ibid., 11.
31. [The] strongest opposition to Esperanto came from France, whose strongly nationalistic government opposed the internationalist aims of Esperanto. French nationalism was expressed, inter alia, in support for the use of French as the international language. Since Versailles, English had threatened the status of French.... France was thus hardly likely to favour any kind of threat to the prestige of its language.

 Forster, *The Esperanto Movement*: 175.
32. Ibid., 178.
33. L. L. Zamenhof, *An International Language: The Problem and its Solution*, trans. Alfred E. Wackrill (London: Review of Reviews, [1900?]), 10–11.
34. Ibid., 10.
35. Forster, *The Esperanto Movement*: 106.
36. Zamenhof, "Little by little Esperanto-land will become a school for future brotherly humanity, and in this will consist the most important merits of our congresses." Ibid., 101.
37. Reference to the new Esperanto state as "Amikejo" is made in Okrent, *In the Land of Invented Languages*: 81. Okrent states that 3 percent of the 4,000 inhabitants of Moresnet spoke Esperanto (120 speakers), but does not document this statistic. A New York Times article about the subject ("New European State," February 23, 1908) states that the population of

Moresnet in 1908 was "about 3,000." This article misattributes the invention of Esperanto to Gustave Roy. "New European State," *The New York Times*, February 23, 1908.
38. Okrent, *In the Land of Invented Languages*: 81.
39. "An Esperanto City," *The Strand Magazine* (December 1908): 518.
40. Ibid., 520.
41. Ibid., 517.
42. Ibid., 518.
43. Ibid., 515.
44. For example, the first World Esperanto Congress in Boulogne in 1905 featured a performance of Molière's *La Marriage Forcé* (*The Forced Marriage*) in an Esperanto translation by Victor Dufeutrel. Marjorie Boulton, Zamenhof, *Creator of Esperanto* (London: Routledge and Paul, 1960), 85. For an overview of literature in Esperanto (including original drama), see Pierre Janton, *Esperanto: Language, Literature, and Community* (Albany: State University of New York Press, 1993), 91–111.
45. Although I use the past tense here to refer to Esperantists of the time, I do not mean to imply that Esperanto is no longer learned and spoken; this is not the case (though the motivations and expectations of those learning the language today may differ from those of its first speakers).
46. See the discussion of "restored behavior" in Richard Schechner, *Between Theater and Anthropology* (Philadelphia: University of Pennsylvania Press, 1985), 35–116, and passim.
47. Mike Sell, *The Avant-Garde: Race, Religion, War* (London: Seagull Books, 2011), 41.
48. United States of America War Office, *Esperanto: The Aggressor Language (FM 30–101–1)* (Washington, D.C.: U.S.A. War Office, 1962), 2.
49. The video of the training film is available on YouTube at the time of this writing (search for "Esperanto: The Aggressor Language").
50. The origin and invention of the word "dada" is contested (or was perhaps deliberately obscured). In his diary, Ball claims that he invented it in April 1916, three months after the cabaret opened. (He also states that "for Germans it is a sign of foolish naïveté, joy in procreation, and preoccupation with the baby carriage.") Hugo Ball, *Flight out of Time: A Dada Diary* (New York: Viking Press, 1974), 63. Huelsenbeck states that he and Ball discovered it by chance while perusing a French-German dictionary. "Dada Lives! (1936)" in *Robert Motherwell, Dada, the Dada Painters and Poets: An Anthology*, 2nd ed. (Boston, MA: G.K. Hall, 1981), 280.
51. Richard Huelsenbeck, "First Dada Lecture in Germany," in *The Dada Almanac*, ed. Richard Huelsenbeck and Malcolm Green (London: Atlas Press, 1993), 113.
52. Tristan Tzara, "The First Celestial Adventure of Mr. Antipyrine, Fire Extinguisher," in *Dada Performance*, ed. Mel Gordon, trans. Ruth Wilson (New York: PAJ Books, 1987), 53–54. For a description of the staging of Tzara's play at the Maison de l'Ouevre in Paris on March 27, 1920, see Berghaus, *Theatre, Performance, and the Historical Avant-Garde*: 159.

53. Tristan Tzara, "The Gas Heart," in *Theater of the Avant-Garde, 1890–1950: A Critical Anthology*, ed. Bert Cardullo and Robert Knopf, trans. Michael Benedikt, (New Haven Yale University Press, 2001), 272–273.
54. Ibid., 273.
55. Ibid., 272, 277.
56. Richard Huelsenbeck, *Memoirs of a Dada Drummer*, trans. Joachim Neugroschel (New York: Viking Press, 1974), 23.
57. Hugo Ball, ed., *Cabaret Voltaire: Recueil Littéraire et Artistique* (Zurich: Meierie, 1916), 6–7. Timothy Shipe claims Janco's part is a collage of fragments of American popular songs. Timothy Shipe, "The Dada Movement: Violating Boundaries," in *Migrations in Society, Culture, and the Library: WESS European Conference*, Paris, France, March 22, 2004, ed. Thomas D. Kilton and Ceres Birkhead (Chicago: Association of College and Research Libraries, 2005), 183.
58. Ball, *Flight out of Time*: 157.
59. See, for example, Steve McCaffery, "Cacophony, Abstraction, and Potentiality: The Fate of the Dada Sound Poem," in *The Sound of Poetry, The Poetry of Sound* ed. Marjorie Perloff and Craig Dworkin (Chicago: University of Chicago Press, 2009), 119.
60. Quoted in Ball, *Cabaret Voltaire*.
61. There is no recording of Tzara, Huelsenbeck, and Janko delivering the poem. A version by the group Trio Excoco can be heard on Ubuweb: http://ubu.artmob.ca/sound/tzara_tristan/Tzara_Janco-Hulsenbeck_Lamiral-cherche.mp3.
62. Tristan Tzara, "Manifesto on Feeble Love and Bitter Love [1920]," in *Dada, the Dada Painters and Poets: An Anthology*, ed. Robert Motherwell (Boston, MA: G.K. Hall, 1981), 95.
63. Jahan Ramazani, *A Transnational Poetics* (Chicago: University of Chicago Press, 2009), 48.
64. Huelsenbeck, "First Dada Lecture in Germany," 111, 112.
65. Huelsenbeck, *Memoirs of a Dada Drummer*: 12.
66. Ball, *Cabaret Voltaire*: 5. My translation.
67. T. J. Demos, "Dada Zurich: The Aesthetics of Exile," in *The Dada Seminars*, ed. Leah Dickerman and Matthew S. Witkovsky (Washington, DC: Center for Advanced Study in the Visual Arts, National Gallery of Art, in association with D.A.P./Distributed Art Publishers, 2005), 12.
68. Ibid., 9, 10.
69. James Harding argues that the modernist avant-garde was "always-already" informed by transnational influences. See James Harding, "From Cutting Edge to Rough Edges: On the Transnational Foundations of Avant-Garde Performance," in *Not the Other Avant-Garde: The Transnational Foundations of Avant-Garde Performance*, ed. James M. Harding and John Rouse (Ann Arbor: University of Michigan Press, 2006), 18–40.
70. Janco reports that the dadaists also held evenings for specific language (or national) groups: "We held Russian events where anyone could go up on the podium and sing popular Russian music, Romanian evenings

with Romanian dancers and music, and so on." Francis M. Naumann, "Janco/Dada: An Interview with Marcel Janco," *Arts Magazine* 57, no. 3 (1982): 80–86.
71. I am not the first to make this observation. See, for example, Leonard Wilson Forster, *The Poet's Tongues: Multilingualism in Literature* (Cambridge: Cambridge University Press 1970), 82; Rudolf E. Kuenzli, "Hugo Ball: Verse Without Words," *Dada/Surrealism* 8 (1978): 30–35; Demos, "Dada Zurich": 10.
72. Ball, *Flight out of Time*: 26.
73. Ibid., 68.
74. Ibid., 70–71.
75. See Watson E. Mills, ed., *Speaking in Tongues: A Guide to Research in Glossolalia* (Grand Rapids, MI: W.B. Eerdmans, 1986). The connection between glossolalia and Ball's work is also made in Leonard Forster, *Poetry of Significant Nonsense: An Inaugural Lecture* (Cambridge: Cambridge University Press, 1962).
76. Recordings by Trio Exvoco—and, curiously, by Marie Osmond—may be heard here: http://www.ubu.com/sound/ball.html. The band Talking Heads featured lines from "Gadji Beri Bimba" in the song "I Zimbra," which appeared on their 1979 album *Fear of Music*.
77. Quoted in Erdmute Wenzel White, *The Magic Bishop: Hugo Ball, Dada Poet* (Columbia, S.C.: Camden House, 1998), 220.
78. Ibid. The hat reference is found in Ball, *Flight out of Time*: 70.
79. The text of Ball's are provided in White, *The Magic Bishop*: 218–221.
80. See Leanne Hinton, Johanna Nichols, and John J. Ohala, *Sound Symbolism* (Cambridge: Cambridge University Press, 1994).
81. See Eric Yorkston and Geeta Menon, "A Sound Idea: Phonetic Effects of Brand Names on Consumer Judgments," *Journal of Consumer Research* 31(2004): 43–51.
82. "Cultures of Modernity: Book of Abstracts, IFTR" (Munich: Ludwig-Maximilians-Universität 2010), 242.
83. Annabelle Melzer, *Latest Rage the Big Drum: Dada and Surrealist Performance* (Ann Arbor, MI.: UMI Research Press, 1980), 202.
84. Kurt Schwitters, Pierre Joris, and Jerome Rothenburg, *Pppppp: Poems, Performance Pieces, Proses, Plays, Poetics* (Cambridge, MA: Exact Change, 2002), 55–56.
85. Ibid., 234. For an account of the visual design, notation schema, and typography of Schwitters' poem (in its various editions) see Nancy Perloff, "Schwitters Redesigned: A Post-War Ursonate from the Getty Archives," *Journal of Design History* 23, no. 2 (2010): 195–203. See also the section on Schwitters in Herbert Spencer, *Pioneers of Modern Typography* (London: Lund Humphries, 1982), 93–99.
86. Schwitters, Joris, and Rothenburg, *Pppppp*: 80.
87. Ibid., 237.

88. The recording and score may be accessed on Ubuweb: http://www.ubu.com/sound/schwitters.html.
89. A possible exception is the "Rr rr rr rr rr rrumm!!!!!!" utterance that Schwitters makes in the rondo movment, which is marked "screeched, with rising intonation." Schwitters, Joris, and Rothenburg, *Pppppp*: 59.
90. Ibid., 67, 69.
91. Hans Richter, *Dada, Art and Anti-Art* (New York: Oxford University Press, 1978), 142–143.
92. The way in which Schwitters' audience reportedly lost control during his recital calls to mind the phenomenon of actors "corpsing" (breaking character and laughing incontrollably) in performance. Nicholas Ridout writes: "volition abandoned, the [corpsing] body becomes a helpless object, shaken and squeezed until it starts to burst all over, overflow, exceed its bounds, lose all coherence." Nicholas Peter Ridout, *Stage Fright, Animals, and other Theatrical Problems* (Cambridge: Cambridge University Press, 2006), 142.
93. Roman Jakobson, *Child Language, Aphasia and Phonological Universals* (The Hague: Mouton, 1968), 21.
94. Daniel Heller-Roazen, meditating on Jakobson's study, speculates that adult language might retain an echo(lalia) of the infinitely varied babble from which it emerges. Daniel Heller-Roazen, *Echolalias: On the Forgetting of Language* (New York: Zone Books, 2005), 11–12.
95. The "protosemantic" aspect of poetic utterance is theorized in Steve McCaffery, *Prior to Meaning: The Protosemantic and Poetics* (Evanston, IL.: Northwestern University Press, 2001).
96. See A. Gregory and H. Clark Barrett Bryant, "Recognizing Intentions in Infant-Directed Speech: Evidence for Universals," *Psychological Science* 18, no. 8 (2007): 746–751.
97. David Crystal, *How Language Works: How Babies Babble, Words Change Meaning, and Languages Live or Die* (Woodstock, NY: Overlook Press, 2005), 84.
98. Gerald Janecek, *Zaum: The Transrational Poetry of Russian Futurism* (San Diego, CA: San Diego State University Press, 1996), 1.
99. Despite the hostile environment for the promotion of Esperanto in Tsarist Russia (state officials suppressed the publication of the periodical *La Esperantisto* from 1895 to 1905), Russia had a flourishing Esperanto community. A 1906 article in *The New York Times* notes that Esperanto is "finding great favor in Russia," due in part to the popularity of a singer known as Mlle. Tamara, the "Russian Nightingale," who, it is reported, was enchanting Moscow audiences by singing and reciting in Esperanto. The article also reports that the political police had censored the singer's songs and recitations. "Esperanto in Russia," *The New York Times*, June 3, 1906. See also E. J. Dillon, "The Esperanto Movement in Russia," *The North American Review* 185, no. 617 (1907): 403–409.
100. Quoted in Raymond Cooke, *Velimir Khlebnikov: A Critical Study* (Cambridge: Cambridge University Press, 1987), 208.

101. Velimir Khlebnikov, *Le Pieu du Futur*, trans. Luda Schnitzer (Lausanne: Editions L'Age d'Homme, 1970), 240. My translation.
102. Velimir Khlebnikov and Paul Schmidt, *The King of Time: Selected Writings of the Russian Futurian* (Cambridge, MA: Harvard University Press, 1985), 146.
103. Ibid.
104. Ibid.
105. Marina Yaguello, *Lunatic Lovers of Language: Imaginary Languages and Their Inventors* (London: Athlone Press; Fairleigh Dickinson University Press, 1991), xv.
106. Khlebnikov and Schmidt, *King of Time*: 147.
107. Ibid., 159.
108. Ibid.
109. Ibid., 149.
110. Velimir Khlebnikov, Charlotte Douglas, and R. Vroon, *Collected Works of Velimir Khlebnikov*, Volume I (Cambridge, MA: Harvard University Press, 1987), 376. Khlebnikov makes a starlight analogy in his essay "On Fundamentals": "We may even imagine a word that contains both the starlight intelligence of nighttime and the sunlight intelligence of day. This is because whatever single ordinary meaning a word may possess will hide all its other meanings, as daylight effaces the luminous bodies of the starry night." Ibid., 377.
111. Ibid., 370.
112. Ibid., 383. "Dyr bul schyl" (1913) is a famous zaum poem by Kruchenykh. Khlebnikov wrote a zaum poem called "Bobeobi" (c.1908).
113. See, for example, Steven Pinker, *The Language Instinct: How the Mind Creates Language* (New York: HarperPerennial, 1995); Peter Carruthers, "The Cognitive Functions of Language," *Behavioral and Brain Sciences* 25 (2002): 657–726.
114. Khlebnikov, Douglas, and Vroon, *Collected Works of Velimir Khlebnikov*, Volume I: 293.
115. Khlebnikov and Schmidt, *King of Time*: 151.
116. Ibid.
117. I am indebted to Claire Warden for this point.
118. Ibid., 191.
119. Ibid.
120. See John Milner, *Vladimir Tatlin and the Russian Avant-Garde* (New Haven: Yale University Press, 1983), 197–203. The English-language premiere of Khlebnikov's play, directed by Peter Sellars, using a translation by Paul Schmidt, took place on December 6, 1986 at the Museum of Contemporary Art in Los Angeles. The production was remounted at the Brooklyn Academy of Music in November 1987. An abridged version of the production was broadcast (and recorded) as part of the fourth season of the MOCA-produced Territory of Art radio series.
121. Vladimir Tatlin, "On Zangezi," in *The Tradition of Constructivism*, ed. Stephen Bann (London: Thames and Hudson, 1974), 114.

122. Khlebnikov and Schmidt, *King of Time*: 192.
123. Ibid., 194.
124. Ibid., 198.
125. Ibid., 203.
126. Ibid., 204.
127. Ibid., 206–207.
128. Ibid., 208–209.
129. Ibid., 235.
130. Ibid., 195.
131. Ibid., 205, 214–215.
132. Ibid., 211.
133. Andrew Wachtel, *An Obsession with History: Russian Writers Confront the Past* (Stanford, CA: Stanford University Press, 1994), 167.
134. The photograph is reproduced in Milner, *Vladimir Tatlin and the Russian Avant-Garde*: 199. Chris Salter comments: "For the scenography, Tatlin erected an impressive, tower-like structure composed of one-dimensional shapes poised on an acute axis such that the edifice appeared to be frozen in the moment of toppling over." Chris Salter, *Entangled: Technology and the Transformation of Performance* (Cambridge, MA: MIT Press, 2010), 14.
135. Tatlin, "On Zangezi," 114.
136. Wachtel proposes that the character of Zangezi is a self-portrait by Khlebnikov of his younger, more naïve, self. "It is clear that the author Khlebnikov knows and understands more than his character Zangezi, for the author recognizes the failure of his project whose goal is to escape history, while Zangezi does not." Wachtel, *An Obsession with History*: 169.

CHAPTER 4

1. Evelyn Glennie, "Hearing Essay," http://www.evelyn.co.uk/hearing_essay.aspx (May 23, 2011).
2. Evelyn Glennie, *Good Vibrations: An Autobiography* (London: Arrow, 1990), 46.
3. Brian Massumi, *Parables for the Virtual: Movement, Affect, Sensation* (Durham: Duke University Press, 2002), 28.
4. Erin Hurley, *Theatre & Feeling* (Houndmills, Basingstoke, Hampshire; New York: Palgrave Macmillan, 2010), 22–23.
5. "Lo-Fi: Abbreviation for low fidelity, that is, an unfavourable signal-to-noise ratio. Applied to soundscape studies a lo-fi environment is one in which signals are overcrowded, resulting in masking or lack of clarity." R. Murray Schafer, *The Soundscape: Our Sonic Environment and the Tuning of the World* (Rochester, VT: Destiny Books 1993), 272.
6. Schafer 78. For a critique of Schafer's politics of noise, see Jamie C. Kassler, "Musicology and the Problem of Sonic Abuse," in *Music, Sensation, and Sensuality*, ed. Linda Phyllis Austern (New York: Routledge, 2002), 321–334.

7. See Lynne Kendrick and David Roesner, eds., *Theatre Noise* (Newcastle: Cambridge Scholars, 2011).
8. Robert Orledge, *Satie Remembered* (Portland, Oregon: Amadeus Press, 1995), 74–75.
9. Erik Satie and Ornella Volta, *Satie Seen through his Letters* (London; New York: M. Boyars, 1989), 175–176.
10. Quoted in James Harding, *Erik Satie* (New York: Praeger, 1975), 197.
11. Ibid.
12. Quoted in Orledge, *Satie Remembered*: 154.
13. William Weber, "Wagner, Wagnerism, and Musical Idealism," in *Wagnerism in European Culture and Politics*, ed. David Clay Large, William Weber, and Anne Dzamba Sessa (Ithaca: Cornell University Press, 1984), 29, 34.
14. Richard Wagner, *Wagner on Music and Drama: A Compendium of Richard Wagner's Prose Works*, ed. Albert Goldman and Evert Sprinchorn (New York: E.P. Dutton, 1964), 45–46.
15. See James H. Johnson, *Listening in Paris: A Cultural History* (Berkeley: University of California Press, 1996).
16. Brown 6. William Weber defends the listening habits of eighteenth-century audiences and offers a correction to what he regards as a nineteenth-century bias on the part of James H. Johnson. See William Weber, "Did People Listen in the 18th Century?," *Early Music* 25, no. 4 (1997): 678–691. Peter Szendy wonders if "inattentive" listening (or what he calls "listening *askew*") is not a more honest, open, and informed mode of engagement than the ideology of silent, meditative ("absorbed") listening, advanced by Wagner and consolidated around the figure of Beethoven at the beginning of the nineteenth century. See Peter Szendy, *Listen: A History of Our Ears* (New York: Fordham University Press, 2008), 122, 128.
17. Wagner, *Wagner on Music and Drama*: 365.
18. Ibid., 366.
19. On this point, Albert Goldman and Evert Sprinchorn write: "Looking at pictures of the sets used at Bayreuth, the awkward dragon, the strange swimming machines for the Rhine maidens, we might wonder how anyone could be hypnotized by this cluttered scenery and these creaking machines." Albert Goldman and Evert Sprinchorn, "Introduction," in *Wagner on Music and Drama: A Compendium of Richard Wagner's Prose Works*, ed. Albert Goldman and Evert Sprinchorn (New York: E.P. Dutton, 1964), 29.
20. Elias Canetti, *Crowds and Power*, trans. Carol Stewart (New York: Viking Press, 1963), 37.
21. Neil Blackadder suggests "one of the most important transformations in theatrical practice in the nineteenth century was its shift from a primarily aural to a predominantly visual medium." Neil Martin Blackadder, *Performing Opposition: Modern Theater and the Scandalized Audience* (Westport, CT: Praeger, 2003), 10.
22. Nicholas Ridout, "The Vibratorium Electrified," in *Vibratory Modernism*, ed. Anthony Enns and Shelley Trower (Basingstoke: Palgrave, 2013), 223.

23. Blackadder, *Performing Opposition: Modern Theater and the Scandalized Audience*. Theatre audiences continued to make noise in this period (and not just in popular theatre), to the chagrin of some cultural commentators. Robert P. McParland, surveying reports of *fin de siècle* audiences (mostly in London and New York) notes the various sounds that audiences made, including laughing, booing, cheering, rustling dresses and playbills, shuffling feet, coughing, and general conversation. Robert P. McParland, "The Sounds of an Audience," *Mosaic* 42.1 (2009): 117–132. The nature and extent of the "riot" that greeted *Ubu Roi* is open to debate; it seems to be a tale that has grown in the telling (as has the infamous *Sacre* riot). See Thomas Postlewait, *The Cambridge Introduction to Theatre Historiography* (Cambridge: Cambridge University Press, 2009), 60–86.
24. Alberto Savinio, "Le Drame et la Musique," *Les Soirées de Paris* 23(1914): 243. My translation.
25. Christopher Schiff, "Banging on the Windowpane: Sound in Early Surrealism," in *Wireless Imagination: Sound, Radio, and the Avant-Garde*, ed. Douglas Kahn and Gregory Whitehead (Cambridge, MA: MIT Press, 1992), 168–169.
26. Rick Altman, *Silent Film Sound* (New York: Columbia University Press, 2004), 130–131.
27. See Emily Ann Thompson, *The Soundscape of Modernity: Architectural Acoustics and the Culture of Listening in America, 1900–1933* (Cambridge, MA: MIT Press, 2002).
28. Ibid., 3–4.
29. Schafer, *The Soundscape*: 10 and passim; Thompson, *The Soundscape of Modernity: Architectural Acoustics and the Culture of Listening in America, 1900–1933*: 3.
30. Günter Berghaus, *Italian Futurist Theatre, 1909–1944* (Oxford: Oxford University Press, 1999), 135. The phrase "artificial optimism" derives from Christine Poggi, *Inventing Futurism: The Art and Politics of Artificial Optimism* (Princeton: Princeton University Press, 2009).
31. See Berghaus, *Italian Futurist Theatre*: 85–155. In the discussion that follows, my information about the *serate* is drawn from Berghaus' study. However, the observations I make about acoustic matters are my own.
32. Ibid., 101.
33. Quoted in ibid., 126.
34. Marinetti, "The Variety Theatre," in *Futurist Performance: Includes Manifestos, Playscripts, and Illustrations,* ed. Michael Kirby and Victoria Nes Kirby (New York: PAJ Publications, 1986), 181.
35. Ibid., 182, 183.
36. Umberto Boccioni et al., "Technical Manifesto of Futurist Painting," in *Futurist Manifestos*, ed. Umbro Apollonio (New York: Viking Press, 1973), 28.
37. Daniel Albright, *Untwisting the Serpent: Modernism in Music, Literature, and Other Arts* (Chicago: University of Chicago Press, 2000), 210.

38. Luigi Russolo, "The Art of Noise" (1911), reproduced in Kirby and Kirby, *Futurist Performance*: 169, 171.
39. Luciano Chessa argues that the composer aimed to *spiritualize* noise rather than merely replicate its material force (thus revealing Russolo's ties with symbolism and the occult). Luciano Chessa, *Luigi Russolo, Futurist: Noise, Visual Arts, and the Occult* (Berkeley: University of California Press, 2012).
40. Berghaus, *Italian Futurist Theatre*: 121.
41. Ibid., 129.
42. "Art and Practice of Noise: Hostile Reception of Signor Marinetti," *Times*, June 16, 1914, 5.
43. See "Manifesto of Futurist Playwrights: The Pleasure of Being Booed" in Filippo Tommaso Marinetti, *Critical Writings*, trans. Doug Thompson, 1st ed. (New York: Farrar, Straus, and Giroux, 2006), 181–184.
44. For a detailed account of the futurists' touring productions, see Berghaus, *Italian Futurist Theatre*: 187–231.
45. "The Futurist Synthetic Theatre," in Kirby and Kirby, *Futurist Performance*: 199.
46. Ibid., 202.
47. Ibid., 247. All the subsequently cited *sintesi* appear in the same source. The dates provided are those of first publication. Translations are by Victoria Nes Kirby.
48. Ibid., 289.
49. Ibid., 258.
50. Ibid.
51. Ibid., 258, 259.
52. Ibid., 302.
53. Jennifer DeVere Brody, *Punctuation: Art, Politics, and Play* (Durham: Duke University Press, 2008), 150.
54. See Berghaus, *Italian Futurist Theatre*: 215–223.
55. Reprinted in Marinetti, *Critical Writings*: 107–117.
56. Ibid., 112.
57. Ibid., 107–108.
58. Ibid., 116. My emphasis.
59. Ibid.
60. Steve McCaffery, *Prior to Meaning: The Protosemantic and Poetics* (Evanston, IL: Northwestern University Press, 2001), 165.
61. Marinetti, *Critical Writings*: 193, 194.
62. Ibid., 193.
63. Ibid., 194.
64. Ibid.
65. Ibid., 194.
66. Ibid.
67. Ibid., 195.
68. Ibid., 198.
69. Ibid.

70. Ibid., 198.
71. The 1935 recording is representative. It can be heard on Ubuweb: http://ubu.artmob.ca/sound/artist_tellus/Tellus-21-Artists_03_marinetti.mp3
72. Marinetti, *Critical Writings*: 195.
73. See Mark Morrisson, "Performing the Pure Voice: Elocution, Verse Recitation, and Modernist Poetry in Prewar London," *Modernism/Modernity* 3, no. 3 (1996): 37.
74. Quoted in John D Erickson, *Dada: Performance, Poetry, and Art* (Boston: Twayne Publishers, 1984), 5.
75. Richard D. Leppert, *The Sight of Sound: Music, Representation, and the History of the Body* (Berkeley: University of California Press, 1993).
76. Quoted in Harry Seiwert, "Marcel Janco," in *Dada Zurich: A Clown's Game from Nothing*, ed. Stephen C. Foster, Brigitte Pichon, and Karl Riha (New York: G.K. Hall; Prentice Hall International, 1996), 126.
77. Quoted in John Elderfield, "Introduction," in *Flight Out of Time: A Dada Diary* (New York: Viking Press, 1974), xxiii.
78. Arp's description does not agree with the identifications provided by an unknown hand on the back of the original photograph of the painting. For details, see Seiwert, "Marcel Janco," 136.
79. Richard Huelsenbeck, *Memoirs of a Dada Drummer*, trans. Joachim Neugroschel (New York: Viking Press, 1974), 10.
80. Richard Huelsenbeck, "First Dada Lecture in Germany," in *The Dada Almanac*, ed. Richard Huelsenbeck and Malcolm Green (London: Atlas Press, 1993), 111.
81. Richard Huelsenbeck, "Dada, or the Meaning of Chaos," *Studio International* 183, no. 940 (1972): 27.
82. The tom-tom drum has Native American and Asian, not African, origins. If Huelsenbeck knew this, he likely did not care; he was not a stickler for historical or ethnographical accuracy.
83. Hugo Ball, *Flight out of Time: A Dada Diary* (New York: Viking Press, 1974), 51.
84. Huelsenbeck, *Memoirs of a Dada Drummer*: 9.
85. Berghaus states that the text of the Dadaist bruitist poems was "only a skeleton, a sort of libretto, that was overlaid with an orchestration of noises, produced on drums, rattles, whistles, pots, and pans." Günter Berghaus, *Theatre, Performance, and the Historical Avant-Garde*, 1st ed. (New York: Palgrave Macmillan, 2005), 170.
86. Karin Füllner, "Richard Huelsenbeck: 'Bang! Bang! Bangbangbang': The Dada Drummer in Zurich," in *Dada Zurich: A Clown's Game from Nothing*, ed. Stephen C. Foster, Brigitte Pichon, and Karl Riha (New York: G.K. Hall; Prentice Hall International, 1996), 98.
87. Ball, *Flight out of Time: A Dada Diary*: 61.
88. Huelsenbeck, "Dada, or the Meaning of Chaos," 28.
89. Huelsenbeck, "First Dada Lecture in Germany," 111–112. My emphasis.

90. Füllner, "Richard Huelsenbeck: 'Bang! Bang! Bangbangbang': The Dada Drummer in Zurich," 99.
91. Huelsenbeck, *Memoirs of a Dada Drummer*: 14.
92. Richard Huelsenbeck et al., *Blago Bung, Blago Bung, Bosso Fataka!: First Texts of German Dada*, trans. Malcolm Green (London: Atlas Press, 1995), 60–61.
93. See John Mowitt, *Percussion: Drumming, Beating, Striking* (Durham: Duke University Press, 2002), 6. For a discussion of dances by Sophie Täuber and Mary Wigman as examples of "percussive primitivism," see Adrian Curtin, "Vibration, Percussion and Primitivism in Avant-Garde Performance," in *Vibratory Modernism*, ed. Anthony Enns and Shelley Trower (Basingstoke: Palgrave, 2013).
94. Brandon LaBelle, *Acoustic Territories: Sound Culture and Everyday Life* (New York: Continuum, 2010), 139–140. Here, LaBelle is, in part, paraphrasing the work of John Mowitt. See Mowitt, *Percussion: Drumming, Beating, Striking*.
95. Mowitt, *Percussion: Drumming, Beating, Striking*: 3, and passim.
96. Kimberly Jannarone, "The Theatre Before its Double: Artaud Directs in the Alfred Jarry Theatre," *Theatre Survey* 46, no. 2 (2005): 247–273.
97. Antonin Artaud, *The Theatre and Its Double*, trans. Victor Corti (Surrey: Oneworld Classics, 2010), 58.
98. 'What the Tragedy *The Cenci* at the Folies-Wagram Will Be About' in Antonin Artaud, *The Cenci: A Play*, trans. Simon Watson Taylor (New York: Grove Press, 1970), 11.
99. Roger Blin et al., "Antonin Artaud in '*Les Cenci*'," *The Drama Review* 16, no. 2 (1972): 95, 144, 106.
100. Artaud, *The Cenci: A Play*: 22, 45.
101. See Antonin Artaud, *The Theater and its Double* (New York: Grove Press, 1958), 26–27.
102. Artaud, *The Cenci: A Play*: 27, my emphasis.
103. Ibid., 50, 55.
104. Quoted in Blin et al., "Antonin Artaud in '*Les Cenci*'," 102.
105. Artaud, *The Cenci: A Play*: 29.
106. See Artaud, *The Theater and its Double*: 55–56.
107. The recording is held at the Audiovisual Department of the BnF (*fonds* Artaud, "Musique de scène pour *Les Cenci*").
108. This is track no. 17 on the recording held at the BnF (MSSAUD-105).
109. Artaud, *The Cenci: A Play*: 58, 59.
110. Lisa Gold, *Music in Bali: Experiencing Music, Expressing Culture* (New York: Oxford University Press, 2005), 111.
111. Armory, "Les Cenci," *Comoedia* (May 8, 1935).
112. Quoted in Blin et al., "Antonin Artaud in '*Les Cenci*'," 138, 134, 133.
113. Ibid., 132.
114. Ibid., 136.

115. Ibid., 141.
116. Ibid., 142.
117. Ibid.
118. See Denis Hollier, "The Death of Paper, Part Two: Artaud's Sound System," *October* 80 (1997): 27–37.
119. Antonin Artaud, *Collected Works [of] Antonin Artaud*, ed. Victor Corti, vol. 4 (London: Calder & Boyars, 1968), 114.
120. Quoted in Blin et al., "Antonin Artaud in '*Les Cenci*'," 127. I translated the last sentence from the complete review, held at the BnF (*Fonds* Artaud, NAF 27431–27864).
121. The *Solidarité Française* was founded in 1933 and disbanded in 1935. Its slogan was "France for the French." See Robert Soucy, *French Fascism: The Second Wave, 1933–1939* (New Haven: Yale University Press, 1995), 59–104.
122. See Constance Spreen, "Resisting the Plague: The French Reactionary Right and Artaud's Theatre of Cruelty," *Modern Language Quarterly* 64, no. 1 (2003): 71–96.
123. "An Affective Athleticism" in Artaud, *The Theater and its Double*: 135.*The Theater and its Double*, trans. Mary Caroline Richards (New York: Grove, 1958), p. 135. Artaud is referring here to the soul of an actor, but I believe it also pertains to the ideal participant of his theatre of cruelty.
124. See Kimberly Jannarone, *Artaud and His Doubles* (Michigan: University of Michigan Press, 2010).
125. Carolyn Birdsall, "'Affirmative Resonances' in the City? Sound, Imagination, and Urban Space in Early 1930s Germany," in *Sonic Interventions: Sex, Race, Place* ed. Sylvia Mieszkowski, Joy Smith, and Marijke de Valck (Amsterdam: Rodopi, 2007), 57, 79.
126. See Vincent Meelberg, "Touched by Music: The Sonic Strokes of *Sur Incises*," in *Sonic Mediations: Body, Sound, Technology*, ed. Carolyn Birdsall and Anthony Enns (Newcastle: Cambridge Scholars Publishing, 2008), 61–76.
127. "On the Balinese Theatre" from Artaud, *Collected Works [of] Antonin Artaud*, 4: 39, 41.
128. Tsutomu Oohashi et al., "Inaudible High Frequency Sounds Affect Brain Activity: Hypersonic Effect," *Journal of Neurophysiology* 83 (2000): 3548–3358. This article is paraphrased in Steve Goodman, *Sonic Warfare: Sound, Affect, and the Ecology of Fear* (Cambridge, MA: MIT Press, 2009), 184.
129. I adapt a formulation of centripetal "audiosocial radiation" from Goodman, *Sonic Warfare*: 11.
130. Judith Becker, *Deep Listeners: Music, Emotion, and Trancing* (Bloomington: Indiana University Press, 2004), 71, 56.
131. Albright, *Untwisting the Serpent: Modernism in Music, Literature, and Other Arts*: 40.
132. Frantisek Deak, "Russian Mass Spectacles," *TDR* 19, no. 2 (1975): 7.

133. Lynn Mally, *Culture of the Future: The Proletkult Movement in Revolutionary Russia*, Studies on the history of society and culture (Berkeley: University of California Press, 1990), xv.
134. Neil Edmunds, *The Soviet Proletarian Music Movement* (Oxford; New York: Peter Lang, 2000), 11, 32.
135. Arseny Avraamov, "Symphony of Sirens," in *Baku, Symphony of Sirens: Sound Experiments in the Russian Avant-Garde*, ed. Miguel Molina Alarcon, trans. Alexander Kan (London: ReR Megacorp, 2008 [1924]), 70.
136. Arseny Avraamov, "Sinfonia Gudkov," *Gorn* 9 (1923): 115–116. Translation by Katia Bowers.
137. Ibid., 112.
138. For a spatial reconstruction of Avraamov's symphony overlaid on a 1913 Russian map of Baku, see Delia Duong Ba Wendel, "The 1922 'Symphony of Sirens' in Baku, Azerbaijan," *Journal of Urban Design* 17, no. 4 (2012): 552.
139. Fülöp-Miller, writing about Avraamov's symphony, notes that "it is not surprising that this 'music' could be heard far beyond the walls of the town of Baku." René Fülöp-Miller, *The Mind and Face of Bolshevism: An Examination of Cultural Life in Soviet Russia*, trans. F. S. Flint (New York: A.A. Knopf, 1929), 184. Fülöp-Miller does not indicate how he makes this determination.
140. Wendel, "The 1922 'Symphony of Sirens' in Baku, Azerbaijan," 555.
141. The point about the original function of the tower is made by Wendel, who notes "the analogous relation between radio transmissions and the aural and temporal effects of the symphony." Ibid., 551.
142. Avraamov, "Symphony of Sirens," 70.
143. Augoyard and Torgue define anamnesis as "[an] effect of reminiscence in which a past situation or atmosphere is brought back to the listener's consciousness, provoked by a particular signal or sonic context. Anamnesis, a semiotic effect, is the often involuntary revival of memory caused by listening and the evocative power of sounds." Jean-François Augoyard and Henry Torgue, *Sonic Experience: A Guide to Everyday Sounds* (Montreal; London: McGill-Queen's University Press, 2005), 21.
144. Quoted in Miguel Molina Alarcon, *Baku: Symphony of Sirens: Sound Experiments in the Russian Avant-Garde* (London: ReR Megacorp, 2008), 19–20. My emphasis.
145. Avraamov uses the following lines from Gastev's poem as an epigraph for an article on the *Symphony of Sirens*: "When the morning sirens roar/ over the working outskirts, –/ it is above all not the call of slavery:/ it is the song of the future." Quoted in Avraamov, "Sinfonia Gudkov," 109.
146. I adapt Von Geldern's reading of Evreinov. "For Evreinov, the Revolution served the purposes of the performance, not the performance the Revolution. The facts were given an explicitly artistic organization. *The Storming of the Winter Palace* was a step beyond his 'theatricalization of life'; it was a theatricalization of history, history as it should have been." James Von

Geldern, *Bolshevik Festivals, 1917–1920* (Berkeley: University of California Press, 1993), 201.
147. The Bolsheviks' motivations for forming the Azerbaijan SSR vary according to the history being told. See Sheila Fitzpatrick, *The Russian Revolution*, 3rd ed. (Oxford; New York: Oxford University Press, 2008), 69–70. Charles van der Leeuw, *Azerbaijan: A Quest for Identity* (New York: St. Martin's Press, 2000), 124.
148. See Benedict R. Anderson, *Imagined Communities: Reflections on the Origin and Spread of Nationalism* (London: Verso, 1983), 132.
149. See Avraamov, "Sinfonia Gudkov," 109.
150. Details of Avraamov's job are provided in Edmunds, *The Soviet Proletarian Music Movement*: 71.
151. Avraamov, "Symphony of Sirens," 70.
152. Augoyard and Torgue write about the "sharawadji" effect as an example of sonic sublimity: "an aesthetic effect that characterizes the feeling of plenitude that is sometimes created by the contemplation of a sound motif or a complex soundscape of inexplicable beauty." The "sharawadji" effect may be triggered by the "sonic wandering of the astonished and wonderstruck stroller listening to the multiple sounds of the city." Augoyard and Torgue, *Sonic Experience: A Guide to Everyday Sounds*: 117, 118.
153. William Benzon, *Beethoven's Anvil: Music in Mind and Culture* (Oxford: Oxford University Press, 2002), 28.
154. Augoyard and Torgue, *Sonic Experience: A Guide to Everyday Sounds*: 130.
155. The audio reconstruction of Avraamov's symphony is provided on CD in Alarcon, *Baku: Symphony of Sirens: Sound Experiments in the Russian Avant-Garde*.
156. Audrey Altstadt-Mirhadi, "Baku: Transformation of a Muslim Town," in *The City in Late Imperial Russia*, ed. Michael F. Hamm (Bloomington: Indiana University Press, 1986), 283.
157. Wendel, "The 1922 'Symphony of Sirens' in Baku, Azerbaijan," 558.
158. Leeuw, *Azerbaijan: A Quest for Identity*: 107–108; Samuel Freeman, "Azerbaijani," in *An Ethnohistorical Dictionary of the Russian and Soviet Empires*, ed. James Stuart Olson, Lee Brigance Pappas, and Nicholas Charles Pappas (Westport, T: Greenwood Press, 1994), 64.
159. Leeuw, *Azerbaijan: A Quest for Identity*: 121.
160. Ibid., 124–125.
161. Information pertaining to the ethno-religious and socioeconomic statuses and geographic locations of Baku's inhabitants is provided in Tadeusz Swietochowski, *Russia and Azerbaijan: A Borderland in Transition* (New York: Columbia University Press, 1995), 21.
162. Altstadt-Mirhadi, "Baku: Transformation of a Muslim Town," 308.
163. Azerbaijanis' "enduring tactic of passive resistance" vis-à-vis tsarist leadership is identified in Freeman, "Azerbaijani," 63.
164. Tracy C. Davis, "Theatricality and Civil Society," in *Theatricality*, ed. Tracy C. Davis and Thomas Postlewait (Cambridge: Cambridge University Press, 2003), 145.

165. Fitzpatrick identifies a dilemma for the Bolsheviks, namely that "the politics of proletarian internationalism in practice had a disconcerting similarity to the policies of old-style Russian imperialism." Fitzpatrick, *The Russian Revolution*: 70.

Conclusion

1. See Kirsten Shepherd-Barr, " 'Mise en Scent': The Théâtre d'Art's *Cantique des cantiques* and the Use of Smell as a Theatrical Device," *Theatre Research International* 24, no. 2 (1999): 152–159; Sally Banes, "Olfactory Performances," in *The Senses in Performance*, ed. Sally Banes and André Lepecki (London: Routledge, 2007), 29–37; Mary Fleischer, "Incense & Decadence: Symbolist Theatre's Use of Scent," in *The Senses in Performance*, ed. Sally Banes and André Lepecki (London: Routledge, 2007), 105–114; Stephen Di Benedetto, *The Provocation of the Senses in Contemporary Theatre* (London: Routledge, 2010).
2. See Karin Bijsterveld, *Mechanical Sound: Technology, Culture, and Public Problems of Noise in the Twentieth Century* (Cambridge, MA: MIT Press, 2008).
3. Quoted in Mike Sell, *Avant-Garde Performance and Material Exchange: Vectors of the Radical* (New York: Palgrave Macmillan, 2011), 208.
4. Ibid., 210–211.
5. Hayden White, *Tropics of Discourse: Essays in Cultural Criticism* (Baltimore: Johns Hopkins University Press, 1978), 89.
6. For a critique of White's argument, see Noël Carroll, *Beyond Aesthetics: Philosophical Essays* (Cambridge: Cambridge University Press, 2001), 133–156.

Bibliography

Agnew, Marie. "The Auditory Imagery of Great Composers." *Psychological Monographs* 31 (1922): 268–278.
Alarcon, Miguel Molina. *Baku: Symphony of Sirens: Sound Experiments in the Russian Avant-Garde*. London: ReR Megacorp, 2008.
Albright, Daniel. *Untwisting the Serpent: Modernism in Music, Literature, and Other Arts*. Chicago: University of Chicago Press, 2000.
———. *Modernism and Music: An Anthology of Sources*. Chicago: University of Chicago Press, 2004.
Allen, David. *Performing Chekhov*. London: Routledge, 2000.
Alter, Nora M. and Lutz P. Koepnick. *Sound Matters: Essays on the Acoustics of Modern German Culture*. New York: Berghahn Books, 2004.
Altman, Rick. *Silent Film Sound*. New York: Columbia University Press, 2004.
Altstadt-Mirhadi, Audrey. "Baku: Transformation of a Muslim Town." In *The City in Late Imperial Russia*, edited by Michael F. Hamm, 283–318. Bloomington: Indiana University Press, 1986.
Anderson, Benedict R. *Imagined Communities: Reflections on the Origin and Spread of Nationalism*. London: Verso, 1983.
Apollinaire, Guillaume. "The Breasts of Tiresias." In *Modern French Theatre: The Avant-Garde, Dada, and Surrealism*, edited by Michael Benedikt. New York: Dutton, 1964.
Armory. "Les Cenci." *Comoedia* (May 8, 1935).
Aronson, Arnold. "Avant-Garde Scenography and the Frames of the Theatre." In *Against Theatre: Creative Destructions on the Modernist Stage*, edited by Alan Ackerman and Martin Puchner, 21–38. London: Macmillan, 2006.
"Art and Practice of Noise: Hostile Reception of Signor Marinetti." *Times* (June 16, 1914).
Artaud, Antonin. *The Theater and Its Double*. New York: Grove Press, 1958.
———. *Collected Works [of] Antonin Artaud*. Edited by Victor Corti. Vol. 1. London: Calder & Boyars, 1968.
———. *Collected Works [of] Antonin Artaud*. Edited by Victor Corti. Vol. 4. London: Calder & Boyars, 1968.
———. *The Cenci: A Play*. Translated by Simon Watson Taylor. New York: Grove Press, 1970.
———. *The Theatre and its Double*. Translated by Victor Corti. Surrey: Oneworld Classics, 2010.

Attali, Jacques and Yves Stourdze. "The Birth of the Telephone and Economic Crisis: The Slow Death of the Monologue in French Society." In *The Social Impact of the Telephone*, edited by Ithiel de Sola Pool, 97–111. Cambridge, Mass.: MIT Press, 1977.

Augoyard, Jean-François and Henry Torgue. *Sonic Experience: A Guide to Everyday Sounds*. Montreal; London: McGill-Queen's University Press, 2005.

Avraamov, Arseny. "Sinfonia Gudkov." *Gorn* 9 (1923): 99–105.

———."Symphony of Sirens." In *Baku, Symphony of Sirens: Sound Experiments in the Russian Avant-Garde*, edited by Miguel Molina Alarcon, 70–71. London: ReR Megacorp, 2008 [1924].

Bacht, Nikolaus. "Jean Paul's Listeners." *Eighteenth Century Music* 3, no. 2 (2006): 201–212.

Ball, Hugo, ed. *Cabaret Voltaire: Recueil Littéraire et Artistique*. Zurich: Meierie, 1916.

———. *Flight out of Time: A Dada Diary*. New York: Viking Press, 1974.

Banes, Sally. "Olfactory Performances." In *The Senses in Performance*, edited by Sally Banes and André Lepecki, 29–37. London: Routledge, 2007.

Barker, Howard. *Death, the One and the Art of Theatre*. London: Routledge, 2005.

Barricelli, Jean Pierre. "Counterpoint of the Snapping String: Chekhov's The Cherry Orchard." In *Chekhov's Great Plays: A Critical Anthology*, edited by Jean Pierre Barricelli, 111–132. New York: New York University, 1981.

Bay-Cheng, Sarah. *Mama Dada: Gertrude Stein's Avant-Garde Theater*. New York: Routledge, 2004.

Bebb, Richard. "The Voice of Henry Irving: An Investigation." *Recorded Sound: The British Institute of Recorded Sound* 68 (1977): 727–732.

Becker, Judith. *Deep Listeners: Music, Emotion, and Trancing*. Bloomington: Indiana University Press, 2004.

Beckett, Samuel. *Proust*. New York: Grove Press, 1970.

Benjamin, Walter. "On Some Motifs in Baudelaire." In *Illuminations*, edited by Hannah Arendt, 155–200. New York: Schocken Books, 1968.

———. *The Arcades Project*. Cambridge, Mass.: Belknap Press, 1999.

———. *Illuminations*. London: Pimlico, 1999.

Benzon, William. *Beethoven's Anvil: Music in Mind and Culture*. Oxford: Oxford University Press, 2002.

Berghaus, Günter. *Italian Futurist Theatre, 1909–1944*. Oxford: Oxford University Press, 1999.

———. *Theatre, Performance, and the Historical Avant-Garde*. 1st ed. New York: Palgrave Macmillan, 2005.

Bijsterveld, Karin. *Mechanical Sound: Technology, Culture, and Public Problems of Noise in the Twentieth Century*. Cambridge, Mass: MIT Press, 2008.

Birdsall, Carolyn. "'Affirmative Resonances' in the City? Sound, Imagination, and Urban Space in Early 1930s Germany." In *Sonic Interventions: Sex, Race, Place* edited by Sylvia Mieszkowski, Joy Smith and Marijke de Valck, 57–66. Amsterdam: Rodopi, 2007.

Blackadder, Neil Martin. *Performing Opposition: Modern Theater and the Scandalized Audience*. Westport, Conn.: Praeger, 2003.

Blin, Roger, et al. "Antonin Artaud in 'Les Cenci'." *The Drama Review* 16, no. 2 (1972): 90–145.
Boccioni, Umberto, et al. "Technical Manifesto of Futurist Painting." In *Futurist Manifestos*, edited by Umbro Apollonio. New York: Viking Press, 1973.
Bottomore, Stephen. "An International Survey of Sound Effects in Early Cinema." *Film History* 11, no. 4 (1999): 485–498.
——. "The Story of Percy Peashaker: Debates about Sound Effects in the Early Cinema." In *The Sounds of Early Cinema*, edited by Richard Abel and Rick Altman, 129–142. Indiana: Indiana University Press, 2001.
Boulton, Marjorie. *Zamenhof, Creator of Esperanto*. London: Routledge and Paul, 1960.
Bratton, Jacky. *New Readings in Theatre History*. Cambridge: Cambridge University Press, 2003.
Braun, Edward. "The Cherry Orchard." In *The Cambridge Companion to Chekhov*, edited by Vera Gottlieb and Paul Allain, 111–120. Cambridge: Cambridge University Press, 2000.
Brecht, Bertolt and John Willett. *Brecht on Theatre: The Development of an Aesthetic*. New York: Hill and Wang, 1992.
Brody, Jennifer DeVere. *Punctuation: Art, Politics, and Play*. Durham: Duke University Press, 2008.
Brooks, John. "The First and Only Century of Telephone Literature." In *The Social Impact of the Telephone*, edited by Ithiel de Sola Pool, 208–224. Cambridge, Mass.: MIT Press, 1977.
Brown, Frederick. *An Impersonation of Angels: A Biography of Jean Cocteau*. New York: Viking Press, 1968.
Brown, Ross. *Sound: A Reader in Theatre Practice*. Basingstoke: Palgrave Macmillan, 2010.
Bryant, Gregory A. and H. Clark Barrett. "Recognizing Intentions in Infant-Directed Speech: Evidence for Universals." *Psychological Science* 18, no. 8 (2007): 746–751.
Bull, Michael. "Thinking about Sound, Proximity, and Distance in Western Experience: The Case of Odysseus' Walkman." In *Hearing Cultures: Essays on Sound, Listening, and Modernity*, edited by Veit Erlmann, 173–190. New York, NY: Berg, 2004.
Canetti, Elias. *Crowds and Power*. Translated by Carol Stewart. New York: Viking Press, 1963.
Cardullo, Bert and Robert Knopf. *Theater of the Avant-Garde, 1890–1950: A Critical Anthology*. New Haven, Conn.: Yale University Press, 2001.
Carlson, Marvin A. *Speaking in Tongues: Language at Play in the Theatre*. Ann Arbor: University of Michigan Press, 2006.
Carroll, Noël. *Beyond Aesthetics: Philosophical Essays*. Cambridge: Cambridge University Press, 2001.
Carruthers, Peter. "The Cognitive Functions of Language." *Behavioral and Brain Sciences* 25 (2002): 657–726.
Carter, William C. *Marcel Proust: A Life*. New Haven: Yale University Press, 2000.

Caws, Mary Ann. *Manifesto: A Century of Isms*. Lincoln: University of Nebraska Press, 2001.
Chekhov, Anton. "The Cherry Orchard." In *The Wadsworth Anthology of World Drama*, edited by W.B. Worthen, 597–620. Andover: Cengage, 2004.
Chessa, Luciano. *Luigi Russolo, Futurist: Noise, Visual Arts, and the Occult*. Berkeley: University of California Press, 2012.
Cocteau, Jean. *La Voix Humaine, Pièce en Un Acte*. Paris: Stock, 1930.
———. *The Human Voice*. London: Vision, 1951.
———. "The Eiffel Tower Wedding Party." In *The Infernal Machine, and Other Plays*, 409 pp. New York: New Directions, 1963.
Connor, Steven. "The Modern Auditory I." In *Rewriting the Self: Histories from the Renaissance to the Present*, edited by Roy Porter, 203–223. London: Routledge, 1997.
———. "Edison's Teeth: Touching Hearing." In *Hearing Cultures*, edited by Veit Erlmann. New York: Berg, 2004.
———."Rustications: Animals in the Urban Mix." http://www.stevenconnor.com/rustications/.
Cooke, Raymond. *Velimir Khlebnikov: A Critical Study*. Cambridge: Cambridge University Press, 1987.
Corbett, John and Terry Kapsalis. "Aural Sex: The Female Orgasm in Popular Sound." *TDR* 40, no. 3 (1996): 102–112.
Covington, Kate. "The Mind's Ear: I Hear Music and No One is Performing." *The College Music Society* 45 (2005): 25–41.
Crystal, David. *How Language Works: How Babies Babble, Words Change Meaning, and Languages Live or Die*. Woodstock, NY: Overlook Press, 2005.
"Cultures of Modernity: Book of Abstracts, IFTR." Munich: Ludwig-Maximilians-Universität 2010.
Culver, Max Keith. "A History of Theatre Sound Effects Devices to 1927." Ph.D. dissertation, University of Illinois at Urbana-Champaign, 1981.
Curtin, Adrian. "Vibration, Percussion and Primitivism in Avant-Garde Performance." In *Vibratory Modernism*, edited by Anthony Enns and Shelley Trower, 227–247. Basingstoke: Palgrave, 2013.
D'Arcy, Geraint and Richard J. Hand. "Open Your Eyes/Shut Your Eyes: Staging Kandinsky's *The Yellow Sound* at Tate Modern." *Performance Research* 17, no. 5 (2012): 56–60.
Danius, Sara. *The Senses of Modernism: Technology, Perception, and Aesthetics*. Ithaca: Cornell University Press, 2002.
Dann, Kevin T. *Bright Colors Falsely Seen: Synaesthesia and the Search for Transcendental Knowledge*. New Haven: Yale University Press, 1998.
Davis, Tracy C. "Theatricality and Civil Society." In *Theatricality*, edited by Tracy C. Davis and Thomas Postlewait, 127–155. Cambridge: Cambridge University Press, 2003.
De Groote, Pascale. *Ballets Suédois*. Ghent: Academic Press, 2002.
Deak, Frantisek. "Russian Mass Spectacles." *TDR* 19, no. 2 (1975): 7–22.

———. *Symbolist Theater: The Formation of an Avant-Garde*, PAJ Books. Baltimore: Johns Hopkins University Press, 1993.
Demos, T. J. "Dada Zurich: The Aesthetics of Exile." In *The Dada Seminars*, edited by Leah Dickerman and Matthew S. Witkovsky, 7–29. Washington, DC: Center for Advanced Study in the Visual Arts, National Gallery of Art, in association with D.A.P./Distributed Art Publishers, 2005.
Di Benedetto, Stephen. *The Provocation of the Senses in Contemporary Theatre*. London: Routledge, 2010.
Dieckhoff, Alain. *The Invention of a Nation: Zionist Thought and the Making of Modern Israel*. New York: Columbia University Press, 2003.
Dillon, E.J. "The Esperanto Movement in Russia." *The North American Review* 185, no. 617 (1907): 403–409.
"Discovering Esperanto: A Fascinating Language." edited by E@I/International League of Esperanto Teachers.
Draycott, Jane. *Prince Rupert's Drop*. Manchester: Carcanet, 2004.
Düchting, Hajo. *Wassily Kandinsky 1866–1944: A Revolution in Painting*. Köln: Taschen, 2000.
Eco, Umberto. *The Search for the Perfect Language*. Oxford: Blackwell, 1995.
Edmunds, Neil. *The Soviet Proletarian Music Movement*. Oxford; New York: Peter Lang, 2000.
Eisenstadt, S. N. *Multiple Modernities*. New Brunswick, N.J.: Transaction Publishers, 2002.
Elderfield, John. "Introduction." In *Flight Out of Time: A Dada Diary*, xiii–xlvi. New York: Viking Press, 1974.
"The Electrophone." *San Francisco Call* (September 3, 1893), 8.
Enns, Anthony and Shelley Trower, eds. *Vibratory Modernism*. London: Palgrave, 2013.
Erickson, John D. *Dada: Performance, Poetry, and Art*. Boston: Twayne Publishers, 1984.
Erlmann, Veit. *Hearing Cultures: Essays on Sound, Listening, and Modernity*. New York, NY: Berg, 2004.
Esperanto as an International Auxiliary Language. Report of the General Secretariat of the League of Nations Adopted by the Third Assembly, 1922. Paris: Impr. des Presses universitaires de France, 1922.
"An Esperanto City." *The Strand Magazine* (December, 1908).
"Esperanto in Russia." *The New York Times* (June 3, 1906).
"Extraits de la Presse Concernant la Représentation des 'Mamelles de Tirésias' le 24 juin 1917." *SIC* 19–20 (1917).
Fauser, Annegret. *Musical Encounters at the 1889 Paris World's Fair*. Rochester: University of Rochester Press, 2005.
Feld, Steven. "Waterfalls of Song: An Acoustemology of Place Resounding in Bosavi, Papua New Guinea." In *Senses of Place*, edited by Steven Feld and Keith H. Basso, 91–135. Santa Fe, N.M.: School of American Research Press, 1996.
Feldman, Jessica R. *Victorian Modernism: Pragmatism and the Varieties of Aesthetic Experience*. Cambridge: Cambridge University Press, 2002.

Fergusson, Francis. "The Cherry Orchard: A Theatre-Poem of the Suffering of Change." In *The Idea of a Theatre*. Princeton: Princeton University Press, 1949.
Fishman, Joshua A. *Language and Nationalism: Two Integrative Essays*. Rowley, Mass.: Newbury House Publishers, 1972.
Fitzpatrick, Sheila. *The Russian Revolution*. 3rd ed. Oxford; New York: Oxford University Press, 2008.
Fleischer, Mary. "Incense & Decadence: Symbolist Theatre's Use of Scent." In *The Senses in Performance*, edited by Sally Banes and André Lepecki, 105–114. London Routledge, 2007.
Folkerth, Wes. *The Sound of Shakespeare*. London: Routledge, 2002.
Forster, Leonard. *Poetry of Significant Nonsense: An Inaugural Lecture*. Cambridge: Cambridge University Press, 1962.
Forster, Leonard Wilson. *The Poet's Tongues: Multilingualism in Literature*. Cambridge: Cambridge University Press 1970.
Forster, Peter G. *The Esperanto Movement*. The Hague; New York: Mouton, 1982.
Foy, George. *Zero Decibels: The Quest for Absolute Silence*. New York: Scribner, 2010.
Freeman, Samuel. "Azerbaijani." In *An Ethnohistorical Dictionary of the Russian and Soviet Empires*, edited by James Stuart Olson, Lee Brigance Pappas and Nicholas Charles Pappas, 60–75. Westport, Conn.: Greenwood Press, 1994.
Friedman, Donald Flanell. *An Anthology of Belgian Symbolist Poets*. New York: Garland Pub., 1992.
Friedman, Susan Stanford. "Periodizing Modernism: Postcolonial Boundaries and the Space/Time Boundaries of Modernist Studies." *Modernism/Modernity* 13, no. 3 (2006): 425–443.
Fuchs, Elinor. "Reading for Landscape: The Case of American Drama." In *Land/Scape/Theater*, edited by Elinor Fuchs and Una Chaudhuri, 30–52. Ann Arbor: University of Michigan, 2002.
Füllner, Karin. "Richard Huelsenbeck: 'Bang! Bang! Bangbangbang': The Dada Drummer in Zurich." In *Dada Zurich: A Clown's Game from Nothing*, edited by Stephen C. Foster, Brigitte Pichon and Karl Riha, 89–103. New York: G.K. Hall; Prentice Hall International, 1996.
Fülöp-Miller, René. *The Mind and Face of Bolshevism: An Examination of Cultural Life in Soviet Russia*. Translated by F. S. Flint. New York: A.A. Knopf, 1929.
Garner, Stanton B. "Sensing Realism: Illusionism, Actuality, and the Theatrical Sensorium." In *The Senses in Performance*, edited by Sally Banes and Andre Lepecki, 115–122. New York: Routledge, 2007.
Glennie, Evelyn. *Good Vibrations: An Autobiography*. London: Arrow, 1990.
———. "Hearing Essay." http://www.evelyn.co.uk/hearing_essay.aspx.
Goble, Mark. *Beautiful Circuits: Modernism and the Mediated Life*. New York: Columbia University Press, 2010.
Gold, Lisa. *Music in Bali: Experiencing Music, Expressing Culture*. New York: Oxford University Press, 2005.

Goldman, Albert and Evert Sprinchorn. "Introduction." In *Wagner on Music and Drama: A Compendium of Richard Wagner's Prose Works*, edited by Albert Goldman and Evert Sprinchorn, 11–36. New York: E.P. Dutton, 1964.
Goodman, Steve. *Sonic Warfare: Sound, Affect, and the Ecology of Fear*. Cambridge, Mass.: MIT Press, 2009.
Gottlieb, Lynette Miller. "Images, Technology, and Music: The Ballets Suédois and Les mariés de la Tour Eiffel." *The Musical Quarterly* 88, no. 4 (2005): 523–555.
Haas, Birgit. "Staging Colours: Edward Gordon Craig and Wassily Kandinsky." In *Textual Intersections: Literature, History and the Arts in Nineteenth-Century Europe*, edited by Rachael Langford, 41–52. Amsterdam: Rodopi, 2009.
Häger, Bengt Nils Richard, et al. *Ballets Suedois: The Swedish Ballet*. New York: H.N. Abrams, 1990.
Hahl-Koch, Jelena. *Kandinsky*. London: Thames and Hudson, 1993.
Hall, Stuart. "Introduction." In *Modernity: An Introduction to Modern Societies*, edited by Stuart Hall, David Held, Don Hubert and Kenneth Thompson, 3–18. Oxford: Blackwell, 2000.
Halliday, Sam. *Sonic Modernity: Representing Sound in Literature, Culture and the Arts*. Edinburgh: Edinburgh University Press, 2011.
Handley, Miriam. "Chekhov Translated: Shaw's Use of Sound Effects in *Heartbreak House*." *Modern Drama* 42 (1999): 565–576.
Harding, James. *Erik Satie*. New York: Praeger, 1975.
——. *Contours of the Theatrical Avant-Garde: Performance and Textuality*. Ann Arbor: University of Michigan Press, 2000.
——."From Cutting Edge to Rough Edges: On the Transnational Foundations of Avant-Garde Performance." In *Not the Other Avant-Garde: The Transnational Foundations of Avant-Garde Performance*, 18–40. Ann Arbor: University of Michigan Press, 2006.
Harding, James and John Rouse. *Not the Other Avant-Garde: The Transnational Foundations of Avant-Garde Performance*. Ann Arbor: University of Michigan Press, 2006.
Hegel, Georg Wilhelm Friedrich. *Aesthetics: Lectures on Fine Art*. Translated by T. M. Knox. Vol. 1. Oxford: Clarendon Press, 1975.
Heller-Roazen, Daniel. *Echolalias: On the Forgetting of Language*. New York: Zone Books, 2005.
Hinton, Leanne, et al. *Sound Symbolism*. Cambridge: Cambridge University Press, 1994.
Hirsh, Sharon L. *Symbolism and Modern Urban Society*. Cambridge: Cambridge University Press, 2004.
Hollier, Denis. "The Death of Paper, Part Two: Artaud's Sound System." *October* 80 (1997): 27–37.
Huelsenbeck, Richard. "Dada, or the Meaning of Chaos." *Studio International* 183, no. 940 (1972): 26–29.
——. *Memoirs of a Dada Drummer*. Translated by Joachim Neugroschel. New York: Viking Press, 1974.

———. "First Dada Lecture in Germany." In *The Dada Almanac*, edited by Richard Huelsenbeck and Malcolm Green, 110–113. London: Atlas Press, 1993.
Huelsenbeck, Richard, et al. *Blago Bung, Blago Bung, Bosso Fataka!: First Texts of German Dada*. Translated by Malcolm Green. London: Atlas Press, 1995.
Hurley, Erin. *Theatre & Feeling*. Houndmills, Basingstoke, Hampshire; New York: Palgrave Macmillan, 2010.
Issacharoff, Michael. *Discourse as Performance*. Stanford: Stanford University Press, 1989.
Jakobson, Roman. *Child Language, Aphasia and Phonological Universals*. The Hague: Mouton, 1968.
Janecek, Gerald. *Zaum: The Transrational Poetry of Russian Futurism*. San Diego, Calif: San Diego State University Press, 1996.
Jannarone, Kimberly. *Artaud and His Doubles*. Michigan: University of Michigan Press, 2010.
———. "The Theatre Before its Double: Artaud Directs in the Alfred Jarry Theatre." *Theatre Survey* 46, no. 2 (2005): 247–273.
Janton, Pierre. *Esperanto: Language, Literature, and Community*. Albany: State University of New York Press, 1993.
Jelavich, Peter. *Munich and Theatrical Modernism: Politics, Playwriting, and Performance 1890–1914*. Cambridge, Mass.: Harvard University Press, 1985.
Johnson, James H. *Listening in Paris: A Cultural History*. Berkeley, Calif.: University of California Press, 1996.
Joyce, James. *Ulysses*. New York: Vintage, 1986.
Kahn, Douglas. "Introduction: Histories of Sound Once Removed." In *Wireless Imagination: Sound, Radio, and the Avant-Garde*, edited by Douglas Kahn and Gregory Whitehead, 1–30. Massachusetts: MIT Press, 1992.
Kamusella, Tomasz. *The Politics of Language and Nationalism in Modern Central Europe*. Basingstoke; New York: Palgrave Macmillan, 2009.
Kandinsky, Wassily. "The Yellow Sound: A Stage Composition." In *The Blaue Reiter Almanac*, edited by Wassily Kandinsky and Franz Marc, 207–240. Boston: MFA Publications, 1971 [1912].
———."On the Question of Form." In *The Blaue Reiter Almanac*, edited by Wassily Kandinsky and Franz Marc, 147–186. Boston: MFA Publications, 1974 [1912].
———."On Stage Composition." In *The Blaue Reiter Almanac*, edited by Wassily Kandinsky and Franz Marc, 190–206. Boston: MFA Publications, 1974 [1912].
———. *Concerning the Spiritual in Art*. 1st ed. Boston: MFA Publications 2006.
Kassler, Jamie C. "Musicology and the Problem of Sonic Abuse." In *Music, Sensation, and Sensuality*, edited by Linda Phyllis Austern, 321–334. New York: Routledge, 2002.
Kelman, Ari Y. "Rethinking the Soundscape: A Critical Genealogy of a Key Term in Sound Studies." *The Senses & Society* 5, no. 2 (2010): 212–234.
Kendrick, Lynne and David Roesner, eds. *Theatre Noise*. Newcastle: Cambridge Scholars, 2011.

Khlebnikov, Velimir. *Le Pieu du Futur*. Translated by Luda Schnitzer. Lausanne: Editions L'Age d'Homme, 1970.

Khlebnikov, Velimir and Paul Schmidt. *The King of Time: Selected Writings of the Russian Futurian*. Cambridge, Mass.: Harvard University Press, 1985.

Khlebnikov, Velimir, et al. *Collected Works of Velimir Khlebnikov, Volume I*. Cambridge, Mass.: Harvard University Press, 1987.

Kirby, Michael and Victoria Nes Kirby. *Futurist Performance: Includes Manifestos, Playscripts, and Illustrations*. New York: PAJ Publications, 1986.

Knowles, Sebastian D.G. "Death by Gramophone." *Journal of Modern Literature* 27, no. 1/2 (2003): 1–13.

Kristeva, Julia. "Modern Theatre Does Not Take (a) Place." *SubStance* 18–19 (1977): 131–134.

Kuenzli, Rudolf E. "Hugo Ball: Verse Without Words." *Dada/Surrealism* 8 (1978): 30–35.

LaBelle, Brandon. *Acoustic Territories: Sound Culture and Everyday Life*. New York: Continuum, 2010.

Lanier, Douglas. "Shakespeare on the Record." In *A Companion to Shakespeare and Performance*, edited by Barbara Hodgdon and William B. Worthen, 415–436. Oxford: Blackwell, 2005.

Large, J. A. *The Artificial Language Movement*. London: B. Blackwell; A. Deutsch, 1985.

"Le 24 Juin 1917." *SIC* 18 (1917).

Leeuw, Charles van der. *Azerbaijan: A Quest for Identity*. New York: St. Martin's Press, 2000.

Lefebvre, Henri. *Introduction to Modernity: Twelve Preludes*, September 1959–May 1961. Translated by John Moore. London; New York: Verso, 1995 [1962].

Lehmann, Hans-Thies. *Postdramatic Theatre*. London: Routledge, 2006.

Leppert, Richard D. *The Sight of Sound: Music, Representation, and the History of the Body*. Berkeley: University of California Press, 1993.

Lewis, Leopold and David Mayer. *Henry Irving and The Bells: Irving's Personal Script of the Play by Leopold Lewis*. Manchester: Manchester University Press, 1980.

Loehlin, James N. *Chekhov: The Cherry Orchard*. Cambridge: Cambridge University Press, 2006.

Maeterlinck, Maurice. *The Treasure of the Humble*. Translated by Alfred Sutro. New York: Dodd, 1925.

———. "The Intruder." In *Symbolist Drama: An International Collection*, edited by Daniel Charles Gerould, 224. New York: Performing Arts Journal Publications, 1985 [1890].

———. *The Princess Maleine: A Drama in Five Acts*. Translated by Gerard Harry. London: William Heinemann, 1892.

———. *The Plays of Maurice Maeterlinck*. Edited by Richard Hovey. Chicago: Stone & Kimball, 1894.

———. *Alladine and Palomides, Interior, and The Death of Tintagiles: Three Little Dramas for Marionettes*. London: Duckworth & Co., 1899.
Magarshack, David. *Chekhov, the Dramatist*. New York: Auvergne Publishers, 1952.
Mally, Lynn. *Culture of the Future: The Proletkult Movement in Revolutionary Russia*, Studies on the history of society and culture. Berkeley: University of California Press, 1990.
Marinetti, Filippo Tommaso. *Critical Writings*. Translated by Doug Thompson. 1st ed. New York: Farrar, Straus, and Giroux, 2006.
Massumi, Brian. *Parables for the Virtual: Movement, Affect, Sensation*. Durham, N.C.: Duke University Press, 2002.
McCaffery, Steve. *Prior to Meaning: The Protosemantic and Poetics*. Evanston, Ill.: Northwestern University Press, 2001.
McColl Millar, Robert. *Language, Nation and Power: An Introduction*. London: Palgrave Macmillan, 2005.
McGuinness, Patrick. *Maurice Maeterlinck and the Making of Modern Theatre*. Oxford: Oxford University Press, 2000.
McLuhan, Marshall. *Understanding Media: The Extensions of Man*. New York: McGraw-Hill Book Company, 1966.
McParland, Robert P. "The Sounds of an Audience." *Mosaic* 42, no.1 (2009): 117–132.
Meelberg, Vincent. "Touched by Music: The Sonic Strokes of *Sur Incises*." In *Sonic Mediations: Body, Sound, Technology*, edited by Carolyn Birdsall and Anthony Enns, 61–76. Newcastle: Cambridge Scholars Publishing, 2008.
Melzer, Annabelle. *Latest Rage the Big Drum: Dada and Surrealist Performance*. Ann Arbor, Mich.: UMI Research Press, 1980.
Meusy, Jean Jacques. *Paris-palaces, ou, Le Temps des Cinémas (1894–1918)*. Paris: CNRS Editions, 1995.
Milner, John. *Vladimir Tatlin and the Russian Avant-Garde*. New Haven: Yale University Press, 1983.
Misa, Thomas J. "The Compelling Tangle of Modernity and Technology." In *Modernity and Technology*, edited by Thomas J. Misa, Philip Brey and Andrew Feenberg, 1–30. Cambridge, Mass.: MIT Press, 2003.
Monks, Aoife. *The Actor in Costume*. Basingstoke: Palgrave Macmillan, 2010.
Montague, John. *The Rough Field*. Dublin: The Dolmen Press, 1972.
Morrisson, Mark. "Performing the Pure Voice: Elocution, Verse Recitation, and Modernist Poetry in Prewar London." *Modernism/Modernity* 3, no. 3 (1996).
Motherwell, Robert. *Dada, the Dada Painters and Poets: An Anthology*. 2nd ed. Boston, Mass.: G.K. Hall, 1981.
Mowitt, John. *Percussion: Drumming, Beating, Striking*. Durham: Duke University Press, 2002.
"Music, Singing and Dialogues Brought Direct to Your Bedside by Wire." *San Francisco Call* (August 28, 1898), 23.
Napier, Frank. *Noises Off: A Handbook of Sound Effects*. London: F. Muller, 1936.

Naumann, Francis M. "Janco/Dada: An Interview with Marcel Janco." *Arts Magazine* 57, no. 3 (1982): 80–86.
"New European State." *The New York Times* (February 23, 1908).
Nieland, Justus. *Feeling Modern: The Eccentricities of Public Life*. Urbana, Ill.: University of Illinois Press, 2008.
Office, United States of America War. "Esperanto: The Aggressor Language (FM 30–101–1)." Washington, D.C.: U.S.A. War Office, 1962.
Okrent, Arika. *In the Land of Invented Languages: Esperanto Rock Stars, Klingon Poets, Loglan Lovers, and the Mad Dreamers Who Tried to Build a Perfect Language*. 1st ed. New York: Spiegel & Grau, 2009.
Oohashi, Tsutomu, et al. "Inaudible High Frequency Sounds Affect Brain Activity: Hypersonic Effect." *Journal of Neurophysiology* 83 (2000): 3548–3358.
Orledge, Robert. *Satie Remembered*. Portland, Or.: Amadeus Press, 1995.
Ovadija, Mladen. *Dramaturgy of Sound in the Avant-Garde and Postdramatic Theatre*. Montreal: McGill-Queen's University Press, 2013.
Parsons, Denys. "Cable Radio—Victorian Style." *New Scientist* 23, no. 30 (1982): 794–796.
Perloff, Marjorie and Craig Dworkin, eds. *The Sound of Poetry, The Poetry of Sound*. Chicago: University of Chicago Press, 2009.
Perloff, Nancy. "Schwitters Redesigned: A Post-War *Ursonate* from the Getty Archives." *Journal of Design History* 23, no. 2 (2010): 195–203.
Pero, Allan. "The Feast of Nemesis Media: Jean Cocteau's *The Eiffel Tower Wedding Party*." *Modern Drama* 52, no. 2 (2009): 192–206.
Picker, John M. *Victorian Soundscapes*. Oxford: Oxford University Press, 2003.
Pinch, T. J. and Karin Bijsterveld. *The Oxford Handbook of Sound Studies*. Oxford: Oxford University Press, 2012.
Pinker, Steven. *The Language Instinct: How the Mind Creates Language*. New York: Harper Perennial, 1995.
Pitcher, Harvey J. *The Chekhov Play: A New Interpretation*. London: Chatto and Windus, 1973.
Poggi, Christine. *Inventing Futurism: The Art and Politics of Artificial Optimism*. Princeton: Princeton University Press, 2009.
Postlewait, Thomas. *The Cambridge Introduction to Theatre Historiography*. Cambridge: Cambridge University Press, 2009.
Puchner, Martin. *Stage Fright: Modernism, Anti-Theatricality, and Drama*. Baltimore: John Hopkins University Press, 2002.
———. "From the Editor." *Theatre Survey* 48, no. 2 (2007): 225–227.
"The Queen and the Electrophone." *The Electrician* (May 26, 1899), 144.
Rainey, Lawrence S., et al. *Futurism: An Anthology*. New Haven, Conn.: Yale University Press, 2009.
Ramazani, Jahan. *A Transnational Poetics*. Chicago: University of Chicago Press, 2009.
Rayfield, Donald. *The Cherry Orchard: Catastrophe and Comedy*. New York: Twayne Publishers, 1994.

Rebstock, Matthias and David Roesner. *Composed Theatre: Aesthetics, Practices, Processes*. Bristol: Intellect, 2012.
Richter, Hans. *Dada, Art and Anti-Art*. New York: Oxford University Press, 1978.
Ridout, Nicholas. "The Vibratorium Electrified." In *Vibratory Modernism*, edited by Anthony Enns and Shelley Trower, 215–226. Basingstoke: Palgrave, 2013.
Ridout, Nicholas Peter. *Stage Fright, Animals, and other Theatrical Problems*. Cambridge: Cambridge University Press, 2006.
Robida, Albert. *The Twentieth Century*. Translated by Philippe Willems. Middletown, Conn.: Wesleyan University Press, 2004.
Salter, Chris. *Entangled: Technology and the Transformation of Performance*. Cambridge, Mass.: MIT Press, 2010.
Satie, Erik and Ornella Volta. *Satie Seen through his Letters*. London; New York: M. Boyars, 1989.
Savinio, Alberto. "Le Drame et la Musique." *Les Soirées de Paris* 23 (1914): 240–244.
Schafer, R. Murray. *The Soundscape: Our Sonic Environment and the Tuning of the World*. Rochester, Vt.: Destiny Books, 1993.
Schechner, Richard. *Between Theater and Anthropology*. Philadelphia: University of Pennsylvania Press, 1985.
Schiff, Christopher. "Banging on the Windowpane: Sound in Early Surrealism." In *Wireless Imagination: Sound, Radio, and the Avant-Garde*, edited by Douglas Kahn and Gregory Whitehead, 139–190. Cambridge, Massachusetts: MIT Press, 1992.
Schumacher, Claude. *Naturalism and Symbolism in European Theatre, 1850–1918*. Cambridge: Cambridge University Press, 1996.
Schweighauser, Philipp. *The Noises of American Literature, 1890–1985: Toward a History of Literary Acoustics*. Gainesville: University Press of Florida, 2006.
Schwitters, Kurt, et al. *Pppppp: Poems, Performance Pieces, Proses, Plays, Poetics*. Cambridge, Mass.: Exact Change, 2002.
Scott, Clement. "The Playhouses." *The Illustrated London News* (August 2, 1890), 131.
Seidman, Naomi. *A Marriage Made in Heaven: The Sexual Politics of Hebrew and Yiddish*. Berkeley: University of California Press, 1997.
Seiwert, Harry. "Marcel Janco." In *Dada Zurich: A Clown's Game from Nothing*, edited by Stephen C. Foster, Brigitte Pichon and Karl Riha, 125–137. New York: G.K. Hall; Prentice Hall International, 1996.
Sell, Mike. *Avant-Garde Performance and Material Exchange: Vectors of the Radical*. New York: Palgrave Macmillan, 2011.
———. *The Avant-Garde: Race, Religion, War*. London: Seagull Books, 2011.
Senelick, Laurence. "'All Trivial Fond Records': On the Uses of Early Recordings of British Music-Hall Performers." *Theatre Survey* 16 (1975): 135–149.
———."Chekhov's Drama, Maeterlinck, and the Russian Symbolists." In *Chekhov's Great Plays: A Critical Anthology*, edited by Jean Pierre Barricelli, 161–180. New York: New York University Press, 1981.

Seo, Audrey Yoshiko and Stephen Addiss. *The Sound of One Hand: Paintings and Calligraphy by Zen Master Hakuin*. Boston, Mass.: Shambhala, 2010.
Shenton, Herbert N., et al. *International Communication: A Symposium on the Language Problem*. London: K. Paul, Trench, Trubner & Co., 1931.
Shepherd-Barr, Kirsten. "'Mise en Scent': The Théâtre d'Art's *Cantique des cantiques* and the Use of Smell as a Theatrical Device." *Theatre Research International* 24, no. 2 (1999): 152–159.
Shipe, Timothy. "The Dada Movement: Violating Boundaries." In *Migrations in Society, Culture, and the Library: WESS European Conference*, Paris, France, March 22, 2004, edited by Thomas D. Kilton and Ceres Birkhead, 183–190. Chicago: Association of College and Research Libraries, 2005.
Smith, Bruce R. *The Acoustic World of Early Modern England: Attending to the O-Factor*. Chicago: University of Chicago Press, 1999.
Sofer, Andrew. "Spectral Readings." *Theatre Journal* 64, no. 3 (2012): 323–336.
Soucy, Robert. *French Fascism: The Second Wave, 1933–1939*. New Haven: Yale University Press, 1995.
Spencer, Herbert. *Pioneers of Modern Typography*. London: Lund Humphries, 1982.
Spreen, Constance. "Resisting the Plague: The French Reactionary Right and Artaud's Theatre of Cruelty." *Modern Language Quarterly* 64, no. 1 (2003): 71–96.
States, Bert O. *Great Reckonings in Little Rooms: On the Phenomenology of Theater*. Berkeley: University of California Press, 1985.
Stedman, Jane W. "Enter a Phonograph." *Theatre Notebook* 30, no. 1 (1976): 3–4.
Stein, Gertrude. *The Autobiography of Alice B. Toklas*. New York: Harcourt, 1933.
———. *Lectures in America*. New York: Random House, 1935.
———. *Everybody's Autobiography*. New York: Random House, 1937.
Sterne, Jonathan. *The Audible Past: Cultural Origins of Sound Reproduction*. Durham: Duke University Press, 2003.
Styan, J. L. *Chekhov in Performance: A Commentary on the Major Plays*. Cambridge: Cambridge University Press, 1971.
Suárez, Juan Antonio. *Pop Modernism: Noise and the Reinvention of the Everyday*. Urbana: University of Illinois Press, 2007.
Swietochowski, Tadeusz. *Russia and Azerbaijan: A Borderland in Transition*. New York: Columbia University Press, 1995.
Szendy, Peter. *Listen: A History of Our Ears*. New York: Fordham University Press, 2008.
Tatlin, Vladimir. "On Zangezi." In *The Tradition of Constructivism*, edited by Stephen Bann, 112–115. London: Thames and Hudson, 1974.
"The Telephone at the Paris Opera." *Scientific American* (1881): 422–423.
"Terry's Theatre." *Marylebone & Paddington Independent* (July 24, 1890).
"Theatre-Going by Telephone: A Forgotten Amenity of London in the 1920s." *The Times* (May 9, 1957), 3.
"The Theatrophone." *The Times* (May 29, 1891), 5.

Thompson, Emily Ann. *The Soundscape of Modernity: Architectural Acoustics and the Culture of Listening in America, 1900–1933*. Cambridge, Mass.: MIT Press, 2002.
Tolstoy, Leo *War and Peace*. Translated by Anthony Briggs. London: Penguin, 2006.
Tzara, Tristan. "The First Celestial Adventure of Mr. Antipyrine, Fire Extinguisher." In *Dada Performance*, edited by Mel Gordon, 53–62. New York: PAJ Books, 1987.
———. "The Gas Heart." In *Theater of the Avant-Garde, 1890–1950: A Critical Anthology*, edited by Bert Cardullo and Robert Knopf, 272–282. New Haven: Yale University Press, 2001.
———. "Manifesto on Feeble Love and Bitter Love [1920]." In *Dada, the Dada Painters and Poets: An Anthology*, edited by Robert Motherwell, 86–96. Boston, Mass.: G.K. Hall, 1981.
Uzanne, Octave. "The End of Books." *Scribner's Magazine*, 1894, 221–232.
Valency, Maurice. *The Breaking String: The Plays of Anton Chekhov*. New York: Oxford University Press, 1969.
Vincent, Harley. "Stage Sounds." *The Strand Magazine*, 1904, 417–422.
Von Geldern, James. *Bolshevik Festivals, 1917–1920*. Berkeley: University of California Press, 1993.
Wachtel, Andrew. *An Obsession with History: Russian Writers Confront the Past*. Stanford, Calif.: Stanford University Press, 1994.
Wagner, Richard. *Wagner on Music and Drama: A Compendium of Richard Wagner's Prose Works*. Edited by Albert Goldman and Evert Sprinchorn. New York: E.P. Dutton, 1964.
Weber, William. "Wagner, Wagnerism, and Musical Idealism." In *Wagnerism in European Culture and Politics*, edited by David Clay Large, William Weber and Anne Dzamba Sessa, 28–71. Ithaca: Cornell University Press, 1984.
———. "Did People Listen in the Eighteenth Century?" *Early Music* 25, no. 4 (1997): 678–691.
Weheliye, Alexander G. *Phonographies: Grooves in Sonic Afro-Modernity*. Durham: Duke University Press, 2005.
Weiss, Jeffrey S. *The Popular Culture of Modern Art: Picasso, Duchamp, and Avant-Gardism*. New Haven: Yale University Press, 1994.
Welch, Walter L. and Leah Brodbeck Stenzel Burt. *From Tinfoil to Stereo: The Acoustic Years of the Recording Industry, 1877–1929*. Gainesville: University Press of Florida, 1994.
Wendel, Delia Duong Ba. "The 1922 'Symphony of Sirens' in Baku, Azerbaijan." *Journal of Urban Design* 17, no. 4 (2012): 549–572.
White, Erdmute Wenzel. *The Magic Bishop: Hugo Ball, Dada Poet*. Columbia, S.C.: Camden House, 1998.
White, Hayden. *Tropics of Discourse: Essays in Cultural Criticism*. Baltimore: Johns Hopkins University Press, 1978.
Wieda, Nina. "The Ominousness of Chekhovian Idyll: The Role of Intertextuality in Stoppard's *The Coast of Utopia*." In *Ot "Igrokov" do*

"Dostoevsky-trip": intertekstual'nost' v russkoi dramaturgii XIX–XX vv. Moskva: Izdatel'stvo MGU, 2006.
Williams, James S. *Jean Cocteau.* London: Reaktion, 2008.
Worrall, Nick. "Stanislavsky's Production Score for Chekhov's *The Cherry Orchard* (1904): A Synoptic Overview." *Modern Drama* 42 (1999): 519–540.
Yaguello, Marina. *Lunatic Lovers of Language: Imaginary Languages and Their Inventors.* London: Athlone Press; Fairleigh Dickinson University Press, 1991.
Yorkston, Eric and Geeta Menon. "A Sound Idea: Phonetic Effects of Brand Names on Consumer Judgments." *Journal of Consumer Research* 31 (2004): 43–51.
Zamenhof, L. L. *An International Language: The Problem and its Solution.* Translated by Alfred E. Wackrill. London: Review of Reviews, 1900.

INDEX

Note: The letter 'n' followed by the locators refers to notes in the text.

abstraction, 8, 16, 18, 27, 29, 36, 40, 50, 51–7, 62, 97, 124, 128, 131, 167, 178–9, 185, 200
accents, 78, 120
acoustic imaginary, 16, 21–4, 30, 36, 38, 41, 42, 43, 47, 50, 51, 54, 55, 62, 65, 75, 94, 97, 123, 164, 178
 see also hearing; listening; anamnesis
acoustic interiority, 12, 25–31, 35, 43, 51, 60–1, 62, 200, 208n.18
 see also modernity; subjecthood
Ader, Clément, 88
aesthetics, 6, 7, 10, 13, 15, 19, 27, 28, 32, 34, 49, 50–2, 54, 60, 69–71, 73, 76, 79, 80, 98, 101, 115, 120, 122, 148–50, 152, 153–4, 161, 164, 176, 177, 180, 183–5, 186, 197, 201, 204
affect, 3, 9, 12, 50, 60, 123, 127, 131, 144–6, 178, 193, 197, 198, 200
 see also emotion; feeling; mood
Aggressor, 115
Albert-Birot, Germaine, 74, 79–80
Albert-Birot, Pierre, 73, 75, 77, 214n.42
 théâtre nunique, 180
Albright, Daniel, 30, 78, 158
Allen, David, 47
Alter, Nora M., 42
Altman, Rick, 152–3

Amigo, Leopoldo, 194
anamnesis, 191, 207n.1, 232n.143
 see also acoustic imaginary
Anderson, Benedict, 192
anti-theatricality, 96
 compare theatricality
Apollinaire, Guillaume, xi, 17, 65, 66, 68, 82, 84, 125
 The Breasts of Tiresias, 73–81
applause, 1–3, 19, 93, 150, 182, 205n.1
 see also audience behavior; *compare* booing
archaeoacoustics, 153
Arp, Hans/Jean, 120, 172, 229n.78
Artaud, Antonin, xii, 3, 18, 43, 146, 176, 193, 197, 203
 The Cenci, 177–86
atmosphere, 7, 24, 36, 54, 71, 149, 157, 166, 175, 182, 232n.143
 see also affect; mood
audience behavior, 6, 38, 49, 59, 71–2, 75, 76, 81, 85, 88, 93–4, 97, 98, 101, 103, 129–30, 146, 150, 158, 159, 160–1, 164, 168, 183, 185, 195, 197, 199, 202–3, 223n.92, 227n.23
audiovisuality, 66, 72, 81, 82, 85, 149
 see also synaesthesia; visuality
Augoyard, Jean-François, 194, 232n.143, 233n.152
Auric, Georges, 81

avant-gardism
 cultural perceptions of, 1–3
 linguistic, 105, 131, 142
 theatrical, 3, 10, 12, 16, 19, 65, 73, 87, 105, 142, 146, 152, 154, 165, 177, 200–1, 204
 theories of, 12–15, 115
 see also under names of individual movements
Avraamov, Arseny, 18, 23, 146, 203, 232n.145
 The Symphony of Sirens, 186–98

Babbage, Charles, 31
Ball, Hugo, 17, 57, 105, 119, 120, 121, 132, 134, 135, 142, 173, 174, 175, 203, 220n.50, 222n.75
 Lautgedichte (sound poetry), 122–6, 137
Ballets Suédois, 81
ballyhoo, 152–3
Baricelli, Jean-Pierre, 49
Barker, Howard, 205n.3
Barrymore, Lionel, 23
Baudelaire, Charles, 43
Bay-Cheng, Sarah, 106, 213n.23
Becker, Judith, 185
Beckett, Samuel, 95
 Endgame, 117
 Krapp's Last Tape, 87
Beerbohm Tree, Herbert, 64, 68
Beethoven, Ludwig van, 22, 226n.16
Benjamin, Walter, 31, 43, 66, 69–70, 71, 72
Benzon, William, 193
Berghaus, Günter, 154, 155, 227n.31, 229n.85
Berliner, Emile, 64, 212n.5
Berlioz, Hector, 22
Bernhardt, Sarah, 68
Bijsterfeld, Karin, 3, 4
Birdsall, Carolyn, 183

Blackadder, Neil, 226n.21
Boccioni, Umberto
 The Street Enters the House, 156–8, 162
body/embodiment, 2, 12, 26, 30, 42, 86, 117, 143–4, 167, 174, 176, 187, 197, 223n.92
body madness, 155–6
 see also physicality
booing, 3, 154, 160, 227n.23
 see also audience behavior; *compare* applause
Bogdanov, Alexander, 187
Borlin, Jean, 81
Bovy, Berthe, 94, 98
Bratton, Jacky, 18
Braun, Edward, 49
Brecht, Bertolt, 64, 70–1, 83, 177
Brown, Ross, 6, 49, 73, 149
Bruckner, Anton, 22
bruiteur, 75–7, 214n.35, 214n.47
 see also sound effects
bruitism, 173, 174, 176
 see also noise
Bull, Michael, 26

Cage, John, 34, 152, 199
Canetti, Elias, 150
Cangiullo, Francesco, 162, 167–8
Carlson, Marvin, 103, 105
Carlyle, Thomas, 31
Carter, William C., 91
Chapman, Graham, 75
Chekhov, Anton, 14, 16, 24, 25, 62, 203
 The Cherry Orchard, 44–51
Chessa, Luciano, 228n.39
Chiti, Remo, 163
choreography, 60, 81, 82, 87, 93
 see also dance
cinema, 10, 17, 65, 66, 72, 75, 76, 77, 87, 88, 152, 161
Clayson, Susan Hollis, 208n.15

Cocteau, Jean, 14, 17, 65, 66, 71, 88, 169, 202, 217n.101
The Eiffel Tower Wedding Party, 81–7, 169
The Human Voice, 94–9
Coleridge, Samuel Taylor, 51
Connor, Steven, 7, 11, 61, 97
constructivism, 141, 186
Corra, Bruno, 161
costume, 6, 32, 74, 79, 82, 83, 84, 113, 115, 123, 125, 205n.2
Craig, Edward Gordon, 54, 167

dadaism, 8, 16, 17, 18, 105, 146, 165, 176, 197, 202, 220n.50
 Zurich dada, 3, 115–26, 171–5
dance, 51, 54, 60, 85, 86, 129, 144, 146, 172, 173, 180, 184, 222n.70, 230n.93
 see also choreography
Dann, Kevin T., 58
D'Arcy, Geraint, 59
Davis, Tracy C., 197
deafness, 2, 22, 39, 144, 200
Deak, Frantisek, 13, 14
death, 24, 32, 34, 36–7, 38, 40, 43, 47, 49, 91, 98, 125, 140
Debussy, Claude
 Pelléas et Mélisande, 91
Demos, T.J., 121–2
Desbordes, Jean, 99
Désormière, Roger, 178, 179, 180, 181
DeVere Brody, Jennifer, 164
D'Houville, Gerald, 181
Dieckhoff, Alain, 107
diegesis, 6, 96
 compare mimesis
directors, 6, 44, 48, 49, 50, 59, 80, 152
Doesberg, Nelly van, 129
domesticity, 31, 34, 35, 77, 93
 see also public/private
dramaturgy, 19, 35, 43, 44, 65, 203
Draycott, Jane, 91

Duncan, Isadora, 54
Durey, Louis, 81

Edison, Thomas, 63, 212n.5
Edward, Albert (King Edward VII), 91
Einstein, Albert, 106
Ekaku, Hakuin, 1
Eluard, Paul, 99
emotion, 30, 42, 49, 52, 71–2, 102, 144, 146, 164, 166, 168, 179
 see also affect; mood; feeling
Enns, Anthony, 11
environment, 3, 9, 10, 12, 21, 24, 27, 34, 36, 42, 46, 48, 50, 56, 62, 121–2, 123, 144, 152, 158, 163, 165, 173, 183, 186, 187, 195, 201, 223n.99
 see also atmosphere; soundscape
epistemology, 11, 53, 65, 107
Erckmann-Chatrian (Émile Erckmann and Alexandre Chatrian), 94
Erlmann, Veit, 8
Esperanto, 17, 105, 110–15, 116, 132, 133, 136, 142, 219n.28, 219n.31, 219n.37, 220n.44, 220n.45, 223n.99
Europanto, 109, 218n.18
Evreinov, Nikolai, 187, 232n.146
existentialism, 39, 44, 106
exoticism, 125, 152, 180, 201, 203
expressionism, 16, 46, 52, 60

Fauser, Annegret, 93, 216n.80
feeling, 16, 30, 31, 47, 50, 51, 58, 72, 122, 134, 144–5, 155, 173, 176–7, 185, 233n.152
 see also affect; emotion; mood
Férat, Serge, 74, 79
Fergusson, Francis, 49
film, *see* cinema
Fletcher, Lucille, 95
Fluxus, 2
Foley artistry, 71, 75
Folkerth, Wes, 5
folklore, 49, 140

Fuchs, Elinor, 24
Füllner, Karin, 174
Fülöp-Miller, René, 232n.139
futurism, 13, 15, 185
　Italian, 18, 136, 146, 154–71, 173, 197, 202, 203
　Russian, 17, 106, 131–42, 186

Garbo, Greta, 92
Garner, Stanton B., 49
Gastev, Aleksei, 191, 232n.145
Geldern, James von, 232n.146
Glennie, Dame Evelyn, 143–4
glossolalia, 124, 136, 222n.75
　see also language; speech
Gluck, Christoph, 22
Goble, Mark, 92
Gottlieb, Lynette Miller, 85
Graham-Jones, Jean, 13, 15
gramophones, 10, 26, 64, 70, 190, 212n.5
　see also phonographs
Guyard, Niny, 79

Haas, Birgit, 57
Hall, Stuart, 8
Halliday, Sam, 11
Hand, Richard, 59
Handley, Miriam, 49
Harding, James, 13, 200–1, 221n.69
Hartmann, Thomas de, 55
Hausmann, Raoul, 126
hearing, 4–10, 12, 17–19, 21–2, 24–6, 28, 30, 31, 36, 42, 43, 49, 52, 54, 61, 62, 63, 64, 71, 72, 80, 91–2, 98, 99, 132, 143–4, 147, 170, 171, 173, 177, 181, 184–6, 194, 196, 199, 200
　see also affect; listening
Hegel, Georg Wilhelm Friedrich, 28–9
Heller-Roazen, Daniel, 223n.94
Hennings, Emmy, 120, 172, 173
Herder, Johann Gottfried von, 107
Hirsh, Sharon L., 35, 42
historiography, 19, 140, 201, 204

Hitchcock, Alfred, 95
Honegger, Arthur, 81, 160
Huelsenbeck, Richard, xii, 18, 116, 118, 119, 120, 121, 122, 146, 165, 171, 172, 173–6, 179, 180, 197, 220n.50, 229n.82
Hugo, Jean, 81, 83
Hurley, Erin, 144

Ibsen, Henrik, 24
internationalism, 108, 110–12, 115, 116, 121, 126, 186, 192, 193, 196, 197, 234n.165
　compare nationalism
Irving, Henry, 23, 68, 69

Jacob, Max, 147
Jakobson, Roman, 130, 223n.94
Janco, Marcel, 118, 119, 120, 221n.57, 221n.70
　Cabaret Voltaire, 172
Jannarone, Kimberley, 13, 14, 177, 183, 201
Jannelli, Gugliegmo, 162
Jarry, Alfred
　Ubu Roi, 151, 227n.23
Jaws (film), 22
Jelavich, Peter, 58
Jonson, Ben, 51
Jouve, Pierre-Jean, 181
Joyce, James, 8, 68, 117

Kahn, Douglas, 11, 15
Kandinsky, Wassily, 14, 16, 25, 200, 202
　Impression III—Concert, 54
　The Yellow Sound, 51–62
Kazubko, Katrin, 126
Kelman, Ari Y., 4
Khlebnikov, Velimir, 17, 106, 192, 202, 224n.110, 224n.120, 225n.136
　Zangezi, 131–42

Khnopff, Fernand, 16, 29–34, 36, 39, 50, 208n.25
About Silence, 32–3
Listening to Music by Schumann, 29–31, 32, 148
Knott, Frederick, 95
Koepnick, Lutz P., 42–3
Kruchenykh, Alexei, 131

LaBelle, Brandon, 176
Lagut, Irène, 81, 82
language, 22, 32, 50, 55, 92, 118, 119, 120, 121, 123, 124, 130, 134, 135, 144, 165, 166, 171, 195, 201, 202, 223n.70
 body language, 30
 invented language, 12, 105, 106, 108, 109–10, 200
 nonsense language, 105, 117, 119, 124, 130, 142, 200
 universal language, 12, 56, 105, 109, 116, 122, 125, 126, 132, 133, 136, 137, 140, 142, 184, 192, 203
Lanier, Douglas, 68
Latour, Raymonde, 182, 183
Law, Arthur, 63, 64
Lefebvre, Henri, 106
Léger, Fernand, 147
Lehmann, Hans-Thies, 52
Lewis, Leopold
 The Bells, 16, 23–4, 40, 50, 54, 94
listening, 3, 7, 9–11, 23–6, 29, 30, 32, 35, 42, 36, 38, 51, 65–6, 73, 86–95, 97–8, 101, 125, 128, 144, 147–51, 154, 161, 168, 176, 185, 194, 200, 226n.16, 233n.152
 see also audience behavior; hearing
literature, 4, 6, 10, 11, 12, 18, 22, 26, 27, 36, 46, 50, 90–1, 101, 104, 109, 110, 173, 177, 201, 208n.18, 220n.44
 see also poetry

liveness, 65, 70, 73, 74, 76, 79, 87, 88, 93, 201
Loehlin, James N., 44

Maeterlinck, Maurice, 14, 16, 24, 25, 32, 34, 46, 49, 50, 51, 54, 55, 62, 91, 95, 96, 163, 178, 203
 The Blind, 39–44
 The Death of Tintagiles, 36, 38–9
 The Intruder, 36–8
 The Princess Maleine, 35, 38,
Magarshack, David, 49
Marinetti, F. T., 3, 18, 68, 77, 146, 154–6, 160, 161, 174, 185, 197
 parole in libertà (words in freedom), 165–71
McGuinness, Patrick, 42
McLuhan, Marshall, 95
McParland, Robert P., 227n.23
Milhaud, Darius, 81, 147, 148
Millar, Robert McColl, 107–8
mimesis, 75
 compare diegesis
mimodrame, 81, 87
 see also pantomime
mise-en-scène, 6, 36, 42, 59, 65, 82, 93, 103, 146, 149, 179, 181
 see also scenography
modernism, 11, 12, 13, 14, 15, 19, 24, 43, 58, 61, 71, 73, 79, 91, 106, 121, 171, 180, 184, 202, 203, 204
 see also avant-garde
modernity, 18, 35, 51, 52, 103, 119, 173, 174, 175, 176, 177, 202
 language in, 17, 101, 105, 106–16, 120, 142, 216n.6
 sonic, 8–12, 15, 16, 18, 25, 62, 65, 66, 146, 153, 165, 181, 199, 200, 201
 and subjecthood, 24, 25, 28, 31, 51, 60–1, 62, 84, 97, 118, 119, 171

modernity—*continued*
 and technology, 17, 25–7, 61, 64–6, 69–71, 72–3, 87, 88, 91, 94–5, 100, 102, 186
 urban, 42–3, 145, 151–4, 156, 158, 159, 161, 162, 186, 187, 195, 197
Molina, Miguel, 194
Monks, Aoife, 205n.2
Montague, John, 108
mood, 47, 54, 95, 144, 147
 see also affect; atmosphere; emotion; feeling
Moréas, Jean, 42
Morris, Tom, 50
Mozart, Wolfgang Amadeus, 22
music, 5, 9, 11, 15, 19, 25, 32, 34, 35, 40, 49, 50, 51, 57, 61, 65, 68, 91, 103, 118, 121, 123, 127, 128, 149, 154, 165, 168, 170, 171, 177, 183, 184, 199
 absolute music, 29–31
 Balinese music, 180, 184, 203
 chamber music, 31
 dance music, 143
 drumming, 48, 76, 77, 168, 172, 173–6, 180
 Esperanto music, 114
 film music, 22
 furniture music, 147–8, 198, 203
 music hall, 69, 73, 76, 77, 84, 90, 155
 modernist music, 54, 79
 musical idealism, 148, 150, 161
 Muzak, 101
 noise music, 146, 158–61
 opera, 55, 88, 90, 91, 101, 103, 147, 148, 149–50, 161, 169
 percussion, 143, 144, 173, 175–6, 178, 230n.93
 popular music, 222n.76
 proletarian music, 186–7, 192–5, 197
 silent music, 199
 singing, 37, 56, 123, 155, 187, 189, 190, 191, 193, 195, 223n.99
 symphonic music, 22, 161, 190, 195
 theatre music, 55–7, 68, 74, 79, 80, 81, 82, 85, 152, 178, 180–1, 185, 217n.2, 221n.70

Napier, Frank, 48
nationalism, 103, 105, 107, 110, 121, 193, 196, 197, 219n.31
 compare unisonality, internationalism
Nicastro, Luciano, 162
Nieland, Justus, 31, 61
Nietzsche, Friedrich, 106
noise, 11, 18, 32, 62, 68, 74, 79, 141, 144–5, 147, 151, 164–5, 170, 171, 177, 186, 187, 194, 199, 200, 203, 204, 225n.5
 in drama, 23, 38, 40, 41, 51, 162–4
 in modernity, 9–10, 12, 26, 31, 34, 42, 61, 142, 153, 156, 158
 in music. *see* music
 in poetry, 119, 120, 229n.85
 in theatre, 1–3, 6, 36, 48, 50, 64, 67, 75, 80, 101, 145–6, 148, 149, 150, 152, 154–5, 156, 167, 172, 173–4, 175, 176, 180, 181, 182, 183, 197–8, 227n.23
 compare silence

Ockham, William of, 134
ocularcentrism, 8
olfaction, 157, 199
ontology, 25, 26, 31, 39, 43, 47, 51, 53, 62, 66, 86–7, 93, 106, 118, 158, 201, 218n.8
Ovadija, Mladen, 6

painting, 16, 23, 29–31, 42, 52, 53–5, 60, 61, 80, 114, 133, 148, 156–8, 172, 229n.78
Palazzeschi, Aldo, 155, 156

pantomime, 81, 83, 85, 86, 154, 218n.18
　see also mimodrame
Pavis, Patrice, 5
Pero, Allan, 87
performativity, 4, 17, 100, 112, 115, 122, 154, 156, 167, 192, 197
Phillip, Stephen, 64
philosophy, 5, 22, 26, 27, 36, 52, 106–7, 112, 115, 116, 123, 134, 174, 177, 178, 180, 185, 200
physicality, 7, 42, 87, 98, 143, 144, 145, 150, 158, 163–4, 167, 175, 179, 184, 192, 193
　see also body/embodiment
phonographs, 11, 16, 17, 26, 27, 63–4, 65, 66–70, 79, 82–7, 88, 94, 101, 103, 168–70, 175, 212n.5, 215n.61, 217n.2
　see also gramophones
photography, 54, 68, 74, 83, 85, 93, 98, 140, 229n.78
Piatti, Ugo, 159
Picker, John, 31
Pinch, Trevor, 3, 4
Piscator, Erwin, 64, 68, 70
Pitcher, Harvey, 49
Planck, Max, 106
poetry, 13, 17, 18, 34, 36, 43, 51, 57, 80, 83, 84, 91, 105, 106, 108, 114, 118–31, 134, 137, 146, 154, 164–77, 179, 185, 192, 197, 223n.95, 224n.112, 232n.145
　see also literature
politics, 12, 13, 14, 16, 46, 107, 111, 115, 119, 121, 122, 135, 146, 152, 153, 173, 174, 175, 177, 182, 183, 186, 187, 192, 193, 195, 197, 201, 204, 223n.99, 225n.6, 234n.165
Poulenc, Francis, 81, 85
presence, 36, 40, 51, 69–70, 75, 76, 145, 173, 179, 182, 201

primitivism, 74, 115, 116, 122, 124, 125, 130, 171, 172, 175, 176, 180, 230n.93
Proletkult, 187, 193, 197
props (stage), 6, 95
Proust, Marcel, 43, 90–1
public/private, 26–7, 31, 156, 201
　see also domesticity
Puchner, Martin, 18

Quillard, Pierre, 36

radio, 26, 35, 38, 44, 88, 90, 96, 110, 132–3, 190, 224n.120, 232n.141
Ramazani, Jahan, 121
Ravel, Maurice, 160
Rayfield, Donald, 49
Rebstock, Matthias, 6
Reinhardt, Max, 54
Richter, Hans, 129, 130
Ridout, Nicholas, 151, 178, 223n.92
Robida, Albert, 16, 42, 120, 132, 208n.15, 217n.2
　Tales for Bibliophiles, 26–7, 28
　The Twentieth Century, 101–5, 108–9, 114
Rodenbach, Georges, 34
Roesner, David, 6
Rognoni, Angelo, 163–4
Romanticism, 10, 27, 35, 184
Russolo, Antonio, 160
Russolo, Luigi, 64, 158–61, 178, 185, 197, 203
　intonarumori (noise intoners), 159, 160, 187

Sacharoff, Alexander, 54
Saint-Saëns, Camille, 147
Salter, Chris, 213n.9, 225n.134
Sarcey, Francisque, 38
Satie, Erik, 147–8, 150, 185, 198, 203
Savinio, Alberto, 150–1, 182

scenography, 6, 36, 73, 75, 82–4, 86, 100, 137, 141, 146, 225n.134
 see also mise-en-scène
Schaeffer, Pierre, 11
Schafer, R. Murray, 4, 145, 153, 181
Schiff, Christopher, 152
Schleyer, Johann Martin, 109, 111
Schmidt, Paul, 131, 224n.120
Schoenberg, Arnold, 54, 128
Schubert, Franz, 22
Schumann, Robert, 22, 30
Schwitters, Kurt, 68, 122, 132, 142, 203, 222n.85, 223n.89, 223n.92
 "Ursonate," 17, 106, 126–31, 136,
Scott, Clement, 63–4, 66
Sell, Mike, 13, 115
Sellars, Peter, 224n.120
semantics, 4, 12, 22, 46, 51, 55, 60, 79, 86, 87, 101, 105, 120, 122, 126, 127, 131, 134, 128, 166, 170, 171
 protosemantics, 223n.95
senses (human), 3, 4, 5, 6, 8, 12, 19, 25, 26, 39, 51, 54, 55, 66, 71, 72, 73, 143, 146, 151, 162, 183, 199
Settimelli, Emilio, 161
Shakespeare, William, 5
 Hamlet, 114
 Romeo and Juliet, 70
Shaw, George Bernard, 26, 49
Shelley, P.B., 177
Shenton, Herbert, 110
silence, 18, 19, 36, 37, 42, 147, 164, 199
 in drama, 51, 96, 97, 99, 118, 162
 in modernity, 62, 153
 in symbolism, 32–5, 37, 38, 42

 in theatre, 1, 3, 36, 151, 182, 197, 205n.3
 compare noise
Smith, Bruce R., 5
Sofer, Andrew, 23
Solidarité Française, 182–3, 231n.121
sonic modernity, *see under* modernity
Souday, Paul, 81
sound
 acousmatic sound, 11, 36, 39, 178
 electronic sound, 44, 67, 178, 180, 185
 and the sublime, 27, 149, 233n.152
 sound design, 5, 7, 18, 31, 36, 41, 51, 67, 146, 179, 180, 183–5, 197, 198
 sound effects, 5, 44, 48, 49, 51, 56, 60, 66, 67–8, 71, 74, 75, 76–9, 82, 84, 162, 168, 169, 187, 214n.33
 soundscape, 3, 4, 7, 9, 10, 16, 18, 31, 42, 46, 48, 50, 51, 61, 62, 73, 93, 100, 101, 142, 145, 151, 152, 153, 158, 169, 171, 173, 175, 180, 186, 190, 191, 192, 194, 196, 197, 225n.5, 233n.152
 sound studies, 3–4, 11
 sound symbolism (language), 125, 127, 133, 203
 stereophonic sound, 88, 178, 183
spectacle, 15, 66, 73, 79, 82, 83, 85, 86, 87, 94–9, 102, 103, 155, 183, 186–7, 192, 194
 see also visuality
speech, 15, 36, 38, 41, 47, 51, 55, 56, 68, 74, 81, 83, 85, 86, 96, 97, 105, 115–19, 122, 127, 128, 130–1, 137, 140, 142, 143, 151, 163, 170–1, 199, 215n.61
 see also language
stage directions, 23, 42, 44, 45, 46
Stalin, Joseph, 195
Stanislavsky, Constantin, 47–8, 54, 203

Stanwick, Barbara, 95
Stein, Gertrude, 27, 29, 43, 71–2, 73, 77, 85, 213n.23
Stendhal (Marie-Henri Beyle), 177
Sterne, Jonathan, 9, 15, 22, 25–6, 65
Stoppard, Tom
 The Coast of Utopia, 49
Strand Magazine, 67, 88, 89, 112, 113, 114
Stravinsky, Igor, 148, 160
Strindberg, August, 24, 99
Strowski, Fortunat, 181, 182
Styan, J. L., 48, 49
surrealism, 16, 66, 73, 75, 78, 79, 81, 84, 86, 87, 99, 163, 182, 202
symbolism (art movement), 14, 15, 16, 25, 27, 29, 30, 32–44, 46, 49, 51, 52, 54, 57–8, 163, 164, 170, 199, 202, 228n.39
synaesthesia, 16, 51, 52, 54, 56, 58, 98, 158
 see also audiovisuality
Szendy, Peter, 226n.16

Taft, Lorado, 41
Tailleferre, Germaine, 81
Tatlin, Vladimir, 136–7, 141
Täuber, Sophie, 230n.93
Tchaikovsky, Pyotr Illych, 22
telegraphy, 10, 25, 26, 84, 110, 111, 117, 133, 218n.6
telephony, 10, 16, 17, 26, 61, 66, 95–100, 105, 110, 168, 190, 217n.101
 theatre phone/*théâtrophone*, 17, 65, 88–94, 97, 98, 100, 103, 215n.66, 216n.82
Terry, Ellen, 68
theatricality, 87, 197
 compare anti-theatricality
Thomas, Ambroise, 147
Thompson, Emily, 7, 153
Tolstoy, Leo, 46

Torgue, Henry, 194
touch, 6, 11, 54, 98, 99, 143, 144, 175, 176, 183, 184
Trower, Shelley, 11
Tzara, Tristan, 17, 105, 116, 122, 124, 125, 142, 172, 174, 220n.52
 "The Admiral Searches for a House to Rent," 118–20
 The Gas Heart, 8, 117–18

unisonality, 192–3, 195
 see also nationalism

Valency, Maurice, 49
Varèse, Edgard, 160
Verne, Jules, 114
vibration, 11–12, 22, 53–6, 58, 91, 139, 143–4, 170, 175–9, 182, 183–5, 197, 203
Victoria, Queen, 90
Victorianism, 10, 31, 68, 88, 91
visuality, 5, 8, 11, 19, 23, 24, 27, 30, 42, 53–5, 61, 74, 79, 80, 84, 92, 96, 97, 98, 99, 120, 128, 132–3, 137, 151, 156, 164, 167, 169, 171, 208n.6, 222n.85, 226n.21
 see also audiovisual; spectacle
Vitrac, Roger, 182
voice, 4, 5, 9, 10, 21, 22, 38, 39, 57, 61, 63, 65, 66, 68–9, 70, 77, 81, 84, 85, 86, 87, 96, 98, 119, 121, 124, 130, 131, 140, 150, 152, 166, 167, 169–70, 178, 179, 180, 182, 191, 195, 199, 215n.61
 see also Cocteau, *The Human Voice*
Volapük, 109, 111

Wachtel, Andrew, 140, 225n.136
Wagner, Richard, 22, 30–1, 52, 55, 56, 91, 114, 148–50, 161, 185
 Gesamtkunstwerk (total work of art), 51, 196, 198

Weber, Carl Maria von, 22
Wedekind, Frank, 24
Wendel, D. D. B., 190, 195, 232n.141
White, Hayden, 201–2, 203
Wieda, Nina, 49
Wigman, Mary, 230n.37
Williams, John, 22
Worthen, W.B., 49

X-raying, 53

Young, James, 23

Zamenhof, Dr. Lazar Ludwik, 105, 110–12, 114–15, 121, 131, 132, 136, 137, 141–2, 192, 219n.36
zaum, 17, 106, 131–42, 224n.112

GPSR Compliance

The European Union's (EU) General Product Safety Regulation (GPSR) is a set of rules that requires consumer products to be safe and our obligations to ensure this.

If you have any concerns about our products, you can contact us on

ProductSafety@springernature.com

In case Publisher is established outside the EU, the EU authorized representative is:

Springer Nature Customer Service Center GmbH
Europaplatz 3
69115 Heidelberg, Germany

www.ingramcontent.com/pod-product-compliance
Lightning Source LLC
LaVergne TN
LVHW051914060526
838200LV00004B/133